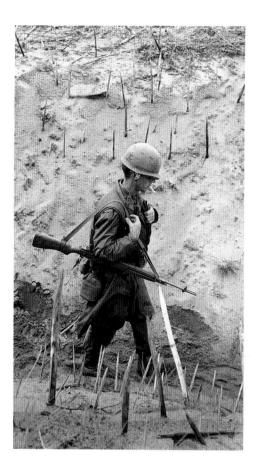

959.704 A

Images from Combat Photographers STAUNTON PUBLIC LIBRAR

OWEN ANDREWS, C. DOUGLAS ELLIOTT, AND LAURENCE L. LEVIN

STARWOOD PUBLISHING, INC. WASHINGTON, D.C.

C.]

Cover: 1968, Spec. 5 Frank Moffit, U.S. Army. A soldier in the 1st Cavalry Division (Airmobile) has marked off months of service on his short-timer's helmet.

Page 1: January 28-29, 1966, Lance Cpl. K. Henderson, U.S. Marine Corps. A marine of the 4th Regiment, 3d Division walks through a punji-staked gully.

Designed by Anne Masters Design, Inc.

Edited by Carolyn M. Clark

Photographs courtesy of the National Archives and Dick Durrance (attributed on page 106)

Copyright © 1991 by Starwood Publishing, Inc. All rights reserved. No part of the contents of this book may be reproduced without the written permission of the publisher.

ISBN 0-912347-75-9

Quality printing and binding in Japan by Dai Nippon Printing Ltd.

5 4 3 2 1 98 97 96 95 94 93 92 91

FOREWORD

It was one of my first photographic research assignments. I had been sitting in the stacks at the National Archives for hours, reviewing World War II photography. I was looking for images that had a quality transcending the moment they captured. Though I could not have said what that would be, I knew I would recognize it immediately. The Navy photography of Edward Steichen, for example, portrays both the individual efforts of sailors and airmen and the magnitude of the historical moment they shared.

Beneath those cramped ceilings, breathing in musty odors that seemed to be of time itself, I started to wonder about war's impact. Like the ever-widening ripples of a stone cast in a lake, the events of history affect each of us differently. Sometimes, we take part in great events or directly feel their effects. More often, we are at a distance; we feel aftereffects in diminishing waves.

For the vast majority of Americans, Vietnam was the six o'clock news. It was a part of our daily lives, yet distant from them. I lived in a small southern town where there were no public protests against the war. That, too, seemed far away.

My first real awareness of the war came with the death of a cousin from California. He was killed by a mortar the day of his nineteenth birthday. This was followed by the dedication of our high school yearbook to a graduate killed in Vietnam. But for some reason, it was the POW-MIA bracelets that brought the war home to me. I can still remember the name — Rudy Becerra — on the bracelet I wore.

Like most projects, *Vietnam: Images from Combat Photographers* evolved over time. After that summer in the stacks at the National Archives, I shared with Larry Levin my idea of compiling a collection of photographs of the Vietnam War that could match the power of Steichen's World War II studies. Larry is a photography editor for *Nation's Business* magazine, and it was his ability to track down even the most rarely published images that enabled me to realize my goal. Together we reviewed over a quarter of a million images. The 94 selected photographs record the individual soldier's experience — times of despair, times of hope, times of action, and times of just plain waiting.

When Larry and I finished our photo edit, Carolyn Clark, with whom I have worked on several books, suggested Owen Andrews to interview combat photographers and write the text. Owen has the ability to get to the core of the most complicated subjects in an uncomplicated manner, and that is precisely what this project needed.

The Department of Defense Still Media Office proved an invaluable resource. A special thanks goes to the team there—Robert Waller, Jr., Greg Hendrix, Dorothy McConchi, and Charles W. Porter III—and to Carolyn Clark for her critical eye and untiring assistance.

C. Douglas Elliott

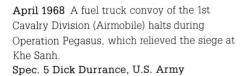

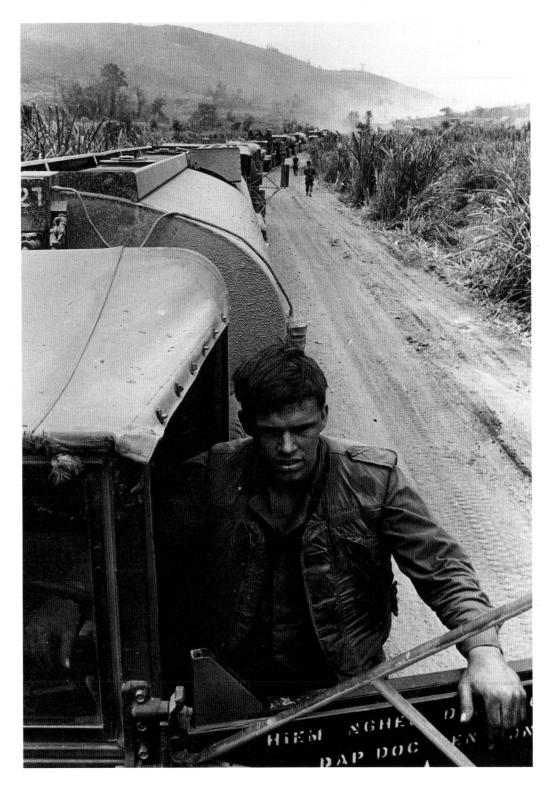

Between 1962 and 1975, military photogra-NT RODUCTION phers for the United States Army, Marine Corps. Navy, and Air Force took millions of photographs of the American war in Vietnam. The record they left, winnowed down today to about a guarter of a million images at the National Archives in Washington, D.C., serves publishers of magazines and histories about Vietnam as an accessible source of inexpensive, well-made images of every aspect of that war.

When published, these photographs carry simple credit lines: "US Army," "US Navy," "USMC." Rarely is the name of the photographer given. Even more rarely does the photographer know in advance that his image has

been used. Most photographers I interviewed told of flipping through books on Vietnam and discovering images they took as young men a quarter century ago.

They seem amused, even proud that their work still finds its way into print. They show little rancor that the images for which they sometimes risked their lives appear anonymously, as military property. Speaking of their days in the service, veteran cameramen quickly demolish the notion that anonymous military photography equals regimented or impersonal photography. As Chuck Cook, a former lieutenant in the 221st Signal Company, remarked, "Every photograph you look at, there's a photographer right there. If you see pain in the photograph, a photographer recorded that pain in the heat, the humidity, the mud, the leeches, and all the rest." Only recently, in books like Dick Durrance's Where War Lives, a collection of personal photographs from his tour of duty as an Army photographer, and Nick Mills' Combat Photographer, a compilation from all the services, has the work of military photographers in Vietnam received closer attention.

The official American photographic record does raise one question: trust. How much can we rely on images commissioned and selected by a government which underplayed the extent of its early commitment to the Diem regime, exaggerated the Tonkin Gulf incident, and persistently misrepresented the war's progress to the press and the public?

We can do so for the same reason that we feel compassion for the young men who were drafted, were healthy and unlucky enough to be assigned to combat units, and carried the burden of the war. Like those foot soldiers, service photographers included every sort from unquestioning patriots to angry skeptics. As Dick Durrance's work shows, the personal vision of a military photographer could diverge sharply from the wholesome, orderly, official view.

Moreover, despite the deception and self-deception that plaqued official accounts of the war, in Vietnam the American military gave the press unprecedented freedom of access to combat zones. That willingness to let the war be documented was also extended to the military's own photographers. Whether they supported the war or questioned it, military photographers could find sustenance in their work as servants of the historical record. As Chuck Cook puts it, "What the photographers did was worth doing-maybe not for the reasons the military said. They just felt that what the soldiers were going through was worth saving."

Whatever a photographer's official mission might be, the reality of combat imposed its own perspective. For example, information officers at the United States Military Assistance Command, Vietnam (MACV) directed the 221st to supply film footage that would counter negative press coverage. But in a war with no clearly defined front and no tangible objectives beyond a body count, an upbeat story line could be elusive. The images that came in from combat operations did not show winners and losers. They showed soldiers — often teenagers — coping as best they could with unrelenting heat and humidity, heavy packs, heavy guns, and an invisible enemy whose mines, booby traps, and snipers could cut life short without a moment's warning.

To get their images, combat photographers suffered the same hardships as the men they documented. Their perspective was the GI's perspective—with two differences: their primary mission was to photograph, not fight, and they enjoyed the luxury of leaving an operation (if transport was available) when they had the pictures they needed and their film had run out. They could go back to camp, clean up, eat hot food, and prepare for a different, perhaps less dangerous mission elsewhere.

These two differences made their Vietnam experience somewhat more palatable than the average GI's. Summing it up, one photographer says, "We saw it all. We saw the best of it, we saw the worst of it. And that gave us an overall picture that the average guy who spent 12 months in the bush couldn't have." For another who didn't get along with a superior officer in a desk job, the officer's idea of punishment — assignment to a combat photography unit — was in fact exactly what he wanted. He preferred the hazardous reality of the front to the surreal tedium of paperwork behind the lines.

Serving as witnesses, not participants, has often made the moral aftermath less painful too. Harry Breedlove, a sergeant first class in Department of the Army Special Photo Office (DASPO), puts it this way: "I don't have the burden of having killed somebody. A lot of other vets feel that burden." Like every aspect of the United States' involvement in Vietnam, the services' photographic operations expanded and grew more complicated as the war progressed. When American military advisors stepped up their active role early in 1962, the Army Pictorial Center (APC) dispatched a series of teams for brief visits. The teams were organized into DASPO, which rotated photographers into Vietnam for three-month tours of duty from a base in Hawaii. DASPO was intended to cover American military news worldwide, and throughout the Vietnam War, teams from Hawaii also went to Korea, Thailand, the Philippines, and other places in the Far East. Until 1965, DASPO provided most of the military photographs of Americans in Vietnam.

DASPO's mission was primarily historical rather than journalistic. DASPO photographers were creating a visual record of operations, equipment, and personnel for the Pentagon archives. Therefore, all DASPO film and captions were shipped to Washington soon after teams came in from the field, and decisions about what to keep and what to throw away were made there. After processing, images became available to military publications, the press, and the public at a photographic library in the Pentagon.

The first Marine correspondent to reach Vietnam was a writer named Steve Stibbens, who went to Saigon in December 1962 to cover Cardinal Spellman's Christmas visit for *Stars & Stripes*. Operating like other members of the press, *Stars & Stripes* correspondents straddled the military and civilian worlds, and Stibbens soon met Horst Faas, the legendary bureau chief for the Assoclated Press. Faas invited Stibbens to join him on a helicopter assault in the Mekong Delta, and then asked him, "Where's your camera? You don't risk your life without taking pictures." Stibbens began carrying a

8

camera, and in January 1963, he photographed the battle of Ap Bac—the first battle of the American war in Vietnam—circling the scene in an L-19 observation plane. Neil Sheehan (who was also there) would find Stibbens' aerial photographs very helpful in later years when he wrote an account of Ap Bac for *A Bright Shining Lie*. (A Stibbens photograph appears on page 19.)

The Marine photographic effort grew rapidly after Marine combat divisions began to arrive in Vietnam in 1965. In the air wings, photographers and journalists operated out of each division's Public Information Office (PIO). In the ground divisions, cameramen in a separate photographic office coordinated their work with the journalists in each PIO. Much of the Marine Corps' photography also came from the staff of *Leatherneck* magazine, based in Washington, D.C.

Marine photographers had more say about which photographs were chosen for official use than their DASPO counterparts, and they distributed them as quickly as possible after each operation. "We didn't think about whether the pictures would be used beyond tomorrow," says Russell Savatt, a career Marine photographer who worked with the First Marine Air Wing in 1965 and 1966. "We just thought about getting them into the papers." When photographers came in from a mission, they prepared the negatives, chose the best shots, printed 125 copies of each, and sent them out immediately to *Stars & Stripes, Leatherneck*, their division publications, the wire services, Marine posts worldwide, and, in some cases, hometown newspapers.

Because of the heat, says Savatt, "We ran our labs in the middle of the night, when it was coolest. We didn't get much sleep." Lab work would have been difficult in any case after long days in the field, and given the primitive darkroom setups available, the quality of the work that survives is remarkable. (A Savatt photograph appears on page 24.)

The Army set up a second photographic group in Vietnam in 1965 and 1966, the 221st Signal Company. Where DASPO answered to the APC in New York and the Department of Defense at the Pentagon, the 221st was an in-country operation linked to MACV headquarters in Saigon, and from 1967 on, its teams worked under the direction of the Southeast Asia Pictorial Center (SEAPC). At its height, the 221st maintained five to seven photo teams at its headquarters in Long Binh and six base detachments at Phu Bai, Pleiku, Can Tho, Saigon, An Khe, and Cam Ranh Bay.

To process their film, the men of the 221st built darkrooms and labs at Long Binh — no easy task, as they had no authorization for much of the equipment they needed. Desperate for air conditioning to preserve their large supplies of film, the company's supply officers struck an undercover deal with a group that repaired airconditioning units from all over the country. After being repaired, these trailer-mounted units rotated through the 221st, spending two or three quiet weeks parked outside their building before heading back to an authorized user.

Film was prepared, reviewed, and released in country, and also went back to the archives at the Pentagon. Part of SEAPC's mission was to offer an alternative to what MACV saw as negative press coverage, so film footage and still photography were made readily available. As SEAPC grew, the 221st largely took over day-to-day combat photography from DASPO, freeing DASPO to work on a range of special projects.

The Army also posted photographers with the public information offices of battalions, divisions, and brigades. Although DASPO and the 221st were the Army's elite photographic units, PIO photographers also made some

9

notable contributions. None is more famous, perhaps, than the work of Ron Haeberle, who went on his first combat photography mission in the closing weeks of his tour of duty in 1968. The place he photographed was the village of My Lai 4, and the operation turned into a massacre of villagers. When the massacre became public knowledge the following year, Haeberle's color images — which he never turned in to his PIO—appeared in *Life*, shocking millions of Americans.

In smaller numbers, the Air Force and Navy also sent photographers into the field. Working out of the major Air

November 1967 On the Go Cong River in the Mekong Delta, a sailor mans a river patrol boat's .50-calibre machine gun. JOC Robert D. Moeser, U.S. Navy Force bases in Vietnam, Air Force photographers assisted in aerial reconnaissance, documented bombing missions, and made portraits of newsworthy pilots. They also compiled portfolios of combat aircraft in flight and recorded every aspect of aircraft maintenance and combat preparation.

The work of Navy photographers paralleled the naval role in the war. From the carriers of the Pacific Fleet, photographer's mates followed every aspect of naval air operations over North Vietnam. In country, photographers from the Combat Camera Group—Pacific (CCGPAC) accompanied the Navy's hazardous river patrols and the often-secret counterguerrilla missions of naval combat assault groups, the Sea, Air, and Land teams (SEALs).

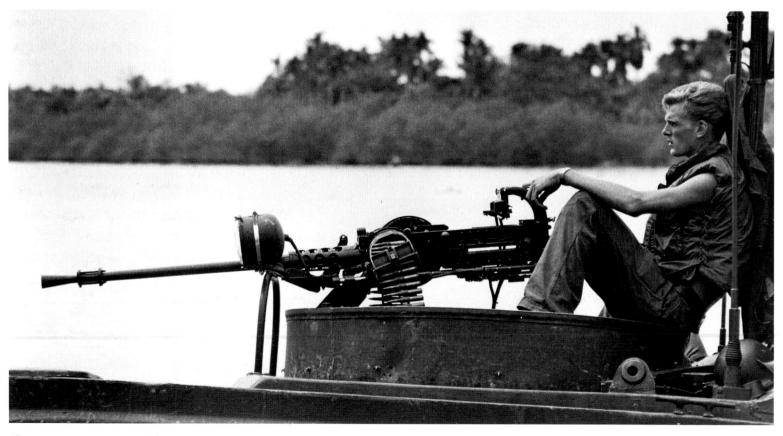

The stated missions and command structures of each photographic outfit differed, but in all the services, the men assigned to photography shared certain similarities. Early in the war, they tended to be career soldiers who had chosen to specialize in photography. As with other career soldiers, Vietnam was a place to prove themselves in combat.

For Harry Breedlove, who joined the Army in the 1950s and spent four years with an armored unit as a tank crew member, photography was a chance to get away from tanks, which had damaged his hearing. He took to it enthusiastically, and after photography school at Fort Monmouth (where many Army and Marine photographers trained), he spent four years in the early sixties with a small photographic unit in Naples. Italy. He recalls how his commanding officer there gave him free access to the darkroom, encouraging him to experiment and improve his photography. In his spare time, he made portraits and photographed weddings. After he returned to the States, the same officer told him about DASPO, then being formed as an elite Army photo unit. Breedlove applied, was accepted, and was posted to DASPO headquarters in Hawaii for a three-year tour of duty. He began his first three-month rotation in Vietnam in December 1965, replacing Kermit Yoho, the first DASPO photographer to be killed in action. (A Breedlove photograph appears on page 48.)

Early Marine photographers were equally seasoned; Russell Savatt had joined the Marines in 1946, got out in 1948, went to the New York Institute of Photography, and reenlisted for Korea in 1951. Arriving in 1965 in Da Nang, where the Marines would soon construct a major press center with facilities for civilian and military journalists, he joined others with long service records and plenty of published photographs. Photography was a low priority then, but Savatt remembers a staff meeting where photographers were invited to explain exactly what equipment would work best in the field. They spoke up for 35mm Nikons, flash units, and Rollieflexes, which the Marine Corps soon supplied. It seemed to Savatt that Marine photographers were better equipped early on than their Army counterparts, many of whom were still working with the XL or Combat Grafic, a 4 x 5-inchformat camera with a view finder — a cumbersome rig if you were trying, for example, to photograph a landing zone from a moving helicopter.

As the services increased their photographic staffs, men like Savatt and Breedlove would guide younger, less experienced marines and soldiers. Some were enlisted men who applied for communications jobs; some were draftees assigned to photography because of a college background in journalism or broadcasting. Bryan Grigsby, who joined DASPO in 1968, learned a lot from Breedlove on patrols together. He recalls that Breedlove could be trusted in combat to look out for his men and help them do their work without needless risk.

A bit of college, an interest in journalism, and a feeling for the techniques and aesthetics of photography gave American military photographers an atypical version of the Vietnam experience. An infantry company might contain people from widely varied backgrounds, people with little in common. For them, the war was a detour a nightmarish one — from the lives they hoped to lead. Combat photographers often shared aspirations; many of those I interviewed recalled close friendships and late nights at the base when they were in from missions, arguing the finer points of the work they tried to do.

Grigsby remembers that when he joined DASPO, he didn't care all that much about photography. Staying alive was more important, and taking pictures seemed

11

like a good way to keep out of trouble. Drinking beer with a friend one night, Grigsby declared that all good photographs are accidents. And his friend said, "No, they're the result of thinking—that's how you make consistently good pictures." Other DASPO photographers also encouraged Grigsby to develop his understanding of the camera. He worked with Dick Durrance, who was "an inspiration to me. Watching him work gave me an early insight into what it took to do this business right." His experiences in Vietnam led Grigsby into a career in photography; he is a photo editor with the Philadelphia *Inquirer* today.

Others deliberately made use of their Army years to learn the photographic trade. Durrance was one; Don Critchfield, a lieutenant in the 221st Signal Company was another. He joined the Army after getting a degree in broadcast journalism in college. "I was lucky," he recalls, "first of all in not getting shot, and secondly, in doing in the military what I had hoped would be my profession." Critchfield got a job with NBC in Saigon as soon as he was discharged and still works with them today, producing stories from Washington for the national news.

Critchfield and the other officers were mostly in their midtwenties. The soldiers on their teams were younger and less experienced. "What we're talking about," says Gary Krull, another lieutenant in the 221st, "are young kids, with lots of freckles, who at 17, 18, 19, learned how to use a camera. And we sent them out to watch the war, told them to be careful, asked them not to get hurt, and by the way, bring back some good footage, because that's what Uncle Sam's paying you to do. And 99 out of 100 times, they brought back damn good footage."

However much these men appreciate what they learned about photography in Vietnam, one hard fact remains —

their experience was gained in combat, in situations more trying, more terrifying than anything they had ever imagined. Bryan Grigsby describes it well: "In the Army, making pictures under very difficult circumstances, one of the big things I learned was that I could do it. I could go out and make pictures when I was scared, so scared that my hands would be shaking and I could hardly load film into the camera."

Photography teams got to combat zones in a variety of ways. Marine photographers based at Da Nang worked with the PIO to determine which operations they should cover, then hitched rides with assault helicopters and transport aircraft. Photographers of the 1st Air Wing took along a writer to do the captions and the story; those with ground-based divisions went alone.

Hitching a ride could be a challenge. Marines were loathe to sacrifice a seat to someone for whom fighting was not the primary mission. Russ Savatt describes how his knowledge of aircraft helped him talk his way aboard; he'd point out to the pilot of a C-34B that his plane could carry 150 pounds more than other C-34s. Or his writer would volunteer to take the waist gunner's place. "The waist gunner didn't appreciate that, but maybe his wife did. Or maybe she didn't!"

Savatt and his colleagues were also prepared to fight if they had to: "Marines are always infantrymen first." As the troops became aware that photographers would fend for themselves, carry their own food and water, and use a gun if necessary, they learned to respect them — even to encourage their presence, if it meant a chance of appearing someday in *Stars & Stripes* or *Leatherneck*.

Striving to meet press deadlines and to cover as many events as possible, experienced Marine photographers tried not to spend too long with one operation. Savatt liked to ride in with the first wave of helicopters, photograph the action, and get a ride out again with the last wave. Sometimes that didn't work; he recalls the day when he landed in elephant grass taller than he was, disappeared from view, and lost contact with the helicopters. "I walked out with the infantry that time."

Photographers of the 221st Signal Company had highpriority clearance for transportation. Once a mission was assigned, they could quickly get seats on aircraft. Commanding officers attended briefings at MACV headquarters in Saigon to find out "where the war was going" and then assigned their teams. Typically, teams included five men: two still photographers, a motion picture photographer, an assistant, and a commanding officer, who might be a lieutenant or an NCO.

Civilian journalists mocked the accuracy of MACV information, and even for military personnel, MACV briefings could be misleading; teams often arrived at combat command headquarters, looking for a ride to the combat zone, only to find that the war had moved somewhere else. Team leaders learned to find potential stories on their own. As in all aspects of the war, the closer you were to the fighting, the better you understood what was really happening. To Don Critchfield of the 221st, it often seemed that people higher up "didn't know what was going on out there. And I did." When assignments weren't handed down, Critchfield obtained approval to follow stories on his own.

To protect the lives of their men, officers of the 221st encouraged them not to go into a landing zone with the first helicopters, but to wait until the LZ had been cleared and a perimeter established. A hot LZ was no place for a photographer whose only official weapon was a .45calibre pistol — which, as one veteran remarked, "is not much use in a firefight." After some bad early experiences, many members of the 221st packed unofficial carbines or shotguns. And there were many occasions when these teams had need of weapons, when units got into situations where resupply helicopters could not reach them. Precautions were not always successful. During the Cambodian invasion, the 221st was badly shaken by the loss of an entire five-man team. Someone sent them into a hot LZ on the first wave of an assault, and their helicopter went down with no survivors.

DASPO photographers also went out in teams of five or six, including still photographers, motion-picture photographers, and sound men carrying tape recorders.

January 18-19, 1968 Members of the 22nd Infantry Regiment (Mechanized), 25th Infantry Division pass an evening near Saigon. Spec. 6 Samuel L. Swain, U.S. Army

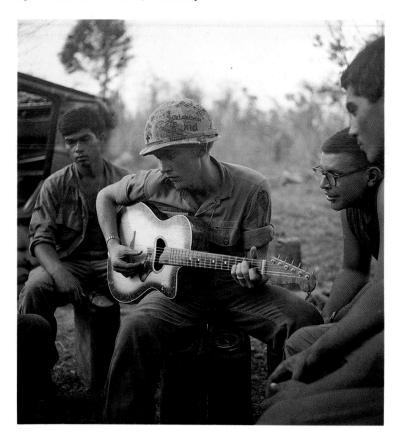

With that many people, it was impractical to cover small operations such as night ambushes or secret squadron patrols. And in these clandestine situations, photography often became impossible. As Harry Breedlove says, "Ambushes were usually at night, and you couldn't get any pictures." Small jungle patrols could be equally futile. The tension of walking a potentially mined and boobytrapped trail left no time to think of anything else. As the unit moved in single file, a photographer who dared shift his thoughts to making pictures had only the man in front, the man behind, and foliage as subjects.

Larger operations offered the safety of numbers.

"That's how the military works," says Don Critchfield. "Except where we had to run out in front and get pictures looking back, I didn't feel the danger—probably the same logic that a school of minnows feels about a predatory fish. Somebody's going to get eaten, but it won't be me."

Once a firefight began, numbers ceased to matter. To many photographers, the experience seems beyond

July 21, 1969 Pfc. Joseph Big Medicine, Jr., a Cheyenne Indian in the 1st Marine Division, writes a letter to his family. Lance Cpl. John A. Gentry, U.S. Marine Corps

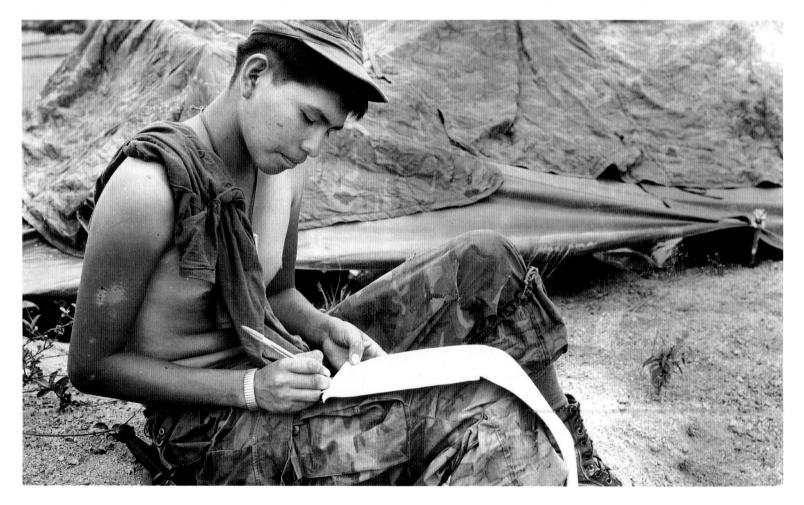

photography's power of expression. "You can't photograph combat," says Bryan Grigsby.

You can't get it on film. It's not there. The only thing you can show is its results — its effect on people, the wreckage, the wounding. Moviemakers give you the perspective of an omnipresent being seeing everything all at once. But when you're in combat, you're really just a tiny little spot, very much alone, very fragile, very much aware of your vulnerability.

To work at all in those conditions, to keep the camera functioning and to keep looking for images, was no small accomplishment. Photographers often found that the camera and the photographic mission could be a kind of filter making it possible to forget themselves and continue taking pictures when everything had turned to chaos and horror.

To let their teams recuperate after stressful combat assignments, officers also looked for missions away from the fighting. Documenting the war meant covering everything from visits by dignitaries, politicians, and entertainers to the stand-down of an infantry division departing for the United States. Combat teams photographed temples, showed the use of geese as earlywarning systems at ARVN bases, toured pacified villages, recorded the use of trained dogs to sniff out guerrillas, searched in the highlands for elephants used as pack animals by the Vietcong, and provided footage of weapons and equipment. Ray Goddard, who went to Vietnam on a series of three-month missions with a DASPO team from 1964 to 1967, explains that there was no typical mission. From one to the next, "the only thing that was the same was your equipment, the people that you worked with for the most part, and the fact that you

were going to go someplace."

Wherever they worked in Vietnam, photographers contended with an unrelentingly hot, humid climate that fouled cameras and damaged film. To counter the effects of humidity, Marine photographers dried out their cameras in a hot box every three or four days. Keeping equipment dry in the wet season was virtually impossible; all military storage lockers in Vietnam required a constantly burning light to retard mold. In the dry season, dust penetrated everything.

The harsh tropical light imposed limitations as well. In sunlight, the shade cast by a hat brim could black out all the features of the face beneath. In a triple-canopy jungle, the shutter had to be set for available light, and if a few sunbeams reached through the foliage, they formed sharply contrasting tiger stripes that obliterated detail. Looking at photographs neatly printed in a book two decades later, these difficulties can be hard to grasp. Every day in country, photographers dealt with them as best they could, and at the war's height, their efforts yielded thousands of pictures a week.

A final obstacle faced by military photographers was the uncertain fate their images met in official hands. When images from DASPO, the 221st, and other Army photographers reached the Pentagon, they were reviewed by a small pictorial staff and filed for release, classified, or rejected. Conscientious and thorough as they were, the pictorial staff faced a virtual avalanche of images at times, and the criteria they applied could be mystifying and frustrating to the cameramen in the field.

Above all, the Department of Defense did not smile upon photographs which showed American soldiers in an unfavorable light. Photographers understood this, and generally refrained from photographing GIs in bars and brothels, or GIs burning villagers' huts, or GIs using

15

overly harsh methods to interrogate prisoners. Photographs of wounded and dead Americans were also handled with extreme caution. A caption was required for every photograph, and the services did not want families of dead and wounded Americans to unexpectedly encounter images of their sons in newspapers and magazines.

Other restrictions, conveyed in written critiques sent back to the field by Pentagon officers, were harder to grasp. For example, where press photographers might shoot dozens of frames of a newsworthy situation, military photographers were discouraged from expending more than one or two frames on a particular soldier, group, or scene.

There was also the problem of clothing. Harry Breedlove, whose much-published photograph of 1st Air Cavalry soldiers jumping from a helicopter onto a hilltop LZ became the basis for the design of the Vietnam Veterans' National Medal, still can't believe that he was sharply reminded to make sure that the soldiers he photographed in combat had their shirts on and looked presentable. "Out there in the field, crawling around, with guys getting shot at, it was absolute chaos sometimes. What are you going to do, stop the men and say, 'Look now, button up your shirt and roll down your sleeves?'"

To military photographers, documenting the war meant showing, as one says, "the pain, the anguish, and the struggle" of the soldiers. Under pressure, picture editors in Washington couldn't always look for the most emotionally powerful or technically accomplished image. One week, they might be advised to select photographs of tanks. Another week, it would be Huey helicopters, and a third, M-16 rifles. For men who were risking their lives, these were difficult criteria to accept. Some responded with a shrug, went on learning their trade, and hoped their best pictures would be saved. Some accepted the military view and went on taking the pictures that would serve the war effort best. Many quietly rebelled and carried personal cameras or held onto images they didn't want to lose.

Looking through our selection of photographs from the official files, the veterans I interviewed often alluded to those personal collections. As they spoke, I sometimes sensed that the content of those pictures isn't what matters—though many undoubtedly deserve to be seen. What matters is a shared experience, private and inexpressible, which those of us who weren't there will never fully grasp. Few photographs can show it. We hope, in publishing the fine work in the official record, to recognize the importance of the images these men made for the nation and the trials they endured along the way.

Owen Andrews

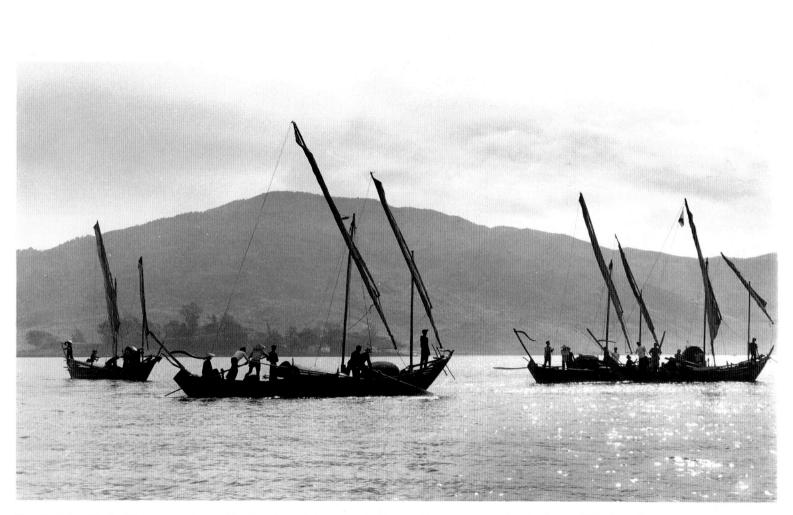

May 1962 In 1960, the Vietnamese Navy and its American advisors organized a coastal patrol fleet of sailing junks. Manned by civilians, these boats were to blend in with river traffic and watch for shipments of Vietcong supplies. Motor-

ized junks were added to the fleet in 1962 after sailboats proved ineffectual. Photographer unknown, U.S. Navy

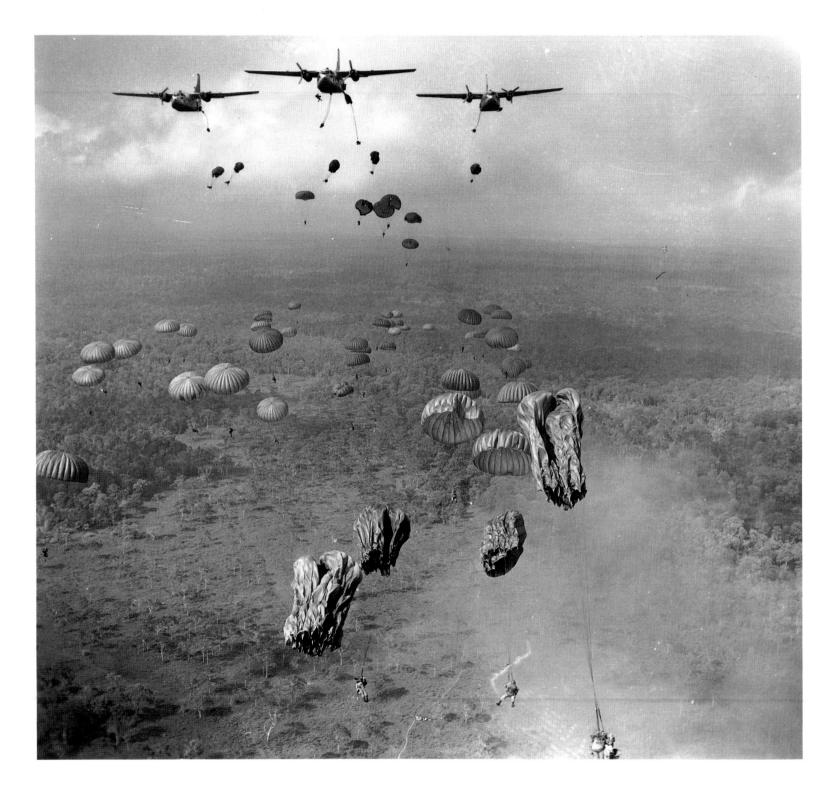

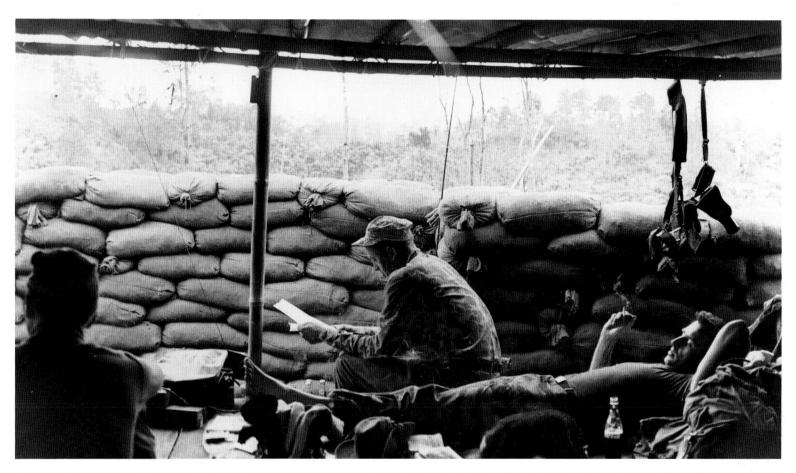

January 15, 1964 Howard Stevens, a Special Forces A-team sergeant, reads his mail at a camp west of Da Lat. Stevens helped train a Montagnard (mountain) tribe to fight the Vietcong. Because the Montagnards knew the

bewildering Central Highlands terrain, Americans and North Vietnamese both sought their support.

S. Sgt. Steve Stibbens, U.S. Marine Corps

March 1963 Hoping to surround Vietcong forces in Tay Ninh Province, South Vietnamese soldiers make a parachute assault — a tactic seldom used in Vietnam — from USAF C-123 transports. USAF aircraft had been ferrying Årmy of the Republic of Vietnam (ARVN) troops into combat on joint missions since late in 1961.

Photographer unknown, U.S. Air Force

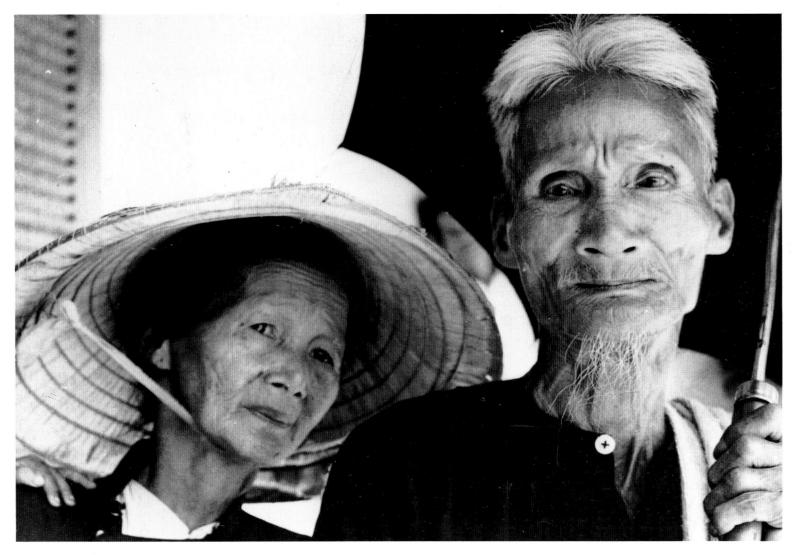

1965 This Vietnamese couple was relocated from their village to a refugee center near Da Nang. Trying to separate neutral or friendly villagers from the Vietcong, marines moved hundreds of peasants in 1965. Variants of this tactic

were repeated all over Vietnam by American troops, causing much resentment among the Vietnamese. Gunnery Sgt. H. Haeberle, U.S. Marine Corps

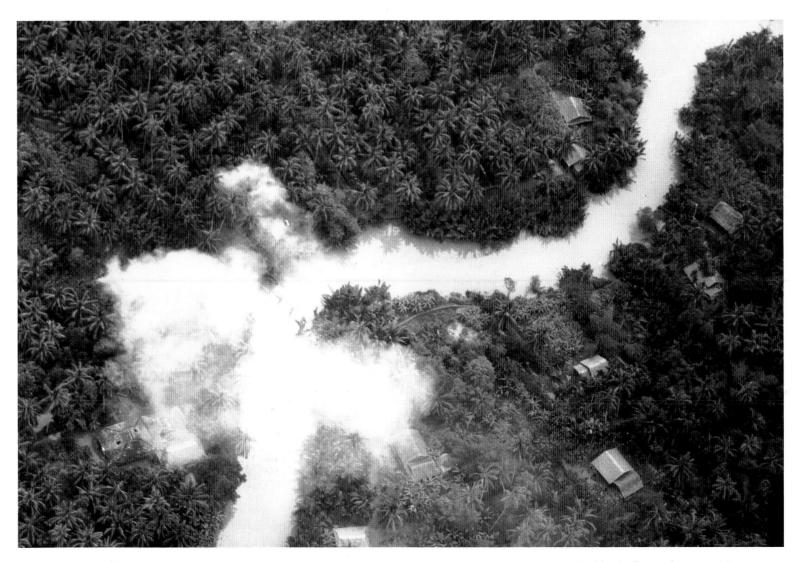

1965 Suspected Vietcong buildings burn after a USAF strike. The Air Force role in Vietnam expanded gradually after October 1961, when the 4400th Combat Crew Training Squadron arrived to instruct South Vietnamese pilots

and fly propaganda missions. By early 1965, Air Force pilots were carrying out air strikes, testing defoliants, and bombing targets in North Vietnam. **Photographer unknown, U.S. Air Force** August 3, 1965 A marine of the 3d Division disembarks at Da Nang. The marine mission near the Demilitarized Zone (DMZ) changed rapidly in mid-1965. President Johnson sent in the first marines in March to defend Da Nang and establish new bases at Phu Bai and Chu Lai. But the strength of the Vietcong quickly led American field commanders to push for more aggressive combat missions.

Photographer unknown, U.S. Marine Corps

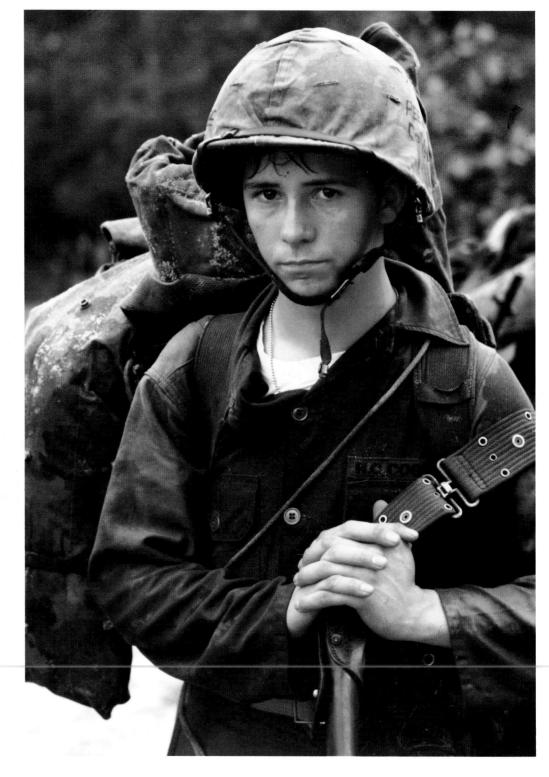

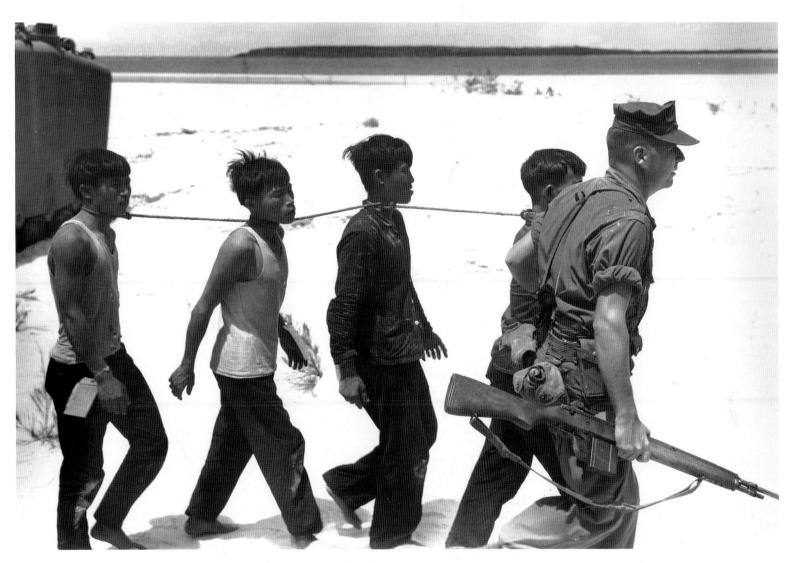

July 25, 1965 The marines found the densely populated coastal villages near their bases full of Vietcong and patrolled vigorously to flush them out. Here, a 3d Division marine leads Vietcong prisoners to a helicopter landing zone,

where they will be transported to a regimental base for interrogation. Sgt. L. D. Choate, U.S. Marine Corps

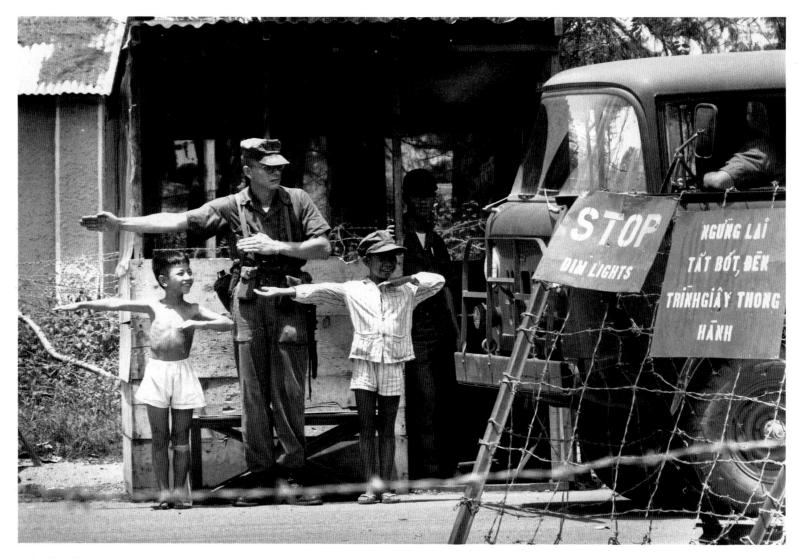

July 28, 1965 At "Checkpoint Charlie," an entrance to the base at Da Nang, two sons of a Vietnamese Air Force sergeant help Marine MP James T. Carter with his duties.

S. Sgt. Russell Savatt, Jr., U.S. Marine Corps

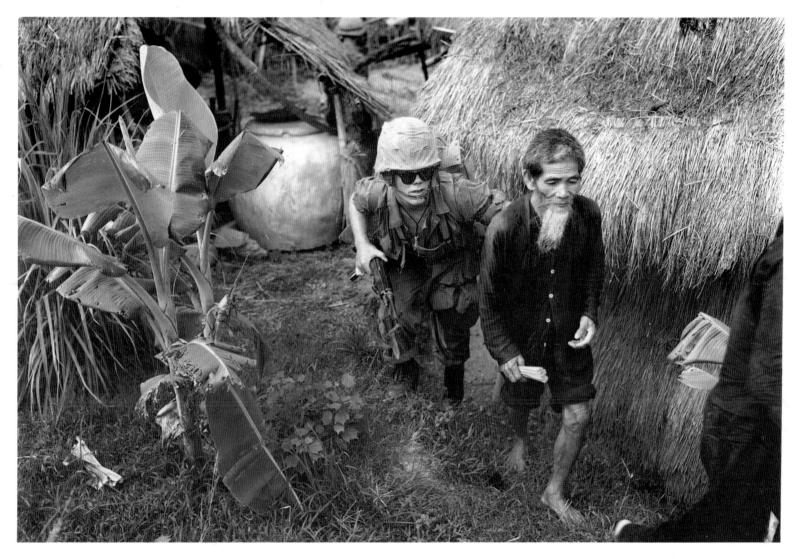

August 3, 1965 In a village 15 miles west of Da Nang, a marine of the 1st Battalion, 3d Regiment takes a Vietcong suspect to the rear during a search and clear operation.

Pfc. G. Durbin, U.S. Marine Corps

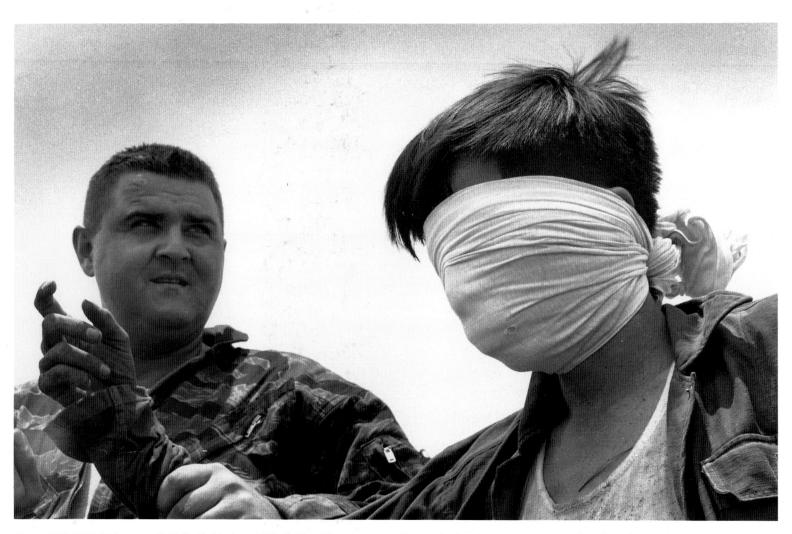

August 18, 1965 S. Sergeant R. E. Steffy binds and blindfolds a Vietcong prisoner. On the day this photograph was taken, the 3d Marine Division began Operation Starlite, a major drive against Vietcong coastal bases near Chu Lai.

During Starlite, American troops fought in large battles for the first time since the Korean War. S. Sgt. H. Shipp, U.S. Marine Corps

September 14, 1965 Soldiers of the 1st Cavalry Division (Airmobile) wait to go ashore at Qui Nhon. The newly formed 1st Air Cav came to Vietnam to test the idea of helicopter-borne "cavalry." Like 19th-century horse cavalry, the Air Cav would move quickly into enemy terrain and act as forward skirmishers, shock troops, and scouts.

1st Sgt. James K. F. Dung, U.S. Army

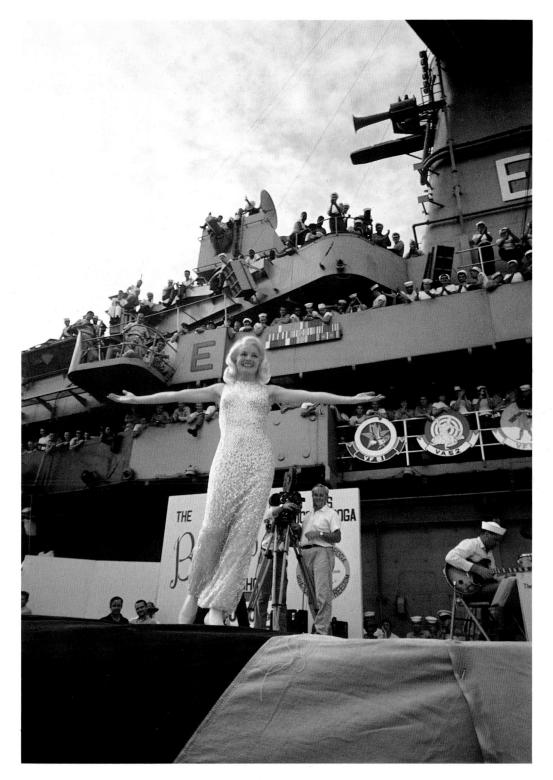

December 1965 Actress Carol Baker, traveling with Bob Hope and his troupe on Hope's first Vietnam trip, greets the men of the attack aircraft carrier USS *Ticonderoga* (CVA-14) as the ship cruises in the South China Sea. Photographer unknown, U.S. Navy

December 17, 1965 Pfc. Chris Banks of the 3d Marine Division trades in worn boots for a new pair at Landing Zone Oak during Operation Harvest Moon. The leather boots worn by marines early in the Vietnam War were later replaced by a canvas and leather boot more suited to tropical combat.

Lance Cpl. K. Henderson, U.S. Marine Corps

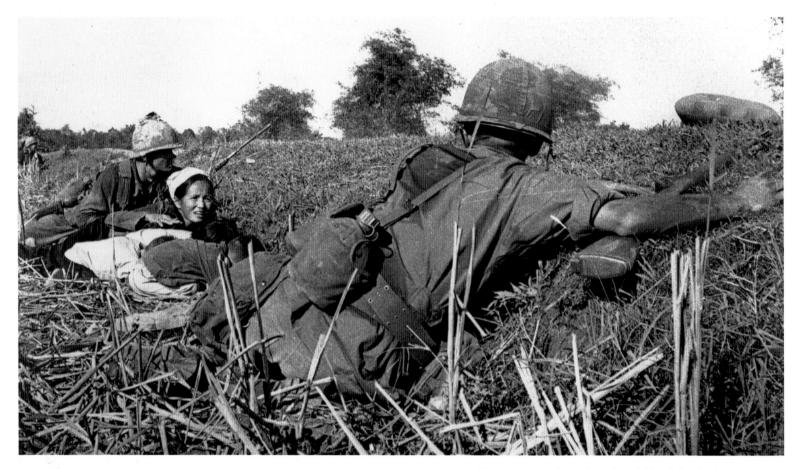

January 16, 1966 Pinned down in a firefight with Vietcong while trying to cross a field surrounded by bamboo hedgerows, soldiers of the 1st Infantry

Division urge a Vietnamese mother to keep her children's heads down. Photographer unknown, U.S. Army

January 22, 1966 A member of a company in the 3d Marine Division looks for snipers in the jungle north of Con Thien. Con Thien (Hill of Angels) stood very near the DMZ. When the North Vietnamese Army (NVA) crossed the DMZ in force in June 1967, marines at Con Thien withstood a ferocious but unsuccessful three-week artillery siege. Patterson, U.S. Marine Corps

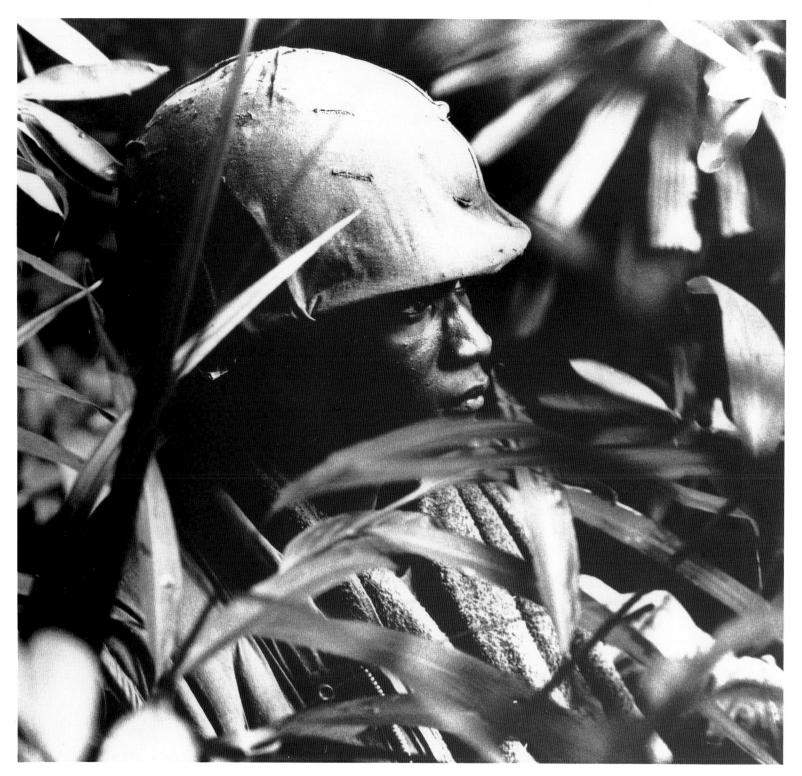

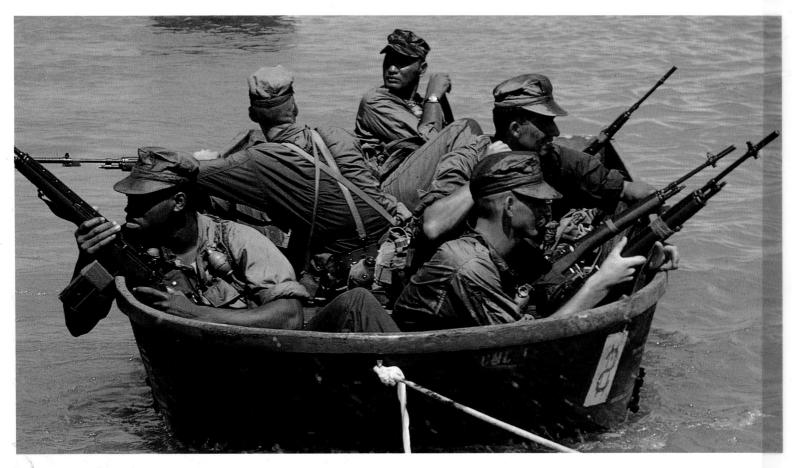

March 26, 1966 Marines of the Special Landing Force approach a beach in the Rung Sat Swamp, 35 miles south of Saigon. Traditional amphibious assaults would give way by 1967 to the tactics of the Army-Navy Mobile Riverine Force

(MRF). Using fast, heavily armed small craft, the MRF destroyed VC hideouts, assisted SEAL operations, and searched river traffic. JOC Erne J. Filtz, U.S. Navy

April 1966 Members of the 327th Regiment, 1st Brigade, 101st Airborne Division wait for takeoff in a USAF C-130 Hercules transport aircraft. They are headed for Operation Austin VI, an effort to intercept Vietcong along trails leading into South Vietnam's Quang Duc Province from Cambodia. Photographer unknown, U.S. Air Force

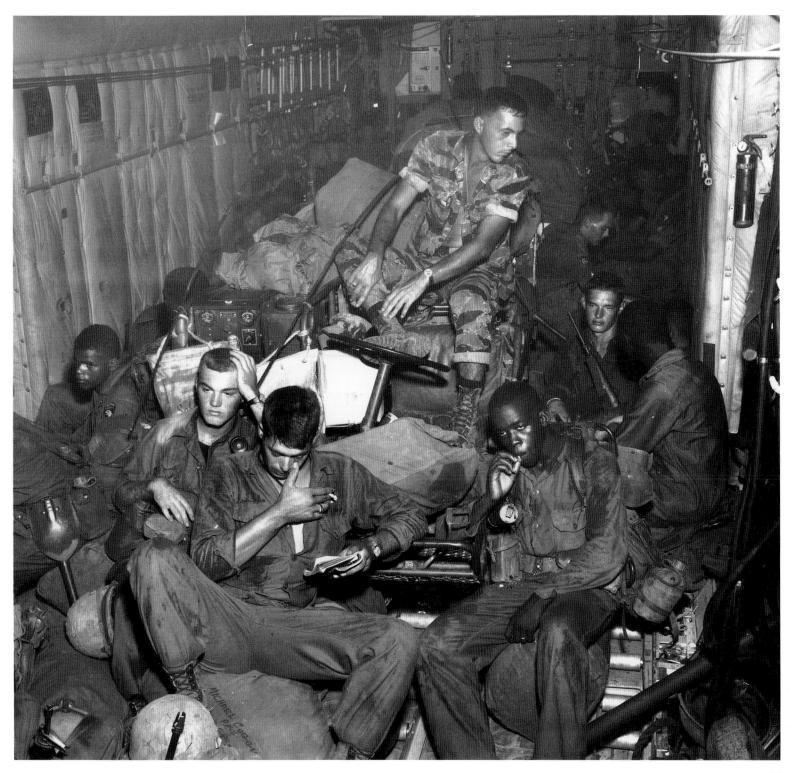

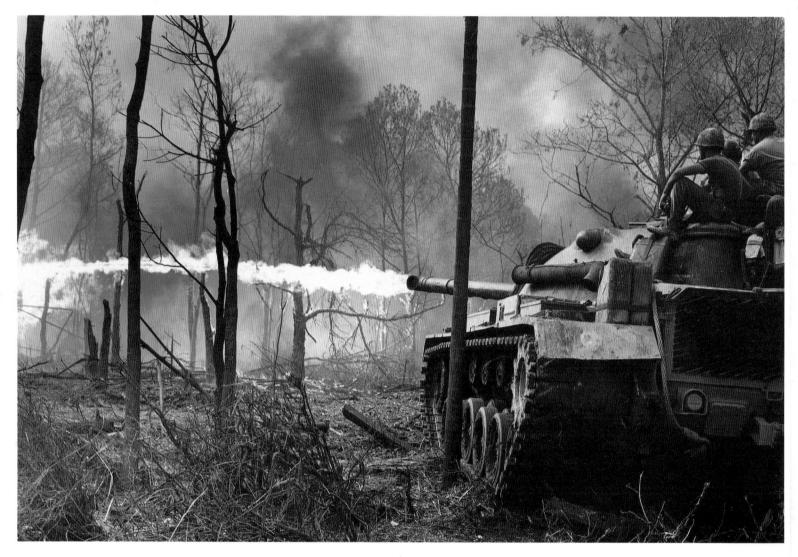

1966 A flame-throwing tank of the 1st Tank Battalion, 1st Marine Division burns a village during Operation Doser in Quang Ngai Province. Almost useless in the swampy Mekong Delta and the rugged Central Highlands, American

tanks were only effective in the piedmont north of Saigon and the flat coastal plain between Da Nang and Hue. Pfc. William C. Norman, U.S. Marine Corps

April 26, 1966 A marine fires a rifle salute to soldiers killed in Operation Osage. Of the half-million marines who served in Vietnam, 11,490 were killed in D. R. Salve, U.S. Marine Corps

action, 1,454 died of wounds, and over 88,000 were wounded.

1966 Serving as forward point for his unit during Operation Macon, a marine moves slowly, cautious of enemy pitfalls. Walking point on a patrol was one of the most dangerous things an American could do in Vietnam; the pointman was the first to move into an ambush and the first to encounter mines and booby traps. Photographer unknown, U.S. Marine Corps

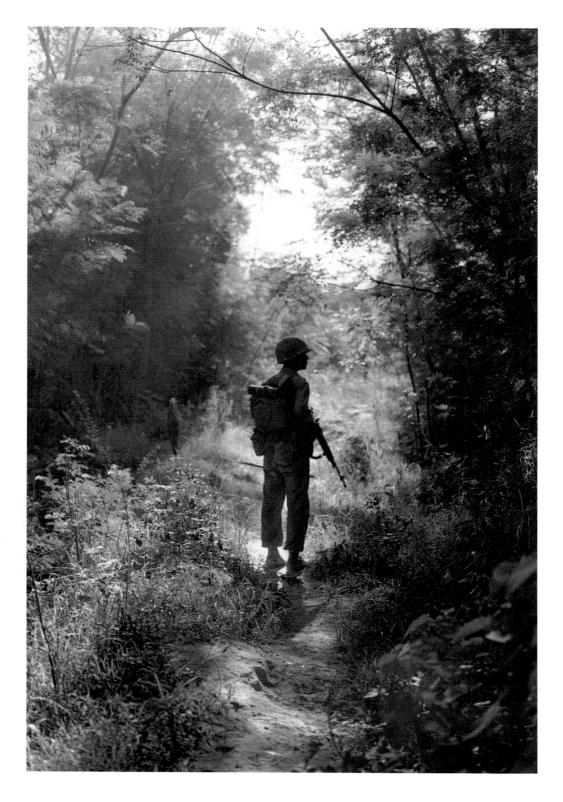

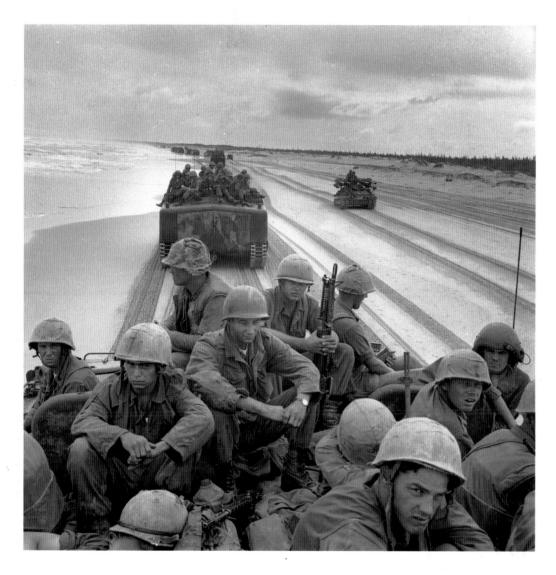

1966 LVTP-5 amphibious tractors transport troops of the 3d Marine Division. Trained to make amphibious assaults on heavily defended coastlines, marines in Vietnam had to adapt to a land war fought in villages where the enemy often slipped away and from isolated hilltop camps where encirclement was an ever-present danger.

Photographer unknown, U.S. Marine Corps

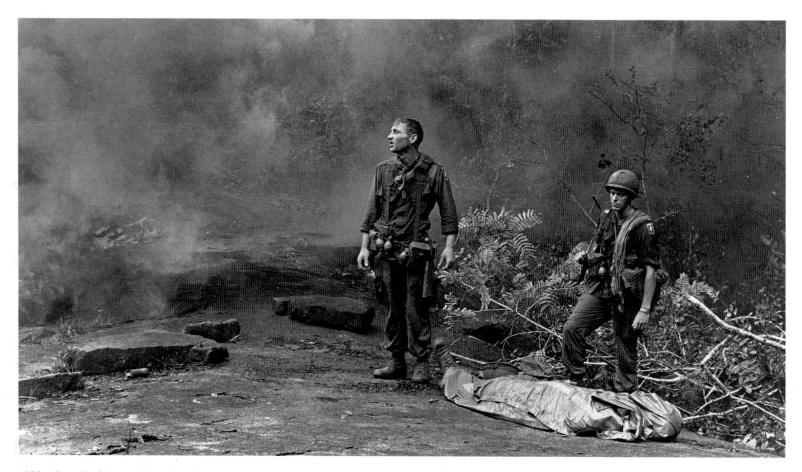

1966 After a firefight in the jungle-covered hills of Long Kanh Province northeast of Saigon, two soldiers of the 173d Airborne Brigade wait for a

helicopter to evacuate them and their dead companion. Pfc. L. Paul Epley, U.S. Army

June 25, 1966 Brig. Gen. Willard Pearson briefs troops of the 1st Brigade, 101st Airborne Division in preparation for Operation Eagle Bait. Looking for ways to make the tactics of the 101st meet the requirements of jungle warfare, Pearson favored night assaults and ambushes. Sgt. Bernie Maniboyat, U.S. Army

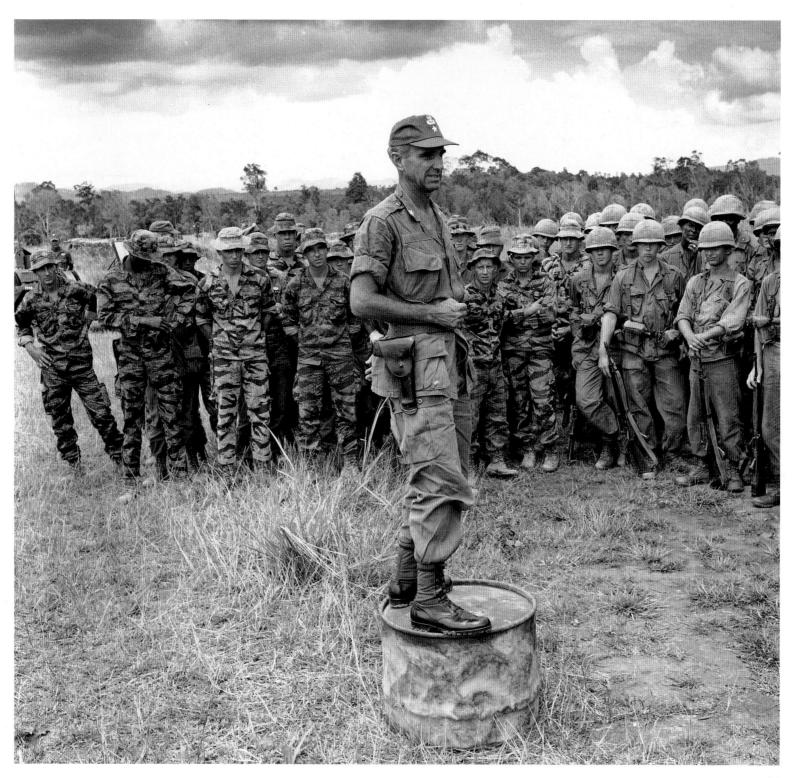

July 12, 1966 Lt. Col. F. S. Wood, commanding officer of a battalion in the 1st Marine Division, escorts Secretary of the Navy Paul Nitze (left) and Maj. Gen. Lewis J. Fields (center) around his base. Nitze strongly favored American intervention in Vietnam; Fields commanded the 1st Division during its first year in country.
S. Sgt. Fleetwood, U.S. Marine Corps

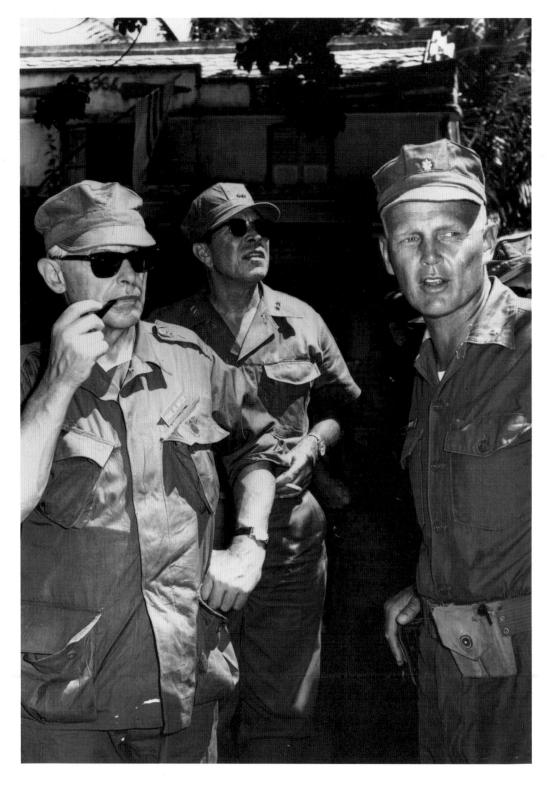

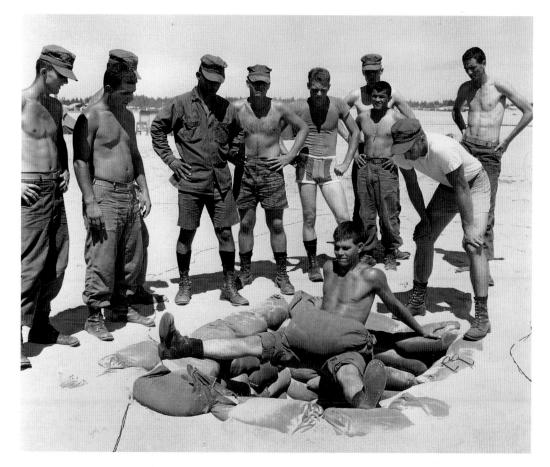

b

August 13, 1966 1st Lt. Jay Robertson of the 2d Battalion, 7th Regiment, 1st Marine Division instructs Pfc. Cecil E. Dorsey in a back, leg, and stomach muscle exercise. Cpl. Gaspard, U.S. Marine Corps August 15, 1966 On a search-and-destroy mission during Operation Colorado, a rifleman in the 1st Marine Division leaps across a break in a rice-paddy dike. Colorado was one of a series of efforts to ruin Vietcong food-gathering operations in the Que Son Valley, a fertile rice-growing region south of Da Nang.

S. Sgt. Fleetwood, U.S. Marine Corps

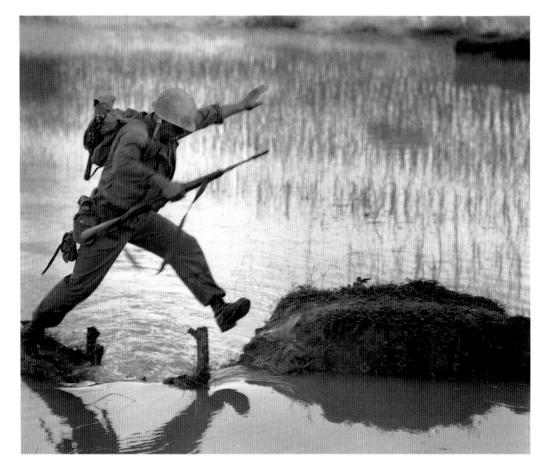

October 1966 A U.S. Army soldier directs a UH-1 Huey helicopter as it comes in to pick up Americans injured in a paradrop mission. First used to move wounded soldiers in the Korean War, medical evacuation helicopters—"slicks" or "dustoffs"—would transport over 300,000 wounded Americans from combat zones in Vietnam.

Photographer unknown, U.S. Air Force

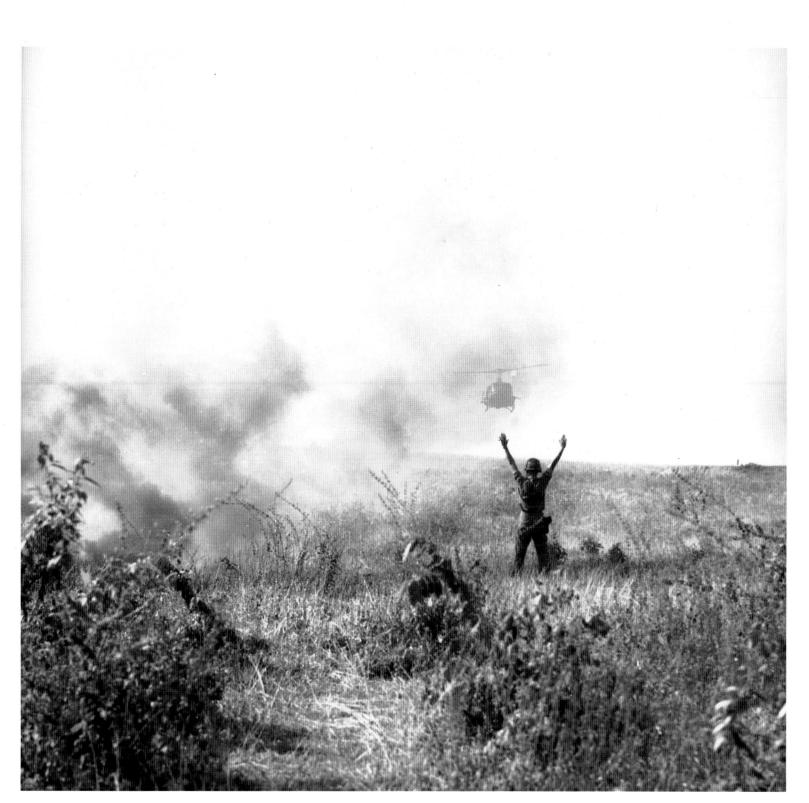

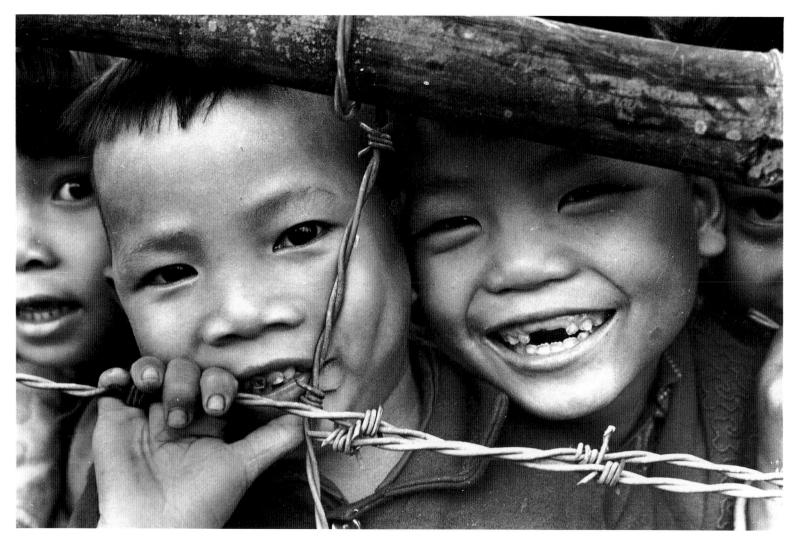

January 12, 1967 Vietnamese refugee children peer through a fence at the Phong Dien refugee hamlet. Throughout South Vietnam, American troops moved peasants out of combat zones. This enabled them to search more

effectively for Vietcong and to fire without fear of harming civilians. But it also engendered a huge displaced population, dependent on American aid. Lance Cpl. B. L. Axelrod, U.S. Marine Corps

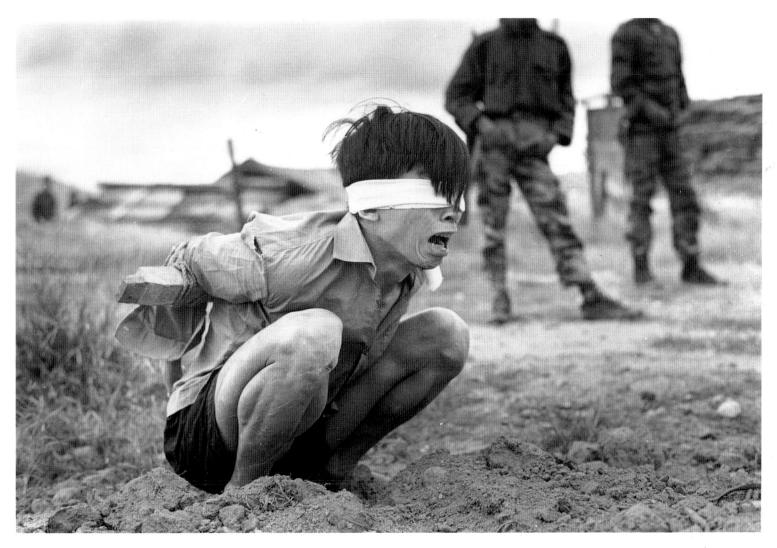

January 27, 1967 A Vietcong prisoner awaits interrogation at the A-109 Special Forces detachment in Thuong Doc, 15 miles west of Da Nang. After interrogation, captured VCs were turned over to the ARVN, which frequently executed them.

Pfc. David Epstein, U.S. Army

March 18, 1967 Near Phan Rang, 1st Lt. Tovar of the Recondos gives instructions to his squad leaders. In 1967, commissioned and noncommissioned officers in the field usually had adequate experience. By 1969, as the policy of one-year rotations exhausted the supply of well-trained officers, the quality of combat leadership had seriously declined.

Pfc. Darryl Arizo, U.S. Army

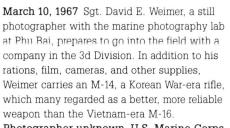

Photographer unknown, U.S. Marine Corps

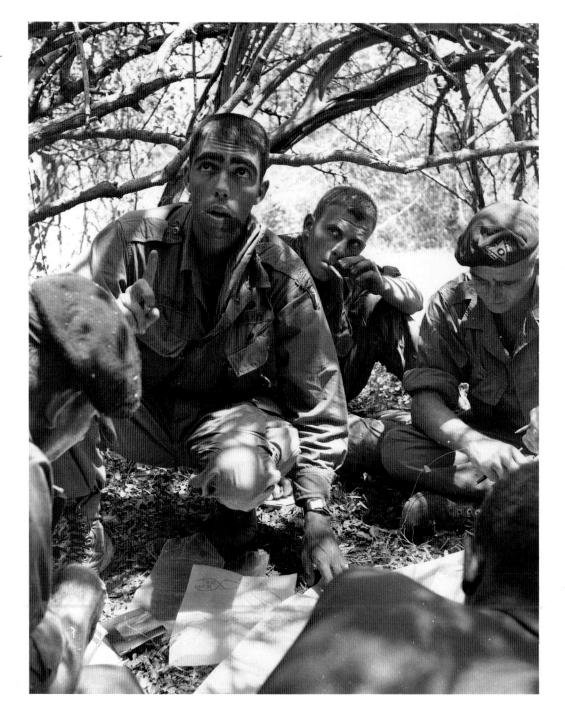

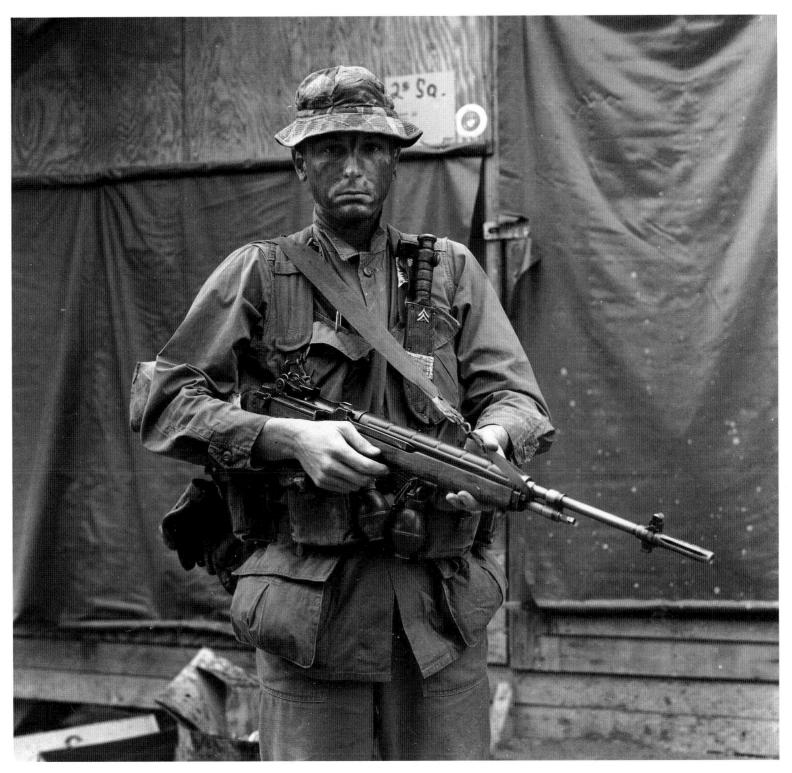

April 24, 1967 Members of a reconnaissance platoon in the 1st Cavalry Division (Airmobile) lower an infantryman into a tunnel near Duc Pho. The hazardous job of searching Vietcong tunnel complexes fell to "tunnel rats," volunteers armed with pistols and flashlights, whose slight builds enabled them to squeeze through openings not designed for the average American. S. Sgt. Harry Breedlove, U.S. Army

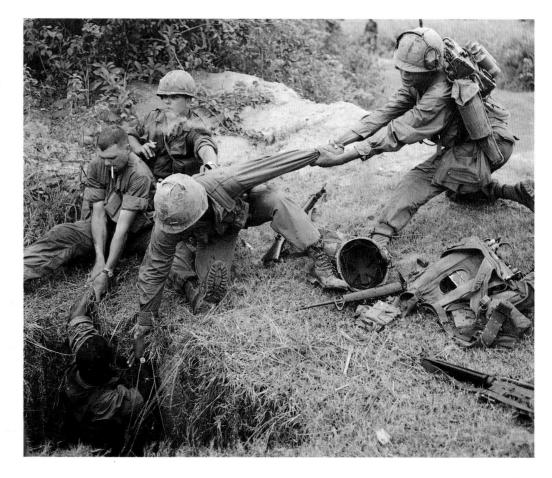

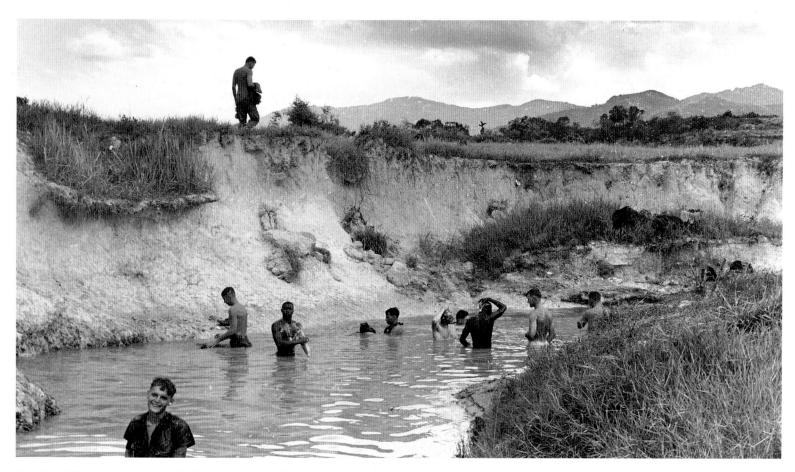

May 27, 1967 A company in the 3d Marine Division bathes in a stream at the base of Hill 51. Streams fit for bathing weren't easy to find in Vietnam, where leeches and other parasites are common. Pfc. P. S. Wargo, U.S. Marine Corps June 9, 1967 Sgt. George Nemesbathe, a mortar section leader in the 1st Cavalry Division (Airmobile), drinks coconut milk during a break in a search-and-seizure patrol in Operation Pershing. A major and much-publicized initiative, Operation Pershing was directed against guerrillas in Binh Dinh Province.

Pfc. Thomas L. Larson, U.S. Army

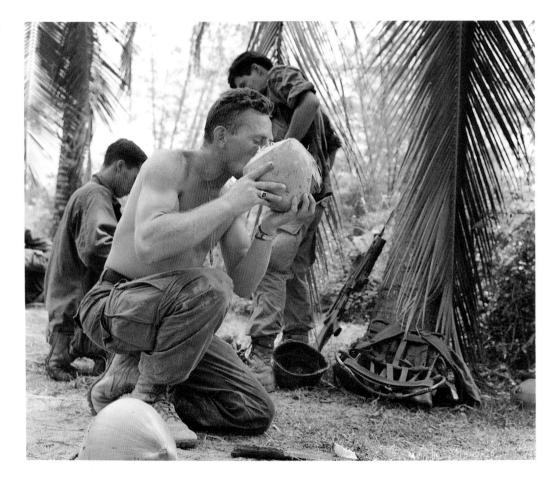

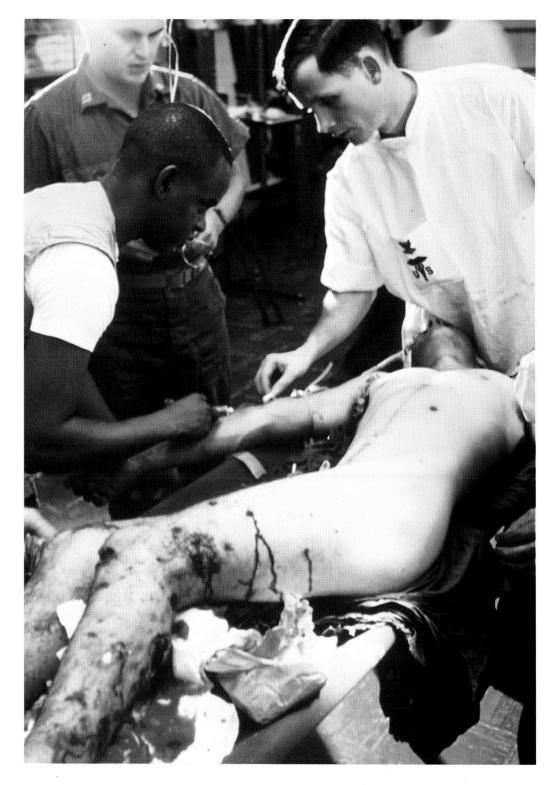

July 1967 Marine Lance Cpl. J. A. Holland, whose legs were badly wounded by shrapnel, receives treatment in the shock and resuscitation ward of the amphibious assault ship USS *Tripoli*. He was evacuated from a beach combat area by helicopter.

JOC Erne J. Filtz, U.S. Navy

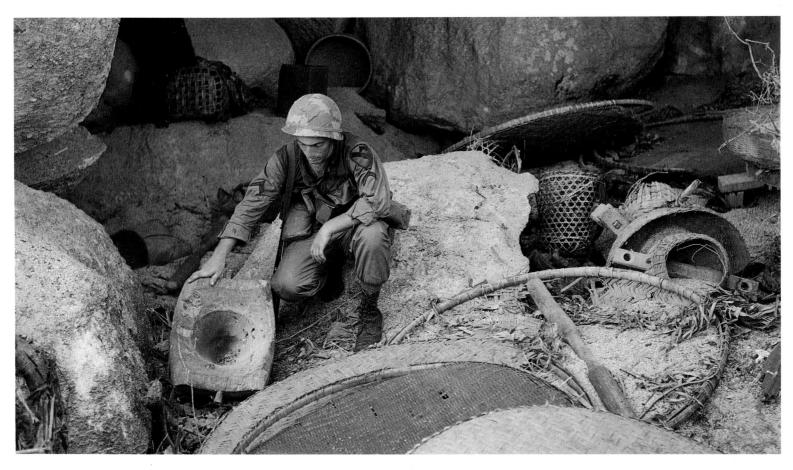

July 28, 1967 Pfc. Carl DeMarco of the 1st Cavalry Division (Airmobile) searches a Vietcong supply cave during Operation Pershing in the An Lao Valley. To prepare for major assaults like the Tet offensive of 1968, the VC spent

months stocking secret food and weapons caches along their infiltration routes. Spec. 4 Dick Durrance, U.S. Army

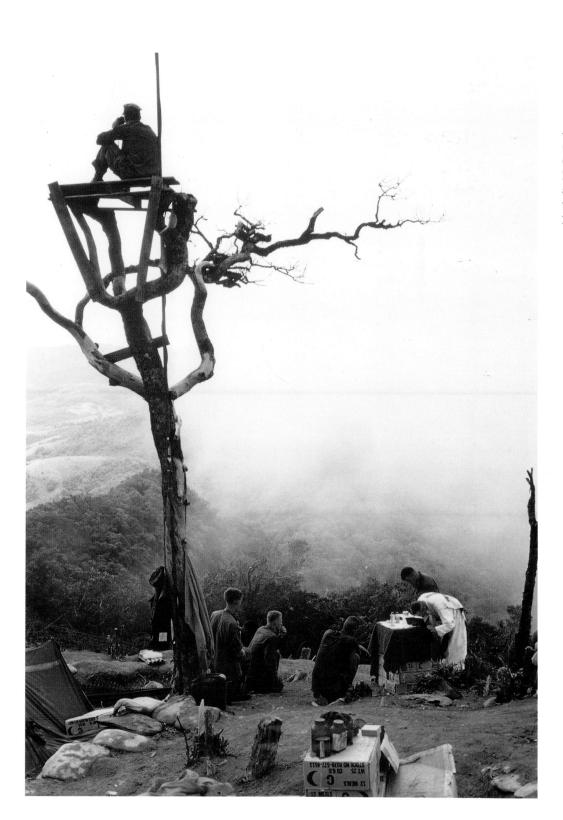

July 31, 1967 A soldier stands watch in an observation platform on Hill 1950 as chaplain (Lt. Cmdr.) McElroy of the 3d Marine Division holds mass. His altar cloth has been draped over a stack of C-ration boxes delivered by helicopter to this remote outpost near the DMZ. Photographer unknown, U.S. Marine Corps August 31, 1967 Members of the 25th Infantry Division drink from their canteens during a break in a patrol. Operating out of Cu Chi, 25 miles northwest of Saigon, the 25th sought to block Vietcong movements between the Ho Chi Minh Trail in Cambodia and the South Vietnamese capital.

Spec. 4 Paul D. Halverson, U.S. Army

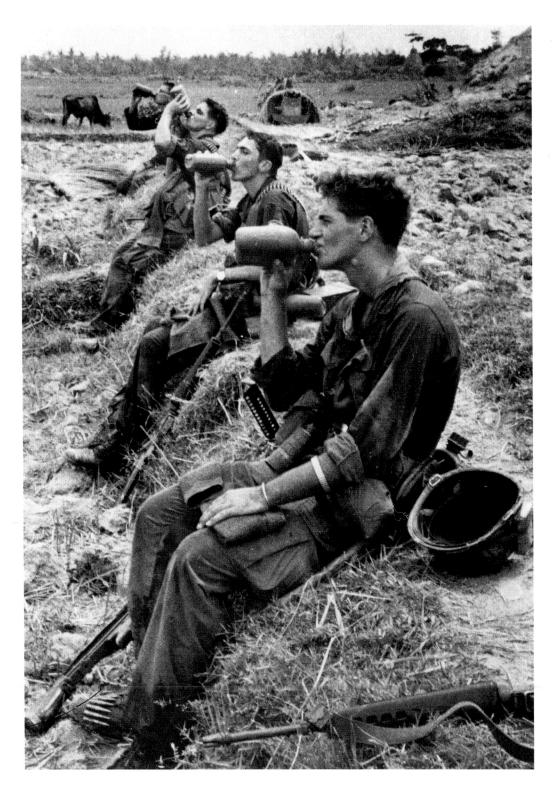

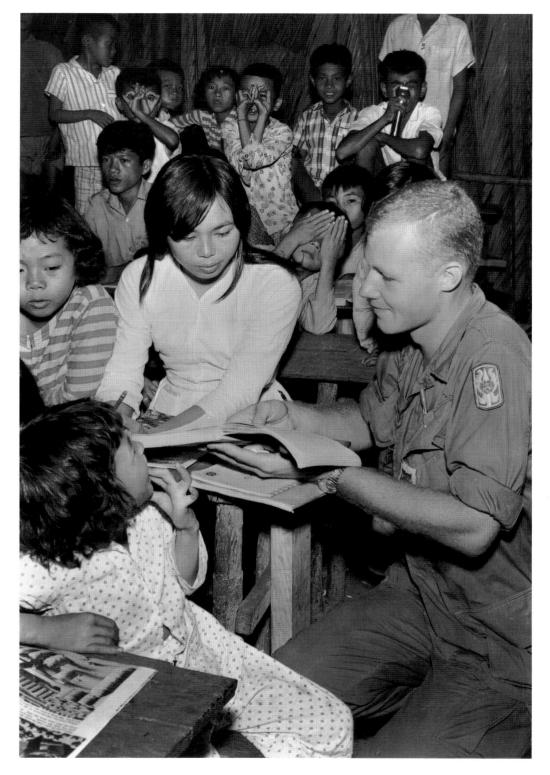

August 30, 1967 Pfc. Alan Wondra conducts an English class during a civic action program (CAP) of the 199th Infantry Brigade (Light). CAPs, which also brought dental and medical care to villages, were intended to improve conditions among rural Vietnamese and win them over to the government. CAPs often followed search-and-seizure missions against local Vietcong.

Spec. 4 Jerrold Fishman, U.S. Army

September 23, 1967 Robin Olds, commander of the 8th Tactical Fighter Wing, receives a tumultuous welcome after his 100th and final combat mission. Olds' wing shot down 24 MiGs, more than any other F-4 wing in Vietnam, and Olds, a veteran of World War II and Korea, was considered the best USAF pilot of the war. Photographer unknown, U.S. Air Force

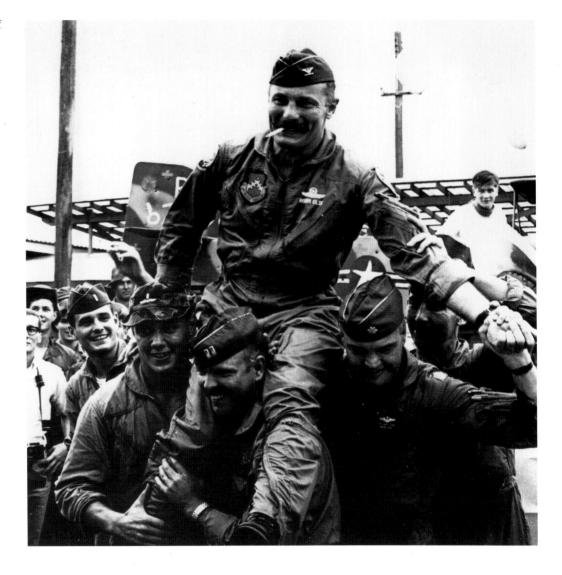

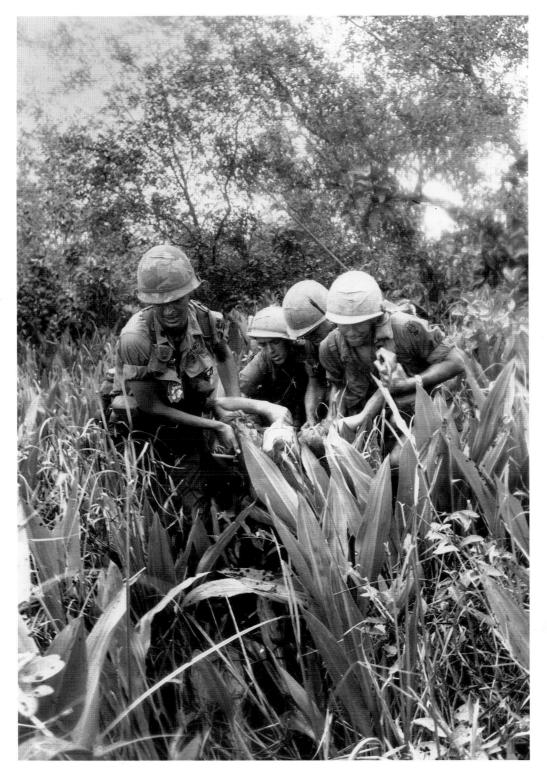

October 14, 1967 Members of a company in the 199th Infantry Brigade (Light) carry a wounded soldier to safety during a firefight in Thu Duc District. From its arrival in late 1966, the mission of the 199th Brigade was to protect the III Corps Tactical Zone and the city of Saigon. When the Tet offensive began on January 31, 1968, the 199th was at the center of the struggle for the capital.

Spec. 4 Jerrold Fishman, U.S. Army

Overleaf:

November 20, 1968 Infantrymen of the 5th Regiment, 1st Marine Division make their way through five-foot-high elephant grass at the start of Operation Meade River. A surprise attack on a Vietcong stronghold, the search-and-cordon operation used 76 helicopters to deliver 3,500 men to the combat area in under two hours. Cpl. S. L. McKenzie II, U.S. Marine Corps

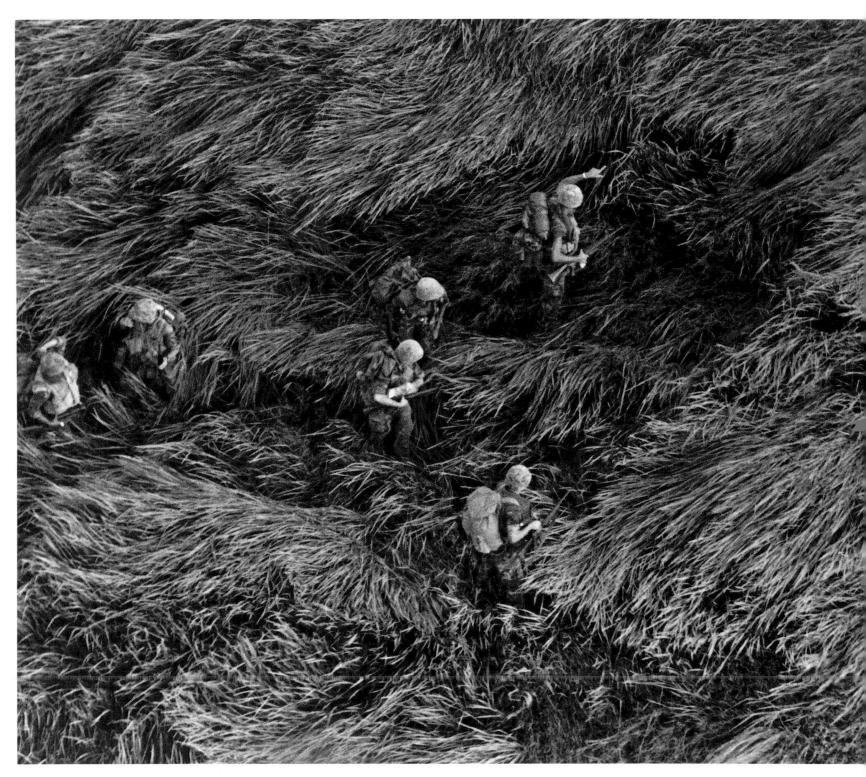

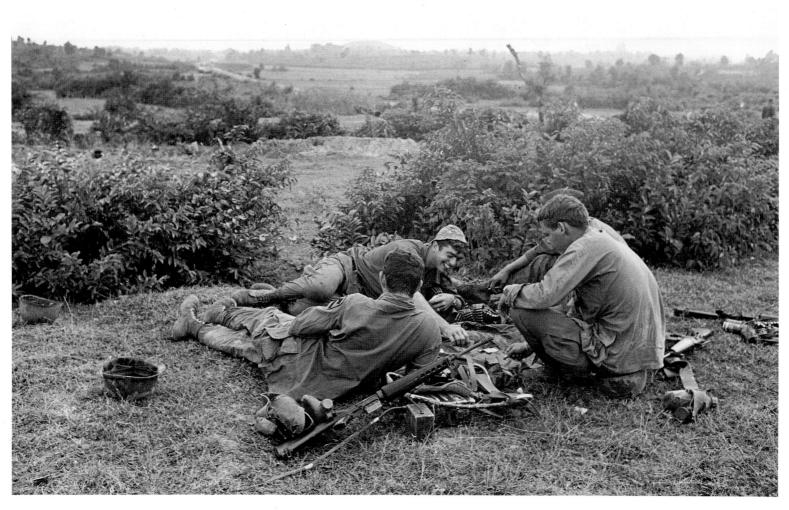

January 1968 Soldiers from the 1st Cavalry Division (Airmobile) take time out to play cards while participating in Operation Wheeler/Wallowa, a search for Vietcong in Quang Nam and Quang Tin provinces. Patrols rarely encountered

VC, but suffered many casualties from mines, booby traps, and snipers. Spec. 5 Dick Durrance, U.S. Army

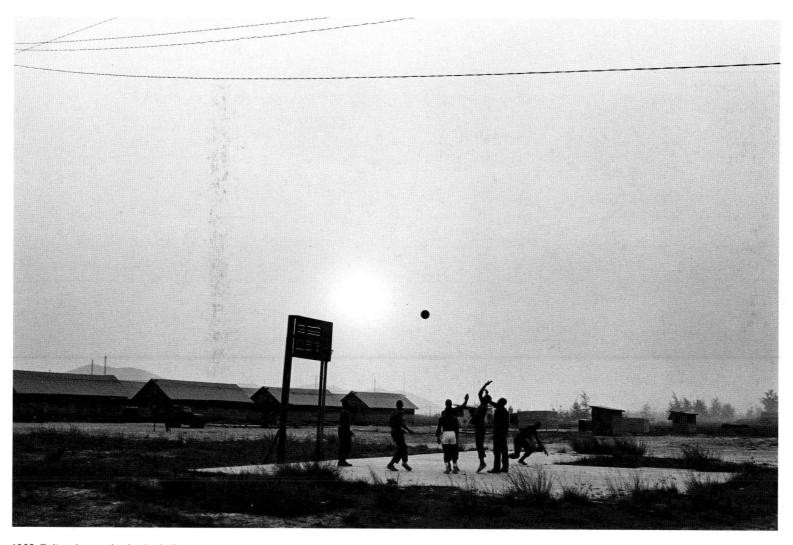

1968 Enlisted men play basketball on a court near permanent buildings at a major American base. Only a fifth of the American soldiers spent the majority of their time on combat duty. For the rest, who staffed the military's massive

logistical and clerical organization, supplies of American food, drink, music, and recreation made Vietnam a bit more familiar. Spec. 5 Dick Durrance, U.S. Army

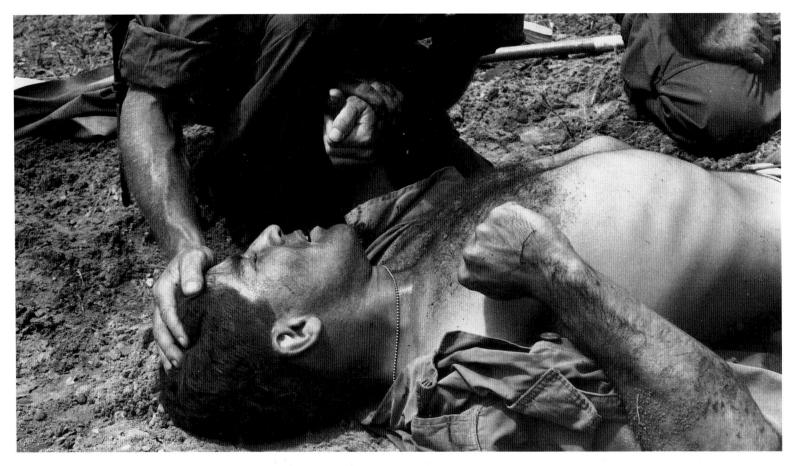

1968 A marine wounded by a booby trap is comforted by another soldier. The Vietcong sowed trails and waterways with mines, grenades on tripwires, and other lethal traps. In many places, walking a patrol became a fearful, step-by-

step search for any hint of these traps—which caused 11 percent of all American deaths during the Vietnam War. Photographer unknown, U.S. Marine Corps

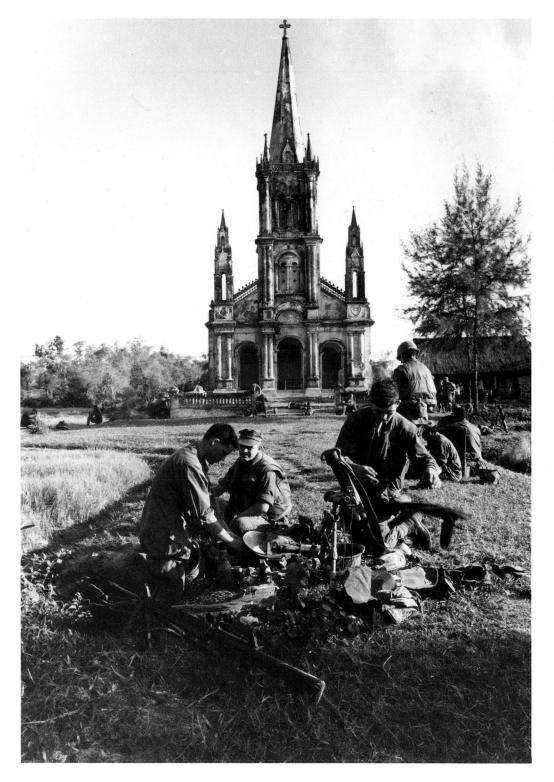

January 11, 1968 Marines in a 60mm mortar section of the 1st Regiment, 3d Division choose a bivouac site near a Catholic church—symbol of an older Western presence in Vietnam—during Operation Badger Tooth in Ouang Tri Province. Cpl. M. R. Wolfe, U.S. Marine Corps

January 1968 A radio operator in the 1st Cavalry Division (Airmobile) prepares to break camp during Operation Wheeler/Wallowa in the Que Son Valley. His radio leans against one of the poles over which he stretched his poncho for shelter the previous night.

Spec. 5 Dick Durrance, U.S. Army

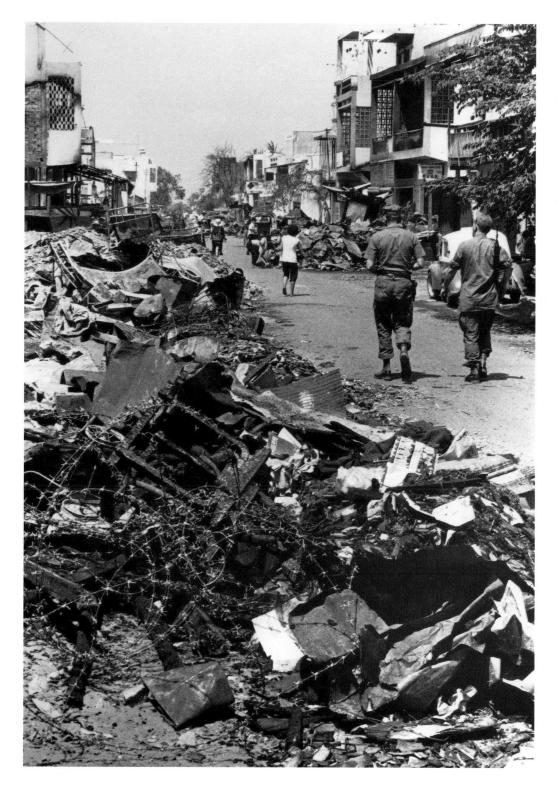

February 1968 Rubble and barbed wire line the streets of Cholon, a suburb of Saigon. Devastated by heavy shelling and house-to-house fighting during the Tet offensive in late January and early February, Cholon was battered again in late February as South Vietnamese army troops attempted to drive out remaining Vietcong. PH1 T. L. Lawson, U.S. Navy February 21, 1968 A Saigon couple survey the ruins of their shop near Tan Son Nhut air base. Their business weathered the street fighting of the Tet offensive, only to be destroyed possibly by Vietcong infiltrators—after order was restored in Saigon. Spec. 5 Dick Durrance, U.S. Army

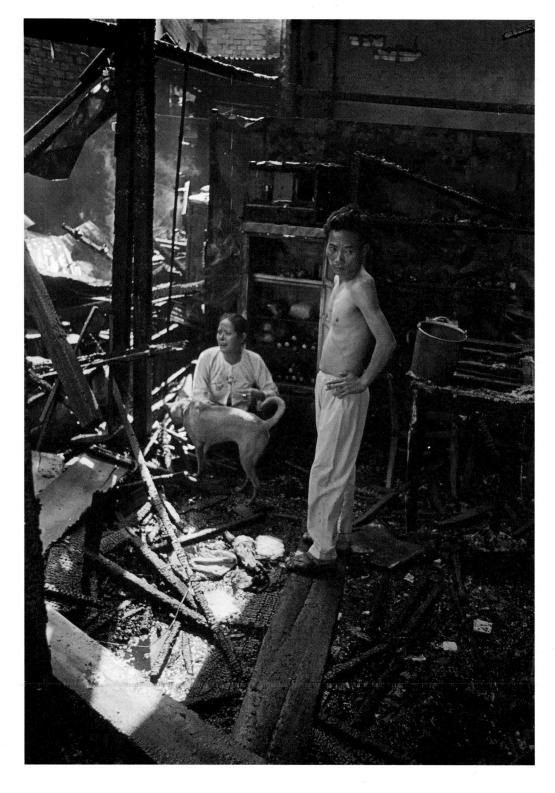

February 1968 Wearing hospital pajamas under his flak jacket, a wounded American soldier keeps watch outside a hospital in Saigon. During and after the Tet offensive, walking wounded were called upon to guard hospitals while

every available able-bodied soldier joined in the effort to end the Vietcong attack on the capital. Spec. 5 Dick Durrance, U.S. Army **1968** Near Chu Lai, a marine lance corporal and a Vietnamese soldier raise an American flag at an outpost where 14 marines are training home guards. Believing the war could only be won in the villages, strategists argued for local defense teams of marines and Vietnamese militia, a plan which was never tried outside the Marines' command area.

1st Lt. Joe Collins, U.S. Marine Corps

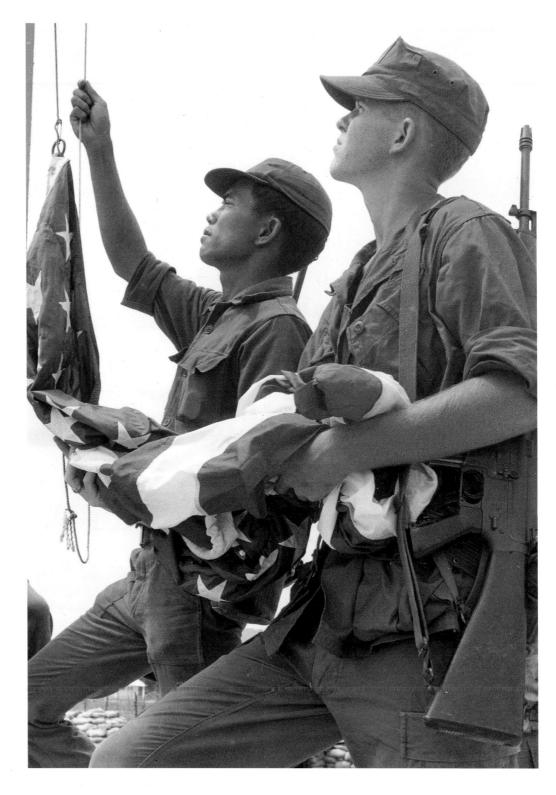

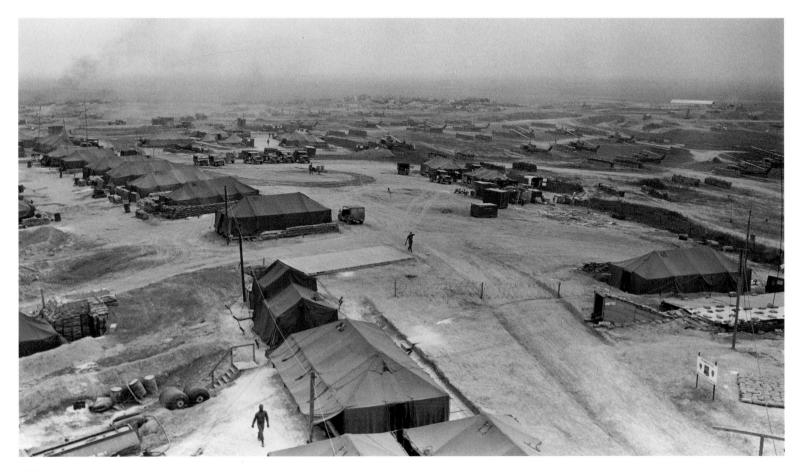

Camp Evans in northern Thua Thien Province was an operations base for the 1st Cavalry Division (Airmobile) in early 1968. A number of UH-1 Hueys, the most widely used American helicopter in Vietnam, are parked on the landing field at upper right.

Spec. 5 Dick Durrance, U.S. Army

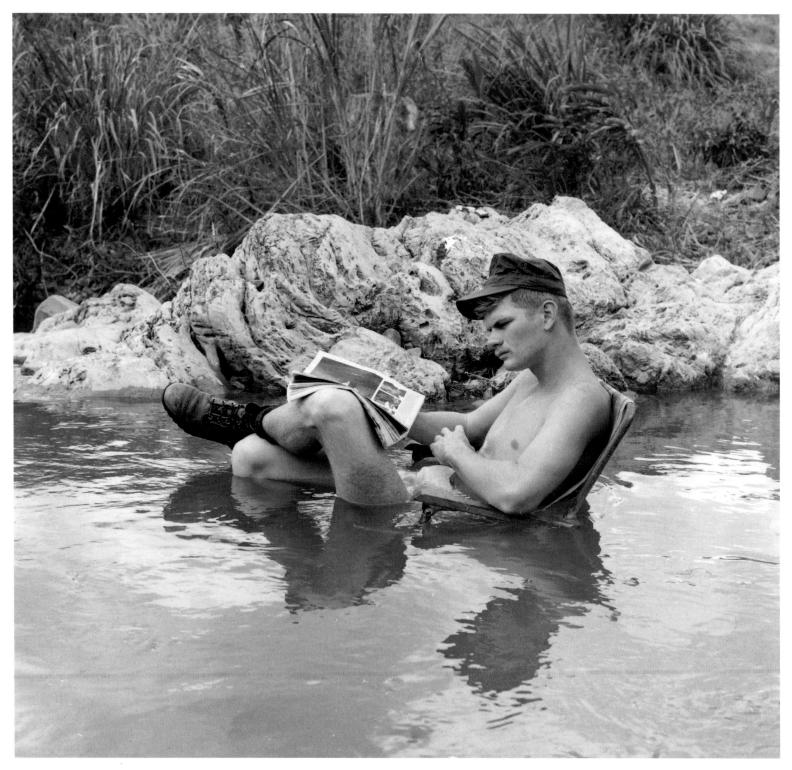

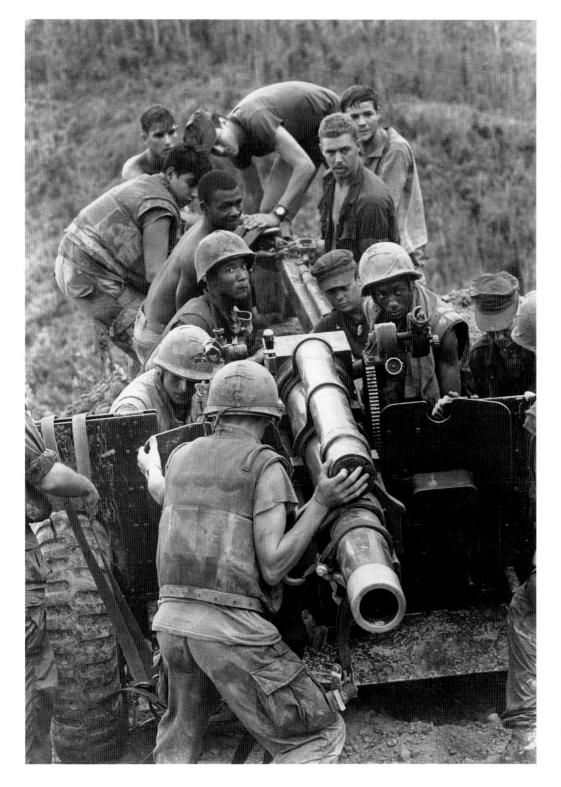

September 5, 1968 Marines maneuver a 105mm howitzer, a mainstay among American field artillery. At fire-support bases, two batteries of three howitzers, each with a four- or five-man crew, gave artillery support to patrolling troops within a ten-mile range. Cpl. S. A. Tilson, U.S. Marine Corps

1968 Cpl. Bob McDonald, a rifleman with the 9th Regiment, 3d Marine Division, relaxes in a mountain stream near regimental headquarters. **Pfc. E. E. Hildreth, U.S. Marine Corps**

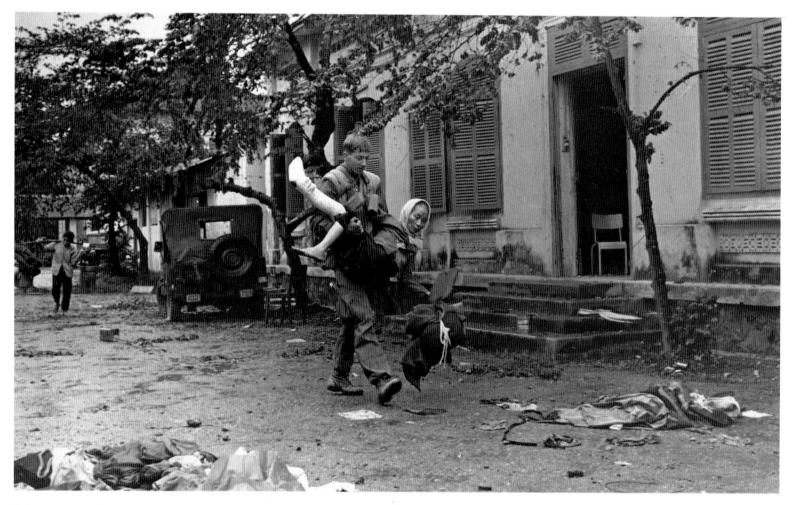

February 5, 1968 A marine carries a Vietnamese woman to safety during the battle for Hue. U.S. Marines and ARVN troops, ferociously fighting from house to house to regain control of the city, strove at first to protect civilians. Later,

when American artillery and air strikes increased, civilian casualties rose. Sgt. Dickman, U.S. Marine Corps

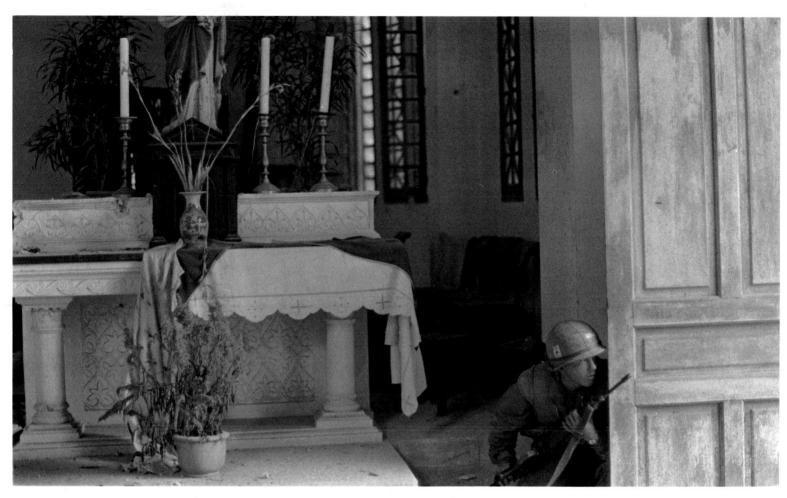

February 9, 1968 A member of Company A, 1st Battalion, 1st Marine Regiment crouches behind a church door in Hue as he checks for the enemy outside. With two other elements of the 3d Division, Company A had been fighting to retake Hue since the battle began on January 31. Sgt. B. A. Atwell, U.S. Marine Corps

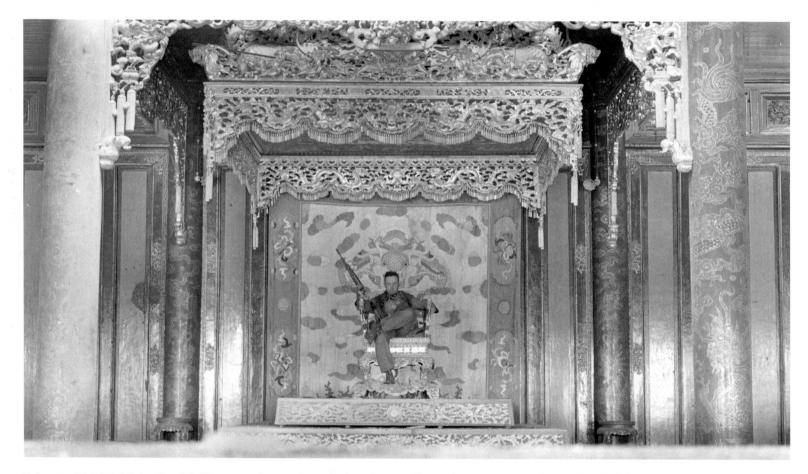

February 24, 1968 Marine Sgt. P. L. Thompson sits on a throne in the palace at Hue shortly after its recapture by South Vietnamese troops. Most of Hue's historic 19th-century buildings, constructed when the city was the home of

Vietnam's emperors, were damaged in the fighting. Harlam, U.S. Marine Corps

February 23, 1968 A crew member on an Ontos recoilless rifle vehicle snatches a few moments' rest during a pause in the fighting at Hue. Reinforcements reached the city slowly; other Marine battalions were tied down in major

battles at Da Nang and Quang Tri. Throughout the brutal, month-long struggle, there was little time for sleep. Lance Cpl. Messenger, U.S. Marine Corps

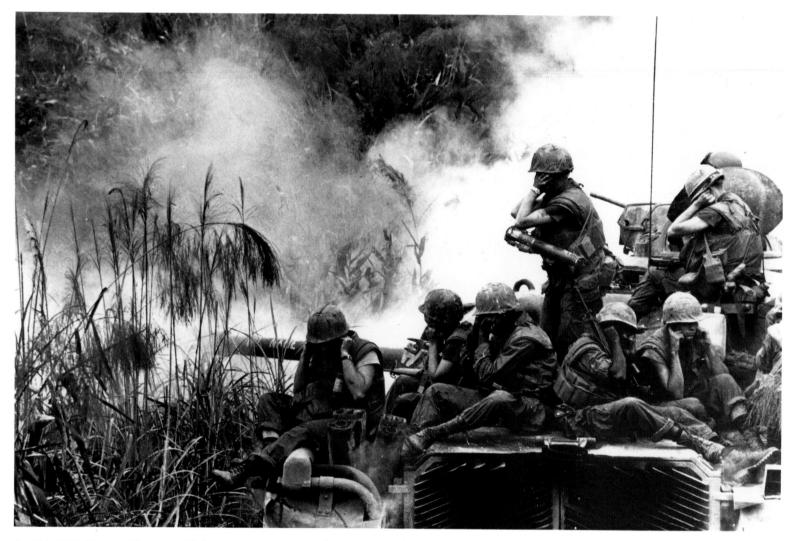

April 3, 1968 Marines riding on an M-48 tank cover their ears as the 90mm gun fires into the jungle during a road sweep southwest of Phu Bai. Despite heavy losses in the Tet offensive, NVA and VC soldiers remained active in the

countryside, and the marines spent several months clearing areas near cities and bases.

Cpl. D. I. Fisher, U.S. Marine Corps

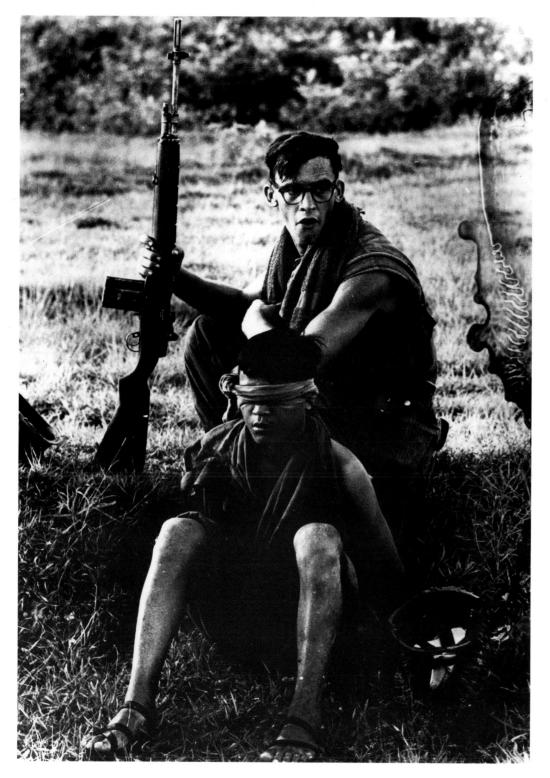

November 20, 1968 Cpl. M. R. Carter of the 1st Marine Division guards an NVA soldier he captured 10 miles northeast of An Hoa during Operation Meade River. Hoping to erase the communist presence near Da Nang, marines captured 180 North Vietnamese and Vietcong soldiers during the operation and killed over 1,200.

Lance Cpl. A. C. Prentiss, U.S. Marine Corps

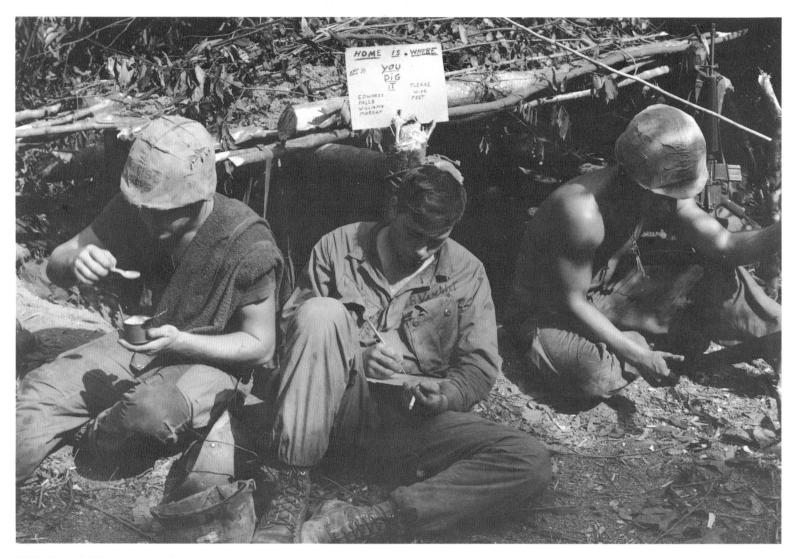

1968 "Home Is Where You Dig It" reads the sign over a bunker occupied by three soldiers of the 1st Marine Division during Operation Worth. Lance Cpl. D. J. Brusch, U.S. Marine Corps

December 1968 USAF F-4 pilot Lt. Col. Gene Levy takes notes during an intelligence debriefing at Cam Ranh Bay air base. Since Halloween of 1968, Air Force missions over North Vietnam had been suspended, and F-4 pilots were limited to supporting ground operations in South Vietnam.

A1c. R. E. Brown III, U.S. Air Force

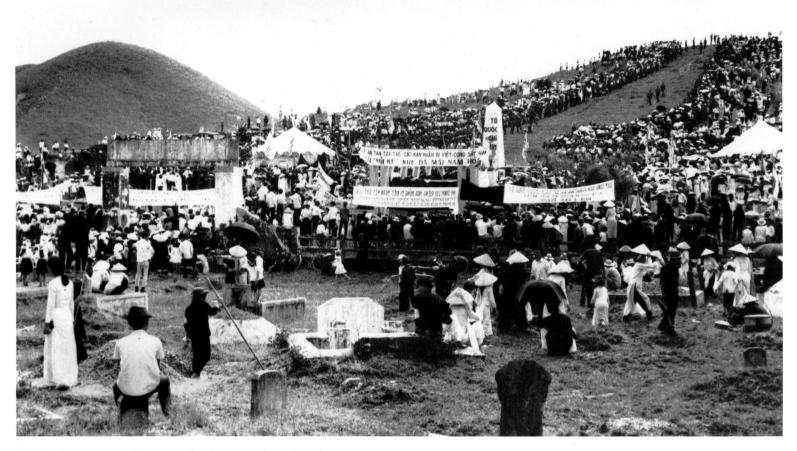

1969 In the cemetery at Hue, city officials arrange the coffins of civilian victims from the siege of 1968 before a funeral service. During the siege, roughly 2,800 civilians were executed by Vietcong firing squads; hundreds

more died during street battles and air strikes. Photographer unknown, U.S. Army

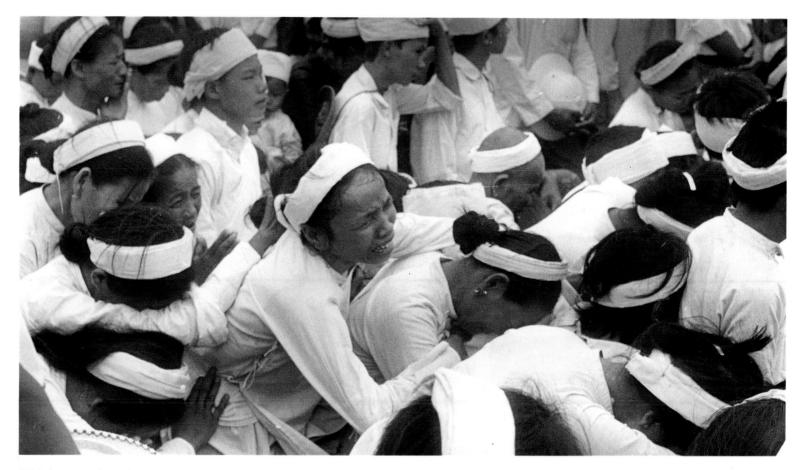

1969 At a mass funeral near Quang Tri City, friends and relatives mourn 60 civilian victims of the Tet offensive. The victims' bodies had recently been

found in shallow mass graves east of the city. Cpl. Trygg Hansen, U.S. Marine Corps

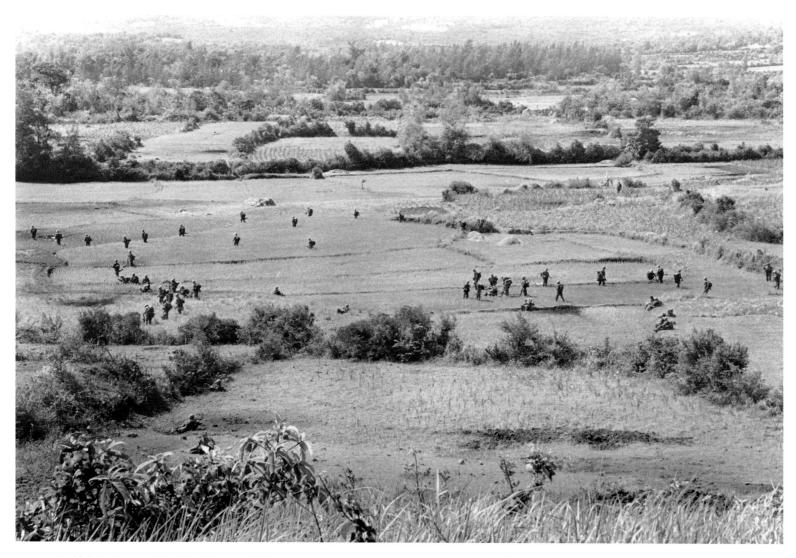

January 1969 Infantrymen of the 26th Marines, 3d Division prepare to form an assault line during a search for Vietcong in the Batangan Peninsula. A strong VC presence, a deadly abundance of mines and booby traps, and an apathetic

population made it difficult for Americans to operate in the thickly settled peninsula. Cpl. D. Kramer, U.S. Marine Corps

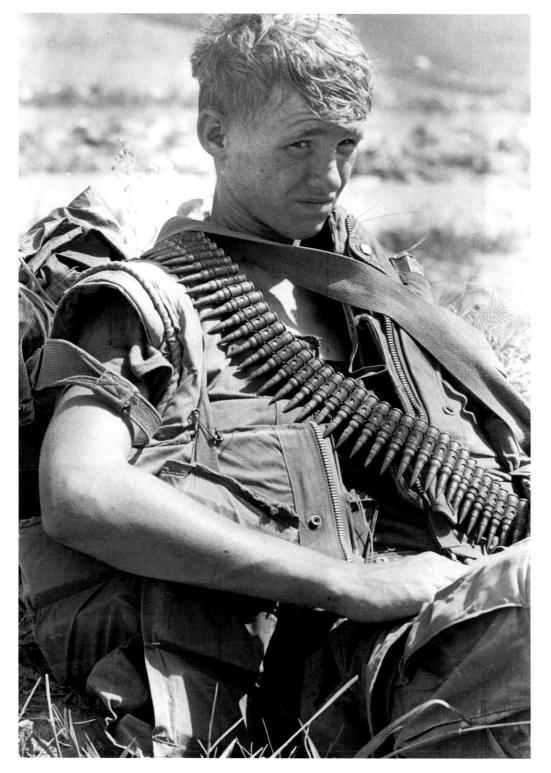

1969 Marine Pfc. Russell R. Widdifield takes a break during a patrol 25 miles north of An Hoa. American GIs in Vietnam carried as much as 100 pounds of gear—a staggering burden in a country where daytime temperatures soar over 100 degrees and the terrain is generally flat and swampy or steep and heavily forested. Cpl. A. V. Huffman, U.S. Marine Corps

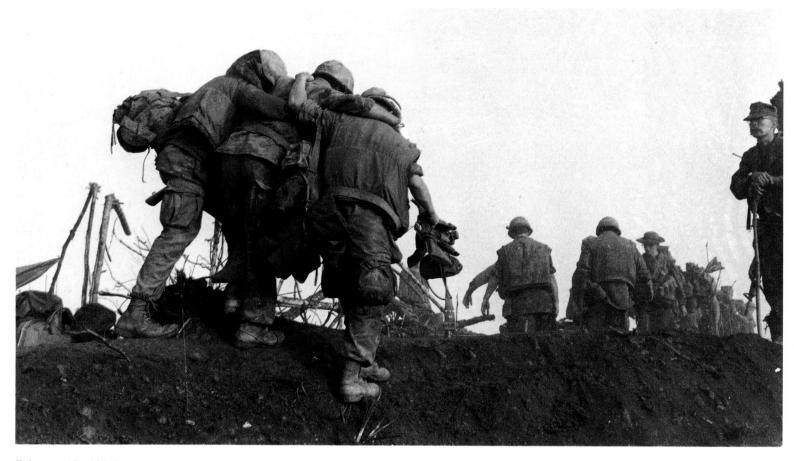

February 13, 1969 Two marines help a wounded buddy during Operation Dewey Canyon. Directed against NVA supply routes near the Laotian border, Dewey Canyon was one of the 3d Division's last major assaults. By year's end,

as part of President Nixon's plan to turn the war over to the South Vietnamese, the 3d left the bitterly contested hilltops near the DMZ. S. Sgt. Bob Jordan, U.S. Marine Corps

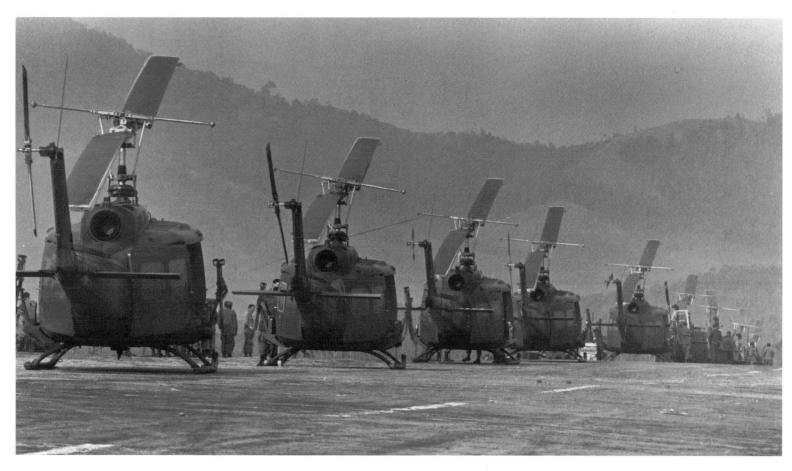

April 10, 1969 At Polei Kleng, 20 miles east of the Cambodian border in the Central Highlands, UH-1D Huey helicopters from the 170th and 189th Helicopter Assault Companies await the loading of troops. The UH-1D, the troop-

transport version of the Huey, carried 11 passengers and 3 crew. Spec. 5 Thomas Lykens, U.S. Army

1969 A member of the 5th Infantry Division (Mechanized) looks out over the fog-shrouded A Shau Valley, a major staging area for the NVA near the Laotian border in Thua Thien Province. Virtually roadless, crisscrossed with mountain ridges, the rain-soaked A Shau region was perfectly suited to guerrilla warfare. Photographer unknown, U.S. Army

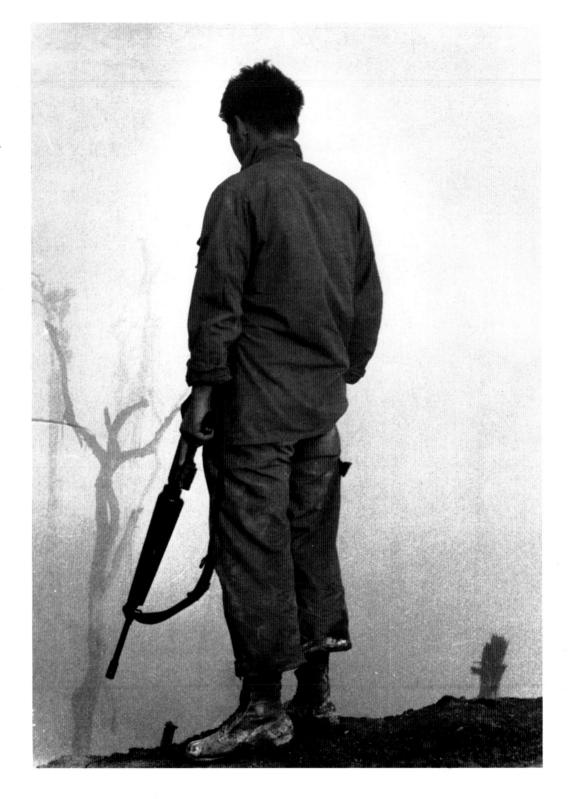

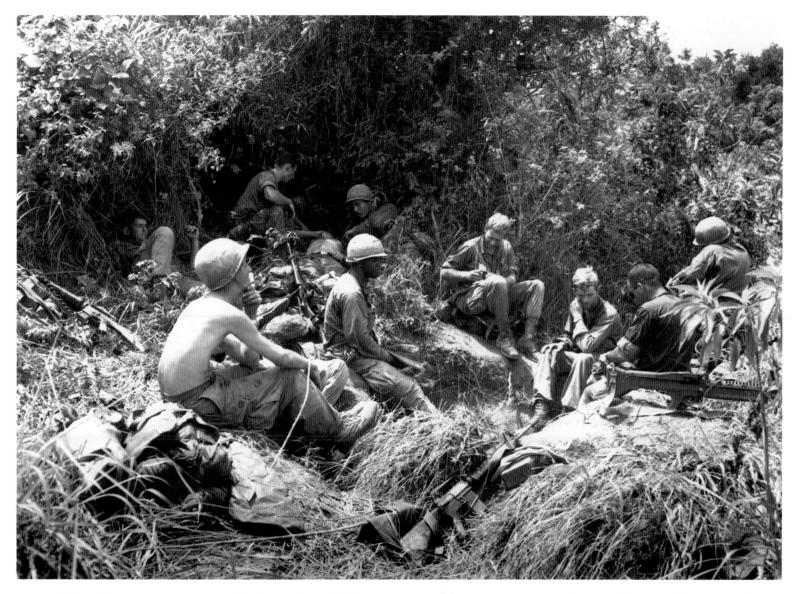

June 2, 1969 Soldiers from two companies of the 101st Airborne Division rest during a jungle march south of Da Nang. The character of the war changed markedly in 1969: the Nixon administration began to plan troop withdrawals,

commanders were encouraged to limit casualties, and soldiers frequently resisted orders to go on hazardous missions. Spec. 5 Stephen Klubock, U.S. Army

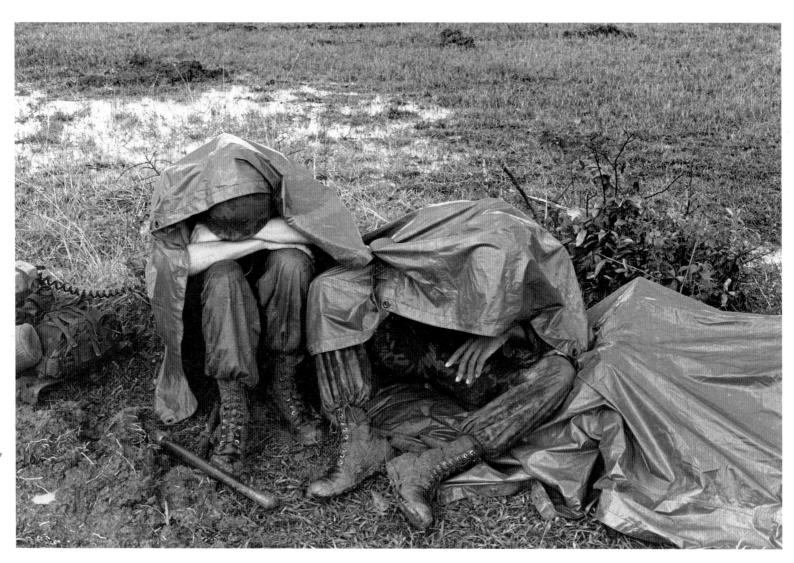

January 1969 Two soldiers of the 26th Marine Regiment huddle under their ponchos during Operation Bold Mariner, the last major marine effort to drive

the Vietcong out of the Batangan Peninsula in Quang Ngai Province. Lance Cpl. W. R. Schaaf, U.S. Marine Corps

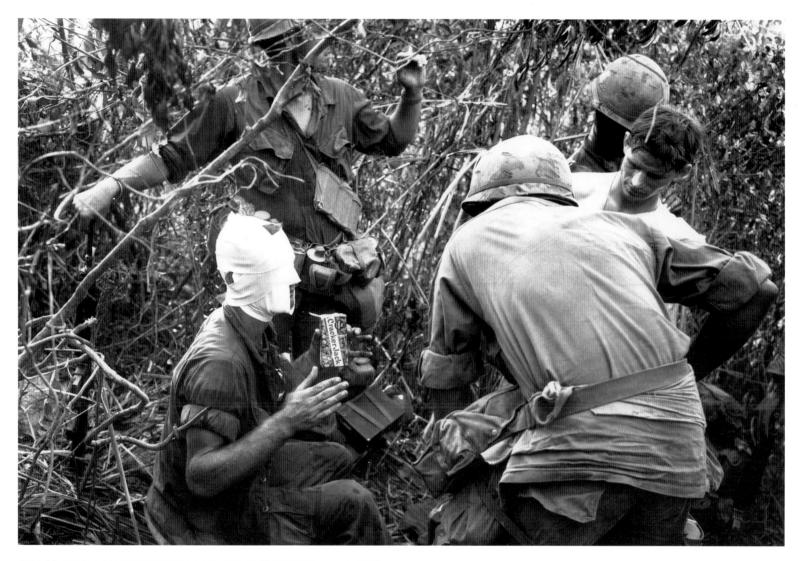

June 26, 1969 A medic attached to a company in the 501st Regiment, 101st Airborne Infantry Division bandages paratroopers wounded in a firefight east of Tam Ky. The box of Cracker Jacks is evidence of the military's efforts to supply soldiers with familiar treats.

Spec. 5 Stephen Klubock, U.S. Army

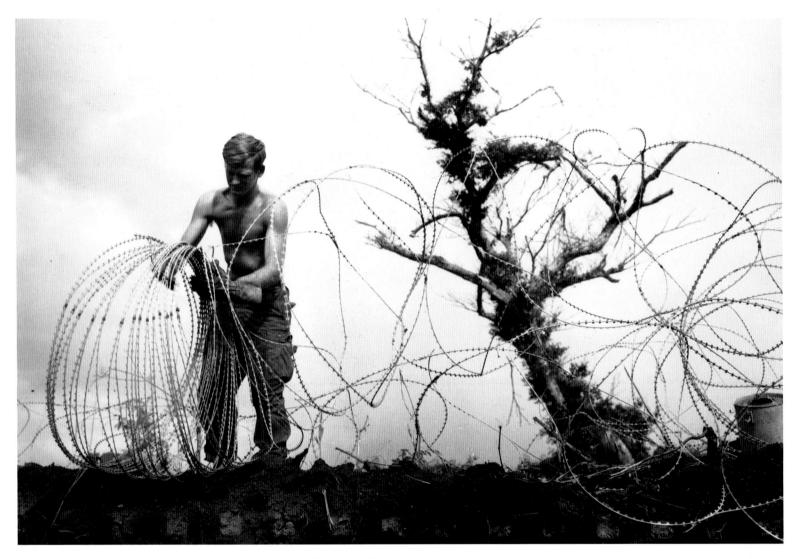

July 1969 A member of the 1st Brigade, 5th Infantry Division (Mechanized) puts up concertina wire around the command post for Operation Utah Mesa in the A Shau Valley. Utah Mesa, which yielded few Vietcong prisoners or

supplies, was the last large-scale American operation in the region. Spec. 5 Ronald Hammeren, U.S. Army

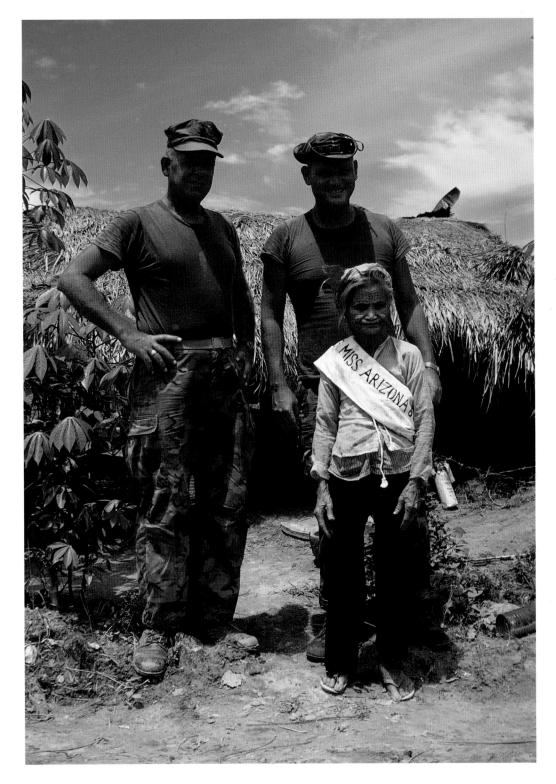

September 1969 Sgt. Maj. Lewis E. Tuttle and Maj. O'Toole of the 1st Marine Division pose with an old woman in the "Arizona" territory west of An Hoa in Ouang Nam Province. When this photograph was taken, the Miss Universe contest was being held in Tokyo. Sgt. John K. Mullins, U.S. Marine Corps

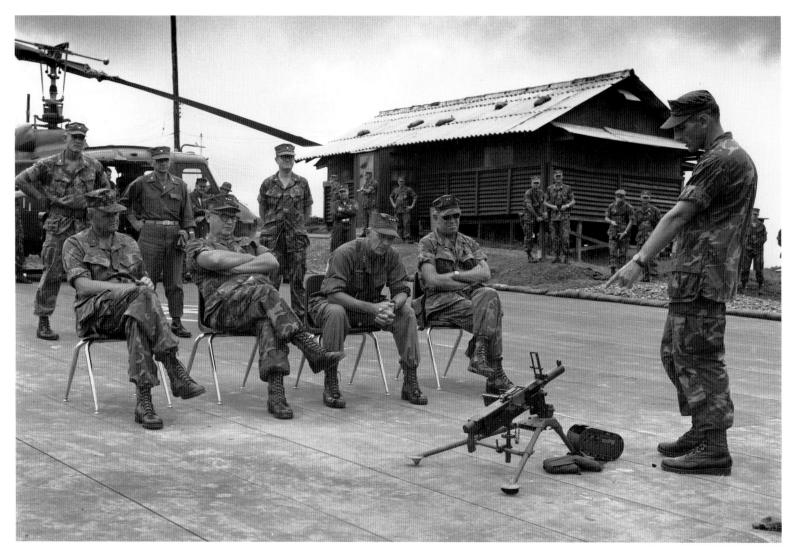

October 30, 1969 Maj. Joseph Flynn of the 1st Marine Division explains an XM 174 40mm automatic grenade launcher to (left to right) Gen. Wilson, Lt. Gen. Henry Buse, Lt. Gen. Herman Nickerson, and Maj. Gen. O. R.

Simpson. Simpson was currently commanding the 1st Division; Nickerson had done so in 1966 and 1967. Lance Cpl. P. LaBrecque, U.S. Marine Corps

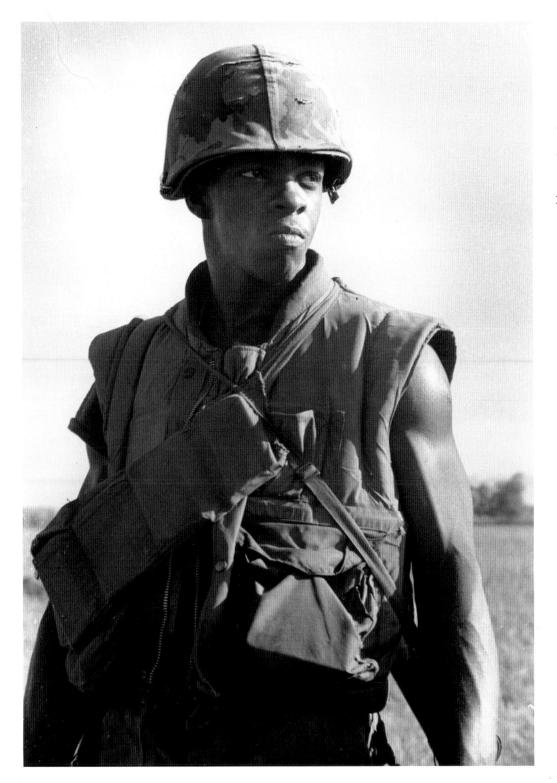

October 30, 1969 A marine in the 1st Division crosses an open field on patrol eight miles south of Da Nang. As 1969 drew to a close, the Vietcong grew more and more difficult to find, and the marines pursued them in small reconnaissance patrols rather than battalion-sized sweeps.

Lance Cpl. John A. Gentry, U.S. Marine Corps

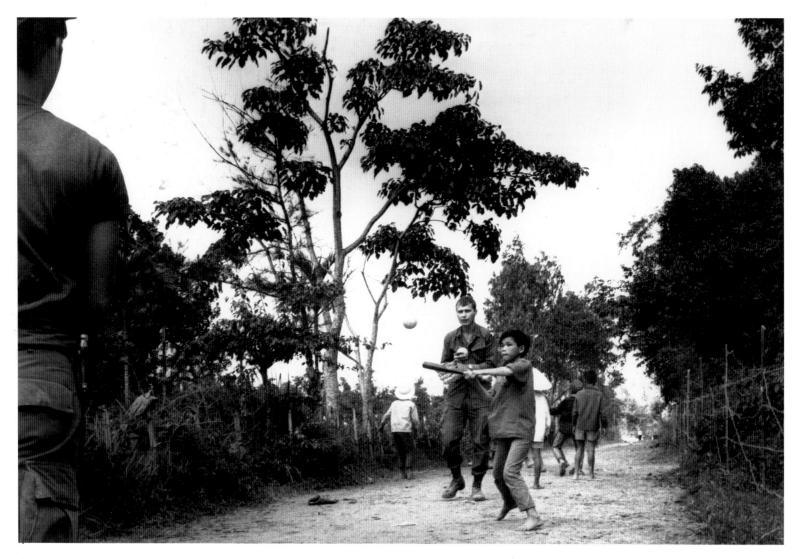

January 15, 1970 Soldiers of the 101st Airborne Division (Airmobile) join the children of Ap Uu Thoung hamlet in a game of baseball. Reflecting the decreasing American war effort, the 101st spent early 1970 defending its

firebases and making goodwill visits to villages. 2d Lt. Roger I. Pinnell, U.S. Army

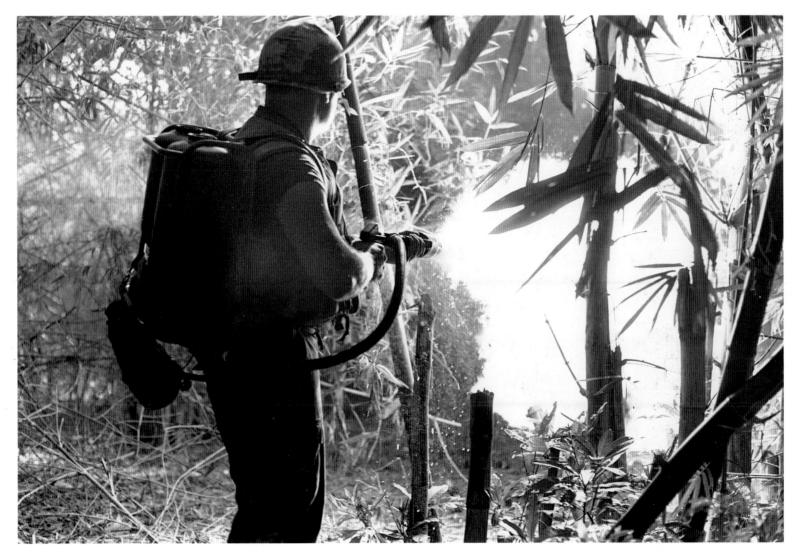

May 22, 1970 A marine sergeant clears an area with a flamethrower. Vietnam's dense vegetation was a never-ending problem for the American military. Hand-held, tank-mounted, and shipboard flamethrowers were used to clear

small areas. For larger areas, Air Force and Navy jets sprayed the chemical herbicide Agent Orange over acres of jungle and riverbank growth. Cpl. Pearson, U.S. Marine Corps

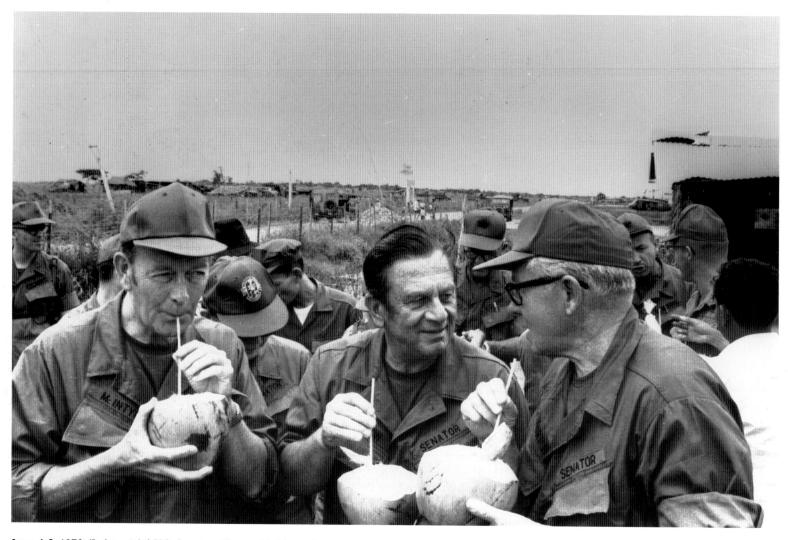

June 4-8, 1970 (Left to right) U.S. Senators Thomas McIntyre, Howard Cannon, and George Murphy drink from coconuts while visiting recently pacified Huu Thanh on a fact-finding mission. Carefully planned by public

information officers, these whirlwind visits rarely gave politicians any insights into the war situation.

Richard H. Beveridge, U.S. Army

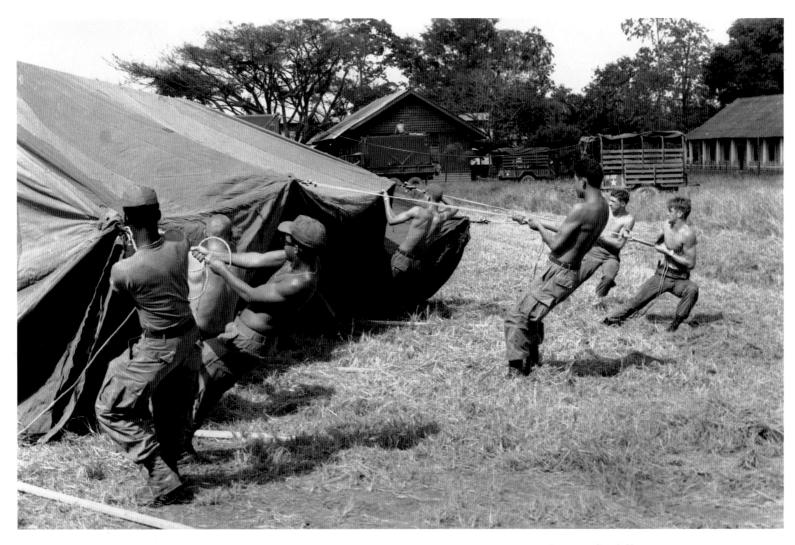

1970 Personnel from the Forward Mobile Staff put up tents at Ban Me Thuot in Darlac Province. Sparsely populated by Montagnard tribesmen, Darlac Province

was one of the least-contested areas in South Vietnam. Photographer unknown, U.S. Army October 8, 1970 Members of the 1st ARVN Division move along a trail near Fire Support Base O'Reilly in Thua Thien Province. As part of President Nixon's Vietnamization program, ARVN troops had taken over the firebase earlier in 1970, but abandoned it in September after a two-month siege.

Spec. 4 James Saller, U.S. Army

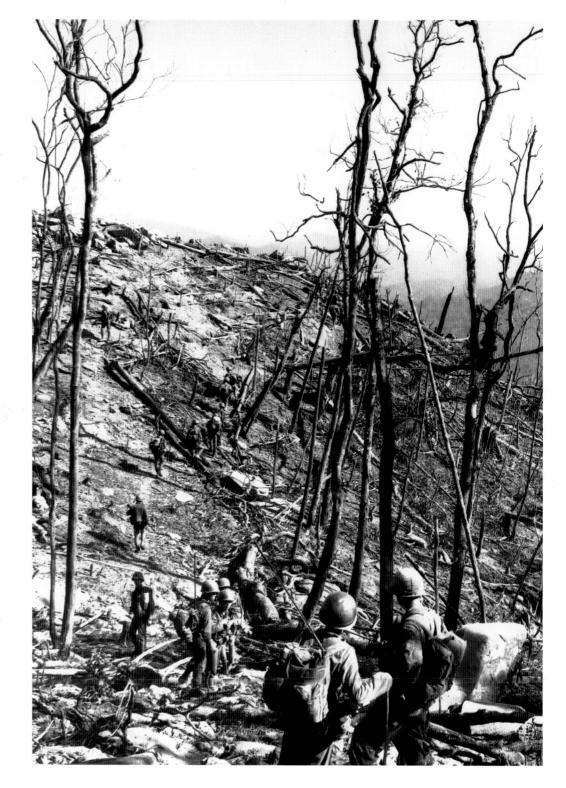

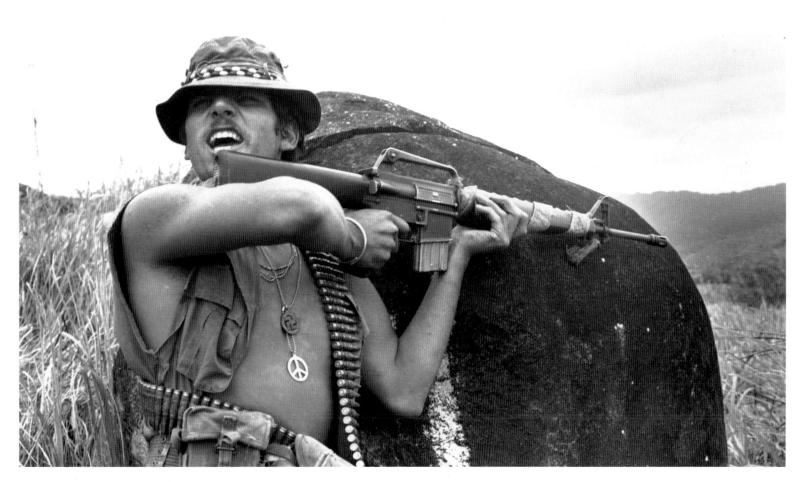

January 19, 1971 Spec. 4 Richard Champion, a squad leader in the 23rd Infantry Division, shouts to his men after receiving sniper fire while patrolling southeast of Chu Lai. Champion's hat, beads, and medallions, which would

have been forbidden in 1965, were common in the fragmented American army of 1971. Pfc. Stephen Befeld, U.S. Army January 20, 1971 Sgt. Richard L. Moser of Detachment I, 460th Tactical Reconnaissance Wing signals the pilot to start the engine of a USAF RB-57. Fitted with infrared heat scanners, lowlight TV cameras, and other devices, RB-57s flew above the Ho Chi Minh Trail, searching for truck convoys.

Sgt. Jack E. Cavner, Jr., U.S. Air Force

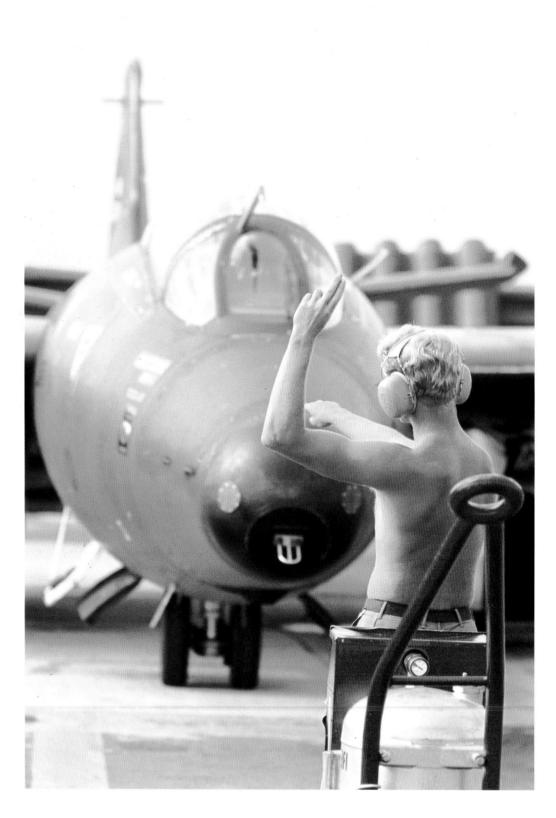

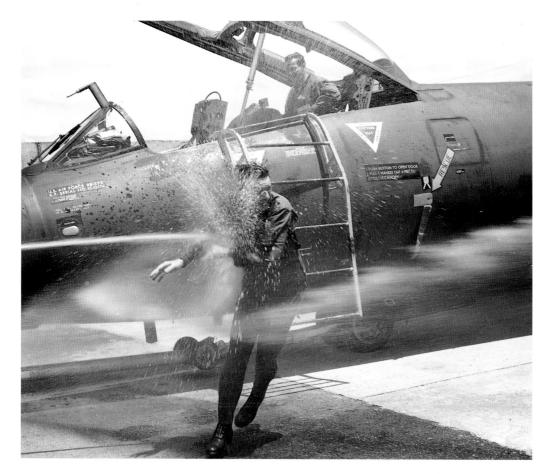

July 1971 Ground crew greet Lt. Col. John Prodan and Maj. Kenneth V. Steinharter of the 460th Tactical Reconnaissance Wing at the end of their last mission in an RB-57. As American ground forces withdrew, the USAF increased reconnaissance and bombing in support of the ARVN.

Photographer unknown, U.S. Air Force

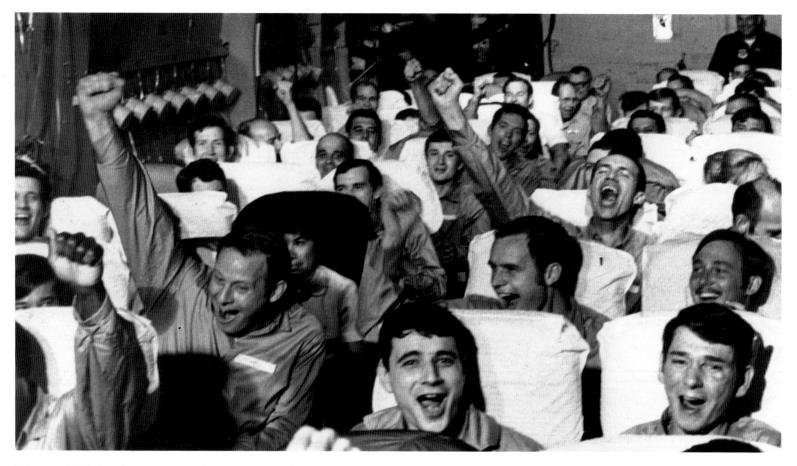

February 1973 American servicemen, former prisoners of war, are cheering as their aircraft takes off from an airfield near Hanoi during Operation Homecoming. The signing of a peace accord between the United States and

North Vietnam on January 27 made possible the release of 565 American prisoners of war. Photographer unknown, U.S. Marine Corps

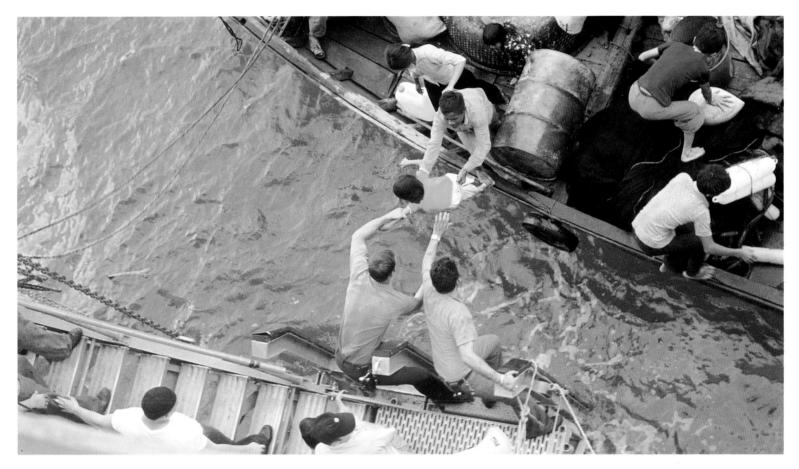

April 3, 1975 As former American strongholds, now defended by the ARVN, fell before the North Vietnamese invasion in early 1975, refugees crowded airstrips and took to the sea. When the huge base at Cam Ranh Bay was

abandoned on April 3, the amphibious cargo ship USS *Durham* was on hand to pick up 3,000 Vietnamese refugees. JO1 Mike McGougan, U.S. Navy April 1975 A marine holds a refugee baby, one of thousands of Vietnamese civilians rescued during the evacuation of Saigon. Overall, 170,000 Vietnamese escaped the country as the North Vietnamese Army took control. Photographer unknown, U.S. Marine Corps

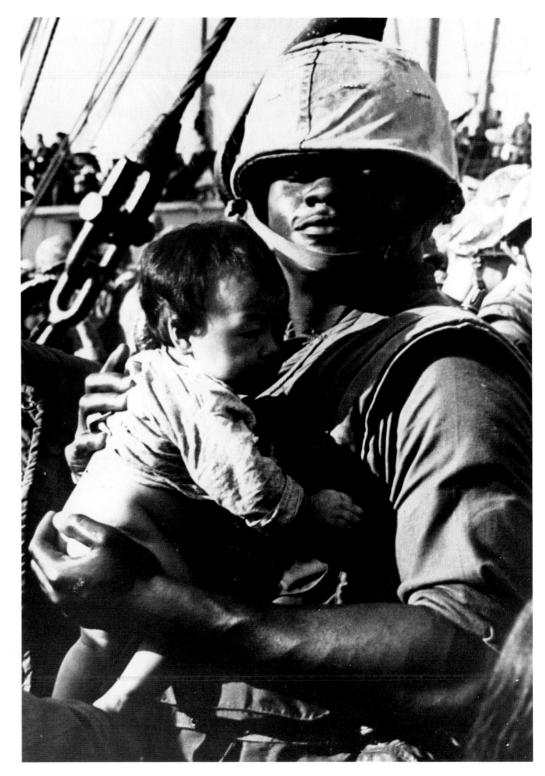

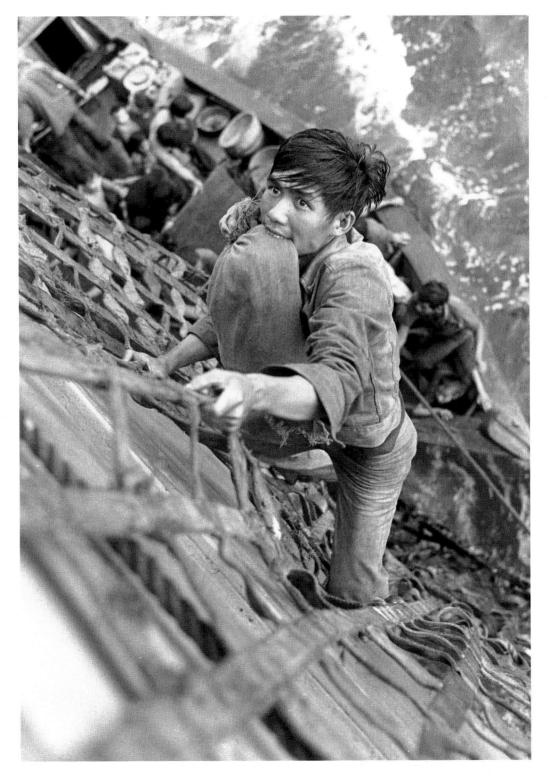

July 30, 1979 South Vietnamese continued to flee the country in small boats long after the war ended. Holding his belongings in a bag between his teeth, a refugee climbs a cargo net to the deck of the combat store ship USS *White Plains*, which picked up 29 refugees from a 35-foot wooden boat.

Photographer unknown, U.S. Navy

Photography sources:

National Archives, Washington, D.C.

Cover: SC-647323. 1: A-186578. 11: CC-45804. 12: 1142266 15: 372113. 17: 1105075. 18: 93093 USAF. 19: SC-611595. 20: A-186275. 21: 95673 USAF. 22: A-185146. 23: A-184793. 24: A-184893. 25: A-185020. 26: A-185754. 27: CC-32090. 28: A-186358. 29: K-31483. 30: SC-626305. 31: A-800474. 32: K-31451. 33: 96668 USAF. 34: A-373622. 35: A-369528. 36: A-187574. 37: A-801215. 38: SC-635974. 39: SC-632107. 40: A-369206. 41: A-369407. 42: A-369409. 43: 100513 USAF. 44: A-801172. 45: SC-636742. 46: SC-639445. 47: A-188552. 48: CC-39781. 49: A-188697. 50: CC-40384. 51: A-704389. 52: CC-41867. 53: A-193262. 54: SC-642158. 55: SC-655291. 56: 102291 USAF. 57: SC-655282, 58-9: A-423006, 62: A-704831. 63: A-190428. 65: 1130131. 68: A-422201. 70: A-192324. 71: A-192415. 72: A-371124. 73: A-190475. 74: A-800450. 75: A-190767. 76: A-371493. 77: A-704884. 78: A-371411. 79: KE- 36067. 80: SC-653965. 81: A-193048. 82: 800458. 83: A-374601. 84: A-192834. 85: SC-651778. 86: SC-652473. 87: SC-650496. 88: 192611. 89: SC-650555. 90: SC-651203. 91: A-372230. 92: A-372541. 93: A-374394. 94: SC-657499. 95: A-374071. 96: SC-656528. 97: SC-655933. 98: SC-659354. 99: SC-661880. 100: K-42981. 101: KE-44571. 102: A-900056. 103: K-108890. 104: A-332418. 105: 1175389. 107: A-373233.

Dick Durrance Collection

8, 60, 61, 64, 66, 67, 69.

Acknowledgments

The editors would like to thank the staff of the Still Media Office, Department of Defense, for their assistance in locating and processing images from the collection; Dick Durrance for providing images from his personal collection; and Bob Springer of the Marine Corps Combat Correspondents Association for helping us contact Vietnam-era Marine correspondents. We are especially indebted to the eight veterans who gave interviews for the introduction: Harry Breedlove, Chuck Cook, Don Critchfield, Ray Goddard, Bryan Grigsby, Gary Krull, Russell Savatt, and Steve Stibbens.

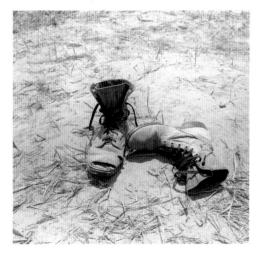

May 23, 1970 Combat boots Lance Cpl. J. E. Threewits, U.S. Marine Corps

AND THE FANS ROARED The Sports Broadcasts That Kept Us On The Edge Of Our Seats

AND THE FANS ROARED

The Sports Broadcasts That Kept Us On The Edge Of Our Seats

Joe Garner = Bob Costas = George Foreman

Narration

Foreword

Copyright © 2000 by Joe Garner Foreword Copyright © 2000 by George Foreman Cover Copyright © 2000 by Sourcebooks, Inc.

Front cover photos, clockwise from upper left: © TM 2000, The Family of Babe Ruth and The Babe Ruth Baseball League, licensed by CMG Worldwide, Inc., Indianapolis, Indiana 46256, USA, www.cmgww.com, All Sport/Mike Powell © TM 2000 Florence Griffith Joyner, licensed by CMG Worldwide, Inc., Indianapolis, Indiana 46256, www.cmgww.com, AP Photo/Elise Amendola, All Sport/Mike Powell, UPI/Corbis-Bettmann Foreword photo (George Foreman, page xi): Deborah Wald Photography Author photo (Joe Garner): Sandy Speer Back cover photos, top to bottom: AP Photo/Boston Herald American/Ray Lussier, All Sport/Doug Pensinger, Corbis/Bettmann

Audio Credits, Photo Credits, and Copyrights at back

Major League Baseball and Minor League Baseball trademarks and copyrights are used with permission of Major League Baseball Properties, Inc.

NHL and NHL trademarks are the property of the NHL and its teams. © NHL 2000. All rights reserved.

All rights reserved. No part of this book may be reproduced in any form or by any electronic or mechanical means including information storage and retrieval system—except in the case of brief quotations embodied in critical articles or reviews—without permission in writing from its publisher, Sourcebooks.

Published by Sourcebooks P.O. Box 4410, Naperville, Illinois 60567-4410 (630) 961-3900 FAX: 630-961-2168

Library of Congress Cataloging-in-Publication Data Garner, Joe. And the fans roared: the sports broadcasts that kept us on the edge of our seats / by Joe Garner. p. cm. ISBN 1-57071-582-3 (hardcover; alk. paper) 1. Sports—History. 2. Radio broadcasting of sports—United States. 3. Television broadcasting of sports—United States. I. Title. GV5/b.G33b 2000 070.4'49796'0973—dc21 00-057367

00-057367 CIP

Printed and bound in the United States of America QG 10 9 8 7 6 5 4 3 2 1 To the athletes, for the great moments— To the broadcasters, for the excitement— To the fans, for the support— To my wife Colleen, for all the above.

And The Fans Roared

CAnd the fans roared?

Table of Contents

And The Fans Roared

		Page	Disc	Track
		Introduction	1	1
		Foreword by George Foreman		
	April 15, 1947	Jackie Robinson Integrates Baseball	1	2
	April 27, 1947	Babe Ruth Says Good-bye	1	3
	June 12, 1948	Citation Wins Triple Crown	1	4
Sep	tember 29, 1954	Willie Mays Makes "The Catch" 14	1	5
June 26, 1959-	-March 13, 1961	Patterson vs. Johansson: A Classic Boxing Rivalry	1	6
C)ctober 25, 1964	Jim Marshall Runs the Wrong Way	1	7
Se	ptember 8, 1969	Rod Laver Wins Grand Slam	1	8
	May 10, 1970	Bobby Urr Goal Wins Stanley Cup 30	1	9
N	ovember 8, 1970	Tom Dempsey Kicks 63-Yard Field Goal	1	10
	January 17, 1971	Jim O'Brien Field Goal Wins Super Bowl	1	11
No	vember 25, 1971	Oklahoma vs. Nebraska: College Football's Game of the Century, , 40	1	12
Sep	tember 28, 1972	Paul Henderson Goal Wins Summit Series	1	13
J	lanuary 22, 1973	Down Goes Frazier!: George Foreman Beats Joe Frazier	1	14
De	cember 16, 1973	O. J. Simpson Tops 2,000 Yards 52	1	15
	January 19, 1974	Notre Dame Ends UCLA's Winning Streak at 88	1	16
	June 4, 1976	Boston Celtics Beat Phoenix Suns in Triple OT	1	17
(October 18, 1977	Reggie Jackson Hits Three Consecutive World Series Homers 64	1	18
	June 10, 1978	Affirmed Wins Triple Crown	1	19
Fe	bruary 23, 1980	Eric Heiden Dominates 1980 Winter Olympics	1	20
Fe	ebruary 16, 1984	Bill Johnson Skis to Olympic Downhill Victory	1	21
	April 5, 1984	Kareem Abdul-Jabbar Breaks NBA Scoring Record	1	22
	August 3, 1984	Mary Lou Retton Vaults to Olympic Gold	2	1

Page Disc Track Walter Payton Breaks Career Rushing Record 88 2 2 October 7, 1984 3 Pete Rose Smacks Hit No. 4,192 92 2 September 11, 1985 Ozzie Smith Home Run Wins Game 5 2 4 October 14, 1985 Bill Buckner's Unforgettable Error 2 5 October 25, 1986 Florence Griffith Joyner Becomes World's Fastest Woman 104 2 September 29, 1988 6 Joe Montana Leads Super Bowl-Winning Drive 7 2 January 22, 1989 The Shot: Michael Jordan Beats Cleveland 2 8 May 7, 1989 2 9 July 23, 1989 October 17, 1989 Earthquake Rocks 1989 World Series 118 2 10 Magic Johnson Returns to Capture All-Star Game MVP Title February 9, 1992 2 11 Duke Beats Kentucky on Christian Laettner Buzzer-Beater 2 12 March 28, 1992 Al Unser Jr. Wins 1992 Indianapolis 500 2 13 May 24, 1992 Buffalo Bills Make Football's Greatest Comeback 2 January 3, 1993 14 Joe Carter Homer Wins 1993 World Series 2 October 23, 1993 15 Kerrigan vs. Harding: Soap Opera on Ice 2 February 24, 1994 16 Cal Ripken Sets Consecutive Games Streak 2 17 September 6, 1995 Michael Johnson Wins 200 and 400 Gold in Atlanta 2 18 July 29 & August 1, 1996 Mike Tyson Bites Evander Holyfield 154 2 June 28, 1997 19 September 26, 1999 Justin Leonard Putt Seals U.S. Ryder Cup Comeback 2 20 Music City Miracle: Tennessee Titans' Miraculous Kick Return January 8, 2000 162 2 21 2 22 June 18, 2000 Acknowledgments 171 Photo Credits 173 Credits 175 **Announcers** 177 About the Author 178

And The Fans Roared

Introduction

And The Fans Roared

To me, there is no more expressive form of communication than the spoken word. This has never been more true than in the broadcasting age of the 20th century. Think for a moment about the reassurance Franklin Delano Roosevelt's voice gave to a nation gripped in the fear of the Depression and after that, a world war. Or recall the vision of a dream, brilliantly articulated in the oratory of Dr. Martin Luther King Jr. Would either have been as effective without the masterful, passionate voices behind the words?

Then there's the adage, "a picture's worth a thousand words," supporting the power of visual imagery. Whoever coined that phrase never experienced the exhilaration of hearing Cubs broadcaster Harry Caray shout "Holy Cow!" as a home run soared over the ivy at Wrigley Field. They never felt the ringside heat evoked by Howard Cosell calling the blow-by-blow of a championship fight.

These announcers' only tools were the spoken word and inflection. No prose could have been more descriptive, no colors could have captured the moments more vividly. I don't think you can tell the stories of the greatest moments in sports without including the calls that made them exciting, in the voices that made them great.

My most recent book was a companion to the one you're holding, entitled *And The Crowd Goes Wild*.

Creating it was a labor of love. My worst day was spent researching great stories, sifting through hundreds of incredible photographs, reminiscing with announcers, and listening to hours of classic play-byplay. Is it any wonder that I wanted to do it again?

Thankfully the heroes and champions of the last sixty years have left us so many more great stories to tell. I admitted in my introduction to *And The Crowd Goes Wild* that I was "only going to be able to scratch the surface" of fans' favorite moments in sports.

Nonetheless, I heard from fans immediately. Many registered their opinions on the hundreds of radio shows on which I've been a guest. Others wrote letters or posted online reviews. For instance, William from Conyers, Georgia, wrote to tell me that while he was enjoying the book, he was already looking for its companion. He went on to say (and I took this next part as a compliment), "If you are *not* planning a second volume, rest assured that I will personally fly to Los Angeles to weld a dunce cap to your head." Like the rest of us, he has favorites, and he proceeded to list eleven "can't-miss selections" for a sequel.

One online reader made a public appeal for the story of Olympic gold medalist speed skater Eric Heiden. It was a great suggestion, and this volume includes Heiden's incredible story, plus Keith Jackson's historic race call. While preparing *And The Crowd Goes Wild* and *And The Fans Roared*, I would also occasionally hear from the announcers. As a fan, it gave me a chance to thank them in person for the excitement they bring to the games. Almost without exception, they were more than willing to share a story-behind-the-story of one of their great calls.

And The Fans Roared

One of my favorites came from Al Wester, the former announcer for the New Orleans Saints. Al told me that just as he was about to make the call of Tom Dempsey's record-setting field goal, *a swarm of bees* hit the WWL transmitter tower, temporarily knocking the flagship station off the air. In an effort to appease disappointed New Orleans listeners, the station manager offered to send a tape of Al's call to anyone who sent the station a check for \$10, made out to their favorite charity, with a selfaddressed stamped return envelope for the tape. Al said that they spent months sending out tapes to fulfill the nearly 5,000 requests they received.

Dempsey's kick is an example of the unexpected dramas in sports. There are other momentous events that come to us gradually, like Kareem Abdul-Jabbar breaking the NBA scoring record, or Pete Rose breaking Ty Cobb's career hits record. The build-up swells leading up to the event, to the point where people press the announcers for how they intend to call the moment. Both Bob Miller, who called two of Wayne Gretzky's greatest achievements, and Milo Hamilton, who called Henry Aaron's 715th home run, told me that while it's important to be aware of the historical nature of the moment, the best announcers tuck their scripts in their briefcases and rely on their instincts and the spontaneity of the moment. To all of the announcers, thanks for the wonderful memories.

I'm very proud to have one of the best sportscasters in the business, Bob Costas, handling the narration on the accompanying compact discs. Bob is an intelligent and eloquent broadcaster. Last time, his demanding schedule prevented him from offering a level of input commensurate with his knowledge, talent, and experience. This time, Bob not only agreed to narrate, but he also consulted on the writing and editing of his narration.

I've heard from parents and grandparents about how they're sharing this book with their children and grandchildren. Both *And The Fans Roared* and *And The Crowd Goes Wild* are full of wonderful old memories. It's gratifying to think that they're helping to create some new ones.

I remember one story in particular from a man in Las Vegas named Al, the father of a youngster named Jacob who aspires to be a baseball player. Al has always read to his son before bed. Realizing that Jacob was growing out of Dr. Seuss and into quite a sports fan, he decided that instead of the umpteenth reading of *Green Eggs and Ham*, each night he would read Jacob a chapter from *And The Crowd Goes Wild*. After he read the chapter, they'd play the corresponding track from the CD. Then Al would fill in the story with his own recollections of the moment, and they'd talk about the athlete, the sport, or the achievement. Al said that Jacob couldn't wait to get to that part of the day. That story alone has made all the hard work worthwhile.

I continue to marvel at the way fans reminisce about their favorite moments. The emotion and the clarity with which they can remember even the smallest detail is remarkable. The fact is these great moments are very personal. I would like to think of *And The Fans Roared* and *And The Crowd Goes Wild* as time capsules. Packed between simple book covers, these memories are stored like heirlooms, to be taken out from time to time, remembered, shared, and then put back on the shelf for a later visit.

Х

Foreword by George Foreman

And The Fans Roared

o me, it was just a meaningless little box on the floor of my brother's place in Houston, Texas. Sure I knew it was a radio, but I didn't know the power it possessed.

I also didn't know anything about Sonny Liston or Cassius Clay. All I knew on that February night in 1964 was that my brother had invited people over to listen to a heavyweight championship fight and I might have a chance to get a sip of beer.

That's the way fifteen-year-olds think.

But as the broadcast of the fight started, I couldn't believe how crazy it made those men sitting around there, how that voice on the radio sent those men into a dizzy world. I just couldn't imagine how that little box could affect people so much. And I never forgot it.

Before the fight, people were saying this guy Sonny Liston was the greatest heavyweight since Joe Louis, that he was going to kill this young boy, Clay. When it was announced after the sixth round that Liston's shoulder was hurting and that he could not continue, it changed that whole room. There were a lot of disappointed people. That announcer made all those people leave the room feeling very different.

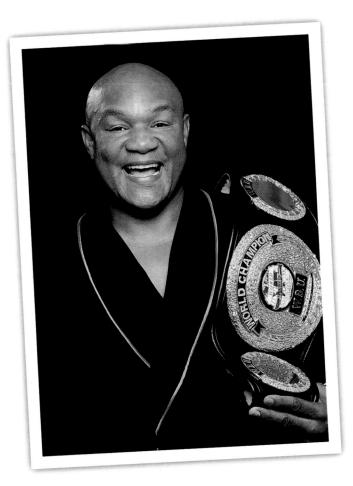

How impressed was I? I walked out without even asking for a beer.

A year later, there was an even more memorable Ali broadcast. At least for me.

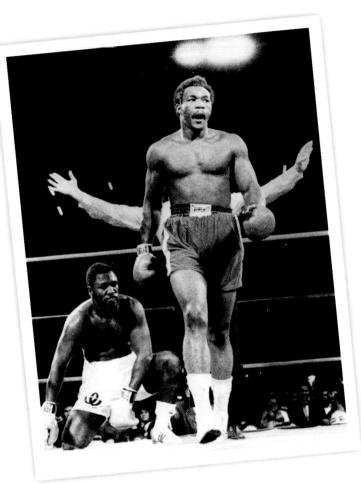

I heard him beat Floyd Patterson on the radio. When the fight was over, my heart was beating so strong from excitement that my friends noticed my reaction.

"You are always picking on people, being a bully," one of them said. "Why not just be a boxer?"

That's when I decided to get into the ring and become a fighter, the night of that broadcast.

And that, of course, led to one of the great broadcast moments in this book, my fight with Joe Frazier in 1973. It was a night that became a highlight not only of my career, but that of announcer Howard Cosell as well. Everybody knows about Cosell's most famous call: "Down goes Frazier! Down goes Frazier!" But few if any know just why Cosell was so excited over the outcome.

And The Fans Roared

It began two years earlier, when Ali first faced Frazier in one of the biggest fights ever.

When Cosell learned that he wasn't going to be one of the announcers on that fight, he was devastated. He was hurt. He literally cried in front of me. "How could they do this to me?" he asked.

Cosell felt he had built up both Ali and Frazier and he deserved to be the blow-by-blow announcer for their big fight. From that point on, Cosell decided he would build up another fighter—me—who could whip both of those guys. He started to believe that I could. He wanted to believe it.

When I started to knock Frazier down in our fight in Jamaica, the screaming Cosell was actually saying to the world, "Look at what I've done. I'm the one who made Ali. I'm the one who made Joe Frazier. Down goes Frazier! Look at what I've done to Frazier. Look at what I've done to the people who kept me off the air."

Cosell is the reason my fight against Frazier is so memorable. If people were to watch it sixty years from now with the sound turned down, all they would see is a big man knocking down a smaller one. The big guy whips the little guy. If you see it without Cosell's voice, it means nothing.

He made that moment, captured it for all time. It sends chills through you, and all because of the feelings living within Cosell. And The Fans Roared

> You almost didn't appreciate him until he was gone. What a great one Cosell was. I've seen and worked with a lot of sportscasters, but he was the best.

> But for me, it was the athletes who made the greatest impact on my life. When I saw them on television, when I saw Ali and some of the greats mentioned in

this book, they made me come alive as an athlete. The example of these superstars achieving new heights in these great broadcasting moments forever changed me into the performer and the person I became.

And I thank them for that.

arge oremy

AND THE FANS ROARED

The Sports Broadcasts That Kept Us On The Edge Of Our Seats

"There goes a line drive to left field!... Brooklyn wins!"

Bob Wolff

Disc 1 • Track 2

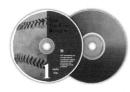

April 15, 1947

Jackie Robinson Integrates Baseball

t doesn't really matter how many home runs Jackie Robinson hit, how many bases he stole, how many championships his team won, or even how many sports at which he excelled. Robinson may have been a tremendous athlete, but all the normal yardsticks have to be thrown out when measuring his impact. His career broke all the rules. By being the first to break the unwritten rule forbidding integration in baseball, Jackie Robinson literally changed the face of sports over the last half of the 20th century, at the same time changing American society forever.

Robinson's appearance in the starting lineup for the Brooklyn Dodgers on opening day of the 1947 baseball season made him the first African-American to play in the major leagues after nearly seventy years of segregation and prejudice. The media paid little attention to the ground-breaking lineup. Either out of ignorance over the significance of the event—or more likely out of disapproval—most accounts buried Robinson's debut at the bottom of the story. But they couldn't bury the reverberations from that breakthrough moment.

Later that year, Larry Doby, another African-American player and former Negro Leaguer, cracked the Cleveland Indians' lineup. But full integration would still be a long time coming. The Boston Red Sox became the last major league team to integrate in 1959. But in the beginning, Robinson stood alone. He was subjected to everything from the cruel taunts and flashing spikes of other players to death threats from anonymous hate-mongers. "Thinking about the things that happened, I don't know any other ballplayer who could have done what he did," said teammate Pee Wee Reese.

In search of the perfect candidate to be the pioneer black player, Dodgers president Branch Rickey wanted someone who could be defiant, but not disrespectful. The player would have to be strong enough to take the abuse and humiliation without giving it back.

Of course, there was another key element required of Rickey's candidate. His choice had to be not only diplomatic enough to make his mark off the field, but talented enough to make a mark on the field. If he was no better than mediocre as a player, who would notice?

Nobody had ever failed to notice Robinson on the athletic field. At UCLA, Robinson was his division's leading scorer

on the basketball team, a star halfback on the football team, the NCAA broad-jump champion, and, of course, a baseball player. Ironically, baseball was only considered Robinson's fourth-best sport in college.

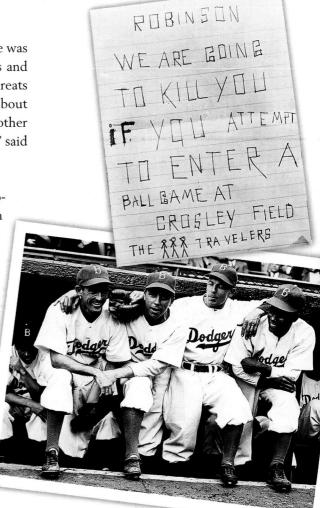

(clockwise from left) Jackie Robinson steals home on Yankees catcher Yogi Berra in the 1955 World Series opener. ■ A threat letter received by the Cincinnati Reds. May 1951 ■ Jackie Robinson and Dodgers teammates

(left to right) A terrific all-around athlete, Jackie Robinson excelled at football at UCLA. ■ Robinson in 1944 with the Kansas City Monarchs
■ Robinson and Dodgers president Branch Rickey sign a contract. In his first year with the Dodgers, Robinson answered all those who questioned his ability, and was named the National League Rookie of the Year. His best season was just two years later, in 1949, when he hit .342 to lead the National League, and was named the league's Most Valuable Player.

Having not come up to the hig leagues until he was twenty-eight years old, Robinson played only ten years in the majors, finishing with cumulative statistics that were certainly good, but not spectacular. He had a career batting average of .311, with 137 home runs, 734 RBIs, and 197 stolen bases. But spectacular is the only word to describe Robinson's style of play. Whether he was challenging a pitcher at the plate, dashing around the bases with his cap flying off, or wading into the raised cleats of a sliding runner as he turned a double play, Robinson had flair.

He excelled at one of baseball's most spectacular plays, the stealing of home plate. Robinson successfully pulled it off nineteen times, including a dramatic steal in the first game of the 1955 World Series against the New York Yankees.

In 1956, Robinson and the Dodgers faced the Yankees again in a World Series rematch, their seventh Series showdown in sixteen years. It would be memorable for two events. First, in Game 5, Yankees pitcher Don Larsen pitched a perfect game, giving the Yankees a three games to two lead in the Series. Then, in Game 6, Jackie Robinson smacked his last base hit in the major leagues.

and the second

Game 6 was scoreless into the bottom of the tenth inning and Robinson was batting clean-up. Yankees pitcher Bob Turley was on the mound. The Dodgers had two men on base, center fielder Duke Snider on first, and second baseman Jim Gilliam on second.

The count was 1-1 to Robinson. "Now the right hander's ready." said radio announcer Bob Wolff. "Gilliam, hands on hips, leads off second base, a little further now. Robinson waits. Here comes the pitch." Robinson connected. "And there goes a line drive to left field! Against the wall! Here comes Gilliam scoring, Brooklyn wins!" shouted Wolff. Jackie Robinson's clutch single won the game and evened the Series at three apiece. But Robinson went 0 for 3 in Game 7. The Yankees beat the Dodgers 9 to 0, decisively taking the championship.

Just prior to the start of the 1957 season, Robinson was traded to the Dodgers' bitter rival, the New York Giants. Instead of reporting, he opted for retirement, ending his historic career.

Roger Kahn perhaps best describes Robinson's effect on society in his book *Boys of Summer*. "By applauding Robinson," wrote Kahn, "a man did not feel that he was taking a stand on school integration, or on open housing. But for an instant, he had accepted Robinson simply as a hometown ballplayer."

(clockwise from left) Robinson warms up.
— Fred Frick, President of the National League, presents Robinson with the MVP plaque. July 6, 1950

— Robinson hits his first home run in a World Series game. October 1, 1952

"I'm glad that I've had the opportunity to thank everybody." Babe Ruth

April 27, 1947

Babe Ruth Says Good-bye

B abe Ruth reached heights few baseball players have ever known. Even in his 15th and final season with the Yankees, Ruth hit .288 with twenty-two home runs and eighty-four RBIs. Not exactly the glory days of 1927 when the Babe hit .356 with sixty home runs and 164 RBIs, but it was still a respectable season for almost any other ballplayer. But he wasn't just any ballplayer. He was Babe Ruth.

So at the age of forty, he left the Yankees, anxious to trade his bat in for a lineup card and become a manager. He was lured over to the National League where Judge Emil Fuchs, owner of the Boston Braves, signed Ruth to a player's contract by offering the hope that the great slugger might become the team's manager the following season. That never happened.

Ruth's other hope was that he could somehow recapture his old magic on the field in a Braves uniform. He appeared to be the Babe Ruth of old for one special day when he hit three home runs in a single game. But those were the last bullets in his gun. On June 2, 1935, hitting just .181, he announced his retirement.

Three years later, Ruth was lured into a Brooklyn Dodgers uniform to be a coach, again with the idea that the job might lead to a managerial position. It didn't, and Ruth again found himself on the outside, looking in at a sport that had been his life. He made personal appearances, awarded trophies to beauty queens, and showed up at Yankee Stadium as a spectator. But he seemed lost, a man in search of purpose.

On April 27, 1947, Major League Baseball held a day for Ruth to honor the man who had resurrected the sport following the Black Sox scandal of 1919. It was celebrated in every

park in the league. Although suffering from incurable throat cancer. Ruth himself came to Yankee Stadium that day, appearing before the crowd in a topcoat and cap, his once tousled hair sparse and gray, his once cherubic face drawn and sagging. Yankee sportscaster Mel Allen introduced the Babe to thunderous applause. Ruth had to wait for the cheering to subside in order to be heard. "You know how bad my voice

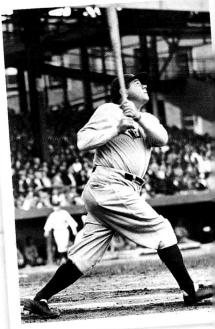

(clockwise from left) The Yankees officially retire Babe Ruth's jersey number.
Ruth watches one of his swats fly.
Ruth warming up at spring training in Tampa.

Babe Ruth

(top to bottom) Ruth addresses the crowd at the ceremony marking Babe Ruth Day. ■ Ruth is surrounded by admirers at Sportsman's Park. June 16, 1948 ■ Ruth greets Lou Gehrig during Lou Gehrig Day at Yankee Stadium. July 4, 1939

sounds?" Ruth said to the hushed crowd. "Well, it feels just as bad."

Loudspeakers carried his voice down the street and up to the trains on the nearby platform. Everywhere, people stopped and listened. "The only real game, I think in the world [is] baseball," said Ruth, his voice cracking. "There's been so many lovely things said about me and I'm glad that I've had the opportunity to thank everybody. Thank you."

Many observed that Ruth's appearance was harder to watch than that of his old teammate, Lou Gehrig, who had said his farewell on the same field eight years earlier. While Gehrig was dying from the effects of an ailment that would become known as Lou Gehrig's Disease, his condition was not readily evident to fans seated in the stands. They were at least watching the same figure they remembered

8

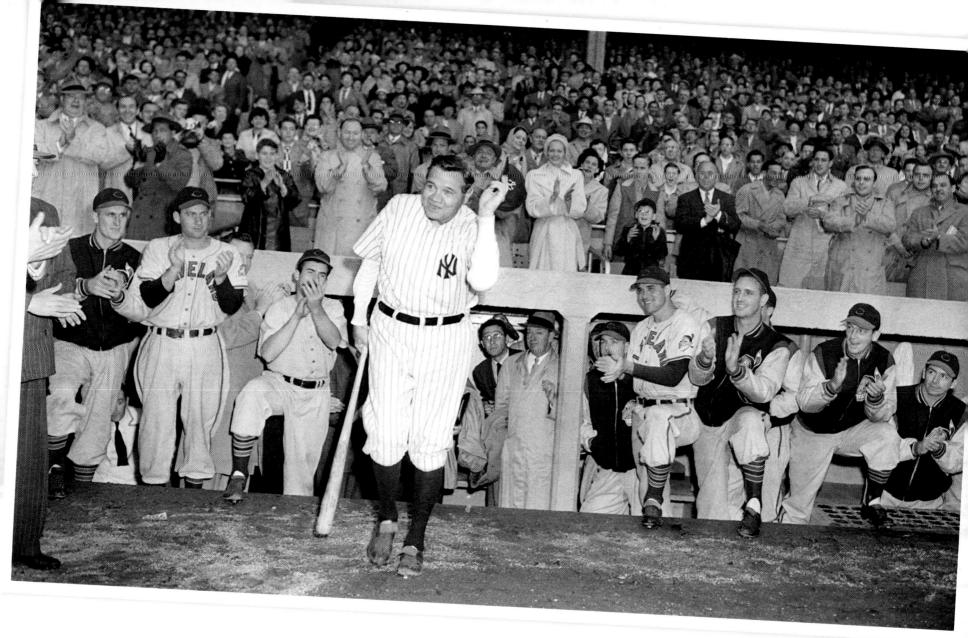

from his playing days. Not so for those who remembered Ruth as the Sultan of Swat.

But Babe Ruth loved the adulation and wasn't about to fade away. Touring ballparks, interacting with the fans, especially the youngsters, seemed to give him new life. But only temporarily.

Babe Ruth returned to Yankee Stadium on June 13, 1948, to commemorate the 25th anniversary of the celebrated ballpark and to retire his uniform, No. 3.

Ruth's condition had worsened drastically in the previous few months and he appeared to be a shell of the robust figure that had once ruled the game. "Even though, by that time, he was wasted away," said journalist Heywood Hale Broun in a special for HBO, "somehow, on that day, he filled the uniform to be once more, for some last gasp, a heroic figure. You had just this moment that you tried to hold and keep."

George Herman "Babe" Ruth Jr. died of cancer at 8:01 p.m. on August 16, 1948. His body lay in an open coffin at the main entrance to Yankee Stadium. It would be the last time Ruth returned to the scene of his greatest glory. For two days, hundreds of thousands came by to pay their respects to a man who was larger than life. (top to bottom) Ruth waves his cap during the ceremonies marking the anniversary of the opening of Yankee Stadium and the retirement of his number. Frank Haggerty, a young fan, wipes a tear as he stands by Ruth's coffin in Yankee Stadium. August 18, 1948

"It is Citation going to win the Belmont Stakes, the third angle of the Triple Crown."

Clem McCarthy

Disc 1 • Track 4

June 12, 1948

Citation Wins Triple Crown

When the 20th century ended, only eleven horses had won thoroughbred racing's Triple Crown, and none since Affirmed in 1978.

Only three-year-old horses are eligible, so each animal only gets one shot at the triple. If a horse is able to win the sport's most celebrated race, the Kentucky Derby at Churchill Downs in Louisville, against the best competition, the horse must then travel to Pimlico in Maryland and again take on all comers in the Preakness. Even if a horse manages to win the first two jewels on the crown, going the distance in New York at the Belmont is no cinch. Winning the Triple Crown indeed requires speed, stamina, and a champion's heart.

Citation, the winner of the 1948 Triple Crown, possessed all of these winning qualities, enough of each for many racing afficionados to consider his

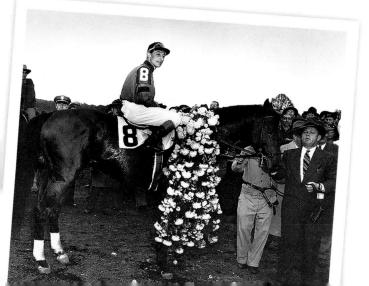

accomplishments the greatest in the history of the sport.

He became the eighth Triple Crown winner—twenty-five years would pass until Secretariat became the ninth. And while the latter's sheer dominance in the three races made him legendary in the public's mind, the great Secretariat never had a year like Citation did in 1948.

Citation raced for the renowned Calumet Farms in Kentucky and was trained by the equally legendary "Plain" Ben Jones, who also nurtured 1941's Triple Crown winner, Whirlaway, and 1947's Horse of the Year, Armed. That

same year, Citation won eight races, with one second-place finish, and was acknowledged as the best in the two-year-old class.

The great colt opened his three-year-old season with a pair of wins against older competition, including Armed in both races. In his fifth start of the season, Citation finished second to Saggy on a muddy track in Maryland. This race was significant for another reason as well—it was the first with Eddie Arcaro in the saddle. Sadly, Citation's regular rider, Al Snider, had been lost while on a Florida fishing trip prior to the race and was never seen

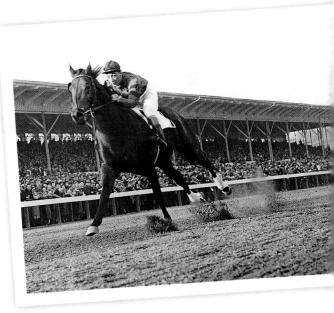

(left to right) Citation and Eddie Arcaro cross the finish line to win the Belmont Stakes. June 12, 1948 ■ Citation and Arcaro stand in the winner's circle with Jimmy Jones after the International Gold Cup Race. ■ Citation races by himself in the Pimlico Special. No one would race a horse against the invincible three-year-old.

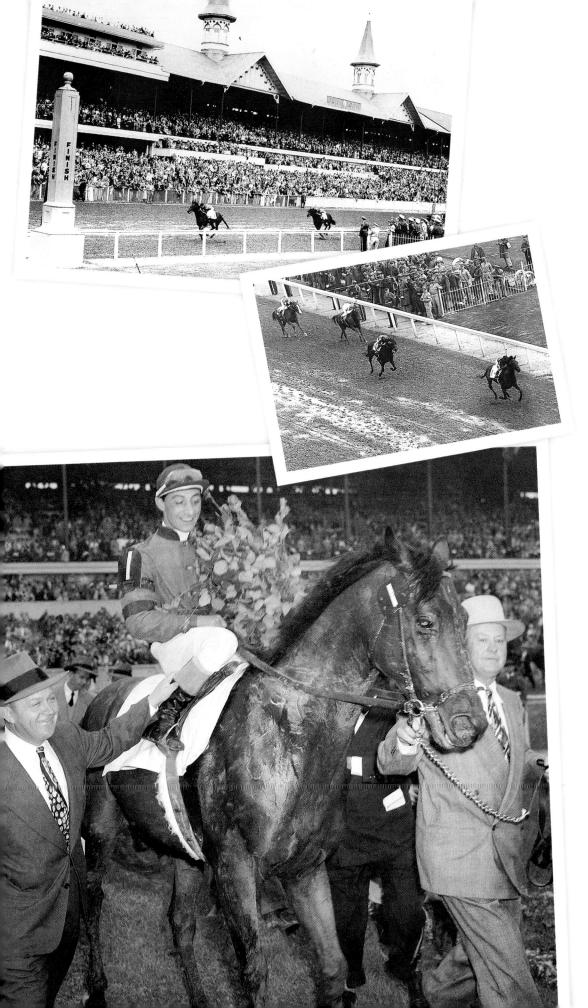

again. Citation avenged the defeat to Saggy just five days later in the Chesapeake Stakes. The victory was the start of a sixteen-race winning streak.

Despite his record, there were some factors working against Citation in the Kentucky Derby. No twoyear-old horse had ever won the Futurity and then gone on to win the Derby as a three-year-old, nor had any horse won the Derby Trial at three and then the Derby. Citation had won both, the latter as a 1-10 favorite.

The 1948 Kentucky Derby was the only Derby that didn't take Place and Show bets. Citation was so far ahead of his competition, track officials sought to reduce their risk.

Only five horses dared take the starting gate against Citation in the Derby, and one of those was halfbrother and stablemate Coaltown, who had not raced as a two-year-old, but was undefeated as a three-year-old. The entry, two horses from the same stable, went off as 2-5 favorites. The gates opened and Coaltown led the pack. Calling the race on CBS Radio, in his distinctive staccato cadence, was Clem McCarthy. "And it is Coaltown breezing along in front by four links...he's as fast as they said he was...Citation is moving up to challenge." As the horses headed for the turn and the final stretch, McCarthy was calling it a two-horse race. "And they're turning for home, Coaltown and Citation head and head!...They're coming in there just like they knew the enemy!...And it is Citation coming to the front. He's everything they said he was. He's gonna win with his ears pricking! It is Citation by two, pulling away...and the other horse Coaltown is hanging on gamely, but that's all he can do is hang on gamely to be second. Citation wins this Derby...by three and a half lengths!" It was the fourth Derby win for both Ben Jones and Arcaro.

The Preakness was even easier than the Derby. Only three horses ran with Citation, who won handily by five and one-half lengths. The time of the race was a relatively scant 2:02.24, prompting

Clem McCarthy to offhandedly comment, "Well, Citation wins it easily, as you couldn't make it much faster than that." After the Preakness, Jimmy Jones, who had taken over training the horse from his father, Ben, ran Citation in the Jersey Stakes. He set a track record and set the stage for the Belmont.

Citation was the overwhelming favorite in the 1948 Belmont Stakes. But the fact remained that many horses with Derby and Preakness wins to their credit have lost the Belmont. Citation was the favorite on paper, but the race is run on a track.

The Belmont Stakes is an endurance race that covers one and one-half miles, the longest in the Triple Crown. The only hope for the rest of the field was that Citation would not have the stamina to go the distance.

Seven horses joined Citation on the Belmont track, including Coaltown, who had skipped the Preakness, and they broke from the gate as one. Citation stumbled at the start and for just a moment, appeared beatable. Jimmy Jones was later quoted as saying, "At three, Citation could fall down at the eighth pole and get up and beat any horse in the world. He could just do everything better than every other horse." Despite faltering early, Citation quickly took command of the race. "And there he goes!" shouted announcer Clem McCarthy. "Citation taking the lead, and opening up by a length and a half...with Faraway in second place...and the others already are trailing so far that you're glad the distance is a mile and a half!...And Citation is pullingaway...he'll have to collapse to lose this race!...It is Citation going to

win the Belmont Stakes, the third angle of the Triple Crown, just as far as Eddie Arcaro pleases. And Arcaro is sitting still at the end...the winner!" Citation won by cight lengths and a time of 2:28.24, a Belmont record.

Citation's winning of the 1948 Triple Crown was his greatest achievement, but it wasn't the whole story of this wonderful horse. The three Triple Crown wins were part of a sixteen-win streak that lasted until early 1950. Overall, Citation won twenty-seven of his first twenty-nine races, with two second-place finishes, an unrivaled accomplishment in the sport of horse racing.

Though Citation was slowed by ankle and tendon problems, he went on to become the sport's first horse with career earnings of one million dollars. Citation finished his career with thirty-two wins in forty-five races, a tremendous achievement that ranks him with Man O' War and Secretariat as one of thoroughbred racing's greatest horses.

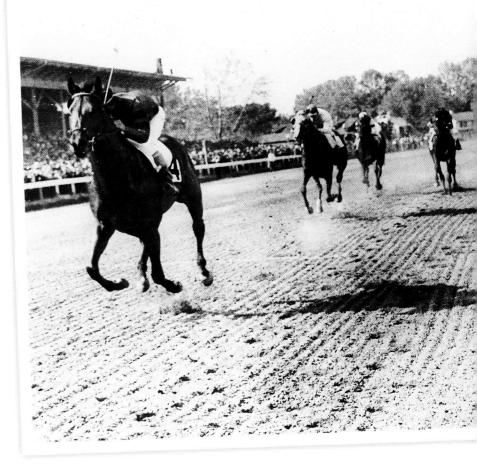

(opposite page, top to bottom) Citation and Arcaro win the Kentucky Derby.
■ Citation hits the finish of the Kentucky Derby.
■ Ben Jones leading Arcaro on Citation

(above) Citation races to a six-length win in the Preakness. May 15, 1948

"Oh my! Caught by Mays!"

Jack Brickhouse

Disc 1 • Track 5

Willie Mays Makes "The Catch"

The argument could be made that Willie Mays was the greatest ballplayer who ever lived, certainly the greatest in the second half of the 20th century. The rebuttal would be that he doesn't hold any of the game's major records. But Willie Mays wasn't about numbers, though he put up his share. He had the power, 660 home career home runs. He had the consistency, 3,283 hits and a .302 lifetime average. And he had the durability, twenty-two years in the big leagues, 2,992 games.

But what set Willie Mays apart from the few who had similar numbers was his glove, and what made him so memorable was his flair. There may have been a few outfielders who could match Mays for speed, but none for excitement. His cap flying, his legs churning, he caught up to most balls that dared invade his air space in center field. And when that ball moved into range, Mays would drop his hands to his waist, fold one on top of the other, and let the ball gently drop into his glove. Mays' unusual method became known as the basket catch, a style few dared try to duplicate.

Yet for all his great catches, including one in which he knocked himself out against a wall at Brooklyn's Ebbets Field, one stands out above all the others. It was at the Polo Grounds, the cavernous home of Mays' New York Giants, in the first game of the 1954 World Series. The Giants, under manager Leo Durocher, came into the Series with a powerful team, a club that had compiled a 97–57 record to win the pennant by five games.

But the Giants' numbers paled in comparison to those of their opponents, the Cleveland Indians. Under manager Al Lopez, the Indians had won a then-league record 111 games, finishing 111–43 to win the American League pennant by eight games.

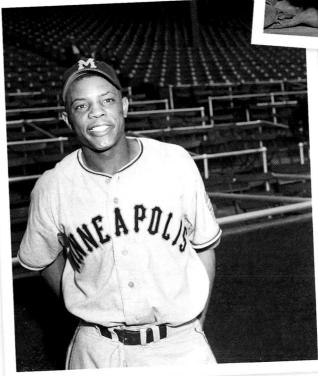

(clockwise from left) Center fielder Willie Mays makes "The Catch." ■ Mays trades in his cleats for Army boots as he reports for duty at Camp Kilmer in New Jersey. May 29, 1952 ■ Mays as a minor leaguer with the Minneapolis Millers. (left to right) Willie Mays hits a home run against the Mets. ■ The bleacher view of Mays' over-the-head catch. In Game 1, first baseman Vic Wertz gave his club the first lead of the Series with a two-run triple off New York pitcher Sal Maglie in the first inning. The Giants tied the score in the third and it was still tied at two when Wertz came to bat in the eighth inning. With Larry Doby on second, Al Rosen on first, nobody out, and Wertz having already collected three hits in the game, Durocher decided to make a move. He yanked Maglie and brought Don Liddle in to pitch.

> But the call to the bullpen seemed like a tragic mistake when Wertz' hot bat connected again. He hit a towering

drive, but, fortunately for the Giants, Wertz had hit it to center field, which, in the Polo Grounds, stretched out 483 feet from home plate to the clubhouse wall. Also fortunately for the Giants, the ball was heading in the direction of Willie Mays. The Giants center fielder knew instantly that the ball was going over his head, and he got a good jump on it.

Mays turned his back and literally raced the ball towards the furthest confines of center field. Veteran sportscaster Jack Brickhouse, along with Russ Hodges, was calling the game on NBC TV, and was certain he was witnessing a home run. "There's a long drive...way back at center field...way back, back, it is a..." At that moment, with his hand and glove extended over his left shoulder, Mays' movements were more akin to an ace receiver hoping to pull in a "Hail Mary" pass than that of a center fielder attempting to catch a promising clout. But his determination paid off. Approximately 450 feet from home plate, ball and man met. "Oh my! Caught by Mays!" shouted an amazed Brickhouse.

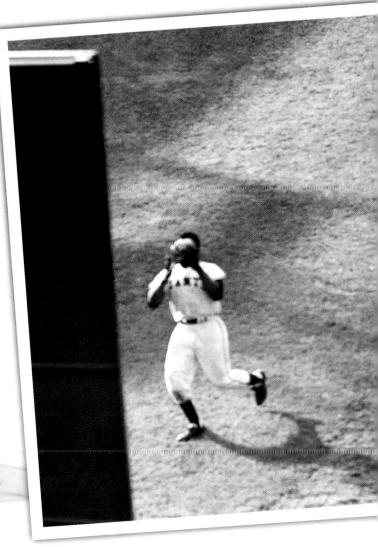

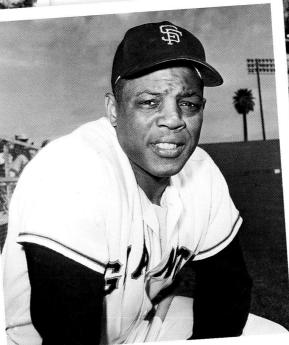

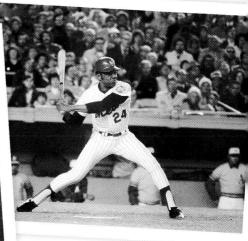

"Willie Mays just brought this crowd to its feet with a catch which must have been an optical illusion to a lot of people!"

If it had just been the catch, it would have been remarkable enough. But Mays knew Larry Doby could advance from second base after the catch. So he followed "the catch" with "the throw."

In his book, *A Day in the Bleachers*, Arnold Hano described Mays' amazing play. "Mays caught the ball," Hano wrote, "and then whirled and threw, like some olden statue of a Greek javelin hurler. As

he threw, off came the cap, and then Mays himself continued to spin around after the gigantic effort of returning the ball whence it came, and he went down flat on his belly and out of sight." Doby only reached third and Mays seemed to have taken the life out of the Indians. They failed to score in that inning or again that day.

Two innings later, Giants pinch hitter Dusty

Rhodes cracked a three-run homer into the right field seats, just 258 feet away, to give his team a 5

to 2 victory. "The longest out and the shortest

home run of the season beat us," said Indians man-

ager Al Lopez. And Cleveland never recovered, los-

It might have been different if Wertz' drive had

dropped. It probably would have been different if

anybody other than Willie Mays had been playing

ing the Series in four straight.

center field.

(left to right) Mays turns to throw, holding Larry Doby to just a one-base advance. ■ Mays moved with the Giants to San Francisco ■ Mays pinch hits for the Mets in the third game of the 1973 World Series. It is his last time at bat.

Willie Mays

"The fight is over! The fight is over!"

Les Keiter

3-1

GEC.

Patterson vs. Johansson: A Classic Boxing Rivalry

At first glance, Floyd Patterson's opponent appeared to be just another of the quickly collapsible deckchairs that his manager, Cus D'Amato, had lined up for him since Patterson became the champ in 1956. Ingemar Johansson of Sweden was best remembered for a disqualification in the 1952 Olympic heavyweight semifinal, after his refusal to venture within arm's length of American Ed Sanders.

At those same Olympics in Helsinki, Floyd Patterson won the gold medal for the middleweight division. Four years later, at age twenty-one, he became the youngest heavyweight champion in history when he knocked out Archie Moore, an opponent nearly twice his age.

For the next three years, Patterson's world title was preserved in the ring rather than contested. The years of his reign were notable for the fighters he avoided, Sonny Liston among them.

He even slept in his dressing room before some of the fights, and was serenely confident as he climbed through the ropes at Yankee Stadium to face Johansson, the owner of a right-hand punch the Swede called "toonder and lightning."

Patterson recalled later, "I said to myself, 'This guy's nothing. I'll just throw combinations....I'll knock him down.'"

Patterson's casual strategy seemed to work for the first two rounds. Then, Johansson caught his over-confident opponent with a right in the third round, a clap of thunder that announced a torrent of blows. Famed fight announcer Les Keiter, at ringside, called the fight on radio. "Johansson knocks champion Patterson flat on his back...Patterson's hurt!" A dazed Patterson was unable to recover. Johansson knocked him down several more times before the fight reached its climax. "Four, five...Patterson kneeling, holding onto the middle strand! Seven, eight, nine-he barely gets up at

nine! Johansson right on top of him...and knocks him down with a right to the chin! Patterson, at the bell, gets up staggering...Wait a minute! The fight is over! The fight is over!" Keiter shouted. Bedlam took over the arena and twenty-six-year-old Johansson was declared the victor.

Included in the original fight contract with Johansson was a clause requiring a rematch if Patterson were to lose. That rematch took place almost exactly a year later at the New York Polo Grounds.

(left to right) Johansson knocks Patterson down in the third round of the heavyweight title fight in Yankee Stadium. June 26, 1959 ■ Patterson and Johansson

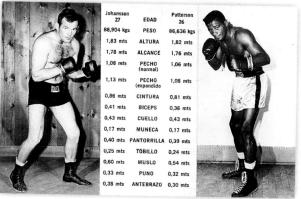

(above) A Spanish language physical comparison between Johansson (left) and Patterson (right) ■ (below, left to right) Johansson knocks down Patterson in their first fight. ■ Johansson goes down in the rematch title fight. June 20, 1960 Patterson prepared himself for the rematch with what he would later call "a terrible and lonely intensity," and focused it on Johansson, who bore the brunt of it in the fifth round.

Again, Les Keiter called the blow-by-blow action. "A left to the chin and Johansson falls on his back!" Patterson's first left hook sent Johansson to the canvas. "The champion on one knee taking the count of five, six... he's up on one knee...nine." Johansson regained his footing, but only for a moment. "The place is bedlam! Is Floyd Patterson close to getting his crown back?...A hit to the right! Johansson is the man who doesn't know where he is tonight!" A second left hook from Patterson was devastating. "Johansson looks like a man sleepwalking. Patterson comes in with a left...Johansson is flat on his back!" Johansson laid on the canvas, his left foot twitching. "It's all over! It's all over!" Keiter announced, "Floyd Patterson has knocked him unconscious...hit with one of the most vicious left hooks I have ever seen!" Floyd Patterson became the first heavyweight champion in boxing history to regain his crown.

But Patterson wasn't celebrating. Appalled at the evidence of his glovework, he knelt on the canvas, cradling Johansson's head in the crook of his arm, and promised his still unconscious opponent a third rematch.

The score between the American champion and his Swedish counterpart now stood at one fight apiece. A third fight was arranged, as promised, and this time it took place in Miami Beach, Florida.

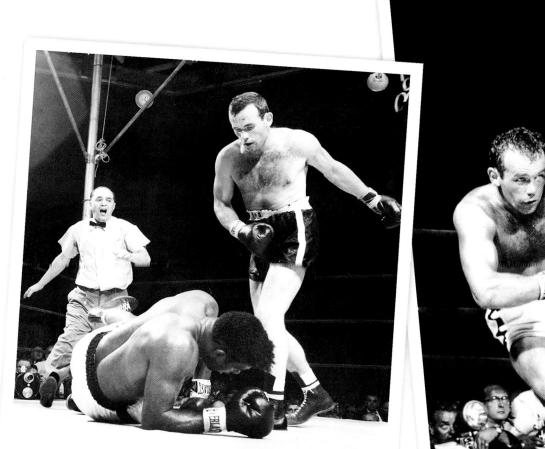

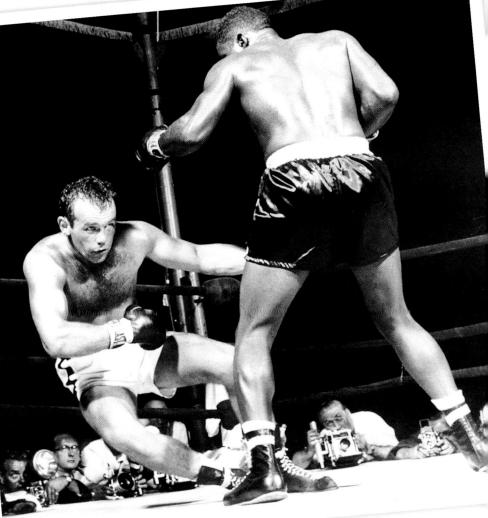

Patterson was not as sympathetic to his opponent this time as he was at the end of the last match. There was enough fire in Patterson's blood to quickly end the third installment of his meeting with Johansson, although this was the most competitive of their three fights.

They began with one of the wildest opening rounds in the history of heavyweight title fights. Twice, Patterson found himself on the canvas. Twice, he shook off the impact of the blows and kept fighting.

"I'll say this, Ingemar's left jab has been most effective in this round than any other," said Keiter, who again was calling the fight. Patterson slipped and was off his feet again in the opening moments of the second round. Defensive at first, behind gloves raised almost to eye level, he gradually regained his equilibrium.

By the sixth round, Johansson had clearly lost the initiative. His movements had slowed, a legacy of the attacks Patterson had launched on his body. "Here's Patterson, coming back again. Throws a straight left to the head, and a right to the ear, and down goes Ingemar!" cried Keiter. Patterson took charge with two swift blows. "Ingemar, down on all fours, gets up to one knee...And it's Patterson on top as Johansson sits down, trying to get up on five, six, he got up. Wait a minute! He did not get up! According to Billy Reagan, the referee, he did not get up in time! Johansson is arguing, but Reagan is pushing Ingemar back into his corner. And that means that the fight is over, and that Floyd Patterson has come on to win by a knockout!"

With none of the Patterson-Johansson battles having gone the distance, it was a

typical conclusion to the third and final match in their rivalry.

The following year, Patterson, badly intimidated, lost his heavyweight title to the fearsome Sonny Liston in a firstround knockout.

Johansson resumed fighting in Europe and won three fights by knockout. He won a fourth fight on a questionable judge's decision, and took it as a sign it was time to retire.

In 1982, the International Olympic Committee retrospectively awarded him the silver medal from the 1952 Olympics. Later that year, Johansson and Patterson ran in the New York Marathon. This time, both went the distance.

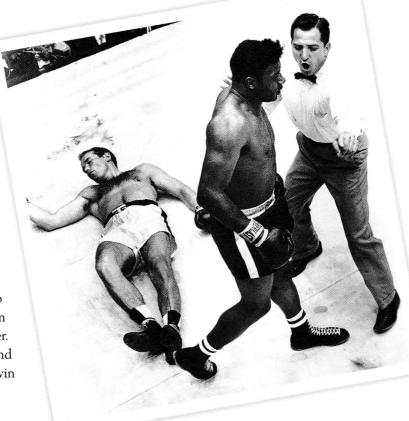

(top to bottom) Johansson falls to the canvas after a knockout blow by Patterson in their third and final fight.
Referee Arthur Mercante motions Patterson to a corner in the fifth round of the second fight. June 20, 1960

"He's running into the end zone the wrong way… thinks he's scored a touchdown."

Lon Simmons

October 25, 1964

Jim Marshall Runs the Wrong Way

t is every football player's nightmare. But for Jim Marshall, it was harsh reality. An excellent defensive lineman for Ohio State University, Marshall played for Cleveland and then starred for the Minnesota Vikings for nearly two decades. But Marshall always will be remembered as the pro football player who ran the wrong way.

For a long time, it was Roy Riegels who had to live with the embarrassment of being known for his sport's most humiliating play. Riegels' unforgettable foible occurred in the glare of the national spotlight. As a member of the California Golden Bears in the 1929 Rose Bowl against Georgia Tech, Riegels ran the wrong way in a game Georgia Tech went on to win 8 to 7. Fortunately for Riegels, he was tackled by his own teammate before he reached the wrong end zone.

Marshall wasn't so fortunate. At 6 feet 4 inches, 248 pounds, Marshall was a powerful and welcome presence on the roster of the Vikings when they were formed in 1961. He became an important figure on the team, and he had even scored a defensive touch-down in 1963. He thought he had equaled the feat after picking up a fumble by the 49ers in the fourth quarter of a game played October 25, 1964, in San Francisco's Kezar Stadium.

San Francisco announcers Lon Simmons and Russ Hodges were in the broadcast booth, and Simmons began calling the fateful play, "Mira straight back to pass, throws, completes it to Kilmer up at the thirty-yard line. Kilmer driving for the first down...loses the football. It's picked up by Jim Marshall!" Suddenly, his excitement turned to disbelief. Seeing the ball lying on the ground at the 49ers forty-yard line, Marshall picked it up and started running. "Marshall is running the wrong way!" called Simmons. "He's running it into the end zone the wrong way...thinks he's scored a touchdown, he has scored a safety...threw the ball up in the air in sheer joy. His teammates were running

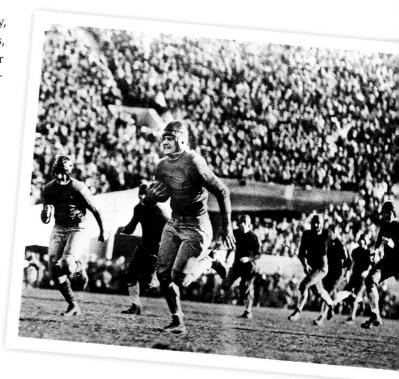

along the far side of the field, Russ, trying to tell him, 'Go back, go back!'"

Not realizing he had somehow gotten turned around, Marshall had targeted his own end zone sixty yards away. "I just picked it up and started running," Marshall said. "I saw the players on the sidelines waving their arms and yelling at me, but I thought they were cheering me on." Marshall's coach, Norm Van Brocklin, was horrified. "I thought he was just clowning," Van Brocklin said. (left to right) Jim Marshall heads toward the wrong end zone as the Vikings sideline frantically points the right direction. ■ The original wrongway runner, Roy Riegels.

"I'll tell ya'," Hodges chuckled, "that's the funniest thing I've ever seen in my life."

Marshall made it all the way into the end zone before another Viking could reach him. He was having a great time celebrating, even throwing the ball into the stands to the cheers of the crowd.

At first, it didn't occur to Marshall just why they were cheering. But he knew something was wrong, very wrong, when the 49ers' Bruce Bosley came up and congratulated him. Marshall looked over at his own sidelines. His teammates weren't cheering.

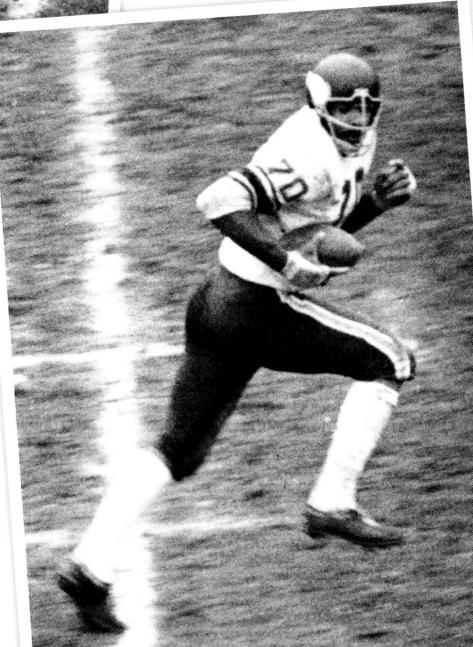

(left to right) Marshall scoops up the loose football. ■ Marshall takes off down the field. When the cold, hard truth hit him like the weight of an on-rushing tackler, Marshall made his way in a daze back to the middle of the field where he knelt and hung his head.

If ever a player wished that the ground would open up and swallow him, it was Jim Marshall in Kezar Stadium that day. But Marshall took the only approach he could, shrugging off the mistake and going back to work. The 49ers got two points on the play as Minnesota was called for a safety, but the Vikings hung on to win 27 to 22. The consequences of Marshall's error did not have the same impact on his team as Riegels' had.

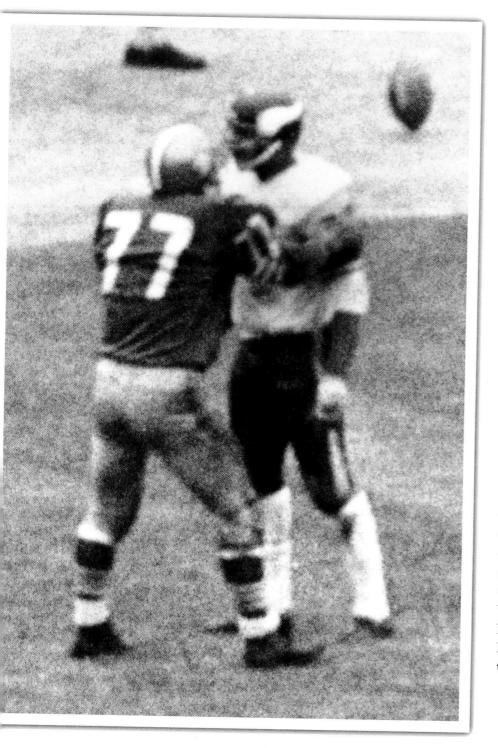

In that 1929 Rose Bowl game, Riegels ran more than sixty yards before he was tackled three yards short of his own end zone. But when California elected to punt on the next play, Georgia Tech blocked the kick and wound up with a safety that proved crucial in its one-point win.

Riegels was amazed to find people would still come up to him

to talk about the disastrous play decades later. So thrilled was he to have company that he told a wire service reporter he was sending a letter to Marshall, telling him, "Welcome to the club."

Marshall soon learned what membership meant. He went on to play fifteen more seasons for the Vikings, finishing with a remarkable total of 282-straight games played, and a record 29 opposing fumbles recovered. Yet, for all the years that followed, when fans talked to Jim Marshall, most still wanted to talk about his run to ridicule.

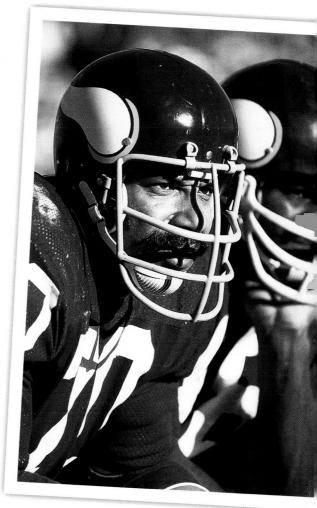

(left to right) A stunned Marshall is congratulated by the 49ers. ■ Vikings defensive lineman Marshall played in 282 consecutive games and four Super Bowls.

25

I E E LAUER TONY ROCHE WATCH COURT-WADE

^{cc} Here goes Rod Laver, trying to close the ring on the Slam.²⁵ Bud Collins Disc 1 • Track 8

Rod Laver Wins Grand Slam

t began in the steamy, mid-summer heat of Brisbane, Australia, and ended on a damp September afternoon in New York City. The remarkable journey saw Rod Laver defy age, injury, and the fast-evolving world of tennis to become one of the immortals of the game.

In 1938, America's Don Budge became the first player in tennis history to win each of the game's big four singles tennis titles: Wimbledon and the Australian, French, and United States championships. Tennis writer Allison Danzig was the first to attribute the term "Grand Slam" to these four titles when she wrote of Budge's sweep of tournament victories. Rod Laver's first "Grand Slam" victory occurred in 1962, when he was not quite twentyfour years old.

Laver became the master of a sport divided. From the mid-1930s, the game's best players had regularly departed the amateur ranks, and therefore Grand Slam competition, for the big money of the professional game. Amateur tennis had the status, but not the names. Professional tennis had the names, but not the status.

At that time, there had been a seemingly endless line of Australian tennis talent, wave after wave of players who won Grand Slam titles for themselves and Davis Cups for their country before deciding to play for money. The foreman of that line was Harry Hopman, the gifted and autocratic captain of Australia's Davis Cup team. In the late 1950s, he began coaching a promising left-hander from the northern state of Queensland. That left-hander was Rod Laver, who possessed astonishing shot control, and who, because of his languid movement about the court, earned the sarcastic nickname "Rocket."

After winning the 1962 Grand Slam, Laver followed the path of his countrymen into the professional ranks, where he was less than successful.

Gradually, the amateur administrators began to understand the folly of banishing the game's best players. In April 1968, the game became "open," with entry into the Grand Slams available to professionals as well as amateurs.

Through 1969, the strongest test of Laver's supremacy came from his fellow Australians. In the sweltering heat of the Australian Open, Laver and Tony Roche, another left-hander, battled each other to a standstill. Their epic semifinal was exemplified by a forty-two–game second set. The rule allowing for a tie-breaker, played when the game score is 6–6, had yet to be introduced. Laver eventually won 7–5, 22–20, 9–11, 1–6, 6–3. It was his sternest challenge

(left to right) Rod Laver holds the winner's trophy at the U.S. Open. September 8, 1969 ■ Queen Elizabeth presents the 1962 Wimbledon trophy to Laver.

(clockwise from upper left) Laver, defending champion, returns the ball in a semifinal match at the 1962 Wimbledon. ■ Laver displays the Wimbledon trophy. July 7, 1961 ■ Laver at Wimbledon in 1969

(opposite page, top to bottom) Ken Rosewall congratulates Laver after his victory in the French Open men's singles finals. June 7, 1969 ■ Laver competes in the final round of the U.S. Open. September 9, 1969 ■ Laver with the 1969 Wimbledon trophy

Rod Laver

28

of the year. He won the first of his four finals against Spaniard Andres Gimeno in straight sets. The French and Wimbledon titles followed, with Laver defeating Australian Ken Rosewall, then beating Australian John Newcombe at Wimbledon.

A recurring case of tennis elbow meant Laver was slow to start and vulnerable in both matches and tournaments. But once he warmed up, he established an unrelenting momentum.

The 1969 U.S. Open, at the West Side Tennis Club in Forest Hills, New York, was a test of patience as much as talent and concentration. A near constant

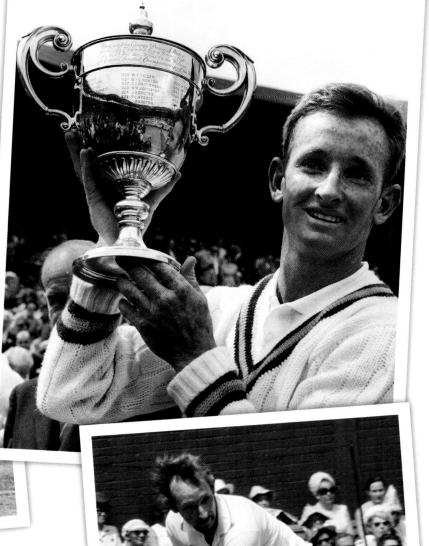

rain caused the cancellation of play on two days, and interrupted matches on three others. The Forest Hills grass was damp and slick. Footing was slippery and some shots were a lottery, either hitting the turf and stopping dead, or skidding through unplayable.

Laver's groundstrokes and temperament were both equal to the unusual situation. At final match point, Laver led 7-9, 6-1, 6-2, 5-2. Anchoring the coverage for CBS Television were Bud Collins and tennis champion Jack Kramer. "Here goes Rod Laver, trying to close the ring on the Slam. And he has one point, needs three," Collins said, summing up the impending conclusion of the historic play. "Thinking about so many things. Trying not to think about his wife in Newport Beach, California, about to have a baby at any moment. That's been on his mind, preying on his mind," Collins said. After faulting on his serve, Laver fired an ace past Roche, his sixth for the match. That was followed by another successful volley and Laver brought the score to 40-love. Roche answered Laver's next serve, putting the score at 40–15. "Just watching Rod as he's doing this great thing here, he doesn't win the matches by people playing badly," Kramer observed, "he wins it by beating them right into the ground." Laver's next serve was into the net. He served again. A quick volley. Then it was over. Laver had defeated Roche in the final set 6-2.

In so doing, Rod Laver's place in the game's history was assured, the only player to win two Grand Slams.

"You are undoubtedly the best player in the entire world, and you may be the best we've ever seen," Alastair Martin, the president of the United States Lawn Tennis Association told Laver after the match at the presentation ceremony. Quiet-spoken and understated at the best of times, Laver appeared genuinely moved by this commendation. "I've lived for tennis," he said later, "and to hear yourself called the best ever at what you've lived for, well, it made me turn over, a little, inside."

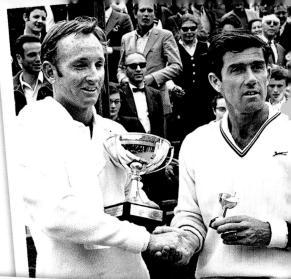

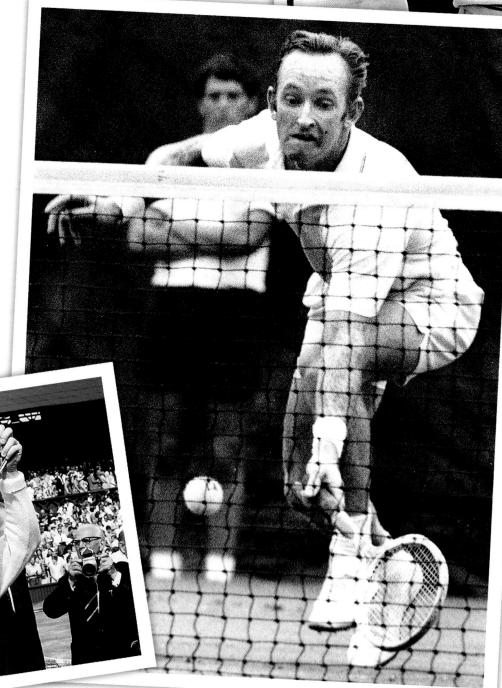

****** Bobby Orr scores! And the Boston Bruins have won the Stanley Cup!******

Dan Kelly

Disc 1 • Track 9

May 10, 1970

Bobby Orr Goal Wins Stanley Cup

f you know nothing about Bobby Orr, know this—when Larry Bird stood at attention before Boston Celtics home games and listened to the national anthem, he stared each night at one of the retired jerseys hanging from the rafters of the storied Boston Garden. It wasn't legendary Celtics Bill Russell's or Bob Cousy's or John Havlicek's. It was Bobby Orr's.

Orr started playing hockey on a frozen lake in Parry Sound, Canada, when he was just five. By the time he was twelve, pro scouts from all of the "original six" NHL teams started scouting him. At thirteen, he signed a junior contract with the Boston Bruins organization. The next year, he was dominating players five years his senior.

Entering the NHL at age eighteen, Orr was named Rookie of the Year in the 1966–67 season, and won his first Norris Trophy as the best defenseman in the league a year later. When he scored twenty-one goals in 1969, it was the first time in more than twenty years a defenseman had scored as many. Orr's offensive prowess redefined his position. He ultimately recorded seven straight seasons with over twenty goals, three over thirty, with forty-six in 1975. He also tallied five seasons over eighty assists and six seasons over one hundred points.

But great players don't just score points, they lead. They win. When the 1969–70 season began, the Bruins were a swaggering bunch. Orr was Boston's best player, but he was modest to a fault. He deferred leadership to tough Ted Green, Phil Esposito, and the other Bruins veterans. But things changed when Green had his skull fractured in September in a stick-swinging melee and young Bobby was forced to make the Bruins "his" team.

Teammate Derek Sanderson told *Sports Illustrated* at the time, "With Greenie gone, there was no question who had to

be our leader, but Bobby wasn't too crazy about it. He's a great kid, but a modest kid. One night after a game, I sat next to him on the bus to the airport and told him, damn it, he had no choice. We needed him, and he was it, whether he liked it or not."

So the kid from Parry Sound—all of twenty-two years old by now—stepped up and took over. Before every game, he walked the Bruins locker room and tapped every player on his pads with his stick. Charging in from the back line, Orr scored thirty-three goals during the season. More importantly, he kept the whole team involved

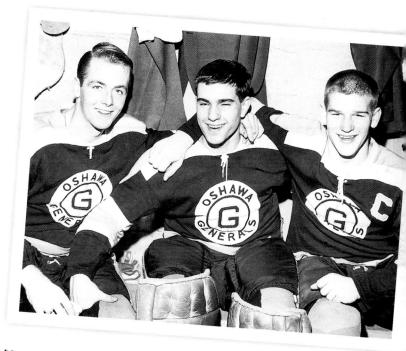

(left to right) Bobby Orr is tripped after scoring the Stanley Cup–winning goal. ■ Bobby Orr (right) starred for the Oshawa Generals as a teenager.

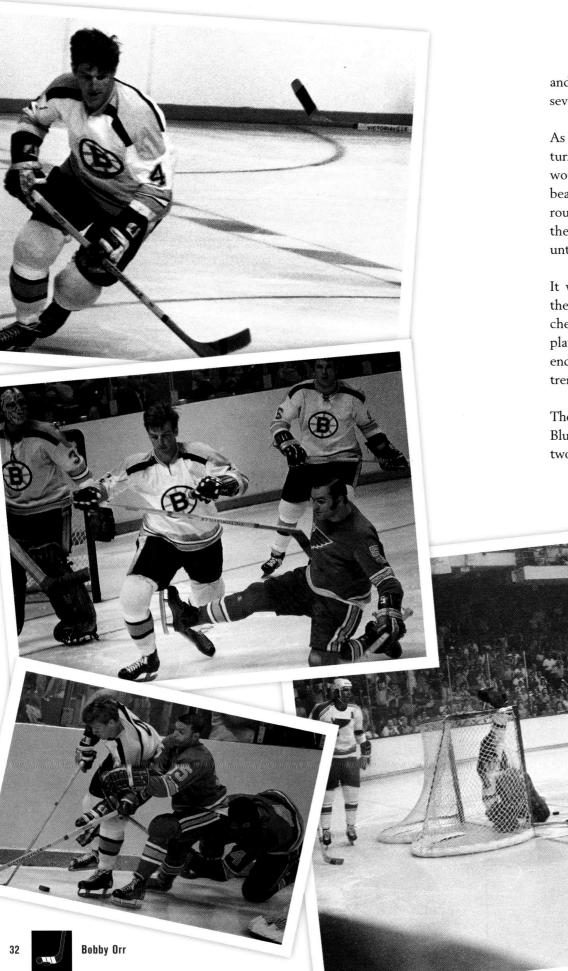

and recorded a previously unthinkable eighty-seven assists.

As good as he was during the regular season, Orr turned it up a notch during the playoffs. In what would prove to be their toughest series, Boston beat the New York Rangers 4 games to 2 in the first round. During the Bruins' four-game sweep of the Chicago Blackhawks, Orr skated virtually untouched, like vapor with a slapshot.

It wasn't a matter of respect. In the NHL, even the greatest stars are prone to receiving big body checks. But even Orr's opponents admired his playing ability. Orr dominated the series on both ends; the only thing close to his offense was his tremendous defense.

The Bruins were heavily favored against the St. Louis Blues in the Stanley Cup Finals. Boston took the first two games in St. Louis by scores of 6 to 1 and 6 to 2. St. Louis coach Scotty Bowman went with veteran goalie Glenn Hall in the third game, and, though the score was closer, Boston won again. They would go for the series sweep on Mother's Day.

The Bruins were determined to win the Stanley Cup on their home ice. On an unseasonably warm Sunday afternoon, the Boston Garden ice was practically steaming. Though the outcome of the series didn't seem to be in doubt, the Blues were determined to go down fighting.

Boston took a 1 to 0 lead, then fell behind 2 to 1. They trailed 3 to 2 in the third, then fought back to tie it. Regulation play ended deadlocked at 3.

Less than a minute later, Orr, Boston's famous jersey No. 4, scored one of the most famous goals in NHL history.

Thirty seconds into overtime, Orr slipped the puck away from the Blues' Larry Keenan, passed it to Sanderson in the corner, then broke in towards the net. Calling the game's final decisive seconds for CBS Television was Dan Kelly. "Sanderson tried a shot that was wide...Bobby Orr behind the net..." Sanderson waited and watched as Orr moved around a defender then centered the puck, "To Sanderson...to Orr!" Without hesitation, Orr onetimed it and blasted the puck through Glenn Hall's legs. "Bobby Orr scores! And the Boston Bruins have won the Stanley Cup!...Bobby Orr, their twentytwo-year-old sensation scores after forty seconds of overtime!" Boston Garden erupted in cheers.

Fittingly, hockey's greatest goal was captured in its greatest photo. Orr, tripped up as he crossed in front of the goal, appears to be really flying, arms outstretched in the classic Superman pose, a look of pure joy on his face.

It was Bobby Orr's moment, but even then, he showed his true greatness. "It wasn't me who scored the winning goal," he would say later. "It was the whole team. The credit belongs to all the boys I played with." (opposite page, left to right) Orr in action against Stanley Cup foes, the St. Louis Blues. ■ Orr is sent flying after his game-winning goal.

(below, left to right) Orr with the Stanley Cup ■ Boston Bruins enjoy a parade in their honor.

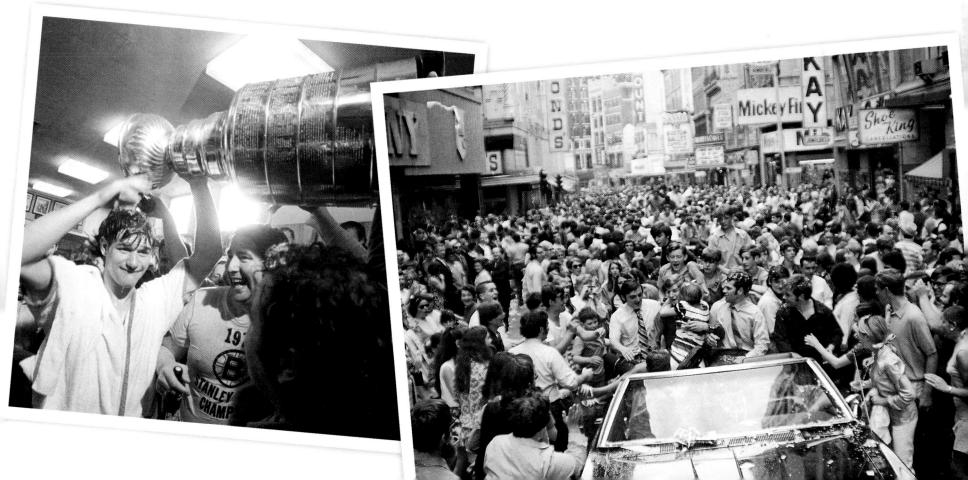

"It's good! The Saints have won!"

Al Wester

Tom Dempsey Kicks 63-Yard Field Goal

Records are made to be broken. But there is one National Football League record that statistically has been tied, but by its measure of determination in the face of adversity, it may never be duplicated.

Tom Dempsey was born with two birth defects that seemed to guarantee he would never make his mark as an athlete—a right foot that was only a stub and a deformed right hand. But Tom loved sports and grew big enough, at 6 feet 2 inches and 255 pounds, to excel athletically. He found his calling kicking footballs.

He skipped college and went straight into the NFL, where he made twenty-two of forty-one field goals and thirty-three of thirty-five extrapoint attempts in his rookie year kicking for the New Orleans Saints. The most memorable boot of Dempsey's career, however, came in just his second season with the Saints.

With just two seconds remaining, the Detroit Lions were leading the home team 17 to 16. Before a stunned crowd of over 66,000, Dempsey set up for an impossible sixty-three–yard field goal attempt.

Dempsey's specially designed right shoe hit the ball perfectly. After what seemed like an eternity in the air, the ball passed through the uprights and over the crossbar by only inches. Dempsey was standing so far back, he couldn't even see the ball on the final feet of its unprecedented flight. He didn't have to. He saw the referee's hands go up. He heard

the crowd. And he knew that he had made history. Jubilant announcer Al Wester began shouting, "It's good! The Saints have won! The Saints have won! The stadium is wild! Dempsey is being mobbed!...Dempsey with a sixty-three-yard field goal, the longest field goal in the history of the National League!"

Dempsey went on to play nine more years, finishing with a total of 159 field goals and 729 points. But nothing would ever surpass the achievement of that day in November, even the fact that Denver Broncos kicker Jason Elam

later tied Dempsey's record. "Tom Dempsey didn't kick that field goal," said Lions linebacker Wayne Walker, who was on the field that day. "God kicked it."

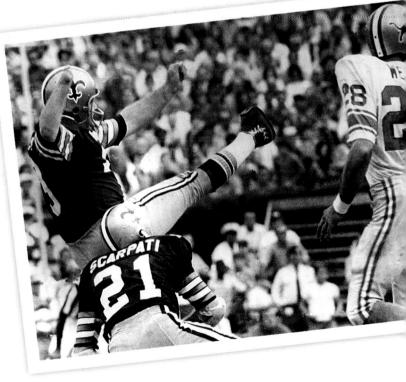

Dempsey kicks his sixtythree-yard field goal.

"Here it is. And...it...is...good!" Jay Randolph

1

January 17, 1971

Jim O'Brien Field Goal Wins Super Bowl

John Elway never did it. Nor did Terry Bradshaw. Nor did Joe Montana. In the long and glorious history of the Super Bowl, Jim O'Brien stands alone.

O'Brien is the only man to win a Super Bowl in the closing seconds of the game, yet many don't even remember him.

O'Brien was a rookie kicker with the Baltimore Colts in 1970–71, the season that concluded with his game-winning field goal over the Dallas Cowboys in Super Bowl V. He lasted only three more seasons in the National Football League, finishing his career with the Detroit Lions in 1973.

In 1970, with O'Brien successful on nineteen of thirty-four field-goal attempts in the regular season, the Colts compiled an 11–2–1 regular season record. In the playoffs, they shut out Cincinnati 17 to 0 and got past Oakland 27 to 17 to reach the Super Bowl at Miami's Orange Bowl.

The Cowboys, who were 10–4 in the regular season, went on to beat Detroit by the unlikely score of 5 to 0, and San Francisco 17 to 10 to qualify for football's big show.

While the Cowboys were thrilled to be in their first Super Bowl, the Colts knew all too well that getting to the Super Bowl wasn't the end of the journey. Two years earlier, the Colts swaggered into Super Bowl III as heavy favorites against the New York Jets, representatives of the supposedly inferior American Football League. In perhaps the greatest upset in Super Bowl history, Baltimore was beaten 16 to 7. This time, nothing short of a victory would do.

The Super Bowl is supposed to be the NFL's finest hour, but this game was a ragged affair with plenty of mistakes and weird bounces and caroms. In all, there were eleven turnovers in the game.

One of those blunders gave the Colts their first touchdown. Baltimore quarterback Johnny Unitas' pass went off the fingertips of receiver Eddie Hinton, then off the hands of Dallas defensive back Mel Renfro, before finally winding up in the hands of Colts tight end John Mackey. Mackey ran forty-five yards to the end zone to complete a seventy-five-yard scoring play. (clockwise from left) Rookie Jim O'Brien kicks the winning field goal. ■ Johnny Unitas loosens his arm before the Super Bowl. ■ Unitas on the ground after being injured during the game.

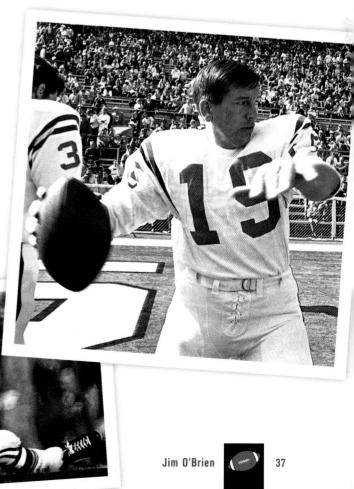

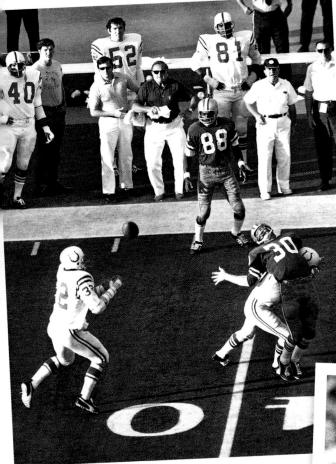

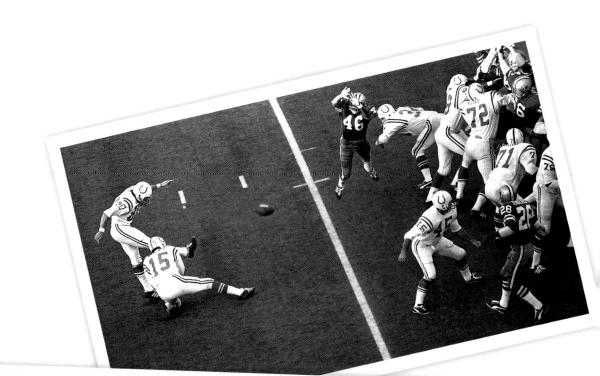

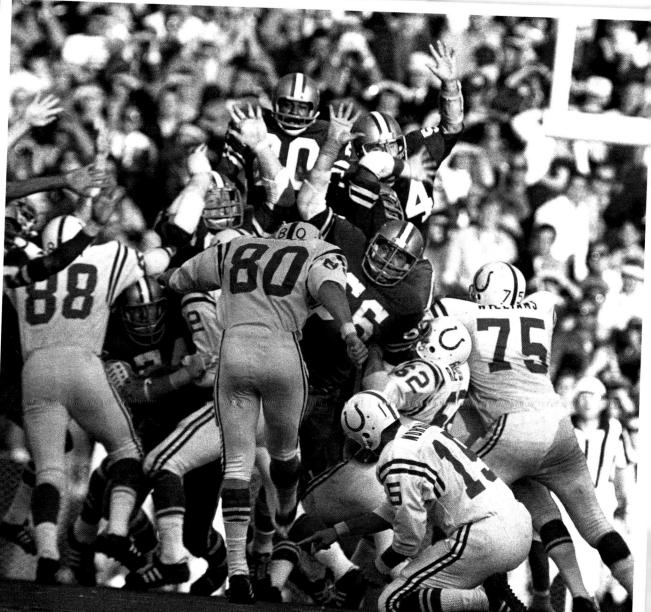

(clockwise from upper left) Mike Curtis (32) intercepts a Dallas pass to set up the winning kick. ■ Jim O'Brien (80) kicks and Earl Morrall (15) holds the gamewinning field goal attempt. ■ Dallas defenders leap to block O'Brien's kick.

 (opposite page, top to bottom) O'Brien celebrates after his successful kick. ■
 O'Brien gets a hug from quarterback Earl Morrull und other Colis. In the closing minutes with the game tied at 13, Baltimore linebacker Mike Curtis intercepted a Craig Morton pass at the Dallas forty-one-yard line and ran it back to the twenty-eight to give the Colts a chance for victory. Two running plays by Unitas' offense netted three yards.

There were nine seconds left in the game. Baltimore called a time-out and then sent out their field goal unit.

Now their chance for victory hung on rookie Jim O'Brien's right foot. All he had to do was kick a thirty-two-yard field goal with much of the world watching, and the Colts would have their first Super Bowl title.

"I knew he was nervous," said quarterback Earl Morrall, who would be O'Brien's holder, "when he reached down and tried to pull some grass out to test the wind. We were playing on artificial turf."

Sportscaster Jay Randolph was calling the game on NBC Radio, "And O'Brien, who had a very gutsy duel with Lou Michaels for the kicking job of the Baltimore Colts, is on. Six feet tall, a rookie, from the University of Cincinnati." The Cowboys were yelling across the line, telling the young rookie that he was going to choke. "Earl Morrall will hold from the thirty-two-yard line...nine seconds remaining, fourth quarter," Randolph continued. "All right, here we go." Center Tom Goode snapped the ball back, Morrall placed it firmly on the turf, and O'Brien stepped forward to take his place in football history. "Here it is. And...it...is...good!" Randolph shouted exuberantly.

In frustration, Dallas defensive tackle Bob Lilly pulled off his helmet, threw it in the air and let it crash to the ground, and the eighty thousand–plus in the Orange Bowl were on their feet.

As the ball took off on its memorable journey downfield, Morrall said he thought his heart had stopped beating. Baltimore linebacker Ted Hendricks turned away, unable to even watch. O'Brien boomed it. "It would have made it from fifty-two, fifty-three yards out," he said.

"It was automatic," he said. "My body and mind had done it enough times. I kicked the hell out of it."

O'Brien's kick sailed through the uprights with five seconds to play. After the ensuing kickoff, a desperate Morton pass failed, and the final score stood at Baltimore 16, Dallas 13. O'Brien leaped into the air and locked in an embrace with Morrall.

In one year, O'Brien had gone from college at Cincinnati to win-

ning the Super Bowl. But in just three years, O'Brien was out of football. He tried various jobs, from selling tools to selling beer. He tried coaching at the collegiate level. Finally, he wound up in the construction business and learned to put it all in perspective. "I don't want to say my whole life was 1.3 seconds," he said. "But 1.3 seconds is more than a lot of people get."

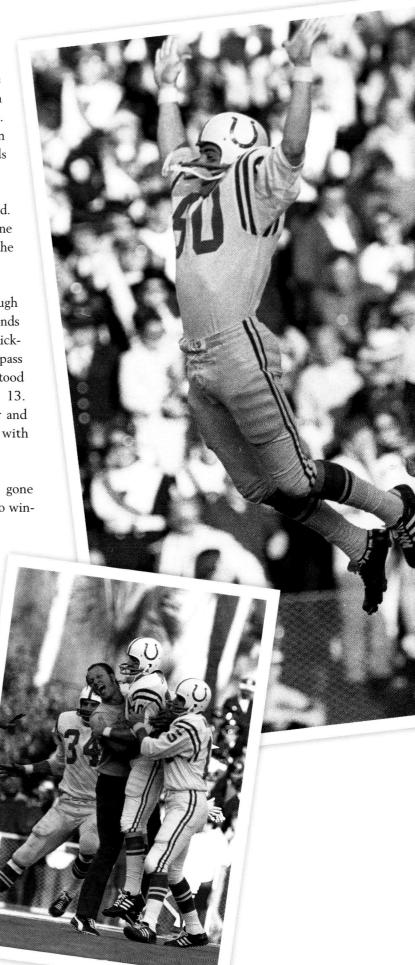

"Holy moly! Man, woman, and child,

did that put 'em in the aisle!"

R

Lyell Bremser

Oklahoma vs. Nebraska: College Football's Game of the Century

O klahoma and Nebraska banged helmets on the football field through most of the 20th century, often with the nation looking on. Their always fierce, never boring rivalry began in 1912, included seventy-eight meetings, and featured some of the most important games in the history of the two institutions.

As the sun set on the 1900s, the Oklahoma Sooners could boast of a slight edge, having won thirty-nine of the games, with thirty-six losses and three ties. The most memorable of the clashes was the 1971 match-up billed as "The Game of the Century."

Played on a cold Thanksgiving Day in Norman, Oklahoma, it matched No. 1–ranked Nebraska against No. 2–ranked Oklahoma. It matched Nebraska tailback Jeff Kinney, "Kinney the Killer," against Oklahoma quarterback Jack Mildren, "Mildren the Magician."

The stakes were high—the winner gained a Big Eight title and a chance to play Alabama in the Orange Bowl for the national championship. Any doubts the 61,826 fans in attendance, or the national viewing audience of approximately eighty million, had that this game would be worthy of the high expectations disappeared quickly when Nebraska's future Heisman Trophy winner Johnny Rodgers opened the scoring with a seventytwo–yard punt return. Nebraska's announcer Lyell Bremser immortalized Rodgers' incredible run on radio over KFAB, Omaha. "The ball is down at the thirty-eight and Oklahoma will have to kick. Joe Wiley stands at his own twenty-four, waits for the snap. Rodgers deep for Nebraska...here's Wiley's kick, it's high...it holds up there. Rodgers takes the ball at the thirty...he's hit and got away...back upfield to the thirty-five...to the forty...he's to the fortyfive." Rodgers broke free at midfield, and Bremser counted down the yards. "To the twenty...to the ten...he's all the way home!"

Nebraska fans cheered wildly and tossed oranges onto the field. "Holy moly! Man, woman, and child, did that put 'em in the aisle! Johnny the Jet Rodgers just tore them loose from their shoes!" cried Bremser.

But neither side was going to be able to run away with this one. Oklahoma was guilty of three fumbles, two of which the Cornhuskers turned into touchdown-scoring drives. Twice Oklahoma fell behind by eleven points and twice the Sooners came back to take the lead.

With Nebraska trailing 17 to 14 at the half, coach Bob Devaney made a key decision. Although he had the kind of offensive line that could open gaping holes, and the kind of back in Kinney who could blast through those holes, Devaney instead

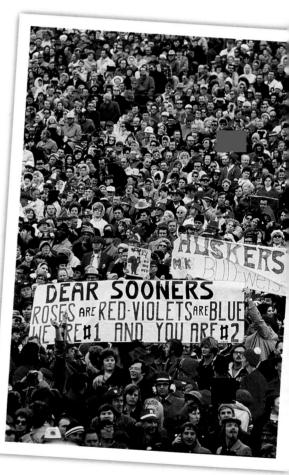

(left to right) Nebraska's Johnny Rodgers scores on a seventy-two-yard punt return. ■ Nebraska fans at the highly anticipated game

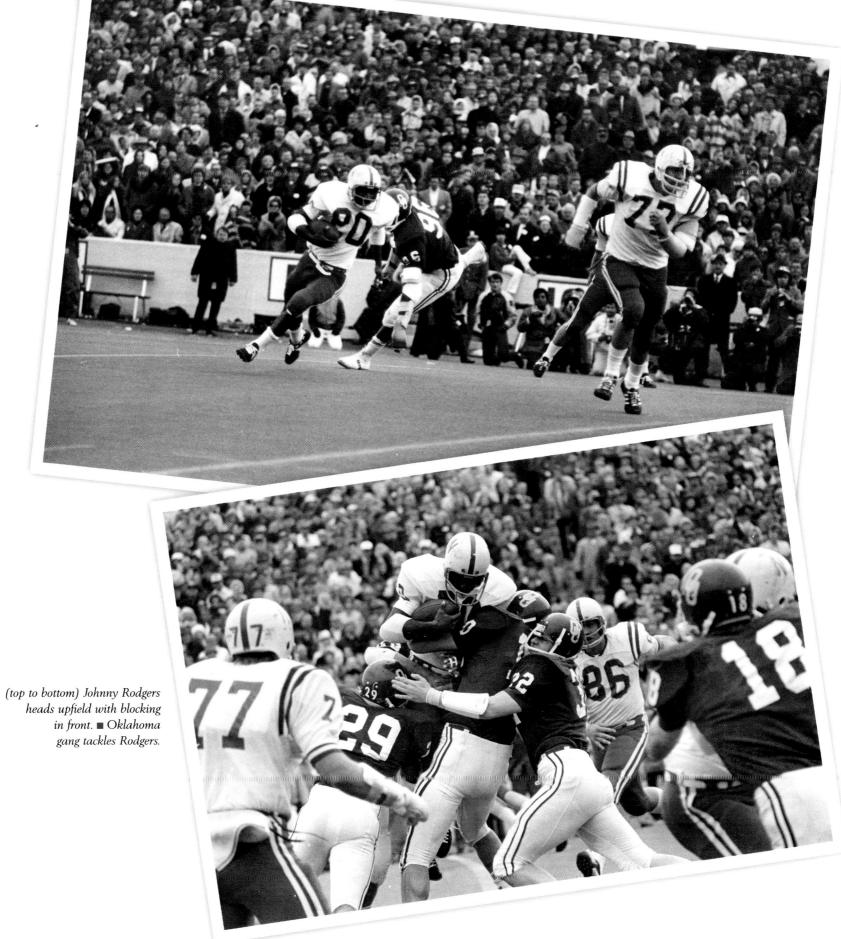

tried to attack on the outside in the first half. Nebraska did not make the same mistake twice.

The Cornhuskers found themselves trailing 31 to 28 with 7:10 to play. Kinney had already scored three touchdowns, on short bursts from one, three, and again one yard out. But Nebraska needed him to do it one more time.

Starting at their own twenty-six-yard line, the Cornhuskers, efficient and determined, moved down the field. When they came down to a thirdand-eight at the Oklahoma forty-six, quarterback Jerry Tagge connected with Rodgers for eleven yards. Kinney went up the middle for thirteen yards. Rodgers took an inside reverse for seven more.

And finally, with the game down to its final minutes and the Cornhuskers closing in on the Oklahoma end zone, the Nebraska strategy was simple, obvious, and, as it turned out, the perfect option: give it to Kinney.

On his fourth consecutive carry, Kinney smashed across the goal line with 1:38 to play, putting the score at Nebraska 35, Oklahoma 31.

Kinney's fourth touchdown upped his rushing total to 171 yards. He was at his best on that final drive. Involved in seven of the twelve plays, Kinney accounted for fifty of the seventy-four yards.

Though he lost, Oklahoma's Mildren could at least boast of numbers equal to those of Kinney, accounting for four touchdowns himself—throwing for two, and running for two others. In all, Mildren generated 467 yards of total offense. But it wasn't enough to stop Nebraska from winning its 30th straight game on its way to a national championship, its second in a row.

When President Richard Nixon called to congratulate Devaney after the victory over Oklahoma, the Nebraska coach told him, "They sold a lot of popcorn today. Nobody left."

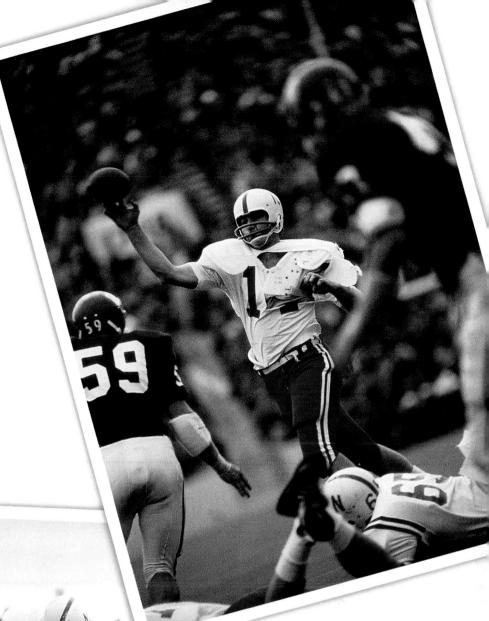

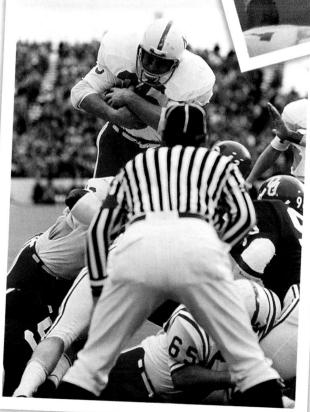

(top to bottom)
Nebraska quarterback
Jerry Tagge tosses a pass.
Nebraska's Jeff Kinney
dives into the line.

****** They score! Henderson has scored for Canada!*****

Foster Hewitt

NADA

September 28, 1972

Paul Henderson Goal Wins Summit Series

A lthough not a military superpower, Canada always has been a hockey power. And in the 1972 Summit Series versus the Soviet Union, the Canadians set out to prove that they still reigned on ice, in every arena from Montreal to Moscow. Who cared about capitalism and Communism? This was the Cold War on ice.

At the time, the National Hockey League was dominated by Canadian players, the arriving wave of talented Europeans just under a decade away. Canadian fans believed deeply, some would say religiously, that their players were the best in the world. Whatever wins the Russians had racked up in the Olympics and international competition had come at the expense of amateurs thrown together while the NHL was in season, while the Soviet "pros" skated together all year long.

The Summit Series was different. Team Canada was an All-Star squad, but these stars were the elite of the NHL: the Bobbys, Orr and Clarke; Yvan Cournoyer and Serge Savard; Stan Mikita and Ken Dryden; the brothers Frank and Pete Mahovlich; the brothers Phil and Tony Esposito; and Paul Henderson.

The eight-game Summit Series opened in the legendary Montreal Forum on September 2. Phil Esposito beat Russian goalie Vladislav Tretiak for the series' first goal just thirty seconds into the first period. Six minutes later, Henderson banged home another for a 2 to 0 Canadian lead. If Team Canada wasn't overconfident before the opening face-off, they were now. But the Soviets tied the game by the end of the first twenty minutes. Before the night was over, they put five more past Canada goalie Ken Dryden for a shocking 7 to 3 win.

Two nights later, in Toronto, Canada evened the series, winning 4 to 1, with a bit of brotherly love. Both Mahovlichs scored a goal, as did Phil

Esposito. Tending the nets, Tony Esposito turned away twenty of twenty-one shots. Game 3, a 4 to 4 tie in Winnipeg, kept the series even.

The two teams then traveled to Vancouver for the last series game to be played in Canada. Dryden continued to struggle and the home team lost 5 to 3. When the Canadian fans booed their boys off the ice, Phil Esposito responded with an angry television tirade. The speech was a turning point that seemed to galvanize Canada—team and fans alike. (left to right) Paul Henderson scores the winning goal for Team Canada in the final game of the Summit Series.
Peter Mahovlich (20) of Team Canada slips the puck past Russian goalie Vladislav Tretiak to score Canada's third goal of Game 2. Canada won 4 to 1.

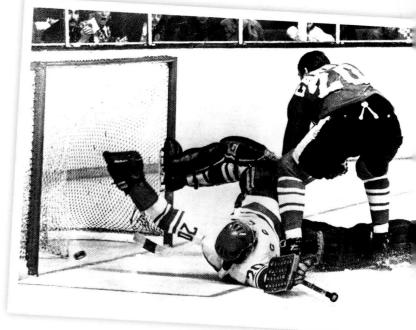

45

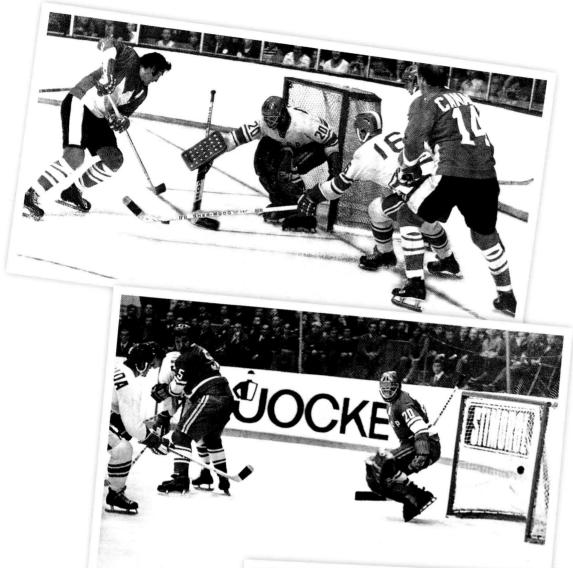

But the two weeks off between games hurt Canada when the Summit Series continued in Moscow. They lost Game 5 by a score of 5 to 3. At 3-1-1, the Soviet squad needed just one win to claim ice supremacy.

All the scoring in Game 6 came in the second period. Paul Henderson's goal at 6:36 gave his side a 3 to 1 lead and Dryden held off the Soviet offense for a 3 to 2 win. The game was marred by some questionable calls by a Russian referee who would not tolerate the more physical style of North American hockey. Playing a man down much of the

game, the Canadians relied on some excellent penalty killing to preserve the victory.

Still facing series defeat, Team Canada brought some momentum onto the Moscow ice for the seventh game. Phil Esposito, easily the best player for either team throughout the tournament, continued his torrid pace, scoring twice in the first period. Rod Gilbert added another to open the third period, giving Canada a 3 to 2 lead. But Alexander Yakushev shot one past Tony Esposito three minutes later, and the two teams skated even for most of the period.

> Even, that is, until Henderson skated in and around two defenders, then lifted the puck over Tretiak and just below the crossbar for his second straight game-winning goal.

The day of the Summit Series final became almost a holiday in Canada, as millions of people otayed home to watch or listen to the game broadcast from Moscow. Prior to the face-off, the Soviets pulled a bit of Cold War brinksmanship that infuriated Team Canada. The scheduled referee literally disappeared and was replaced by the

(top to bottom) Phil Esposito
(left) scores Canada's first goal in Game 2 against Tretiak.
Team Canada forward Paul Henderson (left) beats Tretiak.
Canadian fans proudly cheer on their team.

46

Game 6 official who harbored the disdain for the physical Canadian style. Sure enough, the parade to the penalty box began and before the game was over, the Russians scored three power play goals.

The third period began with the score 5 to 3 in favor of the Soviets. Phil Esposito scored in the third minute to get Canada close. The tying goal by Yvan Cournoyer only heightened the tension on and off the ice. The Russian goal judge failed to acknowledge the score immediately and the scene ended with a Canadian team official being detained by Soviet soldiers. Canadian players rescued him, scuffled with the militia, and then escorted the

official to their bench for protection. The goal stood and the Canadians went on the hunt, while the Soviets tried to just hang on. A tie would still give the Soviets a series victory on goals scored.

With thirty-four seconds left, Paul Henderson came off a quick rest and replaced Pete Mahovlich. Then Henderson moved in for one final advance on Tretiak. Canada's premier play-by-play hockey broadcaster Foster Hewitt picked up the call for the Canadian Broadcasting Corporation. "Liapkin rolled one to Savard... Savard cleared the pass to Stapleton....He cleared to the open wing to Cournoyer...Cournoyer took a shot... the defenseman fell over, Liapkin...Cournoyer has it on that wing. Here's a shot! Henderson made a wild stab for it and fell. Here's another shot! Right in front. They score! Henderson has scored for Canada! Henderson right in front of the net. And the fans at the game are going wild!"

The Canadians won the deciding game of the showdown series. Paul Henderson became a national hero. And all of Canada exhaled, its supremacy on ice secure.

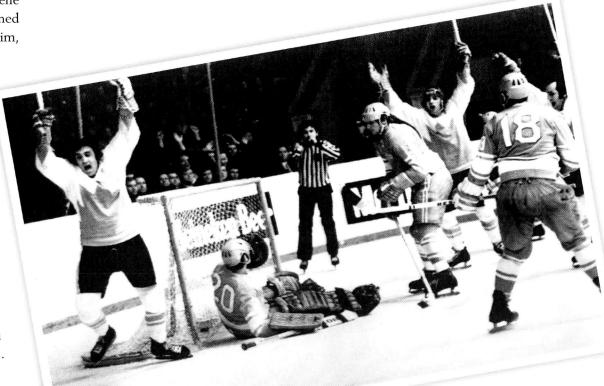

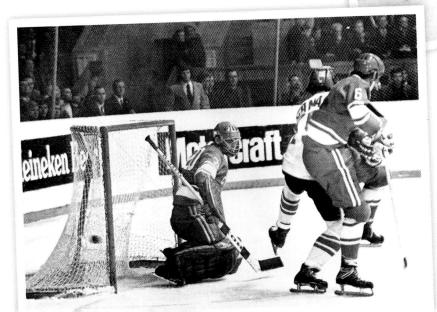

(top to bottom) Team Canada's Phil Esposito, left, raises his arms in celebration after scoring in the final game of the Summit Series.
Team Canada's Paul Henderson is surrounded by Russian players following Bill White's goal in the second period of the final game.

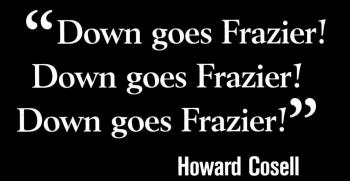

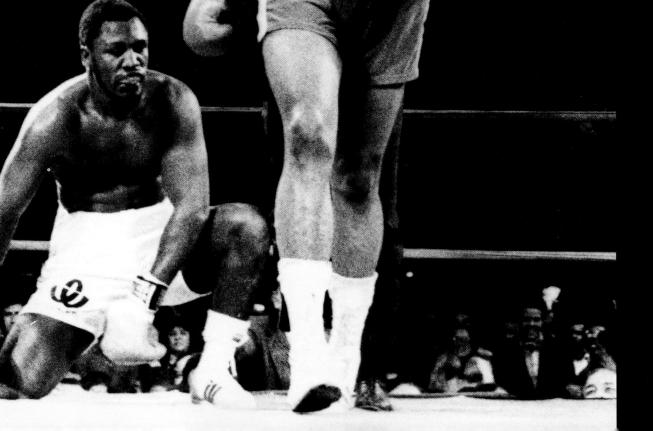

Disc 1 • Track 14

January 22, 1973

Down Goes Frazier!: George Foreman Beats Joe Frazier

ad Smokin' Joe Frazier been reduced to just smoke and mirrors? That was the question being asked when the world's heavyweight champion arrived in Kingston, Jamaica, to defend his crown against George Foreman, the rising young force in the division.

Just two years earlier, Frazier had been the toast of the boxing world when he had won a brutal fifteenround decision over Muhammad Ali in a battle of two undefeated fighters that was justifiably billed as the Fight of the Century. But even in victory, Frazier looked like a beaten man. He was taken to a hospital after the fight and remained there a week.

In his two ensuing fights, against Ron Stander and Terry Daniels, Joe Frazier, though victorious, did not look as devastating as he had in the past. Still, he scoffed at those who questioned whether, at age twenty-nine, he had enough left to hold off the twenty-four-year-old Foreman, whose right hand was rapidly becoming the most feared weapon in the heavyweight division. "Down through the years, I been foolin' them all," Frazier said. "They buried me, cremated me, put me back in the ground."

Joe Frazier entered the ring that night with a record of 29–0 with twenty-five knockouts. Foreman's record was 37–0 with thirty-four knockouts. Both men also owned Olympic gold medals in the heavyweight

division, Frazier's earned in the 1964 Games, Foreman's in 1968. Oddsmakers were not discouraged by speculation that Frazier was past his prime, making him a 5–1 favorite. But some experts, including sportscaster Howard Cosell, on hand in Jamaica for the blow-by-blow description, were picking Foreman.

But nobody could have envisioned what happened once the opening bell rang. It became immediately obvious that Foreman's advantages in height (6 feet 3 inches to Frazier's 5 feet 11.5 inches) and

reach (78.5 inches to Frazier's 73.5 inches) were going to be critical factors. So was Foreman's mindset. Many fighters had been intimidated by Frazier's straight ahead, not-to-be-denied style. His nickname, "Smokin'," came from his tendency to burrow into an opponent and keep smoking until his foe had been consumed. But Foreman knew all about intimidating tactics. This wasn't the jovial, popular salesman and television personality of his later years. This was an angry young man off the mean streets of Houston, Texas, who could fix an

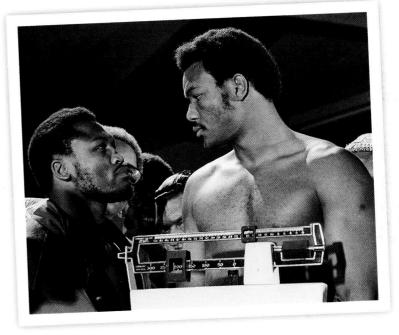

(left to right) The referee stops the fight as challenger George Foreman walks away from a defeated Joe Frazier.
World heavyweight champion Joe Frazier (left) and challenger George Foreman weigh in.

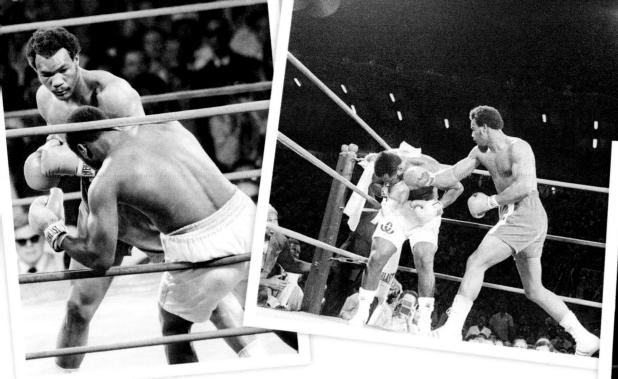

Foreman knocked Frazier down six times in under two rounds.

evil glare on his opponent. And he fixed it on Frazier, both at the weigh-in and during the pre-fight instructions. Frazier had tried to get to Foreman by telling him, "I'm gonna sit you on the ground, George." But he got no reaction from Foreman, who was saving his reply for the ring.

Frazier came out fast, landing the first punch. He hit Foreman on the chin with a left hook, his trademark shot. There was no reaction from Foreman. Right then, Frazier knew he was in trouble. And he quickly found out how much. A Foreman combination rattled Frazier, and a right uppercut put the champion down.

And at that instant, Cosell forever immortalized this bout with three words, uttered in a screaming fashion three times in a row: "Down goes Frazier! Down goes Frazier! Down goes Frazier!" Many say it was Cosell's finest moment. It was certainly one of Foreman's as well.

Frazier got up immediately from the knockdown only to be put down a second and third time before the first round mercifully ended. Each time, it was a Foreman right hand that did the damage. It was

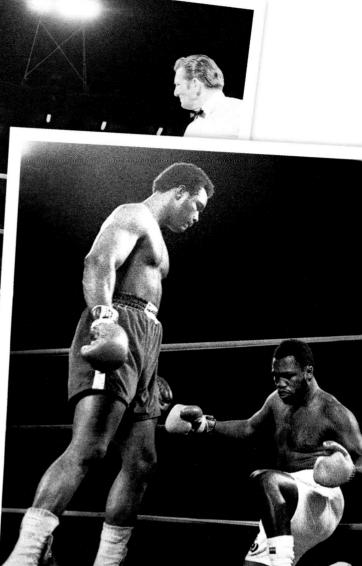

shocking to watch Frazier, the man who had withstood the best Ali had to offer over fifteen rounds, find himself unable to stay on his feet against this young challenger. Defensively, Foreman was using his tall frame and long arms to keep Frazier from getting inside and doing any damage of his own.

Thirty seconds into Round 2, Frazier went down again from a Foreman right hand. "It's target practice for George Foreman," yelled Cosell. Twice more Frazier went down, six times in all after having been down only twice previously in his entire professional career. Finally, after the sixth knockdown, referee Arthur Mercante signaled that Frazier had had enough. The bout was stopped at the 1:35 mark of Round 2. A crowd of thirty-six thousand in Jamaica's National Stadium had seen the world's heavyweight championship dramatically change hands. "On the first right to the body I landed," Foreman said, "I saw him wince and I knew I was going to win."

Frazier could only shake his head at the beating he had taken. "I knew George Foreman was big and strong," Frazier said, "but I didn't realize he was that strong."

Both Foreman and Frazier would go on to experience crushing losses to Muhammad Ali. George Foreman lost to Ali in Zaire, Africa, in the 1974 "Rumble in the Jungle." Joe Frazier was beaten in 1974 in New York, and in 1975 in the Philippines fight labeled the "Thrilla in Manila." Still, as great as those fights were, the Jamaica battle would long be remembered after the particular blows had been forgotten thanks to Cosell's "Down goes Frazier!" Foreman and Frazier fought each other again in 1976, Foreman winning again, this time on a fifth-round knockout.

Joe Frazier retired from boxing for good in March 1981. George Foreman, after a ten-year absence from the ring, again shocked the world by knocking out Michael Moorer in 1994 to regain the heavyweight championship at age forty-five, becoming the oldest man to ever win any boxing title.

(top to bottom) Foreman celebrates after winning the heavyweight title. ■ Joe Frazier falls back during the second round. ■ Foreman stands over Frazier.

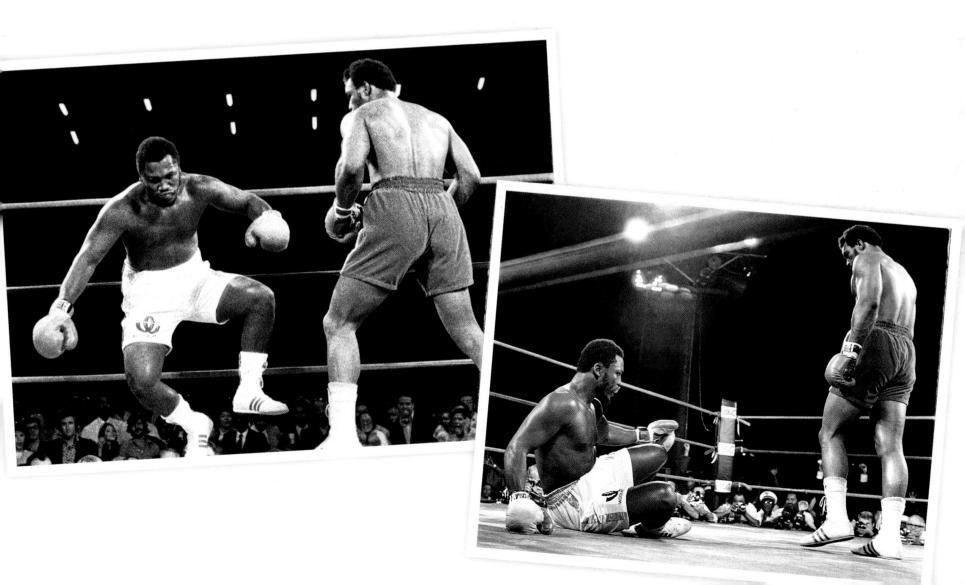

"Two thousand yards, he's done it!…Two thousand for O.J., wow!"

Marty Glickman

O.J. Simpson Tops 2,000 Yards

Following the tragic events of June 12, 1994, O.J. Simpson's life would never be the same. But in the years prior, O.J. Simpson was an American hero. Football fans thrilled to his flashy running style, applauded his ability to leave would-be tacklers grasping at thin air, and admired the way he seemed to float through his pro career with a perpetual smile, despite being stuck on a mediocre team in Buffalo.

Simpson had won over many of his fans before he ever put on a Bills uniform. They remembered his career in cardinal and gold at the University of Southern California. They remembered November 18, 1967, the day Simpson's legs carried him to one of the greatest runs in Trojan history. The scene was the Los Angeles Memorial Coliseum. The opponent was crosstown rival UCLA. With a shot at a national title at stake, Simpson raced sixty-four yards in the fourth quarter on a dizzying, dazzling run through the Bruins secondary for the winning points in a 21 to 20 Trojan victory.

Simpson went on to win the Heisman Trophy the following season before becoming the No. 1 draft pick of the Bills in 1969. Buffalo had earned the right to select Simpson by going 1–12–1 the previous season.

It was tough on Simpson going from the bright sunshine and the powerful offensive line of the winning USC program to the bleak weather of Buffalo and the still bleaker prospects of the Bills. His pro career didn't blossom right away. He didn't crack the one thousand–yard mark until his fourth season in Buffalo, when he gained 1,251 yards.

Then came the 1973 season. The Bills had put together a dominating offensive line, nicknamed the Electric Company, led by guard Reggie McKenzie,

who had become Simpson's best friend on the team. The nickname for the line came from Simpson shortening his own name from Orenthal James to O.J., thus the nickname "The Juice." And since the line supplied power to The Juice, it became the Electric Company. It also became, in Simpson's mind, a force that could lead him into new territory. In the spring of 1973, he told McKenzie, "I'm going after seventeen hundred yards this year." McKenzie responded, "Make it two thousand."

The record at that time was 1,863 yards held by Jim Brown, considered by many to be the greatest running back ever.

(left to right) O.J. Simpson celebrates his record. ■ Simpson gains ground as a collegiate star at USC.

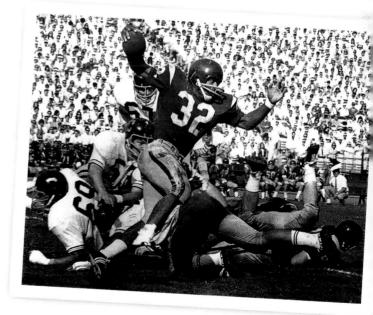

McKenzie's goal of two thousand yards seemed no more than a pipe dream at first. But Simpson quickly turned doubters into believers. He gained 250 yards on opening day against the New England (top to bottom) Simpson breaks through the New York Jets line. ■ Simpson rushes across a snowy field at Shea Stadium.

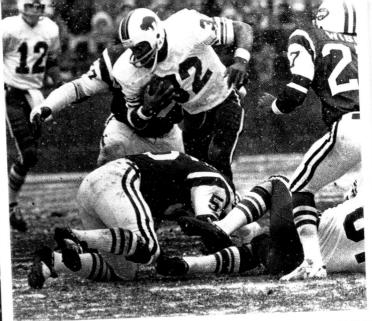

Patriots and never looked back, gaining more than one hundred yards in six of his first seven games.

The Bills only played fourteen regular season games that season. With two remaining, Simpson had 1,584 yards, 279 short of Brown's mark and 416 short of his goal.

In Simpson's 13th game, the opponent was once again the Patriots. And again, Simpson exceeded two hundred yards, gaining 219 on twenty-two carries for an incredible ten-yards-per-carry average. That left him needing just sixty-one yards to pass Brown and 197 to reach two thousand heading into the final game.

The game against the New York Jets in Shea Stadium was played in a snowstorm, but nothing would stop the determined Simpson that day. On his eighth carry of the day, Simpson surpassed Brown's record. By halftime, Simpson had 108 yards, and by the end of the third quarter, his total stood at 147.

The Bills were on their way to a 34 to 14 victory, but the only statistic people seemed to care about was Simpson's rushing total. "They just kept phoning downstairs from the press box so we knew just how much he needed," McKenzie said.

Soon, there was no need to phone, the math was simple. There was a little over six and one-half

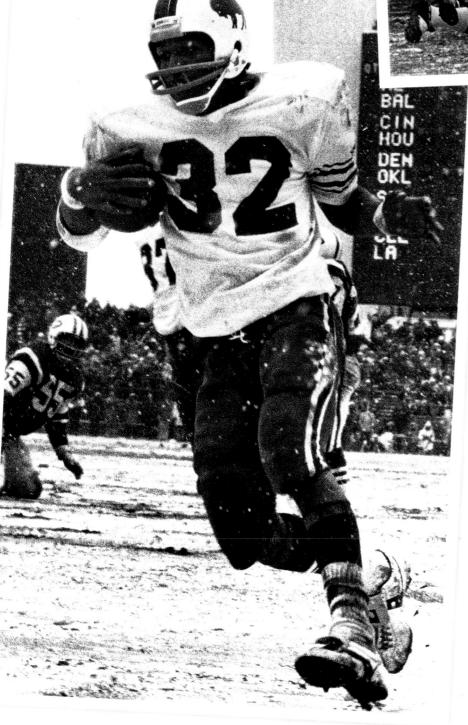

minutes left in the game and a scant four yards separating Simpson from the unthinkable two thousand-yard mark.

Simpson took a handoff, followed McKenzie, and burst through the line for seven yards before the Jets dragged him down to the frozen ground. Everyone was counting off O.J.'s yardage: the players, the fans, and the Jets announcer, Marty Glickman, "Unofficially, our totals show that he's right about the two thousand–yard mark right now. He went from the twenty-yard line then to the fourteen-yard line, six yards on the play." Moments later it was official, "Two thousand yards, he's done it!... Two thousand for O.J., wow! We saw history made!" proclaimed Glickman. "Everybody might as well go home from here 'cause the rest is anticlimactic."

As Simpson got to his feet, he was lifted onto the shoulders of his teammates in celebration of having reached a much higher peak, one that once seemed unimaginable. On 332 carries, averaging six yards a carry, Simpson had gained 2,003 yards in fourteen games.

O.J. Simpson held the record for more than ten years. But by the end of the century, O.J.'s was the fourth-highest single-season total, having been surpassed by Eric Dickerson of the Rams in 1984 (2,105 yards), Barry Sanders of the Lions in 1997 (2,053), and Terrell Davis of the Broncos in 1998 (2,008).

The record, of course, became the least of Simpson's concerns. Despite his acquittal in criminal court, the killings of Simpson's former wife, Nicole Brown Simpson, and her friend Ron Goldman on June 12, 1994, would forever brand Simpson a double murderer in the minds of many. It was a long, dark plunge from that brief shining moment on a snowy day in New York when O.J. Simpson ran to the top of the football world.

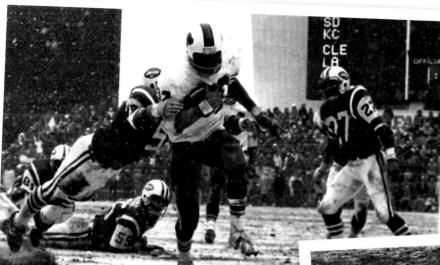

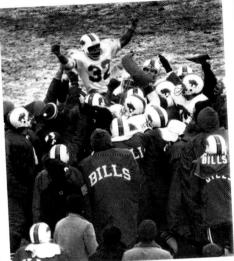

(top to bottom) Simpson breaks tackles en route to a touchdown during his record-breaking game.
■ Bills teammates hoist Simpson onto their shoulders. ■ Simpson closed his career with the San Francisco 49ers.

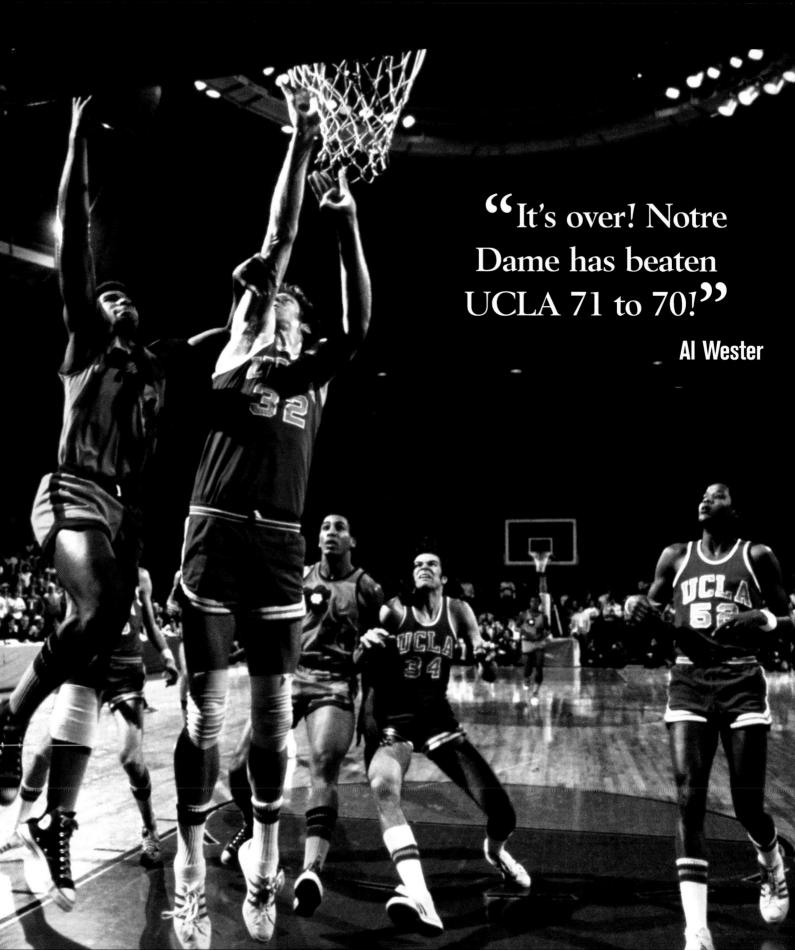

January 19, 1974

Notre Dame Ends UCLA's Winning Streak at 88

Perhaps it's fitting that the greatest college basketball coach of all time had his roots in the basketball state of Indiana, where it's said that basketball is more than a game, it's a religion. John Wooden led his Martinsville, Indiana, high school team to the prestigious state championship. He then went to college at Purdue University, where he was a three-time all-American, and college player of the year in 1932. Had there been an NBA, he very well could have turned pro. Instead, he chose a career as an English teacher and basketball coach, and the rest, as they say, is history.

Wooden was a successful basketball coach at Indiana State University in 1948 when UCLA, a school with little basketball tradition, decided to upgrade its program. With poor athletic facilities and an old intramural gym as its home court, Wooden began building UCLA's basketball program. He went 22-7 his first year with the Bruins and followed that with a 24-7 season. The Bruins were on their way, but it took time before UCLA would win its first of ten national championships under Wooden. That came in 1964 when UCLA, with star Walt Hazzard, went a perfect 30-0 to win the NCAA title without a player over 6 feet 5 inches tall. With Gail Goodrich leading the way, UCLA won the NCAA title again in 1965. The Bruins probably would have won in 1966, but at that time, freshmen were ineligible to play on the varsity

team. UCLA that year had a freshman basketball phenom named Lew Alcindor. When Alcindor, who later changed his named to Kareem Abdul-Jabbar, became eligible, UCLA won three straight NCAA championships.

Most of the college basketball world thought that when Alcindor graduated, UCLA's program would take a dip. But Wooden and UCLA won two more NCAA titles, this time without a super center, but with a solid front line of Steve Patterson, Curtis

Rowe, and Sidney Wicks. With those three graduating in 1971, it was thought that the UCLA dynasty might end, but it didn't.

UCLA greeted another heralded center named Bill Walton, and the Bruins won two more NCAA titles. Wooden had won titles with small teams running a high post offense, and he won titles with dominating centers with low post offenses. He won with whatever talent he had.

Although UCLA lost to Notre Dame 89 to 82 on January 23,

1971, the Bruins would go almost three years without losing another game. The eighty-eight consecutive

(left to right) Notre Dame and UCLA battle at the hoop.
John Wooden coaches his team in the closing seconds.

victories smashed the previous Division I record of sixty straight by San Francisco. UCLA's record run without a loss was accomplished by the "Walton Gang," the nickname for the teams that featured Bill Walton at center.

> UCLA went up against Notre Dame again on January 19, 1974, and led 70 to 59 with three minutes, thirty-two seconds remaining in the game. With a comfortable eleven-point lead, it looked like UCLA would push its winning streak to eighty-nine games.

> > "Well, they're calling it a 'shoot out at South Bend' and that's

what we're getting," said Van Patrick, who was providing the color commentary to Al Wester's playby-play over the Mutual Broadcasting Network. But, UCLA didn't score a single point after that. Notre Dame made a miraculous comeback, scoring twelve points in the closing minutes, the final two points coming on a jumper from the corner by Dwight Clay. "It is good! It is good!...Notre Dame leads UCLA 71 to 70 with twenty-one seconds left!" shouted Al Wester. "UCLA calls time-out." Wester, hoping he could still be heard above the cheering crowd, cried, "This crowd has gone completely berserk! It looked like UCLA would coast in with a victory. They had an eleven-point lead with only three minutes to go in the ballgame, and now it's 71 to 70. We've got twenty-one seconds of playing time remaining and UCLA called a time-out."

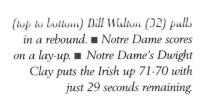

"There's nobody sitting in this stadium, they're all standing. We've got a cliff-hanger at South Bend," shouted Wester, still trying to be heard above the crowd. The Bruins worked the ball in to Walton who took a shot with six seconds left. It missed. Frantically, Bruins forward Dave Meyers tipped it and missed. Guard Pete Trgovich tipped it, it missed. Meyers tipped it again. Finally, Notre Dame's John Shumate grabbed the rebound as time ran out on the Bruins and their streak.

"It's over! Notre Dame has beaten UCLA 71 to 70! And this court is coming apart. You have never seen such bedlam as we've got here in South Bend! They have completely taken over the playing court!" Wester screamed, fighting to be heard above the celebrating. UCLA was no longer invincible. In fact, the Bruins later lost two conference games to Oregon and Oregon State—and lost to North Carolina State in the NCAA Tournament, ending their streak of seven straight NCAA titles.

Bill Walton graduated from UCLA, as did star forward Keith Wilkes and two other starters from the 1974 team. Wooden had to rebuild again, but just as he did after Alcindor left, Wooden got the Bruins into the NCAA Tournament in 1975. After a 75 to 74 overtime win against Louisville in the semifinal game, Wooden announced to his team he would retire following the championship game. His players sent him out a winner, beating Kentucky 92 to 85.

Fittingly, John Wooden won a tenth NCAA championship in his final game as head coach at UCLA. The Wooden/UCLA numbers were staggering: four 30–0 seasons; two 28–2 seasons; ten NCAA titles in twelve years, including seven in a row. Thirty-eight straight NCAA Tournament wins, and a perfect 10–0 record in NCAA championship games. Wooden later said, "If anyone had told me we'd win ten championships in twelve years, I'd have said it was impossible. I never thought a team could dominate as we did. But the fact it happened means it could happen again."

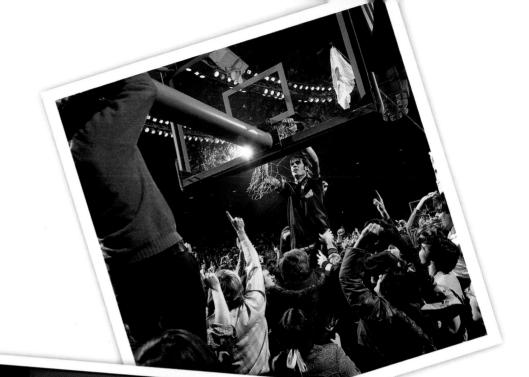

(top to bottom) Victorious Notre Dame cuts down the net. ■ UCLA's Dave Meyers misses a desperate last-second tip-in.

** It's good! And it goes into another overtime! ***

Johnny Most

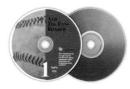

June 4, 1976

Boston Celtics Beat Phoenix Suns in Triple OT

There have been games that were more momentous in the NBA Finals, more historic, more significant. But few, if any, could match Game 5 of the 1976 championship series in terms of sustained drama, extended excitement, and the sheer multitude of memorable moments.

The match-up of the Boston Celtics and Phoenix Suns for the NBA title hadn't exactly been greeted with enthusiasm by advertisers or television executives. A small market like Phoenix can be a tough sell to a national audience, especially considering that the Suns hadn't even won their own division in the regular season.

Phoenix finished third in the Pacific Division, behind both the Golden State Warriors and Seattle SuperSonics, with a mediocre 42–40 record. But in the playoffs, Phoenix beat Seattle in six games in their best-of-seven series, and then squeaked by Golden State, winning the seventh game 94 to 86.

Boston, on the other hand, dominated the Atlantic Division with a record of 54–28 and then got by both the Buffalo Braves and Cleveland Cavaliers in series that each lasted six games.

The Celtics had a star-driven offense led by Dave Cowens, John Havlicek, Paul Silas, and JoJo White. On the scorer's sheet, the Suns, led by Paul Westphal and Alvan Adams, were clearly at a disadvantage. Despite their underdog status, the Suns had scratched and clawed their way to the Finals, and they were not about to go meekly.

When the Celtics won the first two games in Boston by scores of 98 to 87 and 105 to 90, fears that this series would be an uncompetitive, quick rout were reinforced. But once back in Phoenix, the Suns allayed those fears by winning the next two games 105 to 98 and 109 to 107.

Game 5 became pivotal. Back in the comfort zone of their parquet floor, the Celtics were

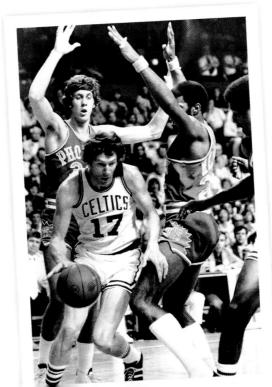

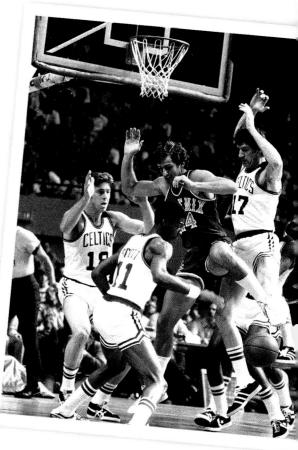

(clockwise from left) John Havlicek puts the Celtics up by one as the clock nearly runs out. ■ Battling for the rebound, Boston's Dave Cowens (left), Charlie Scott (11), and John Havlicek team up on Paul Westphal of the Phoenix Suns.
■ Havlicek dribbles away from the Phoenix Suns' defense.

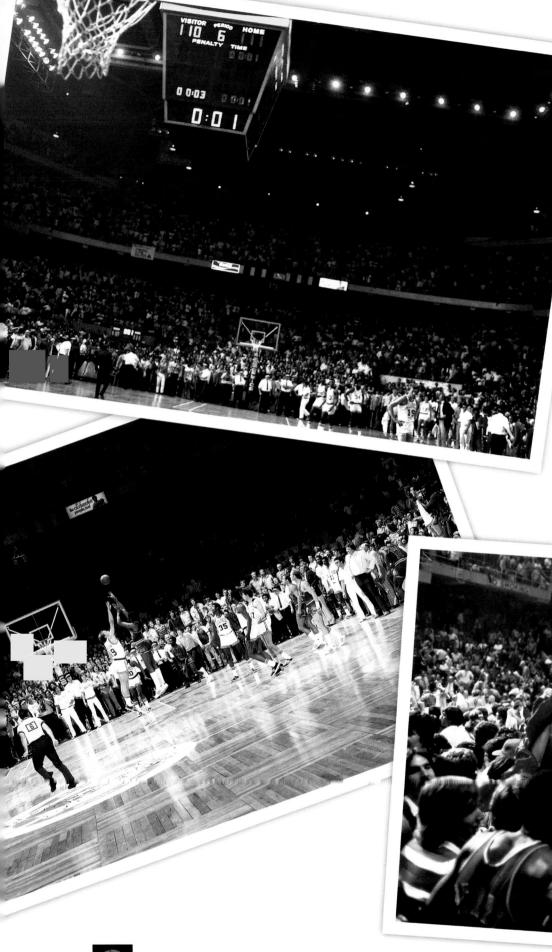

determined to regain control of the series. A Phoenix victory would allow the Suns to go back home for Game 6 with a good chance to win the title.

Supported by a loud and demanding crowd of 15,320 at Boston Garden, the Celtics raced to a twenty-two–point second-quarter lead. But, as they would learn all too well, this was the night the Suns refused to die.

Phoenix rallied to tie the game in the third quarter, only to fall behind again. In the fourth quarter, Westphal led a surge that finally pushed the Suns into the lead with only twenty-two seconds to play. Suddenly, it was the Celtics who were frustrated and looking at potential disaster.

A Havlicek free throw averted that disaster, sending the game into overtime.

Boston had been outscored 50–34 in the second half, but, in overtime, the Celtics again took the early lead. And the Suns again hung close.

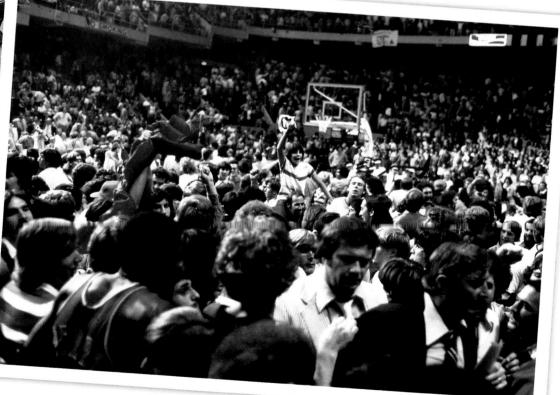

With 1:56 to play in the extra session, Boston was up by four, 101 to 97. But baskets by Curtis Perry and Gar Heard—Heard's coming on a spectacular shot as he leaned back while under the hoop enabled Phoenix to again tie the game.

On they went to the second overtime, where the Celtics again quickly took the lead.

White's driving lay-up with ten seconds to play gave Boston a 109 to 106 lead. But Phoenix answered back in electrifying fashion. Dick Van Arsdale connected on an eighteen-foot jumper with seven seconds left. Westphal stole the Celtics' inbound pass and got it to Perry, who also hit from eighteen feet out. Suns 110, Celtics 109.

Boston responded again with a clutch bank shot by Havlicek, and, although one second remained as Havlicek's shot went through the hoop, the Garden timekeeper neglected to stop the clock.

Pandemonium erupted in the Garden. The fans went wild, pouring onto the floor. The Celtics raced into their locker room to celebrate their apparent 111 to 110 victory.

But the celebration on the floor turned violent when an enraged Boston fan attacked referee Richie Powers after Powers instructed that the clock be reset to one second.

Veteran Celtics play-by-play announcer Johnny Most was astounded by the unruliness of the Boston fans, "This is unbelievable, it's just unbelievable the way this thing has wound up! I don't know what happened!"

The Suns rightly pointed out that the clock should have been stopped after Havlicek's basket, and once the mob was off the floor, back came the Celtics, trudging in disbelief onto the court.

While order was being restored in the Garden, Westphal shrewdly suggested to Phoenix Coach

John MacLeod to immediately call a time-out even though they didn't have one left. As expected, MacLeod's call resulted in a technical foul, giving the Celtics a free throw that White made to give Boston a two-point lead. But it also gave the Suns the ball at mid-court rather than under their own basket.

"All right, here it is, Perry's going to put it in play," Most resumed. "It goes now to Heard." Heard, with defender Don Nelson's long arms in his face, spun around from eighteen feet out and tossed up a high, arching jumper that hit nothing but net as time expired. "It's good! And it goes into another overtime!" cried Most. Guy Manella, the color-man

alongside Most, was shocked by the one-second save, "Oh my goodness gracious, are you kidding me? He hit a turnaround jumper from the top of the lane, which went cleanly through the hoop!"

Incredibly, the Celtics, who minutes before were celebrating victory, now found themselves in a third overtime.

White, who would finish as the game's leading scorer with thirty-three points, including fifteen in the overtimes, had six in the third extra period as Boston took a six-point lead with thirty-six seconds to play.

Ricky Sobers scored two for the Suns. Then, Celtics reserve Jim Ard, who was intentionally fouled, converted two free throws.

Still, there was one more charge left in the Suns. Westphal made a pair of baskets to bring his club back within two. He almost stole a pass in the closing seconds to give his team one more shot, but White grabbed the pass, hung on to the ball, and secured Boston's 128 to 126 triple-overtime win.

The Celtics went on to clinch the championship by winning 87 to 80 in Game 6, but that was anticlimactic. It was Game 5 that people would remember as one of the greatest ever played.

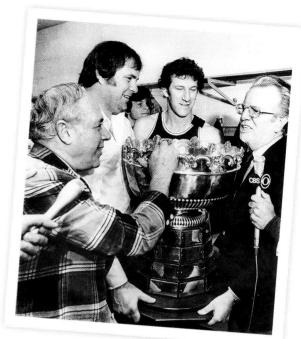

(opposite page top to bottom) Rowdy fans ring the court after one second is put back on the clock with the Celtics leading 111 to 110. ■ Gar Heard scores in the second overtime to tie the game. ■ Fans mob players and exhausted Celtics coach Tom Heinsohn after their triple-overtime victory against the Suns.

(above) NBA commissioner Lawrence O'Brien presents the NBA championship trophy to Red Auerbach, Tom Heinsohn, and John Havlicek after Boston's Game 6 win over the Phoenix Suns. "That's gonna be way back, and that's gonna be gone!"

Ross Porter

Reggie Jackson Hits Three Consecutive World Series Homers

t should come as no surprise that Reggie Jackson's greatest moment came on a night in October. No other player in the long history of baseball has ever put his stamp on a single month the way Jackson did, earning him the nickname "Mr. October."

It's not as if Jackson was invisible the rest of the time. In a career that spanned twenty-one seasons and included stops in Kansas City, Oakland, Baltimore, New York, Anaheim, and Oakland once again, Jackson was one of the most electrifying players of his time. Whether it was hitting one of his 563 career home runs or confronting Yankee manager Billy Martin in the dugout, Jackson lived in the spotlight. His swing was so powerful and so dramatic that even when he struck out, he drew a huge reaction from the crowd. The mere anticipation of what that swing might do was riveting.

But Jackson saved the highest drama for October. He hit .357 in five World Series, slugging ten home runs. Overall, he hit eighteen postseason home runs. Jackson's postseason peak came in the 1977 World Series, the first in fourteen years matching the Yankees with the Dodgers, the Yankees' old archrivals from back when Brooklyn was still home to the Dodgers.

The Yankees' postseason hopes appeared to be in jeopardy in August until Billy Martin made Jackson

his cleanup hitter for the remainder of the season. With Jackson at the center of New York's attack, the Yankees won at a blistering pace to win the AL East by two and one-half games over Boston and Baltimore. After losing two of the first three games to Kansas City in the best-of-five ALCS, the Yankees came back to win their second American League pennant.

While New York struggled, the Dodgers coasted through the season. Under new manager Tommy Lasorda, they opened the season on a tear, took an early lead in the NL West, and went on to win the division by ten games over Cincinnati. The Dodgers then took three of four games from Philadelphia to win the National League championship series.

The World Series opened in New York with each team winning one game. Jackson had been relatively quiet in those games, getting just one hit in six atbats. But even when Jackson's bat was quiet, his mouth wasn't, thus keeping him in the headlines. After Yankee right-hander Jim "Catfish" Hunter lost Game 2, Jackson publicly blasted Martin for starting Hunter. When New York came back to win Games 3 and 4 at Dodger Stadium and take a 3–1 Series' lead, it appeared the Yankees would prevail, despite a season of controversy.

The Dodgers stayed alive by winning Game 5 10 to 4. Of little notice and little consolation in such a

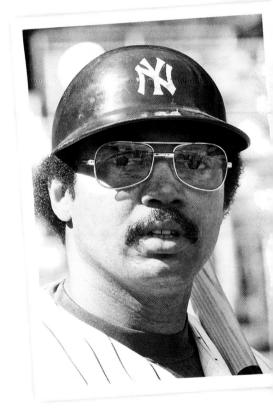

(left to right) Reggie Jackson connects for his third home run in World Series Game 6. ■ Reggie Jackson

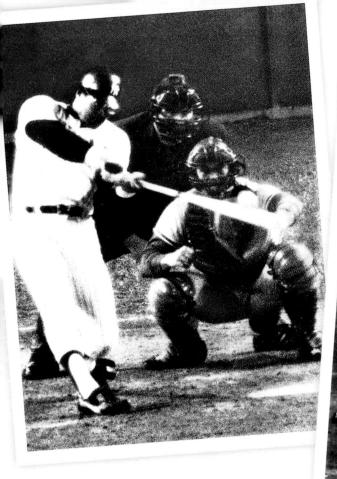

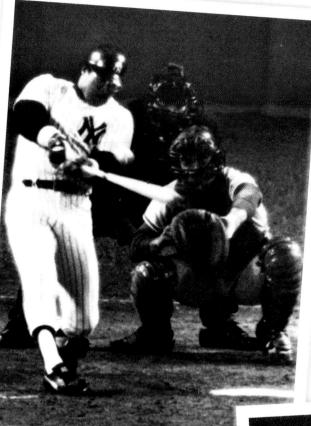

and Reggie Jackson made it the long ball," declared Porter.

Jackson came to the plate again in the fifth inning, facing reliever Elias Sosa. Sosa tried to sneak a fastball down in and past Jackson. Reggie again hit the first pitch into the right field seats, this time scoring Willie Randolph ahead of him. Porter called it, "Way back! Going, going, gone!...Another home run for Reggie Jackson!"

When Jackson strode to the plate in the eighth inning, the crowd was on its feet. The Yankees had a four-run lead and needed only three more

one-sided game, Jackson followed a Thurman Munson homer in the eighth inning with one of his own. It was his second homer of the series, but Reggie was just warming up.

With the two teams back at Yankee Stadium, Game 6 began poorly for the home team with the Dodgers scoring twice in the first inning.

Jackson had walked in his first trip to the plate in the second inning. The next time Jackson came up, in the fourth inning, the Dodgers held a 3 to 2 lead with Burt Hooton on the mound. One pitch later, their lead was gone. "There's a drive to right field and deep. It's going back, a way back, it's gone! A home run, Reggie Jackson!" shouted CBS Radio play-by-play announcer Ross Porter. Jackson lined a home run into the right field stands, scoring Munson ahead of him. "Well, Burt Hooton threw the wrong ball

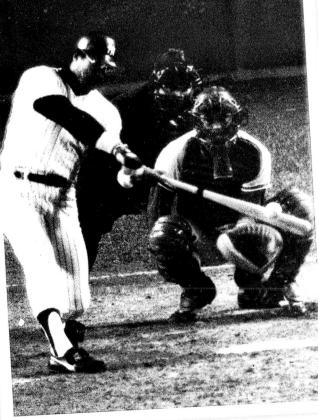

(left to right) Jackson hits home runs No. 1, 2, and 3 on three straight pitches.

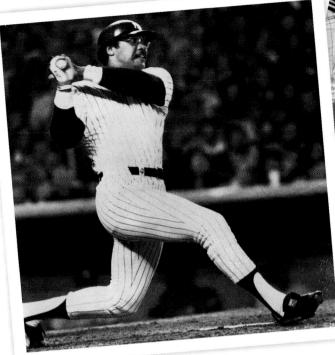

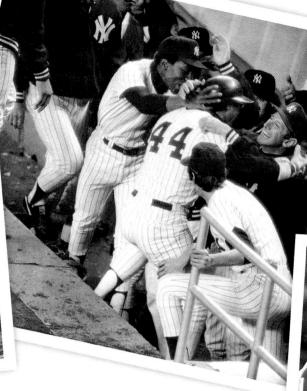

outs against a fading Dodgers club to clinch their 21st world championship. Victory was imminent, but Jackson had a chance at the impossible. "I wasn't thinking home run either of those [first two] times," he said, "but I definitely was going for it the last time." On the mound was Charlie Hough, who came across the plate with a knuckler for the first pitch. Jackson took his trademark swing and the ball soared into the New York night. Again, CBS sportscaster Ross Porter described the moment, "There's a fly ball to center field and deep!

That's gonna be way back, and that's gonna be gone!" The ball landed in the center field bleachers. "Reggie Jackson has hit his third home run of the game!" Porter proclaimed as Jackson made his triumphant tour of the bases and the crowd let out a roar that made Dodgers fans cringe from Brooklyn to Los Angeles.

The Yankees had their World Series triumph and Reggie Jackson had a night for the ages: three home runs on three pitches, giving him four home runs on four swings going back to Game 5. With three homers in a single Series game, he tied a feat accomplished only by Babe Ruth—in 1926 and again in 1928. But even Ruth didn't do it in consecutive at-bats. Jackson also surpassed Ruth by becoming the only man to hit five home runs in one World Series. "Nice company," said Jackson of the comparison with Ruth.

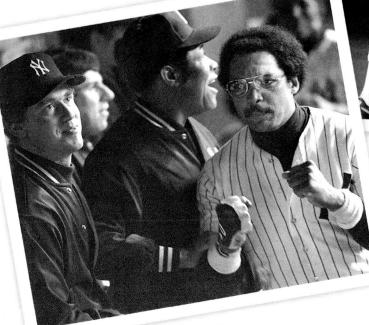

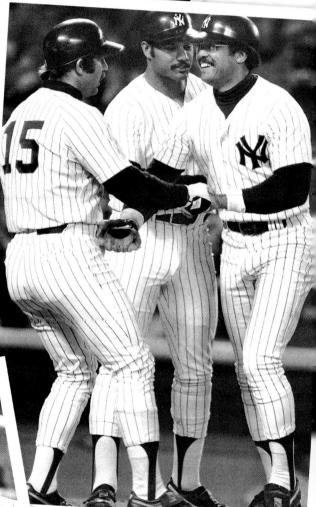

(clockwise from upper left) Jackson swings for his fifth-inning home run.
Jackson is hugged by manager Billy Martin after hitting his third home run. Jackson is congratulated at home plate by Thurman Munson and Chris Chambliss. Jackson clenches his fists after hitting his second home run in Game 6.

"Affirmed's got a nose in front as they come on to the wire!"

Chick Anderson

June 10, 1978

Affirmed Wins Triple Crown

Prior to 1978, there had been ten previous winners of the Triple Crown, the equine equivalent of the summit of Everest. While the winners were worthy of the title, many of the races, including Secretariat's run at Belmont in 1973, became so one-sided they were more like exhibitions. In 1978, the horse and the races were worthy of the title.

Through May and June of 1978, Affirmed and Alydar were as close as their breeding suggested— Alydar's sire, Raise a Native, was Affirmed's grandfather, producing the colt's sire, Exclusive Native. The two waged a fierce, two-way battle over the tracks of Kentucky, Maryland, and New York.

On the face of it, these were races Affirmed should not have been winning, since they defied one of the

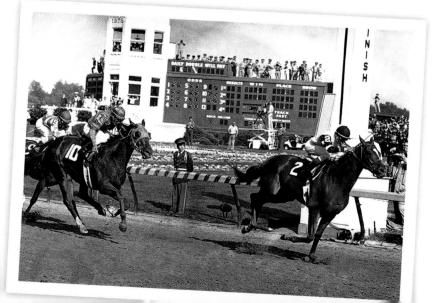

fundamental precepts of the sport, that a good big horse will always beat a good little horse.

At 15.3 hands, Affirmed was far from the classic thoroughbred dimensions. By comparison, Man O' War, the legendary equine hero, stood at just over sixteen hands, and outweighed Affirmed by two hundred pounds.

As two-year-olds, Affirmed and Alydar had raced six times, with Affirmed winning four times, and Alydar twice. In two of those races, Affirmed's winning margins were a nose and a neck.

While the rest of the sporting world anticipated the impending three-year-olds' racing seasons, Affirmed's owner, Louis Wolfson, had other ideas.

> "I didn't feel these two colts should keep racing against each other," he later explained. "If I had been able to obtain Alydar, I would have run them in different races." Through an intermediary, he approached the owners of Alydar, Admiral and Mrs. Gene Markey, to see if they would be interested in selling.

Wolfson's offer was refused. Coming into the 1978 Kentucky Derby, both Affirmed and Alydar were unbeaten for the year in the western and eastern halves of the country, respectively.

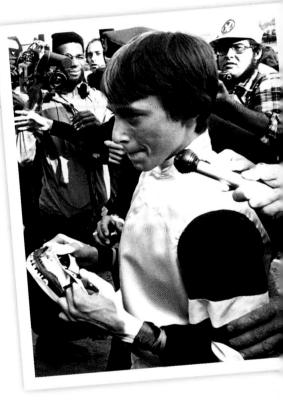

(far left and left) Affirmed and Steve Cauthen win the Kentucky Derby, with rival Alydar trailing. May 6, 1978 ■ (right) Jockey Steve Cauthen in the winner's circle after the Kentucky Derby.

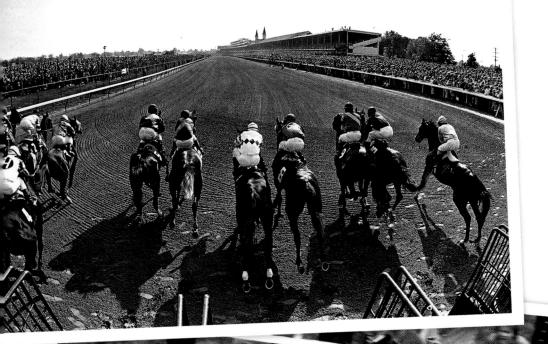

(top to bottom) Bird's-eye view of the start of the 1978 Kentucky Derby. ■ Affirmed edges Alydar at the Preakness Stakes. May 22, 1978
■ Cauthen congratulates Affirmed's owners Mr. and Mrs. Louis Wolfson after winning the Preakness.

CON'SA

Aboard Affirmed at Churchill Downs was the local star jockey, eighteen-year-old Steve Cauthen. Cauthen called Affirmed "an athlete," quick and adaptable, able to hold his pace on the turns.

Alydar was a big, long-striding product of Calumet Farm, which had produced eight previous Derby winners. He was a slow starter and traditionally ran and won from well back in the field.

In the final moments of the Kentucky Derby, Affirmed held at third place and Alydar,

> apparently out of the picture, trailed the leader by as much as seventeen lengths in the back straight. Dave Johnson called the race over ABC Television. "Affirmed towards the railing, down the stretch they come! Affirmed on the inside takes command again! Believe It is second, Alydar gains ground third! Here in the final furlong it's Affirmed with Stevie Cauthen showing the way by two and a half! Believe It...next on the outside! Alydar is third!" It was too great a margin to make up. Though closing fast, Alydar was still a length and one-half short at the finishing post. "It's going to be Affirmed! Affirmed with Steve Cauthen is going to win this 104th running of the Kentucky Derby! Alydar is second, Believe It, third!" Affirmed owned the first installment of the Crown.

> > For the Preakness, Alydar's trainer John Veitch decided on a change of tactics, ordering that his horse be ridden closer to the lead from the outset. But Affirmed took the early lead, with Cauthen setting a gentle pace. Jockey Jorge Velasquez kept Alydar in touch, five lengths from Affirmed. Three furlongs from home, Alydar narrowed the

gap to half a length, and opened a six-length break on the third horse, Believe It. But for all those efforts, Alydar could get no closer. Affirmed won the Preakness by a neck.

Three times, Alydar surged at Affirmed. Three times, Affirmed resisted, finishing with a time of 1:54.24 seconds, second only to the finish of Secretariat.

The Belmont Stakes, the third and final jewel in the Crown, was a mile and one-half, an increased distance which should have suited the bigger, longer-striding Alydar.

But before the half-mile mark, Affirmed and Alydar were on equal terms, racing at full speed. For ABC Television, veteran track announcer Chick Anderson called it to the finish. "Now we've got a speed duel beginning to develop. On the inside Affirmed, on the outside Alydar, and those two are letting out all stops!" So it went for a mile, a pulsating contest between two mighty competitors. At the $\frac{3}{16}$ pole, Alydar appeared to be ahead by a nose. "The two are heads apart and Alvdar's got a lead!" shouted Anderson. "We'll test these two to the wire!" In the split seconds that separated them, every little bit helped. Cauthen, hemmed in on the rails, showed calm and bravado beyond his eighteen years, switching whip hands from right to left. In the last desperate plunge for the line, Affirmed prevailed again. "Affirmed's got a nose in front as they come on to the wire!" Anderson called. Affirmed had captured the Triple Crown.

Although it was the third Triple Crown in six years, after Secretariat in 1973, and Seattle Slew in 1977, in the words of Ogden Phipps, president of the New York Racing Association, it was, "The greatest horse race I have ever seen."

In November 1978, Affirmed was sold to a thirtysix-member syndicate for a then record \$14.4 million. The following summer, he became the first horse to win \$2 million with his victory in the Hollywood Gold Cup.

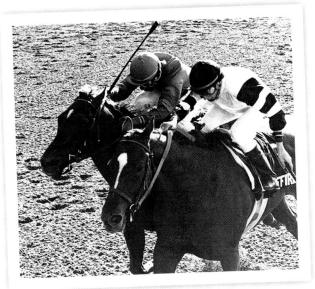

(top to bottom) Affirmed shoulder-to-shoulder with Alydar during the Belmont Stakes. June 10, 1978 Affirmed heads to the wire at the Belmont Stakes.
Cauthen celebrates after winning the Belmont Stakes and the Triple Crown.

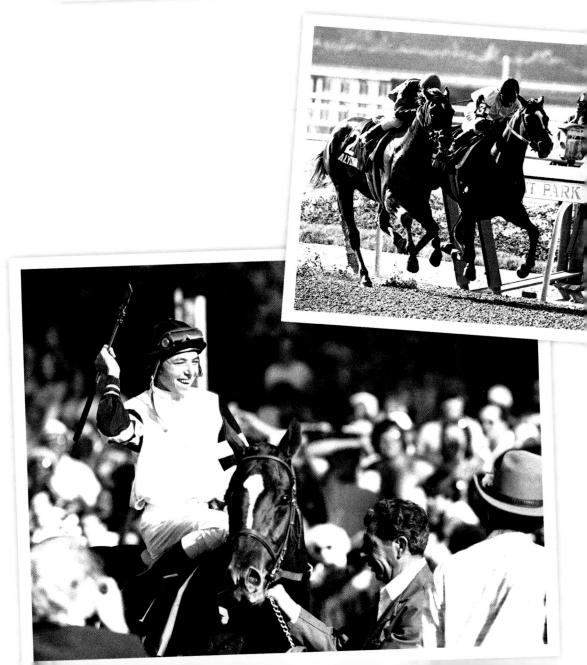

"A new world and Olympic record for Eric Heiden!"

Emmunik

Keith Jackson

February 23, 1980

Eric Heiden Dominates 1980 Winter Olympics

When sportscaster Al Michaels asked a nation, "Do you believe in miracles?" he was calling the historic 1980 United States Olympic hockey team victory over the Soviet Union at Lake Placid, New York. But he could have been speaking directly to an unassuming twenty-one-year-old, with twentynine-inch thighs, who was sitting among those chanting "U-S-A, U-S-A" in the arena that night and watching his countrymen make history.

The young man was speed skater Eric Heiden, and at that moment, he was only one good night's sleep away from making a bit of listory of his own.

Eric Heiden grew up in Madison, Wisconsin, playing soccer and hockey, and speed skating. His parents encouraged their children to compete in sports, and it showed in Eric and his sister Beth, who also became a world champion speed skater. Eric started concentrating on speed skating when he was fourteen, training up to five hours a day.

At seventeen, he earned a spot on the 1976 Olympic team that competed in Innsbruck, Austria. He finished a respectable seventh in the 1,500 meters and an unremarkable 19th at 5,000 meters.

But if Innsbruck was respectable at best and unremarkable at worst, Heiden's next three years were simply amazing. In 1977, Heiden won the first of three straight World Championships, victories that made him a near-legend in Norway. Still, he was nearly anonymous in his home country, which was just the way he liked it.

Even if Heiden disdained the spotlight, he arrived at the Lake Placid Games as the prohibitive favorite in five events. Unlike the U.S. hockey players, Heiden's accomplishments in Lake Placid were not bathed in the glow of an underdog's light.

By the time he watched U.S.A.'s hockey victory over the Soviets, Heiden already had earned four gold medals. Nine days earlier, he won the first of his gold medals in the 500 meters, the distance at which he was considered most vulnerable. In the finals, he met world record holder and defending Olympic champion Yevgeny Kulikov of the Soviet Union. The two were dead-even through 400 meters, but when Kulikov stumbled in the last turn, Heiden pulled ahead and won by .34 seconds, setting an Olympic record in the process. Nearly twenty-four hours later, he raced past Kai Arne Stenshjemmet, again a world record holder, in the 5,000 for his second trip to the top of the medal stand.

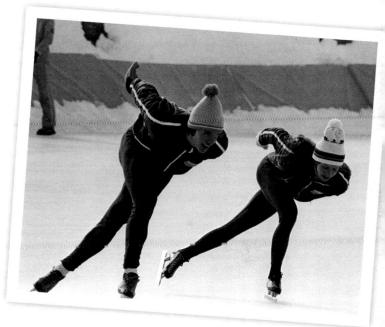

(left to right) Eric Heiden competes in the 1980 Winter Olympics. ■ Heiden skates with his sister, Beth. February 11, 1978

74

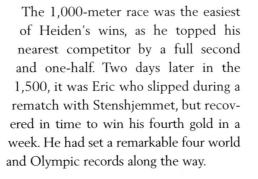

The drive for five was 10,000 meters long, 6.2 miles, over twenty-five laps. It's more of a race against time than against man. Two racers take the track at a time, but the skater with the fastest time of the day wins. The distance requires both great stamina and intense concentration.

Unbeknownst to the three thousand people sitting in the grandstand in 20-degree weather under a steel gray sky, Heiden arrived at the race site at Lake Placid High School at something less than his best. His evening at the hockey game the night before had left him wired, too excited to sleep. He tossed, turned, then overslept, with barely a chance to scarf down a few slices of bread for breakfast before hurrying to the track. He hardly had time to warm up.

But his poor preparation that morning didn't matter. What suspense was left in the competition was gone before Eric Heiden's heat was half over. The only question remaining for his fans was whether another world record would fall.

Keith Jackson anchored the ABC Television coverage of the historic moment. "Let me tell you again," Jackson stated in his trademark staccato delivery, "that nobody has ever won five individual golds. The last time an American medaled in this event was in 1932, forty-eight years ago!"

The starter's pistol fired and Heiden settled into his pace. As the race came down to the final laps, Heiden focused. He bore down in his crouched racing position, his right arm swung back and forth like a powerful pendulum controlling the tempo to his winning stride. "The world record is in jeopardy

(clockwise from top left) Heiden displays his powerful skating style. ■ Heiden competes in the Olympic 500 meters. ■ Heiden skates in front of his scoreboard time. ■ Gold medal winner Heiden catches his breath.

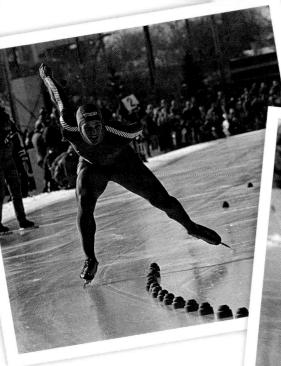

as Heiden turns down off the last turn. The world record 14:34.33!" shouted Jackson. As Heiden came closer to the finish line, Jackson's voice grew in excitement, "Heiden moving powerfully for the finish line! And he snaps the time beam at 14:28.13! A new world and Olympic record for Eric Heiden!" Heiden's final 400-meter lap was turned in 34.5 seconds, close to the pace he skated when he won the 500 meters in 38 seconds. He shattered the world record with a time 6.2 seconds faster than the previous world mark.

It was Heiden's fifth gold medal in five events, the most ever won by an individual Olympic athlete since Mark Spitz' seven swimming golds included three team relay wins. He also had set an amazing five world records.

After the games, Heiden proved it was more than medal count that set him apart from other champions. He announced he would retire at the end of the season, telling the media, "Maybe if things had stayed the way they were and I could still be obscure in an obscure sport, I might want to keep skating. I really liked it best when I was a nobody."

Heiden also turned away the endorsement offers that came his way, agreeing only to appear on a Wheaties box because he had actually enjoyed the cereal as a kid. He tried out for the 1980 Summer Olympics team as a cyclist, but didn't make the squad. He later won the 1985 U.S. pro cycling championship. In 1986, his attempt to compete in the Tour de France ended with a serious crash. Heiden went on to graduate from the prestigious Stanford Medical School, and like his father, became a successful orthopedic surgeon.

A true champion, Eric Heiden sought competition, not medals, and preferred new challenges over fleeting recognition. "I didn't get into skating to be famous," he said at Lake Placid. "It's not a sport you get famous at. If I wanted to be famous, I would have stuck with hockey."

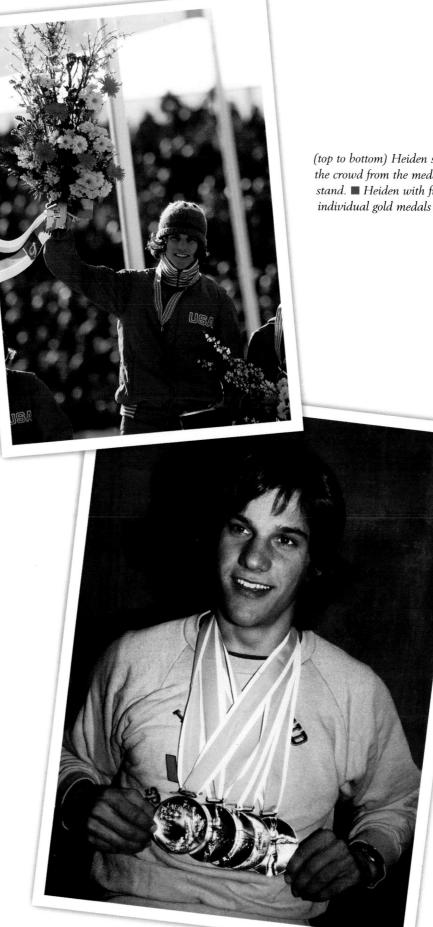

(top to bottom) Heiden salutes the crowd from the medal stand. Heiden with five

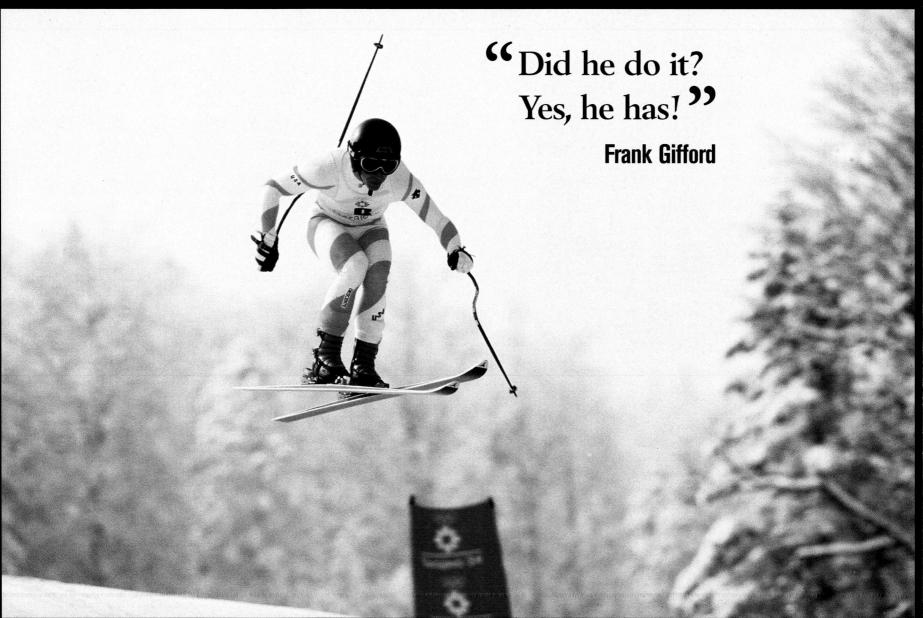

February 16, 1984

Bill Johnson Skis to Olympic Downhill Victory

B ill Johnson may not have had the background of the classic downhill skier, but for one moment in Sarajevo he turned an ideal circumstance into an Olympic gold medal classic.

Great Olympic downhill racers typically hail from places like France or Italy. Bill Johnson spent the early years of his life in the heart of the San Fernando Valley, a Los Angeles suburban area better known for its malls than its mountains.

When Johnson was still a kid, his family left the Valley and headed to the Pacific Northwest, living in both Oregon and Idaho. There, Johnson learned to ski and started racing, eventually making a name for himself in competitions all over the country.

From the beginning, Johnson was hooked on speed. "I liked to challenge the older guys, the ski instructors, to races from the top of the mountain," he said. "Fortunately, somewhere along the way, I also learned to turn."

There were some twists as well. By the time Bill Johnson arrived in Sarajevo, he was known in some parts as Bad Bill Johnson. While not exactly Billy the Kid, Johnson's closest brush with the law was a youthful indiscretion involving a stolen car.

But then there was the time he was kicked off the U.S. National Ski Team in 1981 for being out of

shape. "The season was six months away," he recalled prior to his Olympic run in 1984. "I'm never in shape in July. But they dropped me from the team anyway. So I decided to race on my own that winter and I kicked their butts."

(left to right) Bill Johnson soars in the 1984 Olympics. ■ Bill Johnson

As a result of a sixth-place finish in a World Cup race at St. Anton, Austria, and a Europa Cup championship for class "B" skiers the season before. Johnson was the United States' best downhill skier at Sarajevo in 1984. But that didn't mean much to the Europeans, despite the fact that he won the Lauberhorn at Wengen in Switzerland the month before the Olympics. His forty-fifth-place finish in Austria a week after Switzerland confirmed to the establishment that the win was a fluke, but Johnson bounced back to finish fourth at Cortina, Italy, right before the Gamesmeaning he would be a threat, whether the Europeans liked it or not.

Austria's Franz Klammer, winner of the 1976 Olympic Downhill at Innsbruck referred to Johnson as a "Nasenbohrer" after the Cortina event. Literally translated, it means "nosepicker," but the

inference was that Johnson was immature. His peers saw Johnson as a brash and cocky kid who hadn't done quite enough to back up the braggadocio.

The 1984 men's downhill was delayed a week due to inclement weather. While waiting for the run, Johnson ran his mouth. "I'm going to win the gold medal," he told anyone who would listen. "They might as well give it to me right now." Never mind that no American had ever even medaled in an Olympic downhill event.

If the Games had been held anywhere but Sarajevo, Johnson might have had more trouble backing up his boast. But the course couldn't have been better for the American if he had designed it himself. His gliding style, developed on the Oregon and Idaho slopes, was suited to the relatively easy conditions in Yugoslavia that year. Most European courses had many more sharp turns. Before taking the hill, Johnson admitted as much, "I haven't skied the Olympic course, but I've seen films of it and it's not too steep or tight on the turns. Instead, it's open and flowing, which is the kind I like."

As it turned out, the week of bad weather left the mountain icier than Johnson would have preferred. Skiing sixth, his time trailed the leaders through the tighter top half of the run, but he blazed through the bottom half. ABC Television's team coverage of the downhill event included Frank Gifford and former downhill coach Bob Biatti.

(above) Johnson celebrates his Olympic downhill victory.

(left to right) Johnson waves the American flag. ■ Johnson with his gold medal

As Johnson averaged a speed of 65 m.p.h. on his run, both Biatti and Gifford marveled at his ability to maintain his balance and tight tuck position while skiing at such a breakneck speed, "Look at him try to stay in that tuck all the way down! As soon as he gets out of turn you can see him get right back into it!...He has a very fast pair of skis and he knows how to ride them!" said Biatti.

As he approached the bottom half of the run, Johnson was lagging by just two-tenths of a second. But his go-for-broke determination paid off and he covered the nearly two-mile course in 1:45:49, capturing the lead. For the remainder of the afternoon, he gave victory interviews while he watched the rest of the competitors try to knock him off. None could. Bill Johnson had put a medal where his mouth was.

After the event, Johnson was asked what the win meant to him. His response, in a word, "Millions." Bad Bill hoped to clean up his reputation and cash in on his win like many gold medalists had before him. But Americans rarely turned their Winter Olympic champions into lifelong heroes.

Johnson went on the talk show circuit but was unable to turn his gold into a huge profit. But for a single Olympic moment, Bill Johnson was the right man in the right place at the right time—for all time. **Kareem swing left—
right hand—twelve footer
....good!**

Chick Hearn

RI

Disc 1 • Track 22

April 5, 1984

Kareem Abdul-Jabbar Breaks NBA Scoring Record

os Angeles Lakers assistant coach Bill Bertka labeled it "the most indefensible shot in basketball." He would surely get no argument from any hapless defender who had ever attempted to stop Kareem Abdul-Jabbar's trademark weapon—the sky hook.

Abdul-Jabbar first launched it in 1956 as a nineyear-old named Lew Alcindor, a 5-foot 8-inch fourth grader playing his first year of basketball at Holy Providence School outside Philadelphia.

With Alcindor firing away, his high school, New York's Power Memorial, won seventy-one straight games and was 95–6 overall.

It was much the same story in college at UCLA. In his first game as a Bruin, Alcindor scored thirty-one points to lead his freshman squad to a fifteen-point victory over the varsity in the traditional season opener. It was a stunning debut considering that the UCLA varsity had won two straight national titles and was rated No. 1 in preseason polls.

Once he reached the varsity, the Bruins won the national championship in all three years Alcindor was at center, tallying eighty-eight wins against just two losses.

The No. 1 pick in the 1969 draft by the Milwaukee Bucks, Alcindor moved smoothly into the pro game.

In his first NBA season, he averaged 28.8 points per game, and then surpassed the thirtypoint per game mark in each of his next three seasons. In his second season, with Oscar Robertson feeding him the ball, Alcindor won his first NBA title as he led the Bucks past the Baltimore Bullets in the NBA Finals.

In 1971, Alcindor embraced the Muslim faith, and changed his name to Kareem Abdul-Jabbar.

In 1975, Abdul-Jabbar came back to the city where he had been a collegiate superstar, but this time to wear the purple and gold of the Lakers. He had been traded, along with teammate Walt Wesley, to Los Angeles for Elmore Smith, Brian Winters, and the draft rights to Dave Meyers and Junior Bridgeman.

But to repeat the success he had enjoyed at UCLA and in Milwaukee, Abdul-Jabbar would again need someone to feed him the ball.

That someone arrived in 1979 in the person of twenty-year-old Earvin "Magic" Johnson. With

(left to right) Kareem Abdul-Jabbar shoots his sky hook against the Utah Jazz. He broke Wilt Chamberlain's scoring record during the game. ■ As Lew Alcindor, Abdul-Jabbar starred for UCLA.

Johnson and Abdul-Jabbar on the same floor in the 1980s, the Lakers won five NBA titles.

As the center of the "showtime offense," Abdul-Jabbar kept pouring in the points and moving up the scoring ladder. He passed Jerry West, his Lakers coach for several seasons, who had amassed 25,192 career points. He passed John Havlicek's 26,395 points.

He passed Oscar Robertson, his old teammate, who finished with 26,710 points. He passed Elvin Hayes, his old college rival, who totaled 27,313 points.

And finally, there was Wilt Chamberlain, who had befriended Abdul-Jabbar

when he was still a youngster learning the game on the playgrounds of New York. Chamberlain was the NBA career-scoring leader with 31,419 points when Abdul-Jabbar and his Lakers took the court against the Utah Jazz on April 5, 1984, on a neutral site, Las Vegas' Thomas and Mack Arena.

Abdul-Jabbar began the night twenty points behind Chamberlain. Johnson had come out of the game for a breather late in the third quarter, but when Abdul-Jabbar tied Chamberlain's mark in the fourth quarter, Johnson asked to be put back in, determined to assist in the tiebreaker.

With Abdul-Jabbar double- and triple-teamed, Johnson twice tried to get the ball in to him, only to have it batted away for turnovers. Finally, Johnson's pass got through the flack, but Abdul-Jabbar badly missed a sky hook. Again the Lakers got the ball back, again Johnson maneuvered his way toward his towering teammate and delivered the ball, and again Abdul-Jabbar worked for an open shot.

In his inimitable style, Chick Hearn, the voice of the Los Angeles Lakers radio and TV network, summed up how tantalizingly close Abdul-Jabbar was to making basketball history, "Lakers have a hig lead with nine and a half to play and Kareem needing one point! He's climbed the mountain. He's starting to pitch camp!"

Kareem found himself free fifteen feet from the basket on the right side, the nearest defender, Mark Eaton, also an ex-Bruin, out of reach. Hearn, doing his best to keep his cool, continued to call the action, "The crowd stands for Kareem to get the ball...It's in to Kareem." Just as he had been doing all of his basketball life, Abdul-Jabbar set his feet, pivoted, and fired up a sky hook. "Kareem swing left...right hand...twelve footer...good!" Hearn shouted. The Las Vegas arena reverberated from the unrestrained cheering. Kareem was engulfed by his teammates, as well as his mother and father. "Suffice it to say, ladies and gentlemen, the new king of scoring has ascended his throne," Hearn proclaimed. "What an

emotional moment, and the kind of a shot that I dreamed about for three weeks that he would make, the hook shot."

The game was halted briefly for a courtside ceremony. NBA commissioner David Stern pronounced Kareem one of the greatest athletes ever to play the game. The crowd echoed Stern's sentiment with unreserved cheering and applause.

Abdul-Jabbar stood alone atop the NBA career-scoring list with 31,421 points.

When he retired after the 1988–89 season, his 20th, Abdul-Jabbar had boosted that total to 38,387 points. Chamberlain had piled up his points in fourteen seasons. Michael Jordan, in his twelve seasons, stands third all-time with 29,277 career points. But as great as Jordan was, as dominating as Chamberlain was, they never approached the peak reached by Abdul-Jabbar. But then, they never had the sky hook.

(opposite page, clockwise from bottom left) Kareem Abdul-Jabbar and Magic Johnson ■ Abdul-Jabbar, then known as Lew Alcindor, dunks as a member of the Milwaukee Bucks. ■ Abdul-Jabbar's famous sky hook

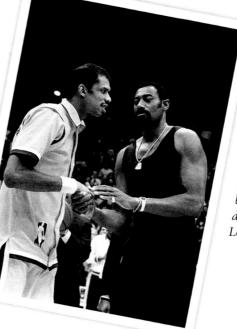

(top to bottom) Abdul-Jabbar acknowledges the cheers of fans after breaking the NBA scoring record. ■ NBA commissioner David Stern congratulates Abdul-Jabbar. ■ Abdul-Jabbar is congratulated by Wilt Chamberlain during a ceremony in Los Angeles.

^{**}The gold medal goes to Mary Lou Retton!^{**}

Jack Whitaker

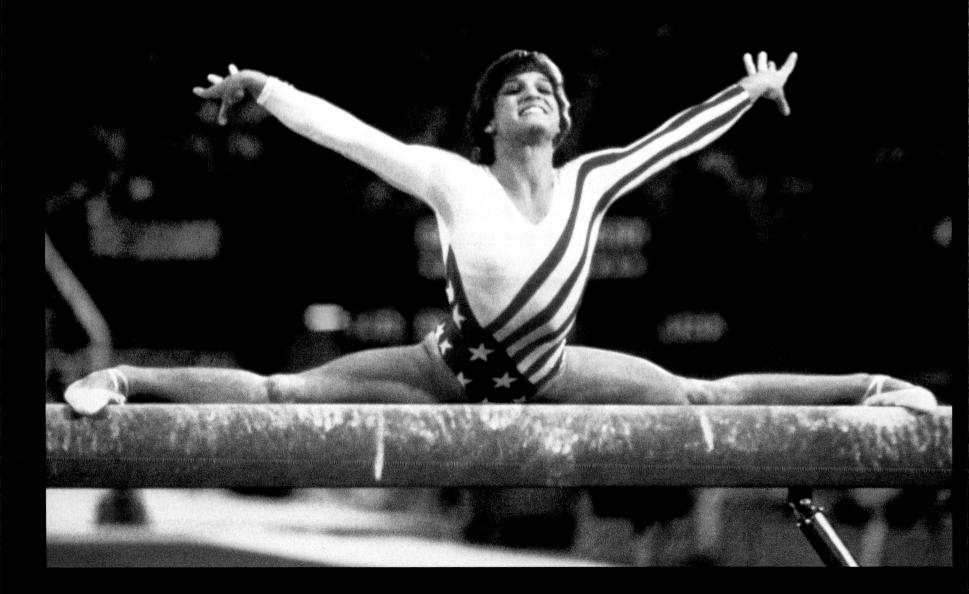

Mary Lou Retton Vaults to Olympic Gold

t's the Olympic Games," she reminded herself as she stood focused on the sidehorse at the other end of the matted runway. The moment demanded perfection, which is a lot to ask of a sixteen-year-old at any time. "This is what I came here to do," she thought, and with that selfreassurance, Mary Lou Retton sprinted with all the energy she could muster. She would launch herself into a realm few athletes ever experience.

A few days earlier, with the gold medal–winning exploits of the United States men's team, gymnastics had captured America's attention. Never mind that some of the world's best gymnasts were missing because of the Eastern Bloc boycott of the 1984 Olympics. At the first Summer Olympics in the United States in fifty-two years, gold was where you found it, and not devalued in the least because someone else had missed out on competition.

Women's gymnastics had become the hot Olympic ticket because of the display of waif-like Romanian prodigy Nadia Comaneci at the 1976 Montreal Olympics. Watching Comaneci on television in 1976 was eight-year-old Mary Lou Retton. The youngest of five children in a sporting family, Retton was inspired. She persuaded her mother to take her to gymnastics classes.

Before long, Retton was winning every contest she entered. Her parents were told her potential was boundless, but could only be fully tapped by a coach who had set up camp in Houston, Texas, after defecting from Romania in 1981. That coach was Bela Karolyi.

On New Year's Day, 1983, Mary Lou Retton left the coal mining town of Fairmont, West Virginia, for Houston. She returned home for only four days between then and the 1984 Los Angeles Olympics.

Retton was a driven, powerful competitor. After arthroscopic knee surgery in June 1984 to remove torn cartilage, she was back in training within two weeks. At 4 feet 9 inches and 94 pounds, she had a strong, compact

build. Her best events in the four gymnastic routines were those which placed an emphasis on explosiveness—the floor exercise and the vault. Her weakest were the uneven parallel bars and the balance beam, with their emphasis on grace and flexibility.

At the start of the individual competition, scores from the team event, won by Romania, had been carried over to the all-around section. Retton led all competitors, but Ecaterina Szabo of Romania trailed by just 0.15 points at the start of the four routines.

The first two routines, though, were Retton's weakest, and Szabo reversed that original margin. Retton tallied scores of 9.8 for the balance beam, and

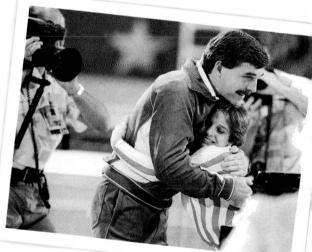

(left to right) Mary Lou Retton concludes her routine on the balance beam at the Olympic Games in Los Angeles, 1984.
Retton hugs coach Bela Karolyi after scoring a perfect 10 in the vault to win the gold medal.

9.85 for the uneven parallel bars. Szabo scored 9.95 in the floor exercise and a perfect 10 on the balance beam, one of an astonishing forty-six perfect scores that would be awarded during the 1984 Olympics men's and women's competitions.

"There are two ways to get a 10," United States team coach Don Peters explained. "One is to perform a routine perfectly. The other is to be so much better than everyone else is that, if the judges gave someone else a 9.9, they have to give you a 10."

Those were the requirements facing Retton as she began the floor exercise. Her performance was a study in explosive, perpetual motion her somersaults and tumbles ending with a motionless plant in the one corner of the thirty-by-thirty-foot floor.

The electronic scoreboard flashed the ultimate affirmation of her performance: 10.

For the 9,023 spectators at UCLA's Pauley Pavilion, the math was simple. A 9.90 on the vault would give Retton a silver medal. A 9.95 would

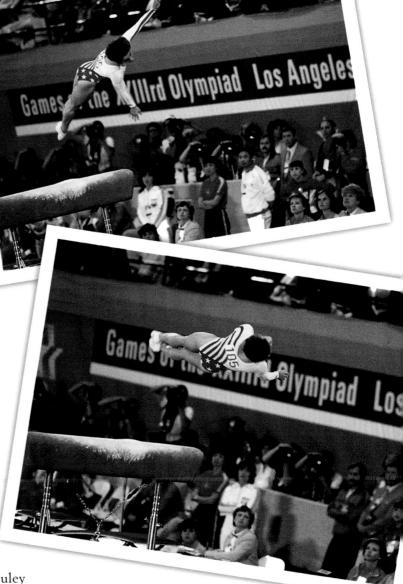

(left to right) Retton scored two perfect 10s on the vault.

(opposite page, clockwise from left) Retton sticks her landing. ■ Retton flashes a smile and waves to her fans. ■ Retton displays her gold medal.

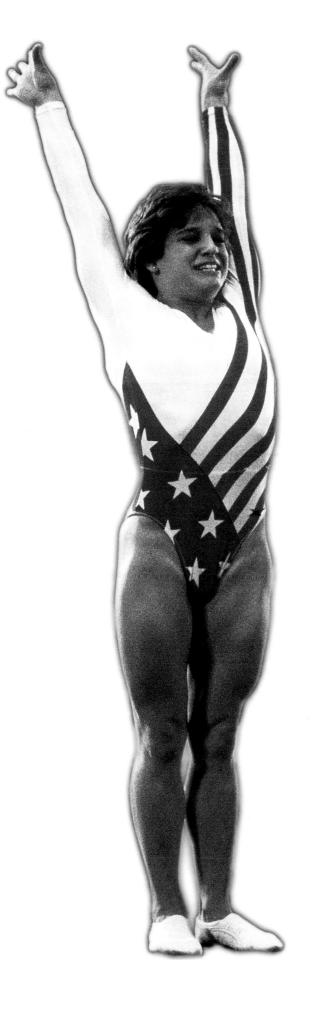

give her a share of first place with Szabo. Only with perfection itself could she claim undisputed ownership of the gold medal.

Retton's leaps off the sidehorse had been known to propel her over eleven feet in the air, giving her a few extra split seconds to carry out incredibly difficult mid-air routines.

Her specialty vault was the Tsukahara, named for the male Japanese gymnast who had devised it. Retton focused, sprinted, and leapt. "I hope she has her wings on today," said Olympic gymnast turned ABC Sports commentator Cathy Rigby. In order, Retton performed a backward somersault, then a forward flip with a 360-degree twist, and then landed, both feet planted, unyielding. The instantaneous transformation from outrageous, gravity-defying movement to such utter stillness was remarkable.

Retton held that pose just long enough to convince the judges it was no accident. Then, unable to contain herself, her trademark smile beamed across her face and she began to jump with excitement, each one higher than the last. "She has done the best vault of her life!" Rigby shouted to co-commentator Jack Whitaker. Retton leapt off the stage and into coach Karolyi's arms, where she was enveloped in a bear hug. Pauley Pavilion reverberated with chants of "10! 10! 10!"

A minute later, the scoreboard silently echoed the cries of the crowd, displaying a 10.00. "The gold medal goes to Mary Lou Retton," shouted Whitaker. "Oh, what a party they'll have in Fairmont, West Virginia, tonight!"

Retton quickly composed herself, and although it wasn't necessary for the gold, she took her second vault, again scoring a perfect 10. Mary Lou Retton captured the gold, as well as a place in the hearts of Americans, while inspiring the next generation of gymnasts worldwide.

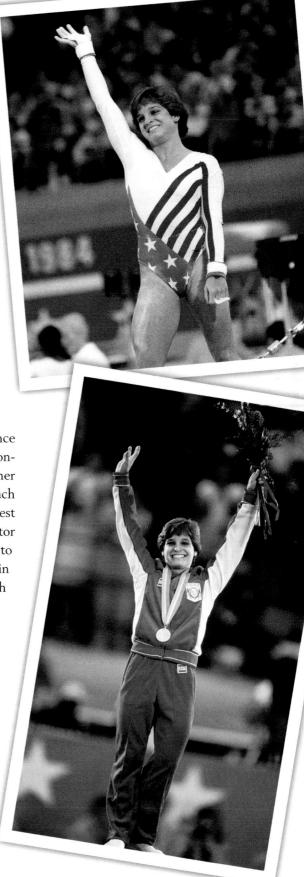

"Quick pitch to Walter...looking for the record, cuts back, he's got it!" Joe McConnell

October 7, 1984

Walter Payton Breaks Career Rushing Record

There was much more to Walter Payton than met the eye. At 5 feet 10 inches and 204 pounds, he did not appear to be that imposing. Closer acquaintance always changed that view. A sportswriter once accidentally brushed against him, and described the experience as touching a pillar of concrete. Payton could absorb the most jarring hit, and not just stay upright, but keep moving forward. He could land a field goal from forty-five yards, boom a punt for seventy, or throw a pass for sixty. He also was one of football's classiest competitors, earning him the nickname "Sweetness," a moniker bestowed on him as much for his agility on the field as for his disposition off the field.

Chicago Bears coach Mike Ditka reached further for his superlatives. "When God said, 'Make me a fullback or a halfback,' he might have said Gale Sayers or Jim Brown. When God said, 'I'm going to build me the best football player,' there might be two names—Jim Thorpe and Walter Payton."

By the start of the 1984 season, Payton had established himself as a legitimate pursuer of Jim Brown's NFL record of 12,312 yards rushing, accumulated during nine seasons with the Cleveland Browns. Payton had recently had arthroscopic surgery on both knees, what he called "my eleventhousand–yard checkup." Nothing less than that could keep Payton out of a game. He had missed only one game due to injury since his 1975 rookie season, and even then he had hotly disputed the decision to bench him.

Brown's rushing record beckoned before the 1984 season was a month old. Against Dallas, needing 222 yards to surpass the mark, Payton had 130 by halftime. But the Bears were struggling and coach Ditka reversed course. Payton carried the ball only five more times for a total of twenty-five yards in the second half. He stood sixty-seven yards short of the record.

The Bears' next opponent was New Orleans. The Saints had good reason to remember Payton. At their previous meeting, he had gained 161 yards on twenty-eight carries, passed for two touchdowns, rushed for another, and caught two

passes for twenty-seven yards. The Bears still lost.

It was cold, gray, and chilly at Soldier Field on October 7, 1984. Chicago was a city distracted, with the Cubs still alive in the National League baseball playoffs against the San Diego Padres.

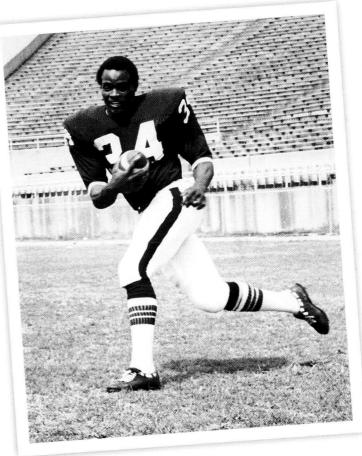

(left to right) Walter PaytonPayton starred in college at Jackson State.

With three seconds left in the first half, a one-yard charge by Payton for a touchdown put the Bears in the lead 13 to 7. On the second play of the second half, quarterback Jim McMahon called for one of the Bears' rushing staples, involving a pitch pass from the quarterback to the runner, and four bodies charging in single file through the Saints' defensive line.

Bears announcer Joe McConnell called it, "Second play of the second half from the twentyone-yard line, Walter needs two to break the record....They send McKinnon in motion through the left side...quick pitch to Walter...looking for the record, cuts back, he's got it!...Walter Payton becomes the National

(top to bottom) Walter Payton (34) leaps over Dennis Winston and scores a touchdown. ■ Chicago Bears' Walter Payton looks for an opening against the Saints. ■ Payton gets by Rickey Jackson in the game's second quarter.

AnngaROOS SWEETVDO JALNSON

Football League's all-time leading rusher, surpassing Jim Brown on his second carry here in the second half, and that's the equivalent to Hank Aaron breaking Babe Ruth's all-time home run record! Just listen to this standing ovation!"

At the play's end, Chicago had notched a six-yard gain, closed by a tackle from Saints linebacker Jim Kovach. The NFL had a new immortal. Walter "Sweetness" Payton, the fourth player in that line.

As the pile untangled itself, Payton shook Kovach's hand, darted away from the swarm of photographers who had taken the field and ran to the Saints' side of the field to shake hands with coach Bum Phillips.

The Bears won the game 20 to 7 and Payton finished with 154 yards rushing to break another of Brown's records—it was his 59th game of one hundred-plus yards rushing.

In the locker room after the game, Payton accepted congratulations over the phone from President Ronald Reagan. To Payton, the record was worth \$100,000 in bonuses from the Bears and a gift of a \$125,000 Lamborghini from his shoe company.

In the following year, the 1985-86 season, the Bears were virtually unstoppable, en route to a 46 to 10 rout of the New England Patriots in Super Bowl XX. Payton finally had a championship ring.

By the time of his retirement after the 1988 season, his 13th, Payton had gained several notable accolades, including an NFL MVP award, the career rushing record of 16,726 yards, and the single game record of 275 yards.

In November 1999, Walter Payton died from complications of a rare liver disease.

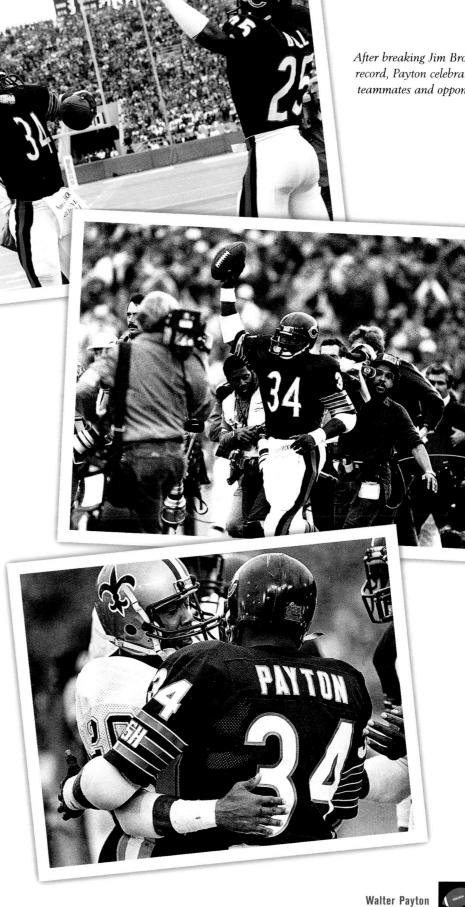

After breaking Jim Brown's record. Payton celebrates with teammates and opponents.

"A clean base hit, and it is pandemonium here at Riverfront Stadium!"

Marty Brennaman

Pete Rose Smacks Hit No. 4,192

E arly in his career he was known as "Charlie Hustle," the rookie with the crewcut who ran to first base on walks. At the end, he was Pete the hustler, the man who was removed from any formal connection to baseball for allegedly betting on the game. He went from a prominent role in his sport for over a quarter century to banishment and a prison cell. But through it all, from the spectacular to the shameful, this much could always be said of Pete Rose: the man could hit. Whether from the right side of the plate or the left, whether against a fireballing right-hander or a tricky left-hander, Rose would crouch low, pick out his pitch, and hit the ball on a sizzling line beyond the reach of any glove.

Pete Rose got his first hit on April 13, 1963, playing for the Cincinnati Reds. It was a triple off the Pirates' Bob Friend. But the milestones had only begun as the hits piled up. Hit number one thousand came on June 26, 1968, a single off the Mets' Dick Selma. He hit number two thousand on June 19, 1973, a single off the Giants' Ron Bryant. Number three thousand, a single off the Expos' Steve Rogers, came on May 5, 1978.

For most players, that was more than enough for a career. But when Rose got his 3,000th hit, he was just thirty-seven years old, and he still had plenty left in his bat. He broke the National League record with hit number 3,631, a single off the Cardinals' Mark

Littell, on August 10, 1981. A double off the Phillies' Jerry Koosman on April 13, 1984, became hit number four thousand. Now, only Ty Cobb and his 4,191 career hits, a record once thought to be unbreakable, lay ahead.

Rose could be assured that his manager would allow him to determine the time and place he attempted to break the record, since the Cincinnati manager that season was none other than Rose himself. On September 8, the Reds were in Chicago with Rose sitting at 4,189 hits. With a homestand upcoming. fans in Cincinnati were hoping Rose would bench himself in order to tie the record at home. But the competitive Rose won out over the sentimental. He got two hits. and his 4,191st to tie Ty

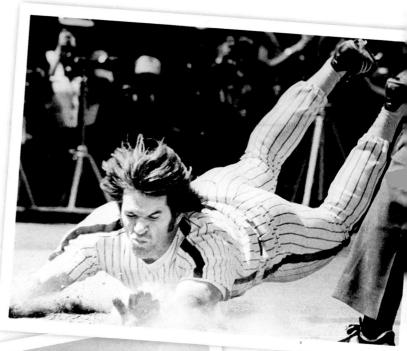

(clockwise from left)
Pete Rose breaks
Ty Cobb's record.
Rose's trademark
headfirst slide
1963 Rookies of
the Year Gary
Peters (left) and
Pete Rose

Cobb's record was a single off the Cubs' Reggie Patterson. Reds fans would see Rose set the record in person.

> Those who came to Cincinnati's Riverfront Stadium

on September 11, 1985, hoping to see history made in the Reds game against San Diego didn't have long to wait. Rose came up in the first inning against Padres right-hander Eric Show, took that easy, smooth, but firm swing from the left side of the plate, and smacked a line drive into short left field. Sportscasters Marty Brennaman and Joe Nuxhall described the excitement and the emotion of the historic moment for the Reds radio network. "There it is! Get out! Get out!" shouted Nuxhall. "Hit number forty-one-ninety-two, a line drive single into left center field," described Brennaman, as the ball dropped in front of outfielder Carmelo Martinez. "A clean base hit, and it is pandemonium here at Riverfront Stadium!"

Career hit number 4,192 was also career single number 3,162. It was a fitting way for the record to go to Rose, who had decided early in his career that he could do for singles hitters what Babe Ruth had done for home run hitters.

Rose rounded first and took in the applause of the crowd and the congratulations of his fellow players. There Rose stood, not only at first base, but atop the all-time hits list, above all the men who had ever played Major League Baseball. He looked up in the stands, imagining his father up there cheering for him, and broke down in tears. It was the first time Rose had cried since his father died.

Joy washed over him as teammates embraced him. Padres first baseman Steve Garvey shook Rose's hand and Reds Davey Concepcion and Tony Perez hoisted him on their shoulders, treating their manager like a football coach who had just won the Super Bowl.

But even with all that, Rose wasn't finished. Before the evening was over, he added his 4,193rd hit, a triple, scoring both Cincinnati runs in a 2 to 0 victory, and made a clutch diving stop of a ground ball on the game's final out.

Rose went on to play another season and add another sixty-three hits to his career count, finishing with 4,256 over twenty-four seasons. But just when the man, who also once hit in a National League–record forty-four straight games, should have been kicking back to enjoy a retirement filled with deserving accolades, Rose's life went into a slump from which he has yet to recover. Banned from baseball for allegedly betting on games, Rose also served five months in an Illinois prison for tax evasion. The place in the Hall of Fame he earned on the field has been denied to him because of off-the-field gambling, a charge he has not admitted to publicly.

But, whether or not he ever gets back into baseball's good graces and into the Hall of Fame, he always will be one of the greatest hitters the game has ever known.

> (opposite page, clockwise from lower left) Rose ties Cobb at Chicago's Wrigley Field.
> ■ Ty Cobb ■ Rose slams his 4,192nd hit.

Rose hits No. 4,192, and celebrates with his team.

Go crazy folks, go crazy!" Jack Buck

Ozzie Smith Home Run Wins Game 5

e was born Osborne Earl Smith on the day after Christmas, 1954, in Mobile, Alabama. Everyone called him Ozzie, and when he made it to the major leagues, he was nicknamed "the Wizard of Oz." Those who watched Ozzie Smith play shortstop for nineteen seasons saw him as a wizard with a glove, but Smith's most memorable moment in his baseball career came with a bat in his hand.

The St. Louis Cardinals acquired Ozzie Smith from the San Diego Padres after the 1981 season to be the defensive ace on the fast Astroturf surface of Busch Stadium. Ozzie did his job in the field. He won thirteen consecutive gold glove awards, a major league record for shortstops.

Entering the 1985 playoffs, Smith's batting average topped .250 only three times in eight full seasons in the big leagues. His best average came during the 1985 season when he hit .276. Even lower were his power totals. In 1,164 regular season games and 4,225 regular season at-bats, the switch-hitting Smith had only thirteen home runs, all from the right side of the plate. Given his past history, and his slight build, Ozzie Smith may have been the last player expected to win a game with a home run.

Major League Baseball expanded its league championship series to seven games in 1985. The National League championship series pitted the Cardinals against the Los Angeles Dodgers. The Dodgers won the first two games of the series at home. The Cardinals followed by winning the next two games at Busch Stadium. Game 5 in St. Louis would give one of the teams the series' lead.

The Cardinals got on the scoreboard with two runs in the first inning off Dodgers ace Fernando Valenzuela. But then Valenzuela shut the Cardinals down for the next seven innings. Meanwhile, Bill Madlock hit a two-run homer for the Dodgers in the fourth inning to

tie the game at 2. The game remained tied until the bottom of the ninth, when the Dodgers top relief pitcher, Tom Niedenfuer, was called on to stop the Cardinals and get the game into extra innings.

Willie McGee led off for the Cardinals and Niedenfuer quickly got McGee to pop out. One away, and next up was Ozzie Smith, who was likely to be no match for the power pitching Niedenfuer. Niedenfuer stood 6 feet 4 inches and weighed 220 pounds. Perhaps more importantly, Niedenfuer was a right-handed pitcher. That meant the switch-hitting 5-foot 9-inch, 155-pound Smith would bat left-handed. In 3,009 at-bats from the

(left to right) Ozzie Smith belts his game-winning home run. ■ Fan favorite Smith signs autographs. (left to right) Smith performs one of his signature back flips during the 1985 World Series. ■ A triumphant Smith rounds the bases.

> left side, Smith had never hit a home run. What followed was one of major league baseball's most improbable moments.

indinals

On his fourth pitch to Smith, Niedenfuer delivered an inside fastball. Smith connected and the ball sailed just inside the foul pole in the right field corner and over the wall.

Describing the scene was Cardinals Hall of Fame broadcaster Jack Buck, who delivered perhaps his greatest call. "Smith corks one into right, down the line! It may go....Go crazy folks, go crazy! It's a home run and the Cardinals have won the game, by the score of 3 to 2, on a home run by the Wizard! Go crazy!" Smith was mobbed at home plate by his teammates as he came across with the winning run. It was the first left-handed home run of his career, and his only postseason homer. Most importantly, it gave the Cardinals a victory over the Dodgers and a 3 games to 2 lead. But the series wasn't over.

ardinal

Two days later in Los Angeles, the Cardinals trailed the Dodgers 5 to 4 in the ninth inning. St. Louis had runners on second and third with two outs. With first base open, Dodgers manager Tommy Latorda elected to have Tom Niedenfuer pitch to Cardinals slugger Jack Clark, a decision on which Lasorda will forever be second-guessed. Clark drilled the first pitch he saw into the left field bleachers to give the Cardinals a 7 to 5 lead. The Cardinals held on to beat the Dodgers and win the series 4 games to 2. Fittingly, the NLCS Most Valuable Player Award went to Game 5 hero Ozzie Smith. Unfortunately for the Cardinals, their luck ran out in the all-Missouri World Series, losing to the Kansas City Royals in seven games.

Ozzie Smith went on to close out a brilliant major league career. He holds the major league record for most assists and double plays, and played more games at shortstop than any other National Leaguer. He was a fifteen-time all-star who thrilled fans by doing cartwheels and flips as he ran out to his position on the field.

In nineteen seasons, he hit only twenty-eight home runs, but even for all of his defensive prowess, Ozzie Smith maybe best remembered for the game-winning homer that made folks in St. Louis go crazy.

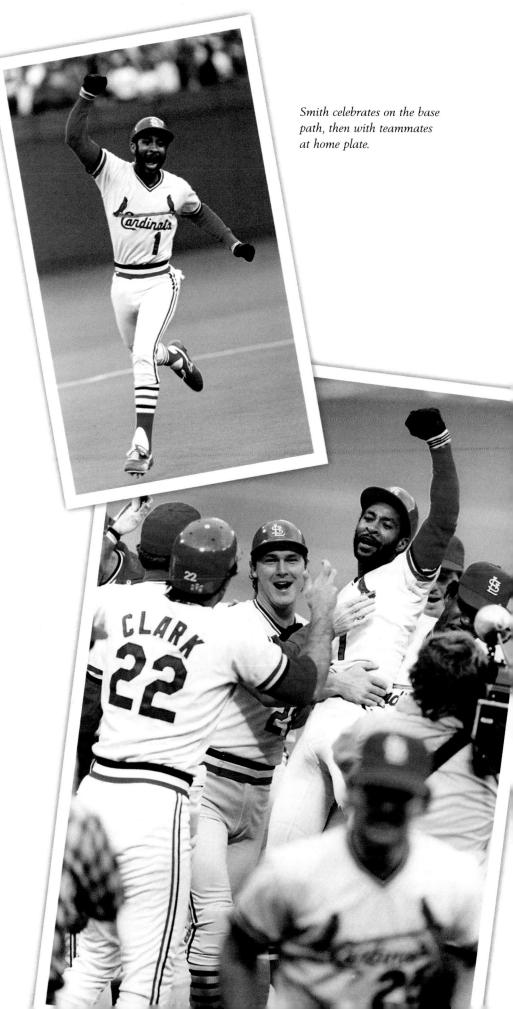

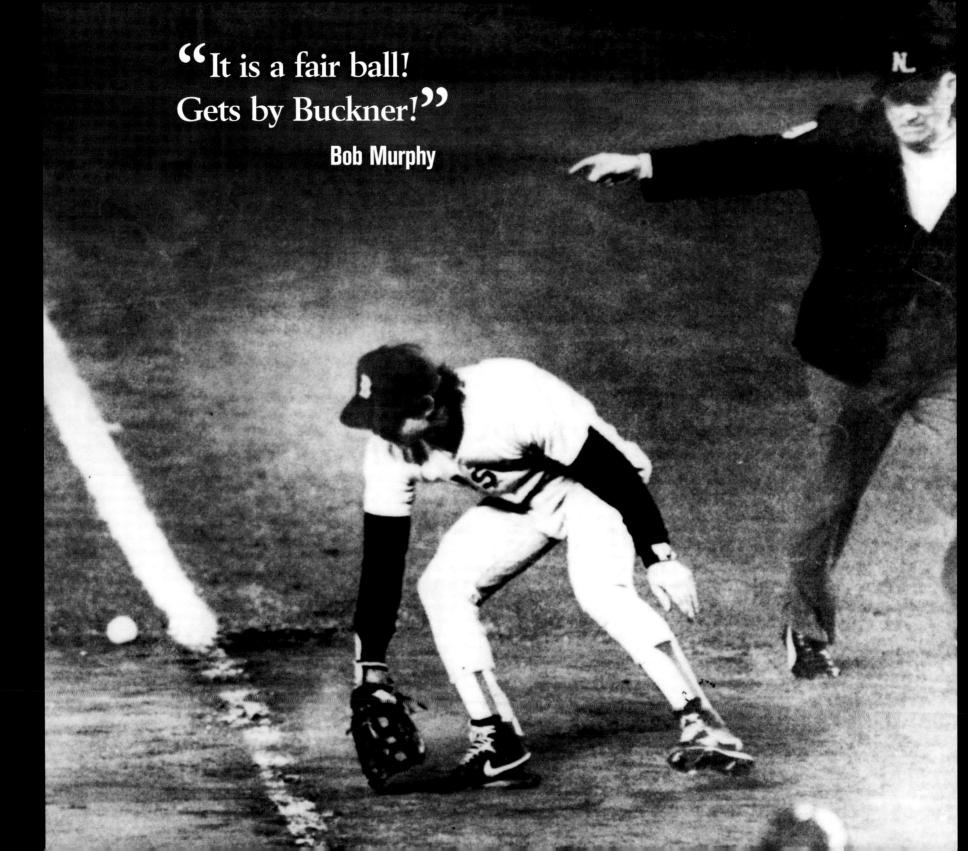

October 25, 1986

Bill Buckner's Unforgettable Error

B ill Buckner was a sometimes magnificent, always consistent hitter. He played twenty-two years in the big leagues, collecting a total of 2,715 hits while compiling a lifetime batting average of .289. He hit over .300 seven times in his career with a high of .324 in 1980 for the Chicago Cubs, which gave him the National League batting title that year. For all his hitting prowess, though, Buckner will never be remembered for his bat, but for his glove and a single play.

The scene was the tenth inning of the sixth game of the 1986 World Series between the Boston Red Sox and the New York Mets. It had been sixty-eight years since the Red Sox last won a Series. It had been sixty-six years since they were saddled with the curse of the Bambino for their role in the worst transaction in sports history—the selling of Babe Ruth to the New York Yankees. Earlier in the 1986 postseason, it had seemed as if the curse was about to strike the Red Sox down again. They were within one strike of elimination when Dave Henderson hit a home run off the Angels' Donnie Moore to keep Boston alive in the American League Championship Series.

In Game 6 of the World Series, victory was again one strike away. But this time, it was the Red Sox who needed the strike. Leading 3 games to 2 in the Series, Boston had taken a 5 to 3 lead in the top of the tenth inning at New York's Shea Stadium. First, Henderson had homered and it appeared as if the man who had saved the American League pennant for his team would top himself by winning the Series. Then, providing a little insurance, second baseman Marty Barrett drove in another run with a single.

In the bottom of the tenth, the Mets, trying to win their first World Series since the Miracle Mets did so in 1969, seemed to have run out of miracles—and outs. They had only one left when Gary Carter singled to keep the Series going. Next came a single by Kevin Mitchell and then yet another by Ray Knight to score Carter. A wild pitch by Boston reliever Bob Stanley with Mookie Wilson at bat allowed Mitchell to come home and again tie the game.

The count to Wilson stood at 3 balls and 2 strikes. The curse of the Bambino reared its ugly head on the next pitch. It was just an easy bouncer up the first base line. All Buckner had to do was pick the ball up and flip it to Stanley, who was racing to cover first base. Even on his bad legs, Buckner would have had no trouble doing that. If only he could have gotten his hands on the ball.

It would have been particularly satisfying for Buckner to have handled the last out since he had

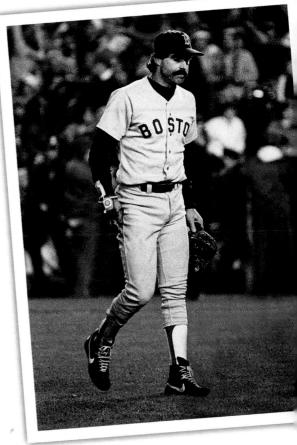

(left to right) Boston Red Sox first baseman Bill Buckner lets a fair ball get past him, allowing the Mets to score the winning run in Game 6 of the 1986 World Series. ■ Bill Buckner walks off the field in humiliation.

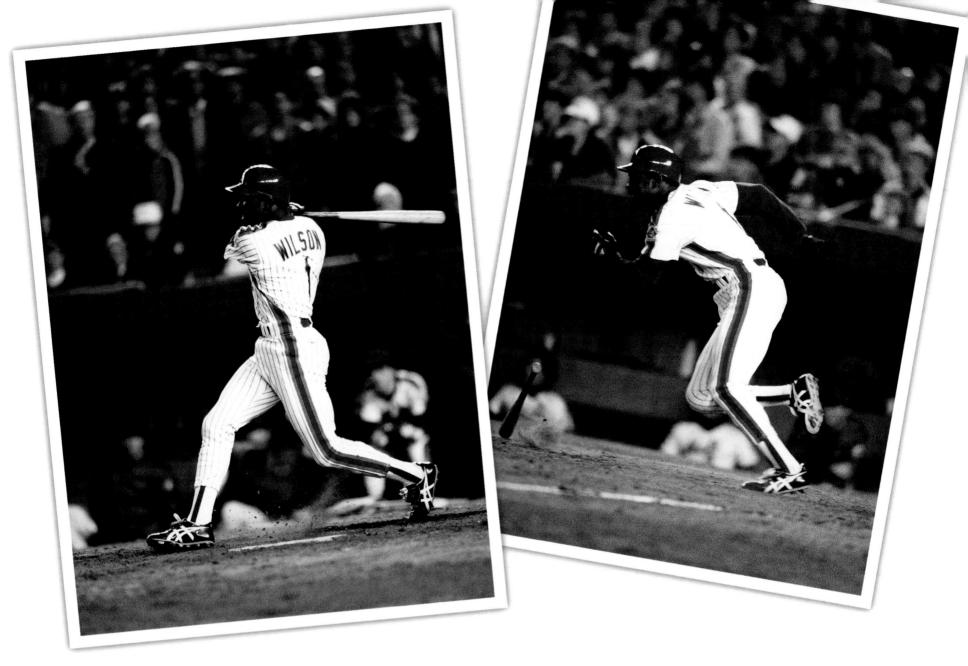

Mookie Wilson hits the game-winning dribbler down the first base line.

batted only .143 in the Series. He had also flied out with the bases loaded to end the eighth inning, blowing an opportunity to put the game away.

Instead, playing on a field that was in bad shape, he would let the game get away.

At the last instant, the bouncer off Wilson's bat skipped up the line towards Buckner, who was unclear if it was fair or foul. Bob Murphy, play-by-play announcer for the Mets Network, echoed that uncertainty, describing it as "a ground ball, trickling...." Then, realizing it was indeed fair, he excitedly proclaimed, "It is a fair ball! Gets by Buckner! Rounding third Knight, the Mets will win the ballgame! The Mets win! They win!" Buckner attempted to scoop up the ball. Instead, the ball rolled under his glove and right through his legs.

"The Mets have won what must be the most amaging game in their twenty-five-year history," announced Murphy. "I can't imagine a more remarkable victory."

And there he stood, a pitiful figure, the ball rolling behind him, and Knight joyously celebrating in front

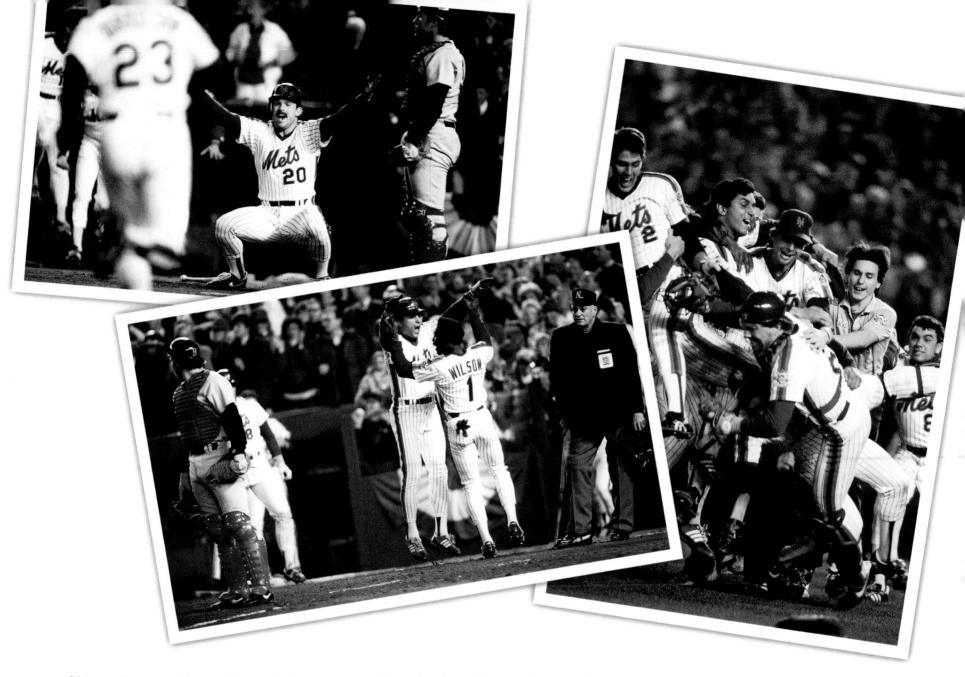

of him as he crossed home plate with the winning run. Wilson said it was, "mirrors, magic wands, whatever," that had given his team the victory. Red Sox fans were more eager to harken back to the Babe Ruth curse. In the hushed Boston clubhouse, a somber Buckner wasn't about to point the finger elsewhere. He was too busy looking inward. "I feel lousy," he said.

In Game 7, the Red Sox blew a 3 to 0 lead and lost to New York 8 to 5, giving the Mets the world championship and new life to an old curse. But, as the years went on, it was Buckner alone who carried the blame for the collapse in the eyes of many Boston Red Sox fans. He retired in 1990 at the age of forty, but he couldn't seem to get away from that ground ball. Even if he could have gotten it out of his mind's eye, there was always someone there to bring it bouncing back.

In 1993, when Buckner was asked to sign a baseball at a park in Pawtucket, Rhode Island, an onlooker yelled, "Don't give him the ball. He'll just drop it." Furious, Buckner allegedly pushed the onlooker up against a wall. "At least once a week," Buckner said, "I hear something about it." The Mets celebrate their Game 6 victory. ■ After Game 7 (far right), the Mets celebrate as world champions.

"This race belongs to Florence Griffith Joyner!"

1981

Charlie Jones

Florence Griffith Joyner Becomes World's Fastest Woman

As transformations go, it was one of the most stunning in the history of sports. Overnight, it seemed Florence Griffith Joyner, customer service representative at a Los Angeles bank and semiretired former Olympic sprinter, had become "FloJo," the gaudy record-breaker for whom the athletic track was a catwalk.

At the 1988 games, the pre-event talk was about the prospects of a relatively unknown woman who had tumbled records at the U.S. Olympic track and field trials in Indianapolis in July 1988.

Until then, hers was a name only a track and field buff would have recognized. She had been a silver medalist in the 200 meters at the Los Angeles Olympics in 1984, and again at the 1987 World Track and Field championships in Rome.

But here she was in Indianapolis, looking as though she'd dressed for Las Vegas. She had brought a wardrobe of more than two hundred racing outfits with her to Indianapolis. One of her outfits consisted of body-hugging gold lamé with a black bikini brief and a bare, muscular leg. She looked otherworldly amidst the staid world of athletics, and her finishing times seemed that way too.

She ran the 100 meters in 10.49 seconds, an astonishing .27 seconds faster than the world

record. That stunning time was followed by a no-less-dominant performance in the 200 meters.

In Seoul, at the first Summer Olympics in the Orient since the 1964 Tokyo Games, FloJo came by her new nickname courtesy of the English tabloids. The tabloids found her record-breaking feats and new, double-barrelled married name, Florence Griffith Joyner, too much for a single headline to carry.

If she had merely run fast, none of the notoriety and hype might have occurred. But Griffith Joyner was beautiful as well as athletically gifted, and long, brightly painted, talon-like fingernails augmented her vivid red Olympic competition uniform. FloJo had dressed for success, which is exactly what followed.

Her 10.49 in the second round of the 100 meters had more than the allowable wind assistance. In the final, her sole competition was the clock. She won in a time of 10.61 seconds, an Olympic record. (clockwise from left) Florence Griffith Joyner wins the 100-meter dash in the 1988 Olympics in Seoul. ■ Griffith Joyner in the 1984 Olympics ■

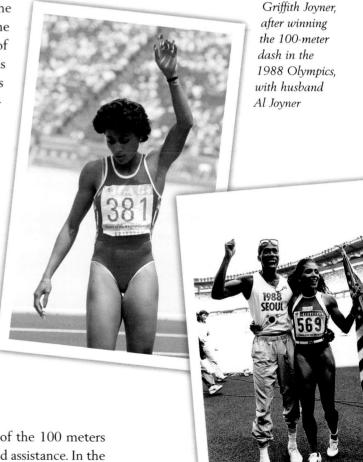

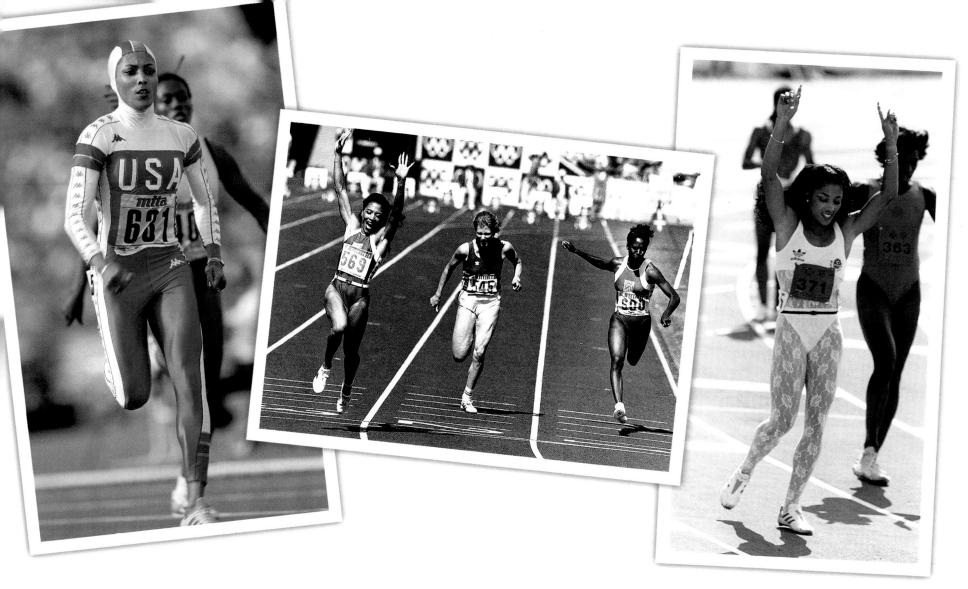

 (left to right) Griffith Joyner competes at the World Track and Field championships in Rome. 1987 ■
 Griffith Joyner wins the 100-meter dash at the Seoul Olympics. ■
 Griffith Joyner's flamboyant outfits won her many fans.

If anything, Griffith Joyner was even more dominant in the 200, breaking the nine-year-old world record by .15 seconds in the semifinals. Just ninety minutes later, she sought to top that mark in the finals.

Calling the race for the NBC Television Network was Charlie Jones, and veteran runner Frank Shorter provided the color. Just before the starter fired the pistol, Jones revealed a prediction Shorter made earlier in the day, that FloJo "will set a new world record in this race." The pistol fired and Jones called the action, "And it's a good start...Florence Griffith Joyner already closing the stagger on Grace Jackson, that is her first goal. And here she comes, she'll pick it up as she turns down the straight!" By the time she had straightened out of the bend, Griffith Joyner already had the race in her keeping. "She's running after another record!" With the finish line approaching, her face was split by the broadest of smiles. "This race belongs to Florence Griffith Joyner!" Jones shouted, trying to be heard above the cheering. As she crossed the line, arms raised in triumph, the clock at the side of the track recorded the magnitude of her performance: 21.34 seconds, a new world record, just as Shorter had foretold.

Another gold medal followed in the $4 \ge 100$ relay. Griffith Joyner fell three meters short in her quest to join Fanny Blankers-Koen of the Netherlands as the only female winner of four

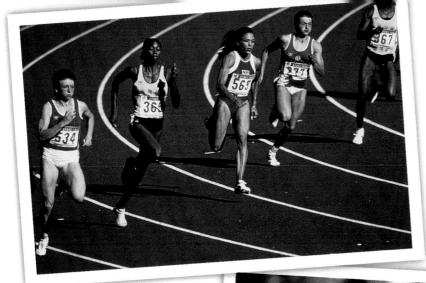

(top to bottom) Griffith Joyner runs in the 200-meter dash in the 1988 Olympics. ■ A victorious Griffith Joyner hoists the American flag at the Seoul Olympics.

track gold medals when her team finished second in the 4 x 400 relay.

In track and field, no such level of achievement is attained without questions. From Indianapolis to Seoul and back again to Los Angeles, Griffith Joyner faced the innuendo that her performances were drug-enhanced. The inevitable answer, from both her and her husband and coach, Al Joyner, a triple jump gold medalist at the 1984 Olympics, was that every drug test she had ever taken had returned negative results.

FloJo's time in the sun was brief. In February 1989, less than two months after her twentyninth birthday, she announced her retirement. Two years later, she gave birth to a daughter, Mary Ruth.

On September 21, 1998, at the age of thirtyeight, Florence Griffith Joyner died in her sleep from suffocation during an epileptic seizure.

As well as breaking records, Griffith Joyner was a pioneer in another way. "You know what I remember about FloJo," a female fan told distance runner Francie Larrien Smith while on the road. "She made it OK for women to be flashy, to be beautiful and glamorous, and be an athlete."

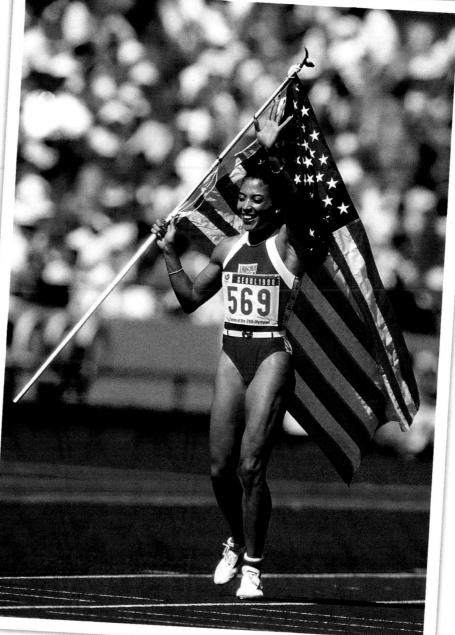

"The 49ers have scored with thirty-four seconds remaining!"

Lon Simmons

January 22, 1989

Joe Montana Leads Super Bowl-Winning Drive

For a few brief moments, he was just an "ordinary Joe," angry, yelling, and breathless, as though overwhelmed by the enormity of the occasion. There was just over a minute to play in Super Bowl XXIII and Joe Montana had just overthrown his receiver. The San Francisco 49ers trailed the underdog Cincinnati Bengals by three points. No team in Super Bowl history had been behind so late in the game and still won. But the 49ers were driving, and had advanced the ball to the Bengals' thirty-five-yard line. "I was sitting there, screaming as loud as I could, and I hyperventilated," Joe Montana said later. "I got dizzy. I almost called time out, but it faded away."

Before, and especially after that moment, Montana was his usual self, "Joe Cool," carrying the 49ers to victory over ninety-two yards in eleven plays, including nine passes, eight of them complete, in a span of two minutes and thirty-six seconds. It was a display of wizardry and aplomb that became known in 49ers lore as "The Drive."

Along with the Washington Redskins and the Oakland/Los Angeles Raiders, the San Francisco 49ers had strong claims on bragging rights for the "team of the decade" after previous Super Bowl victories in 1982 and 1985. But they had struggled through the 1988 season. At one point, their standing was 6–5, indicative of the turmoil within the club as coach Bill Walsh continued to toy with the

notion of replacing the often injured Montana with rising young left-hander Steve Young.

The 49ers had rallied, though, and qualified for the playoffs with a record of 10–6. In the playoffs, Montana held a hot hand and made the job his own during one-sided victories over Minnesota (34–9) and Chicago (28–3).

The 49ers were favorites going into their third Super Bowl, more so when it became known that Bengals fullback Stanley Wilson had been suspended on the morning of the game by the NFL after a cocaine binge the night before.

Quarterback Boomer Esiason later claimed Wilson's absence crippled the Bengals' offense. "We couldn't convert any third-and-ones, and that's because our fullback was in a drug-induced haze," Esiason told the *Cincinnati Enquirer*.

Recent history did not bode well for the AFCchampion Bengals either. AFC teams had been blown out of the game in the preceding four Super Bowls. No one expected this to be any different except the Bengals themselves.

But the Bengals' defense surrendered only a field goal in the first half, then another near the end of the third quarter. The score was tied at six and the

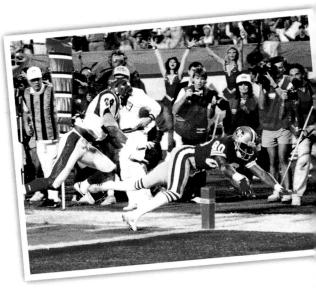

(left to right) Joe Montana in Super Bowl XXIII ■ Jerry Rice (80) scores a touchdown to tie the score during the third quarter.

49ers kicked to Cincinnati's Stanford Jennings. After forty-four minutes and twenty-six seconds of play, Jennings scored the game's first touchdown on a ninety-three-yard return—the longest touchdown drought in Super Bowl history—to give the upstart Bengals a 13 to 6 lead.

Montana responded within minutes of the start of the last quarter, taking his team eighty-one yards in five plays, connecting with Jerry Rice to even the score at thirteen. What had been a sputtering game was suddenly ignited.

Cincinnati's reply was a forty-six–yard surge to the San Francisco twenty-two. Jim Breech's fortyyard field goal, his third of the game, put the Bengals in front 16 to 13. There were three minutes and twenty seconds remaining on the clock. An upset beckoned.

> From the ensuing kickoff, the 49ers were flagged for holding and penalized back to their eight-yard line.

(top to bottom) Joe Montana sets to pass. ■ John Taylor (82) catches the ball while evading Ray Horton (20). ■ Taylor scores the game-winning touchdown for the 49ers.

(opposite page, clockwise from upper left) Taylor celebrates his score. ■ Joe Montana raises his arms in triumph. ■ Montana and Taylor celebrate their game-winning touchdown in the end zone.

110

"The Drive" started with Montana on the very edge of his own end zone.

The 49ers' "West Coast" offense was designed to gain ground yard by yard, rather than in one savage blow. With his first three passes, Montana had gains of eight, seven, and seven yards to three different receivers.

Twice, Montana was able to conserve time by completing sideline passes to wideout Jerry Rice, who stepped out of bounds. The second time was at the Cincinnati forty-eight-yard line, with 1:34 left to play.

First and ten at the Bengals' forty-eight and Montana passed to running back Roger Craig over the middle for a gain of thirteen yards.

First and ten at the Bengals' thirty-five and again Montana hurled to Rice near the sanctuary of the sideline, but this time he overthrew his receiver.

Furious with himself, Montana had to repeat himself at the top of his voice over the din of Miami's Joe Robbie Stadium, calling the plays two at a time to his offense. He began to feel himself hyperventilating. "I just ran out of breath for a second," he said later.

The next play saw offensive lineman Randy Cross penalized for being illegally downfield, pushing the 49ers back to second and twenty at the Bengals' forty-five. Rice had been hobbling on a sore right ankle all week and all game, but he wouldn't show it on the next play, as Montana found him twelve yards upfield. Rice spun away from his defender and gained another fifteen yards.

First and ten at the Bengals' eighteen and Craig took another short pass over the middle, then ran it eight yards to the ten.

In the broadcast booth for the 49ers was announcer Lon Simmons, with Wayne Walker and Joe Starkey doing color. "It's such a sight to watch this," said Starkey. "To watch Joe Montana do this...to watch

this absolute surgeon on the football field, and one of the all-time greats do his thing again, it's almost like poetry."

Second and two at the ten, thirty-nine seconds left in the game, and Montana dropped back. Craig, his first option, was covered, as was his second choice, tight end John Frank.

The cheering in Joe Robbie Stadium grew deafening as a 49ers victory stood a mere ten yards away. Lon Simmons called the action, "At the ten-yard line, thirty-nine seconds remaining...Montana at quarterback, in motion, comes right." Montana called for the "20 halfback curl x-up" with Craig intended as the primary target over the middle, and Rice in motion. Wideout John Taylor had floated into the end zone, between the two Bengals safeties. "Back to throw, Montana steps up, throws," Simmons continued. When Montana spotted that Rice was covered, he looked to Taylor, fired, and Taylor held his first catch of the game. "Touchdown 49ers!" screamed Simmons. "Taylor has it for the touchdown...a ten-yard pass. The 49ers have scored with thirty-four seconds remaining!" Ninety-two yards in eleven plays, and with the extra point from kicker Mike Cofer, the 49ers sealed their 20 to 16 Super Bowl victory.

Veteran Bengals receiver Cris Collinsworth watched from the sideline. "Joe Montana is not human," he later declared. "Every single time he's had the chips down and people are counting him out, he's come back."

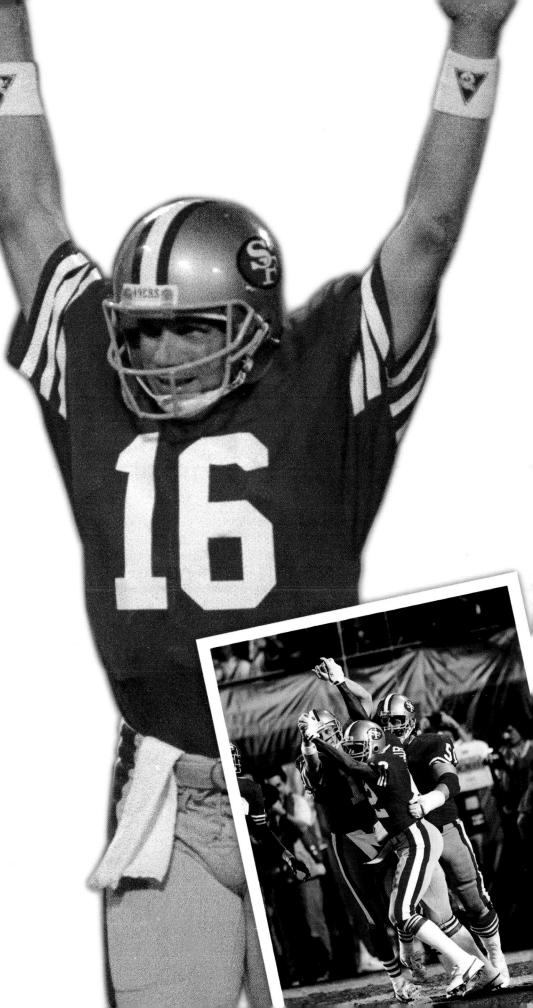

"Good! The Bulls win it! They win it!"

JORDAN

22

Jim Durham

Disc 2 • Track 8

May 7, 1989

"The Shot": Michael Jordan Beats Cleveland

A lthough he had been a star at North Carolina, by 1989, Michael Jordan had yet to prove he could be a clutch player in the NBA. Although Jordan and the Bulls made the playoffs several times, they had not gotten past the second round.

The 1989 playoffs announced Jordan's arrival once and for all. With the Bulls up two games to one in their opening-round, best-of-five series, the Cleveland Cavaliers came back to even the series with a 108 to 105 overtime victory in Game 4.

What made the loss most painful for Jordan was that he had missed a free throw with nine seconds left in regulation time that could have provided the game's winning margin. People were tossing around two words that were almost never before or after written or spoken together, "Jordan" and "choke."

Game 5 in Cleveland again came down to the final seconds. And it appeared that it had come down to another postseason disappointment for the Bulls. After a Jordan jump shot with six seconds remaining put Chicago ahead by one, Craig Ehlo scored on a lay-up for the Cavaliers with just three seconds remaining.

The score stood at Cleveland 100, Chicago 99. Bulls fans listening to the Chicago Bulls radio network heard Jim Durham call the clutch play by Jordan, "The inbounds pass comes in to Jordan." Jordan went up, moving the ball from his midsection into shooting position, and shot. "Good! The Bulls win it! They win it!" cried Durham. "Michael Jordan, with forty-four points in the game, hit the

Jordan burst into a wild, fistpumping celebration. "Superman was superman and no one is going to talk about that missed free throw in Game 4 now!" Durham observed.

shot over Craig Ehlo!"

The game and series went to Chicago. The Bulls went on to beat the New York Knicks in the next round before being eliminated in the conference finals by the Detroit Pistons.

Jordan's greatest celebrations would come in the next decade, when he would lead his Bulls to six NBA championships in the 1990s. Throughout the championship years, he would prove time and time again that a last-second Jordan shot meant near certain defeat for all challengers.

(left to right) Jordan shoots over Cleveland's Craig Ehlo. ■ Jordan dunks for two of his forty-four points.

1.5.4-2

Giro

Greg LeMond Wins Tour de France

Most years, the winner of the Tour de France rides along the Champs-Elysees to the finish line hidden among a swarm of 150 riders, notable only as the one clad in the vivid yellow shirt of the race leader. The finish for the 1989 race was different. The leader, Frenchman Laurent Fignon, pedaled furiously to preserve his advantage, while his challenger, American Greg LeMond, focused on dragging every last second out of his legs. LeMond was attempting a personal and competitive comeback without equal in one of the toughest and most beloved European sporting events.

By all accounts, Greg LeMond should not have been able to compete in the race that year. LeMond, the winner of cycling's Road Racing World Championship in 1983 and the Tour de France in 1986, had been shot accidentally by his brother-in-law while they were turkey hunting on a ranch in Lincoln, California, in April 1987. About sixty shotgun pellets were lodged in LeMond's back and side. Some of them struck his right lung, which collapsed. Others hit a kidney and his liver. Two were lodged in the lining of his heart. His wounds were nearly fatal. Even after surgery, thirty of the lead pellets remained in LeMond's body.

LeMond's medical problems, some unrelated to the shotgun injuries, caused his support to wane. He lost his sponsor and had to join with a lesser cycling team for financial support. Observers gave him no chance of making an impact on the sport.

For a time, LeMond would agree with that assessment. He came close to quitting halfway through the Tour of Italy, the main event preceding the grueling Tour de France, but persisted, encouraged by his results toward the end.

The 1989 Tour de France was less than a week old when LeMond won a forty-five-mile time trial, in which the cyclists race against the clock rather than each other. His victory gave him the lead in the Tour. He lost it five days later in the Pyrenees Mountains to Frenchman Laurent Fignon, but recaptured it in the second of the Tour's three time trials.

Fignon took over the lead again on the last day in the Alps, surging away from LeMond on the torturous ascent up the famous L'Alpe d'Huez. LeMond's fifty-two-second lead evaporated in the final two and one-half miles. Fignon led by twentysix seconds. A day later, he led by fifty seconds after a surprise victory in the third-to-last day of racing. To every expert and any other onlooker, it was a lead that appeared insurmountable.

The last throw of the dice was the third and final time trial, a trek that spanned more than 15.2

(left to right) Greg LeMond speeds to victory in front of the Arc de Triomphe in the 1989 Tour de France. ■ Greg LeMond

(left to right) Greg LeMond and Laurent Fignon climb during the 17th stage of the Tour de France. ■ LeMond sprints down the Champs-Elysees.

(opposite page, clockwise from upper right) LeMond receives the yellow jersev as his son Jeffrey looks on. ■ LeMond on the victory stand ■ LeMond after winning the fifth stage and taking the yellow jersey of the Tour de France ■ LeMond during his first Tour de France win in 1986 miles, from Versailles to Paris. LeMond went to the starting line in the second-to-last position.

Normally, a time trial rider will have his "splits" or cumulative times called to him at every kilometer or mile so he knows his position in relation to his competitors. But ABC Television commentator Sam Posey, who, along with Al Irautwig, led the network coverage of the Tour's final leg, pointed out, "Greg LeMond is the fastest man at all the intermediate checks over all the 136 cyclists who have gone before him. But at his request, he has no idea how well he is doing," said Posey. LeMond decided to ride blind, without the distraction of mental arithmetic. In a desperate effort to pick up the last few valuable seconds, LeMond bore down on his bike's tri-bars. "He assumes that aerodynamic position on the bike," Posey observed. "He will be going faster now than at any other stage in this time trial." LeMond averaged 33.74 miles an hour, and crossed the finish line in twenty-six minutes and fifty-seven seconds, thirty-three seconds quicker than the next best.

At the finish line, a digital clock tolled Fignon's elapsed minutes and seconds. For the Frenchman to prevail, he would have to reach the mark inside twenty-seven minutes forty-seven seconds. "Laurent Fignon approaches the Arc de Triomphe. The key time is 27:47. If he's slower than that, then

the yellow jersey is lost." His clock stopped at 27:55. "The magic time is gone!" Trautwig announced. Moments later, Fignon crossed the finish line and fell off his bike in exhaustion. LeMond triumphed in the closest and most exciting finish the Tour had ever seen.

The day was a story of two comebacks, in a race and in a career, each just as remarkable. The following year, LeMond joined a new French team for a far higher salary, and won the Tour again. He retired in late 1994 after being diagnosed with mitochondrial myopathy, a rare form of muscular dystrophy, almost unheard of among athletes. Although there was speculation that it may have been related to the lead shotgun pellets that LeMond continued to carry in his body, its cause remains unknown.

Bottecchia

Reynolds

Banesto

⁽⁽I'll tell you what, we're having an earth...⁾

Marlbo

Al Michaels

er, there

October 17, 1989

Earthquake Rocks 1989 World Series

They shared a common bay and, in many cases, a common background. But on October 17, 1989, the sixty-three thousand fans who filed into Candlestick Park knew they did not share a common loyalty. Some came to root for the San Francisco Giants, a team rich in tradition that stretched all the way to the other coast, the perfect team for a cosmopolitan city. Others came to root for the Oakland Athletics, a tough, scrappy club, perfect for a blue-collar town.

It was Game 3 of the World Series, with the Giants down two games to none and hoping to avoid winding up at the brink of elimination. But a few seconds before the first pitch was thrown, the insular world of baseball was ripped apart by the harsh, horrifying sounds of reality. At 5:04 p.m., thirtyone minutes before the scheduled start of the game, an earthquake measuring 6.9 on the Richter Scale hit northern California, the epicenter about forty miles south of Candlestick Park.

Terror rolled through the stands as fans with divided loyalties suddenly were locked in a common bond. They were once again fellow Bay area residents, hoping they'd survive the ordeal and emerge to find their homes intact, and their families and friends alive and well.

The destruction outside the park was far worse than within. A bridge had collapsed, buildings had crumbled, and people had died. Inside, the damage consisted of tumbling concrete from sections of the upper deck and the loss of power.

ABC's network telecast began with a recap of the first two games. Anchor Al Michaels had just handed off to color-man Tim McCarver, who was describing game highlights when the video signal began to flicker and then break up. Just before picture and sound

were lost, the TV audience heard Michaels announce the news, "We're having an earth..." An ABC Sports graphic replaced the picture, and over a phone line, Michaels, trying to make light of their situation, said jokingly, "Well folks, that's the greatest open in the history of television, bar none!" ABC was able to restore the telecast with a backup generator, and Michaels, McCarver, and Jim Palmer remained a calm and reassuring presence in what could have been a scene of panic.

Next to the ABC booth, the CBS Radio Network was in a commercial break when the quake hit. Jack Buck, John Rooney, and former major leaguer Johnny Bench were in the CBS broadcast booth but scattered for the nearest exits to wait it out. The rumbling stopped in time for them to take (clockwise from left) Candlestick Park after an earthquake rocked Game 3 of the 1989 World Series Players from both teams gather on the field after the earthquake. Oakland Athletics' Terry Steinbach hugs his wife after the earthquake.

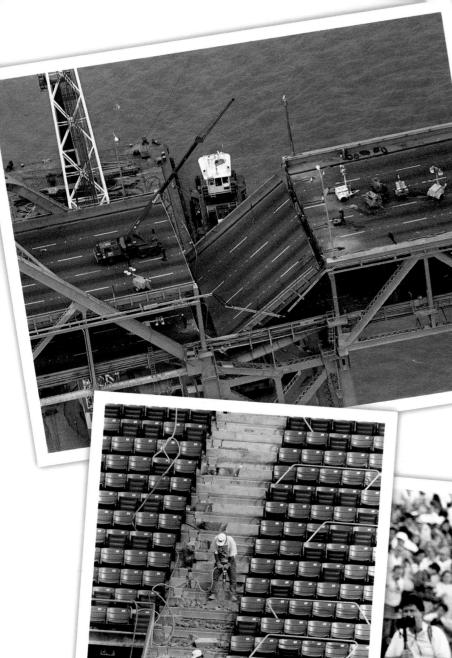

 (top to bottom) The San Francisco– Oakland Bay Bridge after weathering the earthquake ■
 Workers at Candlestick Park use jackhammers to repair damaged
 steps. ■ Players watch fans leave the park in the wake of the earthquake. their positions again before the commercials ended. Admittedly startled by the experience, broadcaster Jack Buck attempted to bring some levity to the moment, saying, "I must say about Johnny Bench folks, if he moved like that when he was playing he'd have never hit into a double play. I never saw anybody move that fast in my life."

Umpire Al Clark, who had been down in a locker room preparing to go to work, rushed out onto the field in his underwear.

Fear also spread through the ranks of players on both teams, both those on the field and those still down in the locker room.

Those on the field said they saw the outfield grass buckle and roll. Those down in the locker room had visions of being buried alive.

Players on the field were now concentrating their focus on the seats, trying to pick out their family members. As they found their wives and kids, some of them sobbing in fear, players had them brought down to the field so that they could all leave together.

High in the upper reaches of the stadium, fans could hear the scoreboard shaking and could see open spaces appear in the concrete. Most flocked to the exits, but a crazy few celebrated. Some started cheering when the quake first struck and reacted with a standing ovation when it was over. They couldn't understand why the game wasn't going to begin, but that wouldn't happen.

With the city outside in a panic and the lights and power within the stadium dead for the evening, baseball commissioner Fay Vincent, on hand in a field box behind the Giants dugout, didn't hesitate. The game was called at 5:35 p.m.

In all, sixty-seven people died in the Bay area quake, with the total damage estimated at around \$7 billion. In comparison, the toll inside the stadium was mild—two people suffered heart attacks and the majority of the fans were merely scared.

In the first frantic hours and days after the earthquake, some questioned the wisdom of even finishing the Series. But, with area residents anxious to rebuild both their structures and their spirits, the Series did indeed resume.

Game 3 had originally been rescheduled for one week after the quake, but the game was again postponed when the onslaught of a storm caused problems with the relief effort. Finally, ten days after Candlestick was rattled, the long-delayed first pitch of Game 3 was thrown.

Picking up where it had left off, Oakland beat San Francisco 13 to 7 in Game 3 and the following day took Game 4 in a 3 to 0 win to sweep their neighbors in four straight.

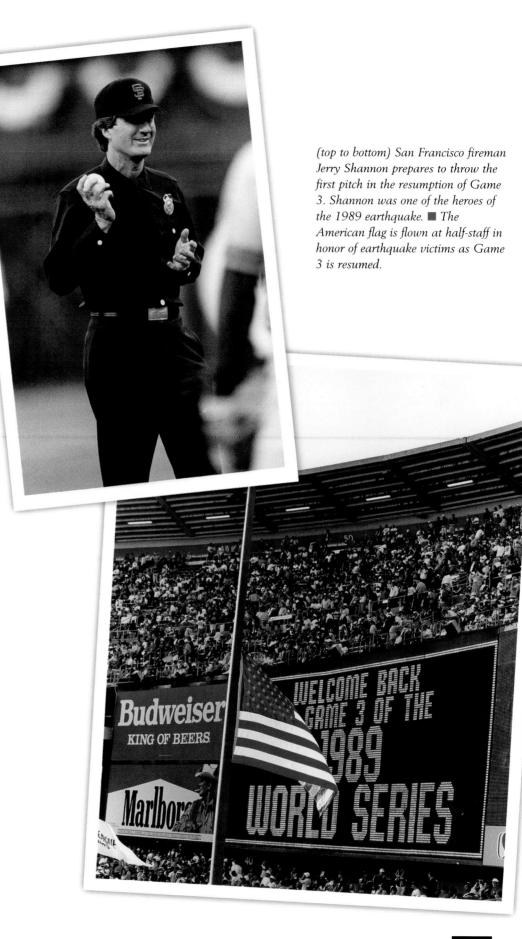

Good! A twenty-five footer over Isiah, what a way to end it!

7

Joe McConnell

Disc 2 • Track 11

Magic Johnson Returns to Capture All-Star Game MVP Title

"G ood afternoon. Because of the HIV virus that I have attained, I will have to retire from the Lakers today."

With one short statement to begin a news conference on November 7, 1991, Earvin "Magic" Johnson, one of the most beloved, best-known, and most respected players in the NBA, not only shocked the sports community, he shocked the entire world. In 1991, the public still perceived the HIV virus and AIDS to be an illness rarely striking anyone other than homosexual males or intravenous drug users. But Magic Johnson was neither, attributing his infection to promiscuous heterosexual behavior.

As the news conference continued, the shock turned to sadness, and fear was in everyone's eyes except Johnson's. With an occasional reassuring smile, Magic did his best to sustain everyone with the promise that he would be OK, that he wasn't going to die anytime soon, and that he planned on doing a lot of living. He told reporters that he intended to be "bugging" them for a long time, and then in a typically self-effacing manner, he asked people to remind him to take his medicine.

Magic Johnson appeared to be the only person at the news conference in control, but then again, he was used to taking control, especially on the basketball court. But doctors feared the physical demands of professional basketball would weaken Johnson's immune system. They urged him to retire, and he did. Figuring he'd played his last NBA game, he immediately got on with the rest of his life as an AIDS awareness spokesman, businessman, and television broadcaster.

Even though Johnson had not played in a game during the 1991–92 NBA season, All-Star ballots already had been printed with his name and the fans rewarded his courage and honesty by voting him onto that year's team. The NBA cleared him to play, so Johnson did.

The stage was set for Magic Johnson to assume his usual starring role, but there were question marks. Since he hadn't played all season, would he be in "NBA shape" to play? Just how advanced was the virus in his body? The questions were quickly answered. For all appearances, Johnson looked to be in midseason form. Magic scored twenty-five points and dished out nine assists. The final minutes proved to be the most memorable. He made a perfect bounce pass assist to teammate Dan Majerle. He twice waved off any kind of defensive help so he could go one-on-one against Isiah Thomas. "Ah, look at this," called Joe McConnell over the NBA Radio

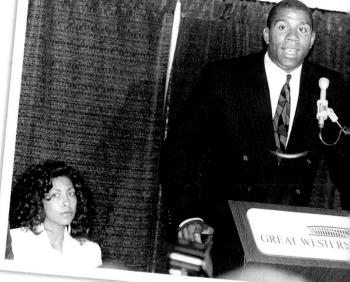

(left to right) Magic Johnson goes for a lay-up during the first quarter of the 1992 NBA All-Star Game. February 9, 1992 ■ Johnson announces his retirement due to testing positive for the HIV virus. Wife Cookie looks on. November 7, 1991 (clockwise from left) Michael Jordan goes one-on-one with Magic Johnson. ■ Johnson starred in college at Michigan State University. ■ Johnson holds up the All-Star Game Most Valuable Player trophy.

Network, "Isiah and Magic, back and forth, back and forth, left hand to right... Magic says, 'Come on guy, give me your best.'" Then it was Michael Jordan's turn, "Now, Michael wants to go one-onone with Magic!...Everybody stands up...forty-two seconds to go...Michael takes Magic baseline...stops...pull-up jumper...in and out no good!

"Rebound Drexler, now to Magic. Magic says, 'Come get me.' Magic with that famous ear-to-ear grin....Twenty-three seconds to go, this game has never been in doubt. It's been all Magic Johnson time here today!" The crowd cheered as the players gave them a show to remember. "Now Magic going one-on-one, fires a threepointer. Good! A twenty-five footer over

Isiah, what a way to end it!" shouted McConnell, as Magic faded away from the basket with his finger pointing in the air. Magic hit a total of three threepointers in the final quarter.

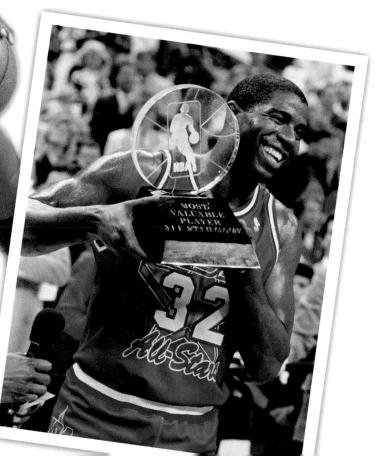

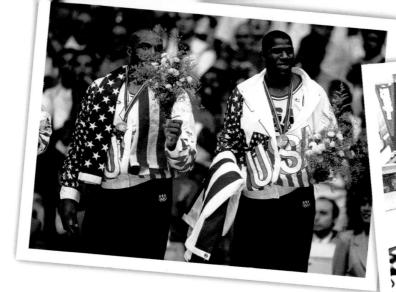

Magic Johnson led the West All-Stars to a 153 to 113 victory over the East, and to top it off, he was named the game's Most Valuable Player.

Players from both sides came on the court to share the moment with Johnson. After the game, Magic said, "It's the first game ever to be called on account of hugs." Recalling the moment in his book *My Life*, Johnson wrote, "There are times in life when you want to take a feeling and put it in a bottle, so you can take it with you forever. I had an entire season's worth of pleasure from that one quarter."

In August 1992, Magic and several other NBA superstars represented the United States at the Olympics in Barcelona. The "Dream Team," as they came to be known, handily won the gold medal in basketball for the U.S. On a larger societal scale, AIDS activists said Johnson showed the world that people infected with HIV could still lead productive lives.

Magic Johnson had hoped to continue his NBA career when he returned from the Summer Games. But his comeback came to an end when rumors began circulating that some NBA players feared playing against an athlete with HIV.

Since then, Johnson has gone on to broadcasting, writing books, and running several businesses. In 1994, Magic coached the Lakers for their final sixteen games of the season. Then, in 1996, he put the Lakers uniform on one more time, and played in the final thirty-two games that season as a bulked-up 255-pound power forward and sometimes power point guard. But, after the Lakers lost in

the first round of the playoffs to Houston that year, Magic Johnson retired from the NBA for good. Provided Magic Johnson remains retired from the NBA, he will be eligible for election to the Hall of Fame in 2001.

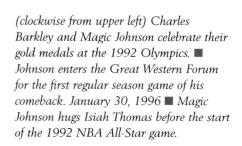

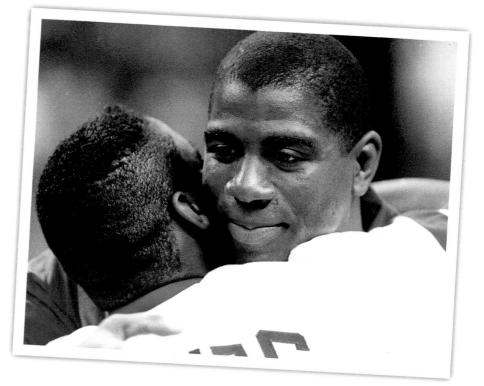

"Laettner catches! Comes down, dribbles. Shoots! Scores!"
Bob Harris

DUK

Duke Beats Kentucky on Christian Laettner Buzzer-Beater

t wasn't a shot that won an NCAA championship. It didn't even gain a berth in the championship game. Yet, the circumstances, the drama, and the sheer explosiveness of the game-winning shot by the Duke Blue Devils' Christian Laettner made it one of the most memorable moments of the decade in college basketball.

Duke entered the 1992 East Regional final against Kentucky with its credentials as a national powerhouse firmly established. The team had won its first national championship the year before, beating Kansas 72 to 65 in the title game.

With four starters coming back for the 1991–92 season, the Blue Devils faced high expectations, and as the season progressed, they matched them. The team won its first seventeen games, and finished the regular season 28–2, ranking No. 1 in the nation, right where it had been since the season's opening tip-off.

Soaring into the NCAA tournament, Duke kept flying high with double-digit victories in each of its first three games. The Blue Devils beat Campbell 82 to 56 in the first round and Iowa 75 to 62 in the second round in Greensboro, N.C.

Then the scene shifted to the Spectrum in Philadelphia where Duke defeated Seton Hall 81 to 69 in a regional semifinal game. Now, all that remained between the Blue Devils and their fifth straight trip to the Final Four were the Kentucky Wildcats.

Kentucky had a special motivation for getting to the Final Four. The team had last been in the NCAA tournament four years earlier, but, as part of the NCAA sanctions imposed on the school in 1989, that tournament appearance, two wins in three games, had officially been treated as if it never happened. The Wildcats were determined to make a mark this time that no one would be able to wipe away.

Kentucky finished sixth in the national rankings and first in the Southeastern Conference in the 1991–92 season. The Wildcats beat Old Dominion 88 to 69 in the first round of the NCAA tournament, and Iowa State 106 to 98 in the second round in Worcester, Massachusetts.

Then, in the regional semifinals at the Spectrum, Kentucky was an 87 to 77 winner over Massachusetts, boosting the Wildcats to a 29–6 record on the season and into a memorable showdown against Duke.

With a 56.9 shooting percentage and a suffocating, pressing defense, Kentucky stayed competitive with the Blue Devils well into the game's second

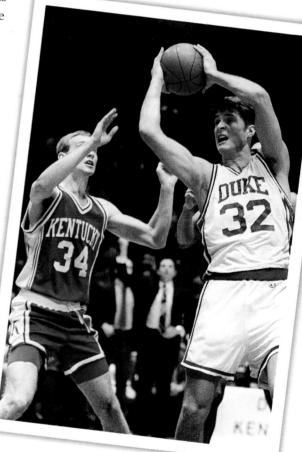

(left to right) Duke's Christian Laettner releases the game-winning shot. ■ Laettner hangs onto the ball during the first half of the East Regional final.

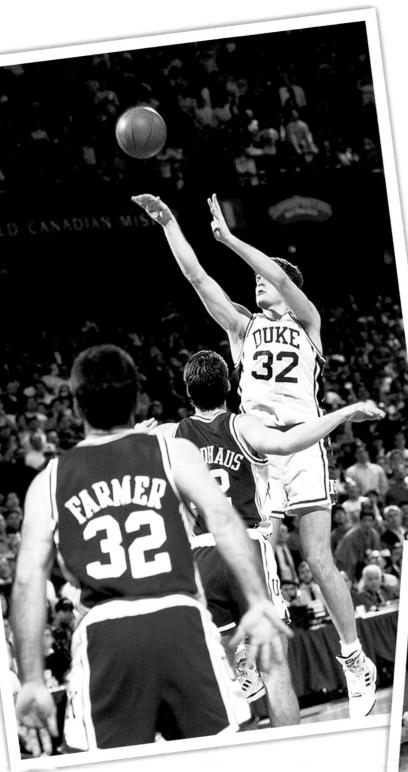

(top to bottom) Laettner rises above Kentucky defenders to hit a miraculous shot. Laettner and Grant Hill celebrate their overtime victory on the floor of the Philadelphia Spectrum. half. But with 7:29 to play, Duke threatened to put the game out of reach, moving into a ten-point lead.

The Wildcats rallied, and with thirty-three seconds to play, the Blue Devils still hadn't shaken their opponents. The score was deadlocked at 93.

Duke's star guard, Bobby Hurley, had a chance to end the game with three seconds remaining. All he had to do was make a ten-foot shot, but he missed.

When Kentucky was unsuccessful in scoring on the ensuing inbounds play, the game moved into a tightly contested overtime period.

It appeared Wildcats guard Sean Woods would be the hero when he drove on Laettner and banked in a shot with 2.1 seconds remaining in the extra period to give Kentucky a 103 to 102 lead.

As he plotted his final play during the ensuing time-out, Duke coach Mike Krzyzewski knew that Kentucky's two tallest starters, Jamal Mashburn and Gimel Martinez, both 6 feet 8 inches, had fouled out. That would make it easier to get the ball to the 6-foot 11-inch Laettner, who hadn't missed a shot in nine attempts from the field.

Laettner was stationed at the free-throw line in front of the Wildcats basket. Calling Duke's last desperate attempt was Bob Harris on the Duke radio network. "All right, Grant Hill will make the inbounds play, so that takes care of that option. Tony Lang and Thomas Hill are in the backcourt to accept the pass. Bobby Hurley up the floor with

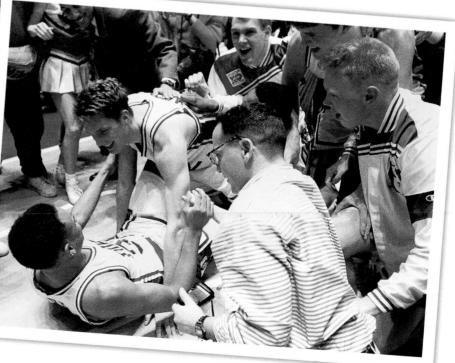

Laettner." Duke had tried the same play earlier in the season only to have Hill's pass miss by a wide margin. But this time, he made a perfect seventyseven-foot throw to Laettner. "They throw it the length of the floor!" Harris shouted excitedly.

Laettner calmly put the ball on the floor for one dribble with the precious two seconds dwindling away. He made a fake to the right, then a pivot to the left and up went the ball from seventeen feet out. And down it came cleanly through the basket to win the game as time expired. "Laettner catches! Comes down, dribbles. Shoots! Scores!" Harris screamed in disbelief.

The arena exploded in cheers. "Christian Laettner has hit the bucket at the buzzer!" Harris recounted. "The Blue Devils win it 104 to 103! Look out Minneapolis, here come the Blue Devils!" Laettner turned and raced up the court, arms spread wide, mouth open, a scream of joy seemingly frozen in his throat as his mind raced to catch up to the moment.

He had played forty-three of forty-five minutes, finishing with thirty-one points and seven rebounds. But Laettner's season was far from finished. Given back a berth to the Final Four that had seemed lost just two seconds of playing time earlier, Duke went on to beat Indiana 81 to 78 in the semifinal game in Minneapolis and then won the championship in impressive fashion, beating Michigan 71 to 51.

Laettner had a game-high nineteen points in the championship game. He won the Wooden Award as player of the year and was also a member of the gold medal–winning U.S. team in the 1992 Olympics. But of all the great shots he had that season, one will always soar above the rest.

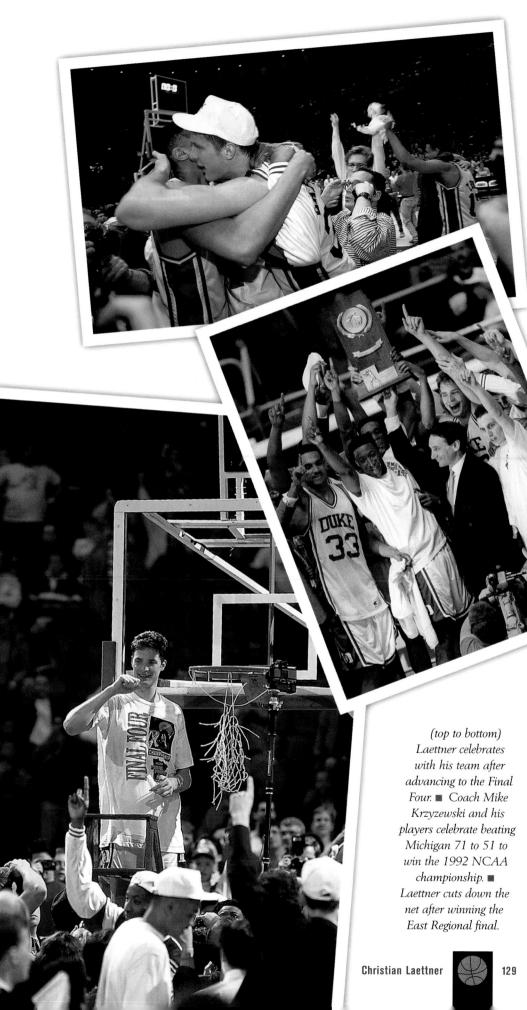

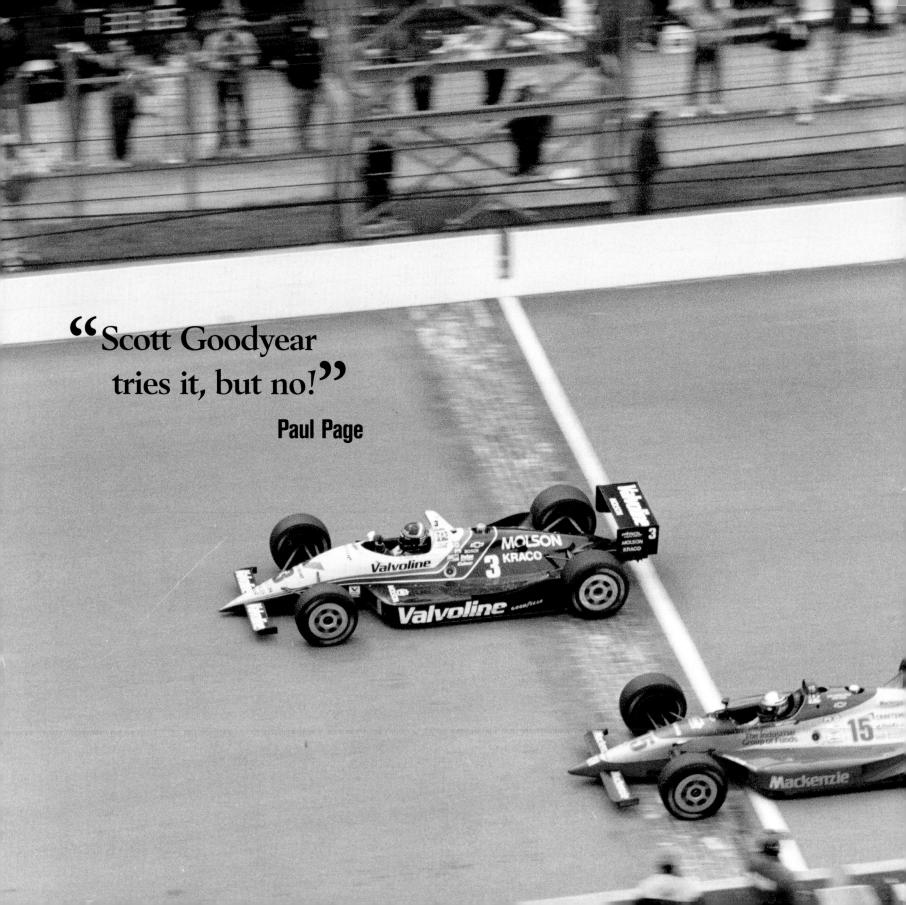

May 24, 1992

Al Unser Jr. Wins 1992 Indianapolis 500

f Charles Dickens wrote about the 1992 Indianapolis 500, he would have said it was the best of races, it was the worst of races. It was a race marred by eleven crashes, injuring thirteen drivers. Eighty-five of the two hundred laps were run under the yellow caution flag, making it the slowest "greatest spectacle in racing" since 1958. But the race also provided the closest finish in Indianapolis 500 history, and missed being the biggest upset by just six feet.

With temperatures in the 50s and a windchill that made it feel like it was in the 30s, the drivers had a difficult time keeping their cars on the track. Racing tires better suited for warm, sticky weather had trouble gripping the cold track.

Polesitter Roberto Guerrero, trying to warm up his tires on the pace lap, slid off the track, and crashed before the race began. Experienced drivers like former 500 winners Mario Andretti, Rick Mears, Emerson Fittipaldi, Arie Luyendyk, and Tom Sneva all crashed and suffered injuries during the race.

One driver who managed to steer clear of the wreckage throughout was Michael Andretti. He clearly had the best-performing car in the race. At one point in the race, he had built a huge twenty-five-second lead, only to see it chipped away by the numerous yellow flags and caution laps.

Still, Andretti held a twenty-two-second lead over second place Scott Goodyear when he took his final pit stop with fifteen laps to go. Michael looked unstoppable, and appeared to be on his way to joining his father, Mario, the 1969 winner, as the only father-son combo in victory lane in Indy 500 history. But, despite his lead, that distinction and honor wouldn't belong to the Andretti family. It would go to the Unsers.

After leading the race during 163 of the first 188 laps, Michael received a dose of bad luck that his father had experienced all too often at the Brickyard. Without warning, his car lost fuel pressure. Mechanical failure ended Andretti's afternoon as he coasted to a stop on lap 189, less than thirty miles from the finish.

Al Unser Jr., "Little Al" as he is known to racing fans, had slipped past Goodyear and into second place on lap 188. With Andretti out of the race one lap later, it was a two-man race to the finish over the final eleven laps. Unser, gunning for his first Indy 500 victory, kept one eye on the track in front of him, and one eye on the rearview mirror as Goodyear was bearing down on him.

Goodyear, who was trying to become the first driver in Indy history to start the race last and finish first, closed the gap, but could not pass Unser, who

(left to right) Al Unser Jr. crosses the finish line to win the Indy 500. Al Unser Jr.

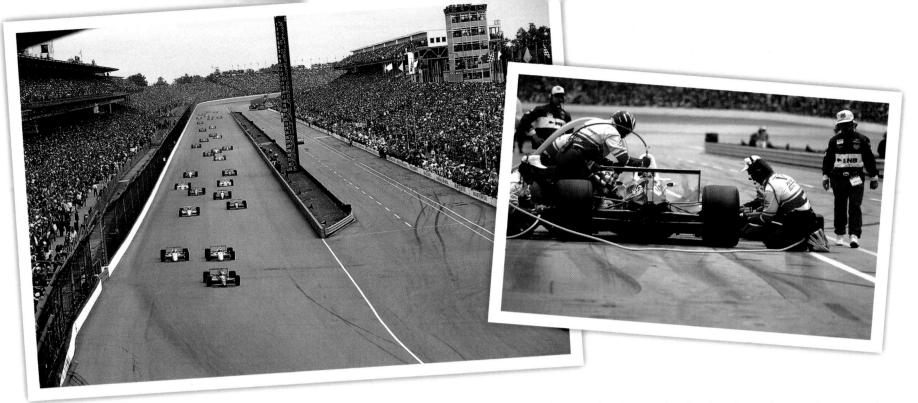

(left to right) The start of the 1992 Indianapolis 500 ■ Unser's pit crew works on his car.

(opposite page, clockwise from upper left) Al Unser Jr. finishes just ahead of Scott Goodyear. ■ Unser wins by the narrowest margin of victory in Indy 500 history. ■ Unser celebrates with the Borg-Warner Trophy behind him. ■ Unser takes a victory lap. maneuvered his car to block any attempt Goodyear made to pass him. "Scott Goodyear is now right there, right behind 'Little Al.' He follows 'Little Al' down the main straightaway. Anywhere 'Little Al' goes there is Scott as well," said Paul Page, who was calling the lap-by-lap action for ABC Television.

Down the final stretch, Unser tried to use the whole track to keep Goodyear behind him, but Goodyear managed to slip inside for one last burst of speed. Sam Posey, calling the race with Paul Page, admired Goodyear's determination, "He can see the possibility of winning the Indy 500 if he can make one pass. But he has got to pass one of the savviest...and most determined drivers in the business."

As Unser logged his 198th lap, Page recalled for viewers that, "On this lap in 1989, Emerson Fittipaldi and 'Little Al' touched wheels. 'Little Al' hit the wall. Fittipaldi went on to the win."

Now at speeds averaging 223 m.p.h., Scott Goodyear and Al Unser Jr. battled nose to tail in the final lap. "If Scott Goodyear has a chance, the time is now," Page shouted, trying to be heard above the roar of the engines. "Don't forget, ten years ago, Johncock and Rick Mears raced on the last lap to the finish. Johncock won that one. That was experience over Rick Mears' relative inexperience. Will that happen again here today?"

No matter which side Goodyear attempted to pass, Unser countered with a preemptive block right to the finish line. Goodyear came up six feet short and thirty-year-old Al Unser Jr. won by just .043 seconds, the narrowest victory margin in the history of the Indy 500. Unser later admitted that Goodyear would probably have won had the race been one hundred yards longer.

Finishing third in the race was Little Al's father, fifty-three-year-old Al Unser Sr. "Even though I ran third today, I did win because my son won," said Big Al. But the focus was on Al Jr., who now joined his father, a four-time winner, and his Uncle Bobby, a three-time winner, in victory lane. Wiping tears from his eyes, Unser summed up his emotions by saying, "You just don't know what this means. This is my life and it [winning] is everything I thought it would be."

Two years later, Al Unser Jr. won his second Indy 500. With a total of nine Indy victories to their credit, the Unser family deservedly has earned the title of the First Family of the 500.

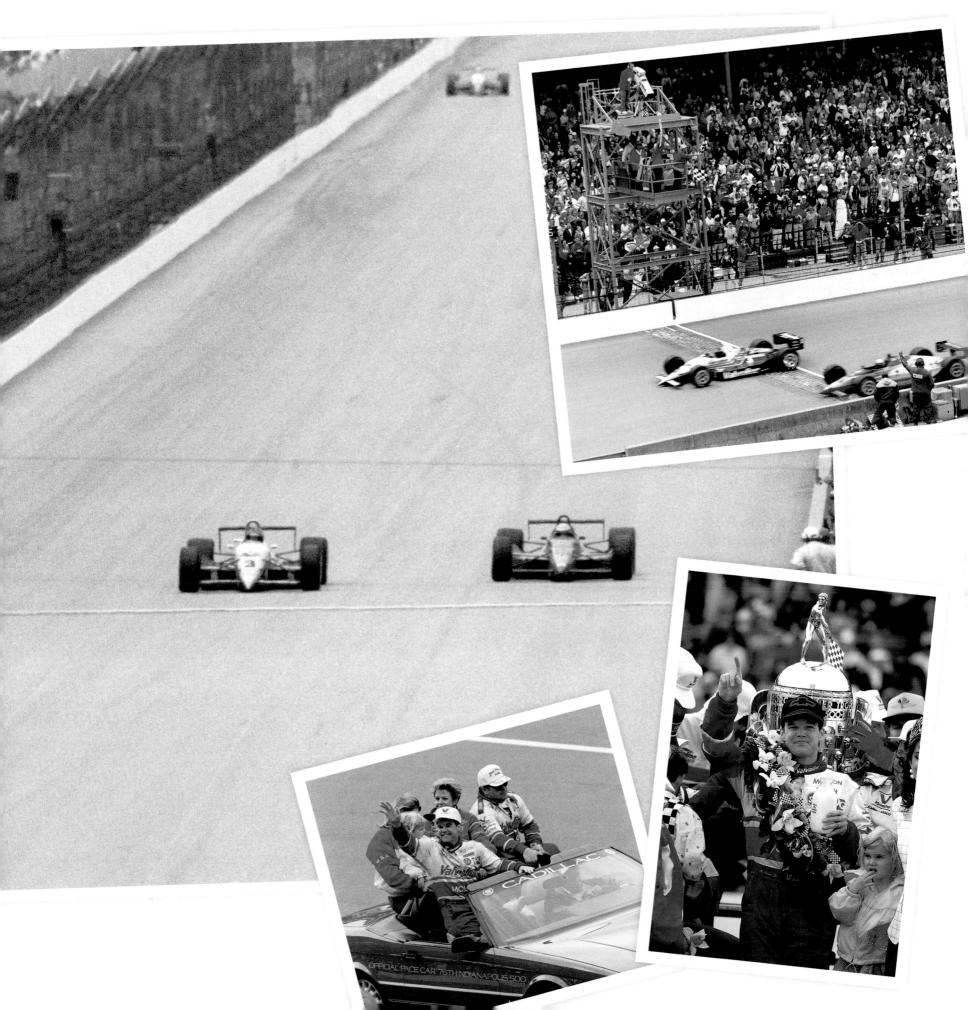

What a comeback by the Bills!... This place is pandemonium! " Van Miller

Buffalo Bills Make Football's Greatest Comeback

n the words of Yogi Berra, "It ain't over 'til it's over." But when Houston Oilers safety Bubba McDowell intercepted Buffalo Bills quarterback Frank Reich and romped into the end zone at Buffalo's Rich Stadium, even the most die-hard of Bills fans had to believe that their American Football Conference wildcard game against the Oilers was finished. McDowell's touchdown gave Houston a 35 to 3 lead with just 1:41 gone in the third quarter. No NFL team had ever come back from such a decisive deficit.

So how could the Bills, who weren't even playing at full strength, hope to rally? Their starting quarterback, Jim Kelly, was out because of a sprained knee. Their star running back, Thurman Thomas, left in the third quarter because of an injured hip. A key defensive player, linebacker Cornelius Bennett, was also out because of an injury.

One man, however, knew that it was possible to pull off such a monumental comeback, because he had already done so. When Frank Reich was at the University of Maryland, he came into a game against Miami in the second half, his team trailing 31 to 0, and led Maryland back to a 42 to 40 victory, one of the greatest comebacks in college football history. "Hey, you did it in college," Gale Gilbert, the Bills' third-string quarterback, reminded Reich in the locker room at halftime. At that point, Houston, thanks to four touchdown passes from quarterback Warren Moon, led 28 to 3. While the Oilers had finished the regular season 10–6, a game behind Pittsburgh in the AFC Central, the Bills had wound up 11–5 in the AFC East, tied for the

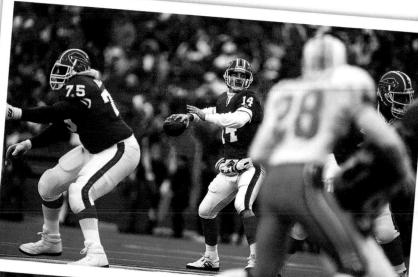

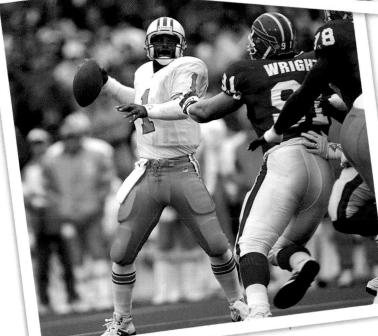

(clockwise from left) Steve Christie and Frank Reich celebrate the gamewinning field goal. ■ Bills quarterback Frank Reich throws a pass. ■ Oilers quarterback Warren Moon cocks his arm to throw.

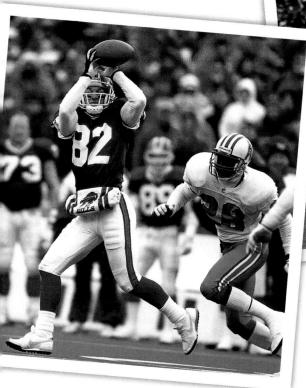

 (left to right) Don Beebe catches a pass.
 ■ Andre Reed's third touchdown miraculously puts the Bills in the lead, 38 to 35.
 ■ Steve Christie boots the winning field goal. Frank Reich holds. top spot with Miami. Miami was deemed the division winner by virtue of a tiebreaker, but Buffalo was at least entitled to host its wildcard game. Its home-field advantage hadn't helped in the first half.

In the second half, however, the home field started rocking with the sounds of 75,141 fans unable to believe what they were seeing. After Reich had enabled Houston to add another seven points onto the scoreboard by throwing an interception early in the third quarter, he took the first tentative steps on the long comeback trail.

And the Oilers helped out. Rather than playing it safe with their huge lead, Houston unsuccessfully attempted a squib kick. The Bills recovered at the fifty-yard line and Reich moved surely and effectively down the field. He began with a pair of passes to receiver Andre Reed, and concluded with a handoff to running back Kenneth Davis, who scored from the Oilers one-yard line. The score now stood at Houston 35, Buffalo 10, still a seemingly insurmountable lead.

Now it was the Bills' turn to try an onside kick. They were successful in recovering it and Reich soon connected with Don Beebe on a thirtyeight–yard touchdown pass. The Bills now faced a not-so-Insurmountable 35 to 17 deficit.

The Oilers got the ball on the kickoff, but couldn't gain ground and punted. Back on the field, Reich again found the end zone, this time hitting Reed with a twenty-six–yard touchdown pass. Houston 35, Buffalo 24. There was still more than a quarter to play, but the ranks of the believers grew.

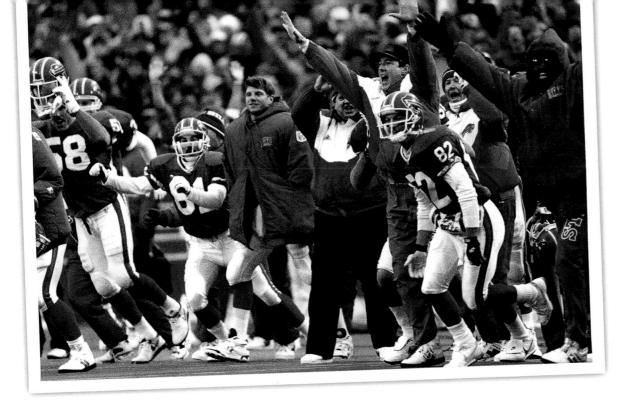

(top to bottom) The Bills' sideline erupts with cheers at their victory. Comeback hero Frank Reich waves to the crowd.

After Moon threw an interception, the Bills drove down to the Houston eighteen-yard line where Buffalo faced a fourth and five. A field goal attempt would have been the safe play. Having come back this far, however, Buffalo coach Marv Levy wasn't about to play it safe. He gave Reich the OK to put the ball in the air and the Bills quarterback again found Reed, this time for eighteen yards and a touchdown. Houston was barely holding their lead when the third quarter mercifully ended for the Oilers. The Bills had scored four touchdowns in six minutes and fifty-two seconds, cutting Houston's lead to 35 to 31, and they weren't done.

With just over three minutes to play in the game, Reich and Reed hooked up on another touchdown pass, this one for seventeen yards. The seemingly impossible had become possible and the lead changed hands—Buffalo 38, Houston 35.

Demoralized, the Oilers were not yet defeated. They pulled a minor comeback of their own to tie Buffalo at 38 on a twenty-six–yard field goal by Al Del Greco, sending the game into overtime. But again, Moon tossed an interception, throwing it on his first possession in the sudden-death period. The Bills took advantage and this time called in Steve Christie to kick a thirty-two–yard field goal.

Summing up the moment, Bills play-byplay announcer Van Miller said, "The kickers don't work very long but they earn their money in a situation like this. We're looking at a thirty-two-yard field goal...and maybe the impossible dream, the impossible comeback by the Bills." Reich took the snap, set it, and Christie booted it. "The kick is on the way, and it is good! The Bills have won it! The Bills have won it!...What a comeback by the Bills!...This place is pandemonium!" Miller shouted. The kick by Christie sealed the Buffalo triumph 41 to 38, a berth in the second round of the playoffs, and a comeback that would give hope to every team that ever fell far behind. "I never thought we were out of it," Reich said.

The Bills went on to defeat Pittsburgh 24 to 3 and Miami 29 to 10 to reach the Super Bowl for the third straight year. But there it was the same sad story for Buffalo, losers of the two previous Super Bowls. At the Rose Bowl in Pasadena, the Bills fell behind the Dallas Cowboys early in Super Bowl XXVII. And, unlike their Texas neighbors, the Cowboys held firm to crush the Bills, 52 to 17. Way back! Blue Jays win it! The Blue Jays are World Series champions!²⁹ Tom Cheek

U

Disc 2 • Track 15

October 23, 1993

Joe Carter Homer Wins 1993 World Series

Until Joe Carter came to bat for Toronto in the ninth inning of the sixth game of the 1993 World Series, only Bill Mazeroski had won a Series with a home run. Mazeroski's memorable blow for the Pittsburgh Pirates came in the ninth inning of the seventh game of the 1960 World Series against the Yankees.

It figured that the Blue Jays would win their second consecutive World Series on a big hit since they had been propelled all season by the power and productivity of their offense. The top three hitters in the American League in 1993 were Blue Jays batting title winner John Olerud (.363), followed by Paul Molitor (.332), and Roberto Alomar (.326). Carter had led the team in both home runs (33) and RBIs (121).

When Toronto got to the World Series in 1992, it was a novelty, the first team outside U.S. borders to reach the pinnacle of America's national pastime. Having beaten Atlanta in that Series, the Blue Jays remained dominant in '93, winning their third straight American League East title under manager Cito Gaston. They compiled a 95–67 record, then eliminated Chicago in six games in the league championship series.

While nobody should have been surprised to see Toronto back in the Series, people certainly didn't expect to see the Philadelphia Phillies there. After all, Philadelphia had finished last in the National League East in 1992 at 70–92 under manager Jim Fregosi. With Fregosi still at the helm, the Phillies improved by twenty-seven games in 1993 to win their division, then knocked off Atlanta in six games to reach the Series.

The Blue Jays and Phillies split the first two games, which were played in Toronto, but the Blue Jays won two of the next three, all in Philadelphia, including the unforgettable fourth game in which the Blue Jays outlasted the Phillies, 15 to 14.

Trailing 5 to 1 in the seventh inning of Game 6, with Toronto ace Dave Stewart on the mound, Philadelphia appeared to stave off elimination by scoring five times. Outfielder Lenny Dykstra supplied the key hit, a threerun homer.

The score stood at 6 to 5 when Toronto came to bat in the bottom of the ninth. Phillies relief pitcher Mitch Williams began by walking Rickey Henderson on four pitches. After Devon White flied out to left, Molitor, who would be named the Series Most Valuable Player, singled to center. (left to right) Joe Carter celebrates his bottom-of-the-ninth-inning home run.
■ Phillies relief pitcher Mitch "Wild Thing" Williams

To the plate came Carter, who didn't swing at the first three pitches as Williams fell behind in the count 2–1. Carter, figuring he had Williams where he wanted him, figured wrong. With an outside slider coming his way, Carter swung and missed. The count stood at 2–2.

Williams knew that Carter liked the inside fastball, so he tried to throw a fastball outside. But instead, living up to his nickname, "Wild Thing," Williams' pitch sailed inside. "Here's the pitch on the way. A swing and a belt!" shouted Toronto announcer Tom Cheek. An instant later, the ball was sailing over the left field fence. "Way back! Blue Jays win it! The Blue Jays are World Series champions, as Joe Carter hits a three-run home run in the ninth inning, and the Blue Jays have repeated as World

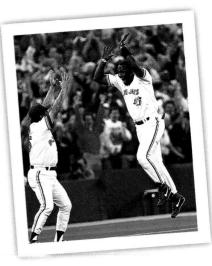

Series champions." Although it cleared the fence by only four feet, in the baseball history books, it will go down as one of the great blasts of all time. "Touch 'em all Joe! You'll never hit a bigger home run in your life!" cried Cheek.

Carter erupted in joy, leaping, dancing, and swinging his arms merrily as he made his way around the bases and into the arms of his equally joyous teammates at home plate. "I can't even describe the feeling," Carter said later. "I don't think they've made that word up yet." Perhaps only Mazeroski would understand.

Williams, known for his bravado, could only sit and cry at his locker stall after Game 6. "It's all my fault," he kept saying. Williams' earlier fits of wildness had already so enflamed fanatical Philadelphia fans that three death threats had been phoned in to team headquarters a few days earlier. In the ensuing days, rocks were thrown through windows of his Pennsylvania home. Williams was soon gone from

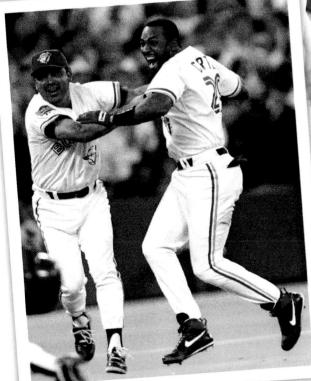

Philadelphia, trying to resurrect his career in Houston, but he never seemed to recover from his one disastrous pitch.

Carter played another four impressive seasons in Toronto. Three times he drove in more than one hundred runs and three times he hit at least twenty-five home runs. But in the minds of Canadians, there would always be one home run that would stand out above all the others.

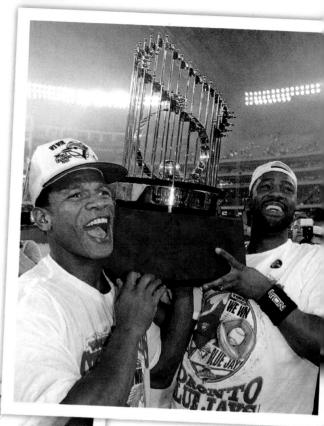

(opposite page) Carter during and after his game-winning homer

(clockwise from upper right) Joe Carter (right) and Rickey Henderson hold up the World Series trophy. ■ Carter celebrates on the field with teammates. ■ Carter and coach Nick Leyva

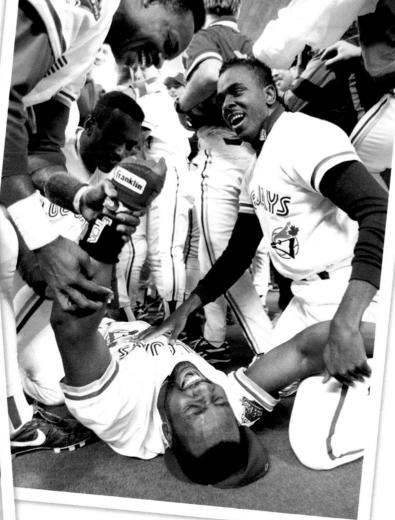

"I think that Nancy Kerrigan knows that this could be a golden performance!"

Paul Wylie

February 24, 1994

Kerrigan vs. Harding: Soap Opera on Ice

Traditionally, figure skating was always a noncontact sport, unlike its roughhouse cousin, ice hockey. All that changed on January 6, 1994, when Nancy Kerrigan left the ice rink of Detroit's Cobo Arena after a practice session for the forthcoming U.S. National Figure Skating championships. What followed was not just an assault by an armed man on an unarmed woman, but an episode that combined high drama with true crime and low farce.

Kerrigan, a bronze medalist at the Albertville, France, Winter Olympics two years earlier, was clubbed above the right knee with a collapsible metal baton. Kerrigan collapsed in pain and shock, screaming, "Why? Why? Why?"

The answer became clear. The former husband of Kerrigan's main skating rival, Tonya Harding, had paid the assailant, Shane Stant, to put her out of contention for the championships. Such a move also would eliminate Kerrigan from Olympic competition since the U.S. championships served as selection trials for the Lillehammer Games.

Harding, professing her ignorance of this turn of events, won the national title and was selected for the Olympic team.

Minutes after the U.S. Olympic Trials concluded in Detroit, the forty-five-member U.S. Figure Skating Association's international committee convened a meeting. Citing a seldom-used USFSA rule which allows the organization to consider skaters who do not compete at the trials, the committee voted to allow Nancy Kerrigan a position on the Olympic team.

Harding's claims of innocence were shredded when her bodyguard, Shawn Eckhardt, and her ex-husband, Jeff Gillooly, were arrested

for their involvement in the attack. Harding suddenly changed her story and admitted knowing of the attack, but not organizing it.

Faced with expulsion from the Olympic team, Harding filed a \$20 million lawsuit against the United States Olympic Committee to block just such an action. The USOC relented, and Harding and Kerrigan were teammates.

On February 23, 1994, the first half of the women's figure skating program began. The stage had been set before an audience that would swell to

(left to right) Nancy Kerrigan skates in the 1994 Olympics ■ Jeff Gillooly ■ Shawn Eckhardt

(clockwise from bottom left) Nancy Kerrigan (bottom) and Tonya Harding on the Olympic practice rink.
Kerrigan grimaces in pain after the attack.
Harding runs through ever-present reporters to stop her truck from being towed.
Harding tearfully approaches the judges during her free skate program.

historic proportions. The showdown pitted Kerrigan, twenty-four, the Boston-bred girl-nextdoor, against Harding, twenty-three, the chronic asthmatic from Portland, and the child of her mother's fifth marriage.

For CBS, which broadcast the Winter Olympics, it was pure ratings gold. "It's a fortunate misfortune for us," said Greg Gumbel, television's Olympic host. Added Neal Pilson, the president of CBS Sports, "I don't think if we sat down to try to script an Olympics, we could have done much better."

That first night of competition attracted a 48.5 rating, the highest ever for an Olympic broadcast, the third highest for a sports event after the Super Bowls of 1982 and 1983, and the sixth highest of all time for any type of program.

An estimated 45.7 million households tuned in to watch Harding make her entrance in a bright red rhinestone skirt and matching lipstick for the technical program. Her choice of musical accompaniment was "Much Ado about Nothing." The judges missed the joke or ignored it, placing her tenth among the twentyseven contestants.

Kerrigan took the ice two hours later, in white with sheer black

sleeves. Her performance, to the strains of an original composition, "Desperate Love," was unsurpassed. At the end of the session, she was in first place.

In repute and in reality, Harding had never handled the pressure of international competition well. So it was at the start of the second program, the free skate. After one aborted jump, Harding tearfully sought an adjournment to repair a broken bootlace, returning with less than thirty seconds left of the two minute warning period after she was re-called to the ice. Her competitive campaign was in a shambles. Skating to the theme from "Jurassic Park," Harding improved her standing, marginally, to eighth place.

Kerrigan was close to flawless in the free skate, with its emphasis on artistic expression as much as pure athleticism. Describing her performance for CBS

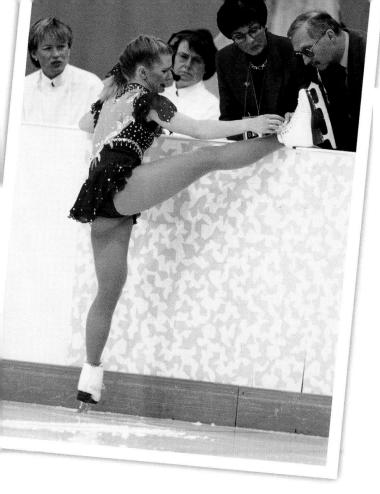

were sportscaster Mark Champion and Olympic silver medalist skater Paul Wylie. "Here comes her triple lutz...she's preparing...it's very important right here. Glances back, triple lutz! She does it beautifully! A huge smile comes across her face! I think that Nancy Kerrigan knows that this could be a golden performance!...Now her trademark spiral in the middle of the ice, she's reaching her arm out with exuberance." Nancy Kerrigan settled into her final pose and her music was drowned out by the cheers of the adoring crowd. She received a standing ovation, and floral bouquets began cascading to the ice.

But closer still to perfection, in the eyes of one judge, was Oksana Baiul, the sixteen-year-old world champion from the Ukraine. With the judges evenly divided in their assessments, the casting vote went to Jan Hoffman, a silver medalist at the 1980 Olympics for the former East Germany. He favored Baiul over Kerrigan by one-tenth of a point.

Despite her second-place finish, silver medalist Kerrigan returned home to a host of endorsements, not all of which she enjoyed. "This is so corny," she was alleged to say during a public appearance at Disney World.

Harding, on the other hand, returned home to plead guilty to conspiring with her former husband and bodyguard to impede the investigation of the assault.

She was fined \$160,000, ordered to perform five hundred hours of community service, and placed on probation for three years. The United States Figure Skating Association banned her from competition for life.

Jeff Gillooly, her ex-husband, pleaded guilty to racketeering and was sentenced to twenty-four months imprisonment. Shawn Eckhardt, the bodyguard, received an eighteen-month jail term for his part in the affair. Shane Stant was also given an eighteen-month sentence for carrying out the assault.

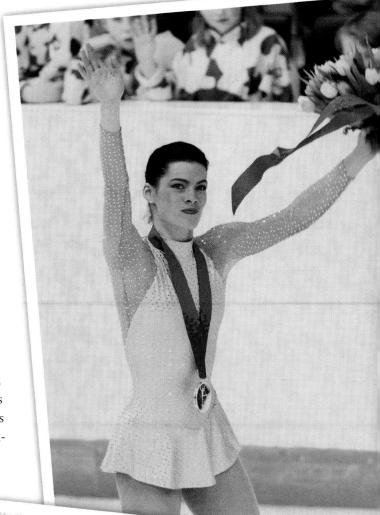

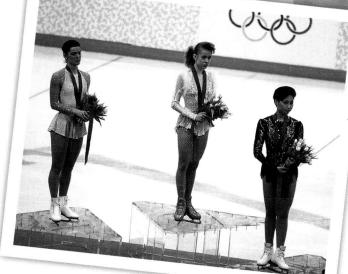

(clockwise from upper left) Harding shows the judges the broken lace on her skate. Ekerrigan waves triumphantly while wearing her Olympic silver medal. Kerrigan (left), Baiul (center), and bronze medalist Chen Lu

^{cc} The record that they thought would not be broken has now officially been broken!²⁹

Ariole

Jon Miller

September 6, 1995

Cal Ripken Sets Consecutive Games Streak

t is the easiest thing a ballplayer is asked to do. And yet, the man who did it the best set a record thought to be unbreakable.

Lou Gehrig earned the nickname "Iron Horse" for his stamina by playing in every game for the New York Yankees from June 1925 to April 1939, a record of 2,130 consecutive games. His streak ended tragically when Gehrig came down with amyotrophic lateral sclerosis, a fatal ailment subsequently named Lou Gehrig's Disease.

It seemed hard to believe that anybody could break Gehrig's streak. A ballplayer would have to play the game every day, 162 games a season, year after year, through bruises and fractures, slumps and fatigue, without ever missing a game. "Winning the lottery is easier than playing 2,130 straight games," said Baltimore Orioles manager Earl Weaver.

It was nearly inconceivable to think the streak could be surpassed by a shortstop, a man required to roam the field, deplete his energy, and constantly place himself in harm's way from runners sliding into second base. Yet, by the end of the 1995 season, Cal Ripken appeared to the one player in baseball who could break the fifty-six-year-old record.

Cal Ripken Jr.'s streak began in 1982 under Weaver. Ripken was a third baseman in those days, but twenty-seven games into the season, Weaver moved Ripken to shortstop and there he stayed for the ensuing thirteen years, hitting and fielding well enough to remain a fixture in the lineup.

Eyebrows were raised initially. After all, at 6 feet 4 inches and 220 pounds, Ripken was hardly a model shortstop. But by combining the intelligence to

(left to right) Cal Ripken waves to fans after breaking Lou Gehrig's consecutive game streak. ■ Young Cal Ripken with father, Cal Ripken Sr. ■ Ripken kisses his wife, Kelly.

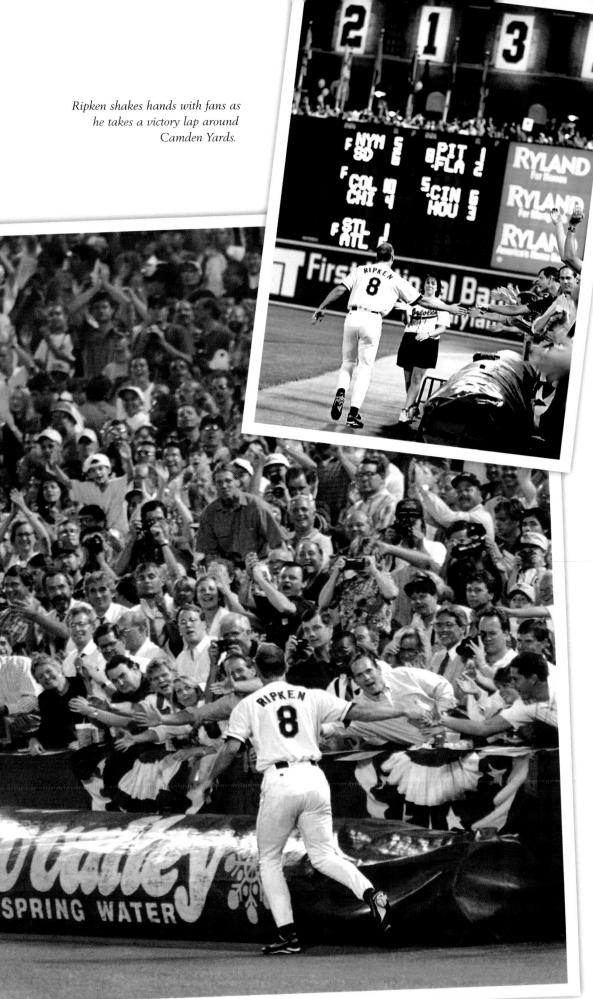

anticipate the bounce of the ball, the quickness to get to it, and the arm strength to get rid of it, Ripken went on to set nearly a dozen fielding records.

At bat, there was no question about his credentials. One of the finest hitting shortstops in baseball history, he will finish his career with more than four hundred home runs and more than three thousand hits.

Still, as inevitably come to every man who steps onto a baseball field, there were difficult times for Ripken, times when he fell into slumps, times when he had trouble handling the ball, times when his Orioles struggled to win games. And, in the later years of his career, any such difficulties elicited criticism of The Streak. Maybe Ripken just needs a rest, the critics said. Maybe he's too concerned about his record and not enough about the team. Maybe they ought to tell him to sit down. Ripken listened politely, gritted his teeth, grabbed his glove, went back on the field, and persevered.

Slumps would pass, and soon the hits were flying off his bat again and balls were landing securely in his glove. And The Streak went on.

As Ripken neared Gehrig's mark at the end of the 1995 season, huge numbers were hung on the warehouse behind the right field stands at Camden Yards to track the streak. The countdown to the monumental game had begun.

On September 5, at the age of thirty-five, Ripken tied Gehrig at Camden Yards in a game in which the Orioles beat the Anaheim Angels 8 to 0.

And then, one night later, doing the seemingly impossible in front of the adoring home crowd at Camden Yards, which included President Bill Clinton and Vice President Al Gore, and a nationwide television audience, Cal Ripken played his 2,131st consecutive game.

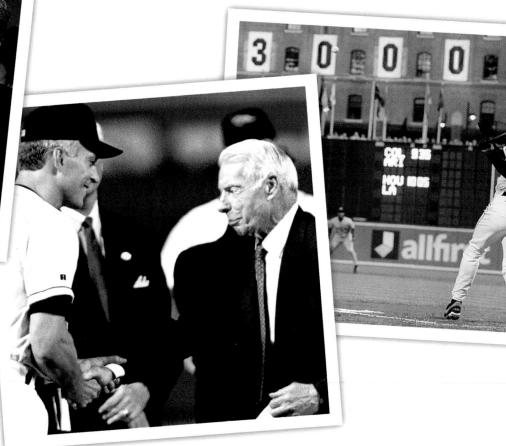

Although he took his regular position at the start of the game, Ripken technically had to wait until the end of the fifth inning for it to become an official game. Orioles announcer Jon Miller called it, as the fifth inning came to a close on a shallow fly ball popped up by the Angels' Damion Easley, caught by Orioles second baseman Manny Alexander. "The inning is over, and the game is an official game," announced Miller. "The record that they thought would not be broken has now officially been broken!" There were fireworks and balloons and streamers as more than forty-six thousand fans who had come to see history made watched the numbers roll over on a giant TV screen: 2,131! The stadium was filled with deafening cheers as the final number rolled into place.

Ripken kept emerging from the dugout to acknowledge them, eight times in all. Still, the crowd roared. Ripken gave his jersey to his wife, Kelly, hugged and kissed his kids, Ryan and Rachel, and waved to his parents, father Cal Sr. and mother Vi, in the stands. Still, the crowd roared.

Finally, he took a victory lap around the stadium. In all, the game was interrupted for twenty-two minutes and fifteen seconds. And, in typical Ripken fashion, he did more than just appear for his record-breaking game. He homered for the goahead run in a 4 to 2 victory over the Angels.

"What all of this is about," said his father, Cal Ripken Sr., who had managed his son, "is a man going to work every day to do his job." Joe DiMaggio, Hall of Fame player and teammate of Lou Gehrig, who was on hand for the postgame ceremonies, said Gehrig "would be looking down in appreciation."

Ripken not only broke the record, but shattered it. He went on to play three more seasons before finally sitting out a game. On September 20, 1998, Batimore's final home game of the season, Ripken asked to be taken out of the lineup after playing in 2,632 straight games. "I think," he said, "the time is right." (left to right) Ripken autographs a bat for President Clinton. ■ Ripken shakes hands with Lou Gehrig's teammate, Joe DiMaggio, during the ceremonies. ■ The Camden Yards warehouse notes Ripken's career hit number 3,000, attained in Minnesota on April 15, 2000.

"Michael Johnson running for the line and into Olympic history!"

Tom Hammond

July 29 & August 1, 1996

Michael Johnson Wins 200 and 400 Gold in Atlanta

n 1992, Michael Johnson left Barcelona, Spain, with an Olympic gold medal as a member of the winning U.S. 4 x 400–relay team. For most athletes, winning a gold medal would be the realization of a lifelong dream. But Johnson dreamed of the day he could stand alone on the medal stand.

Johnson, twenty-eight, had been undefeated in the 400 meters since 1989, and went to the 1992 Barcelona Olympics as the favorite. He had long since overcome his humble origins in the sport, when he was recruited to Texas' Baylor University as a prospective member of the powerful track team's 400-meter relay squad.

But with the second week of competition about to begin in Barcelona, Johnson was laid low with a bout of food poisoning. He competed in the individual races, but as a shadow of his real self. The best he could do was reach the semifinals of the 200-meter dash.

Meticulous in every aspect of his training and his life, Johnson prepared himself for the 1996 games even more ferociously. In August 1995, he won both the 200 and the 400 at the world track championships in Sweden. He began lobbying to have the schedule for the upcoming 1996 Centennial Olympics in Atlanta amended to give him time to rest between the 400 and the 200. He planned to win both. His plans, and the public attention they attracted, dominated his life. "Every phone call I got, that's all people wanted to talk about: the double," Johnson said. "I'd walk down the street and that's all people would say: 'Get the double.'"

The first half of that requirement was duly carried out on a memorable Monday night at the soon-to-be home of the Atlanta Braves. The starter's gun fired, and Tom Hammond began calling the race for NBC Television. "Michael Johnson, with his first steps toward track immortality...Michael Johnson taking it out fairly casually right now as they swing around the back stretch....Now he's kicked it into gear!...Coming to the head of the straightaway and Michael Johnson has the lead...and he's cruising to the finish!...Michael Johnson, coming home all by himself!" He crossed the finish line, setting a new Olympic record. "Michael Johnson is halfway to history!" Hammond announced. Johnson won the 400 meters easily and with such efficiency as to almost make the achievement seem less than it was. It was also the same night Carl Lewis won his ninth Olympic gold medal with an upset victory in the long jump. Johnson's feat was not overlooked, but neither was it celebrated to the extent that he had anticipated.

Three nights later, he settled in to lane three for the final of the 200 meters, a boiling, driven, nervous man.

(left to right) Michael Johnson sprints to victory in the 200 meters. August 1, 1996 ■ Johnson competes in the Olympics in Barcelona. August 3, 1992

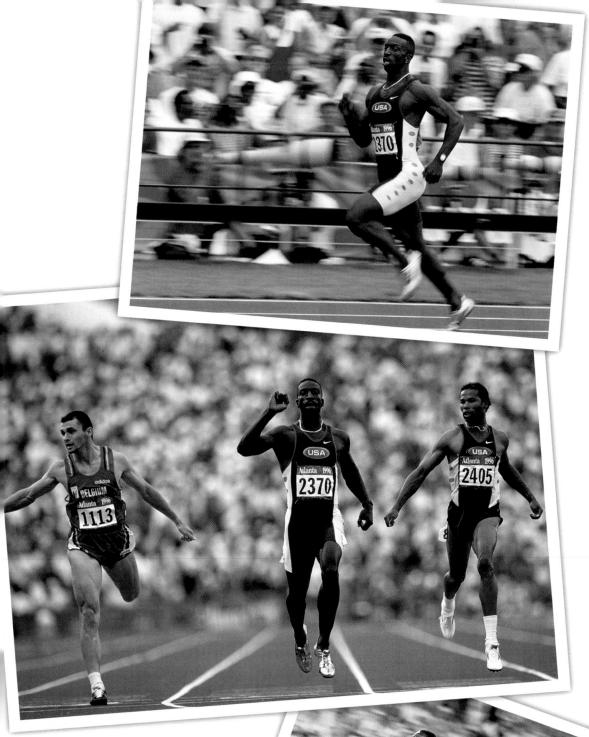

(top to bottom) Michael Johnson runs the 200 meters in the 1996 Olympics. ■ Michael Johnson (center) crosses the finish line in the semifinals of the men's 200meter dash. ■ Michael Johnson wins the gold in the 200 meters. On his feet were shoes that might last a minute. They were gold and weighed 3.4 ounces. At best, they would last two races, and then be discarded. Around his neck, a heavy gold chain bounced. Apart from his arms and shoulders, it was the only sign of movement in his upper body.

Shouts of "Go Michael!" could be heard just before the pistol shot rang out to signal the start of the race. Again, Tom Hammond described the lap-bylap action, "Flash bulbs flashing...and here comes Michael Johnson." Johnson was already running for history, his back military-straight. His strides were short, quick, and precise. "They're approaching the top of the straightaway...Michael Johnson reaching deep...Michael Johnson has dead aim on the finish! Michael Johnson running for the line and into Olympic history!"

As Johnson crossed the finish line, he spread his arms wide and let out a Tarzan-like bellow. It was a roar of triumph, release, and vindication.

Just after 9:00 p.m. eastern time, Johnson entered the record books. As he crossed the line, he glanced below and to his left, where a digital clock announced the magnitude of his achievement. It showed 19.32 seconds, a new world record.

The previous 200-meter world record mark of 19.72 seconds stood for seventeen years after being set by Pietro Mennea of Italy in 1979. Johnson lowered it to 19.66 during the June Olympic trials in Atlanta, then added his new time as an exclamation mark. The end of the race suggested the result was never in doubt, although for the briefest of moments, it was. On his fourth stride out of the blocks, Johnson stumbled slightly, but then recovered guickly to motor toward the lead as the eight runners came out of the bend. "I like to be afraid." Johnson said. "I like to be nervous. I ran like I was nervous."

In lane six, with his nominal advantage of the staggered start already wiped out, Ato Boldon, of Trinidad and Tobago, could sense the inevitable. "I saw him ahead of me, going into the straight and I said, 'Well, there goes first," Boldon said later.

221111112

Johnson again got his Olympic wish, standing alone on the winners dais before a crowd of 82,844, and a television audience of millions more around the world.

In victory, Johnson became the first man to win the 400-200 double (the feat had been achieved twice by women, American Valerie Brisco-Hooks in Los Angeles in 1984, and Marie-Jose Perec of France, also in Atlanta). "The world record is a bonus," Johnson said later. "The most important thing was making history. A lot of people held a world record, I held one before I came here. But nobody else can say they made history, the first to win the 200 and 400."

19.32 seconds. An emotional Michael celebrate his gold-medal victory in the

(top to bottom) Michael Johnson kneels next to his new world record time of Johnson accepts the gold. Michael Johnson carries the American flag to 400 meters.

SWOLCHEITIMING

"Holyfield bit by a dirty Mike Tyson!" Steve Albert

June 28, 1997

Mike Tyson Bites Evander Holyfield

M ike Tyson left the back streets of Brooklyn to become boxing's youngest heavyweight champion. In 1990, he lost his title to journeyman boxer Buster Douglas in one of the greatest upsets in the sport's history. Tyson also married and divorced television star Robin Givens, was convicted of raping a beauty queen, and spent three years in prison. Despite a life filled with twists, turns, triumphs, lawsuits, losses, heartaches, and headlines, Mike Tyson always will be remembered for the night he bit Evander Holyfield, twice.

The Tyson-Holyfield rivalry had more than its share of twists and turns as well. They were originally scheduled to meet on November 8, 1991, after Holyfield had taken the title away from Buster Douglas. That fight was postponed because Tyson suffered a rib injury, then cancelled when Tyson was indicted, tried, convicted, and sentenced for rape. When they finally met in November 1996, Holyfield, the challenger, opened as a 6–1 underdog, yet scored a technical knockout over Tyson when referee Mitch Halpern stopped the fight in the 11th round.

On June 28, 1997, more than sixteen thousand fans crowded into the arena at the Las Vegas MGM Hotel/Casino to witness the rematch. This fight, too, had its share of controversy. It was postponed six weeks when Tyson suffered a facial cut in a sparring match. Then, just days before the fight, Tyson's camp protested the assignment of Halpern to again ref the bout. With combined purses of more than \$60 million at stake and an expected gross of more than \$200 million from worldwide payper-view, Halpern withdrew to abate a brewing storm, and Mills Lane, retired judge turned referee, replaced him. Despite the fact that Holyfield was the champ and winner in their first fight, Tyson again had the odds on his side.

Tyson opened with a straight jab and immediately began stalking Holyfield, who refused to give ground. By the end of Round 1, the crowd was chanting, "Ho-ly-field, Ho-ly-field," and the champ appeared to have hurt the challenger with a hook-jab-hook combination.

Tyson appeared determined to avoid the holding so prevalent in their first meeting, and was moving around the ring to avoid Holyfield's clinches. The strategy had little impact and most of the action took place in close quarters. Tyson was on the receiving end of a head butt just above his right eye ten seconds into Round 2. Tyson had complained about receiving Holyfield's head butts after their first encounter.

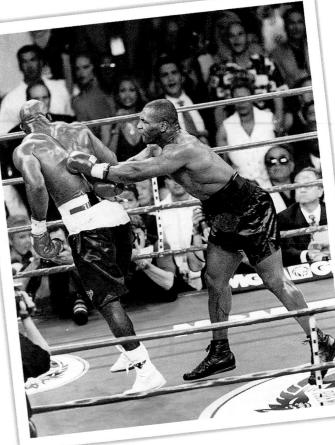

(left to right) Mike Tyson bites the ear of Evander Holyfield in the third round of the WBA Heavyweight Championship fight in Las Vegas. June 28, 1997 ■ After being ordered back to his corner, Tyson shoves Holyfield from behind during Round 3. (clockwise from upper left) Tyson bites Holyfield's ear twice in Round 3. ■ Holyfield holds his ear in pain. ■ Referee Mills Lane looks at Holyfield's ear. Lane eventually disqualified Tyson from the fight and declared Holyfield the winner.

> (opposite page, top to bottom) Holyfield walks back to his corner missing a piece of his right ear. ■ Trainers and police officers surround a wild Mike Tyson after Tyson is disqualified.

> > Referee Lane stopped the round momentarily to warn Holyfield, and to alert the judges that the ensuing cut was caused by the butt and not a punch. Lane later said he felt the butt was "accidental." Holyfield won his second straight round.

Round 3 opened with a furious assault by the challenger, but Holyfield withstood the attack and again the back and forth action evened out.

Then, after another clinch initiated by Holyfield, Tyson got rid of his mouthpiece and took about a one-inch bite out of Holyfield's right ear and spit it out in the ring. Steve Albert and Ferdie Pachecho, calling the pay-per-view fight for Showtime Event Television, watched in disbelief, "Oh my goodness, he's got a bloody right ear! Holyfield bit by a dirty Mike Tyson!...Disgusting tactics here by Mike Tyson!" Albert exclaimed incredulously.

WARRIOR

Holyfield began jumping around in pain and Mills Lane halted the action with just thirty-three seconds remaining in the round. Ordered back to his corner, Tyson shoved Holyfield from behind. After a few minutes, referee Mills Lane was ready to stop the fight for Holyfield but was overruled by Higside physician Dr. Flip Homansky. Tyson had two points deducted from his score and the two fighters again squared off. "Boy, this is getting stranger and stranger. We're getting to see strange things happen in boxing," said Albert.

Almost immediately, the pair were holding each other and Tyson again lost control.

For the second time, Mike Tyson bit down on his opponent and drew blood, this time from Holyfield's left ear. "He bit him again! He bit him again!" shouted Albert. "Mike Tyson has bitten Evander Holyfield for the second time, and it is allout war!" The arena was sheer bedlam. Again, the action was suspended while Holyfield was administered to by doctors.

As the two combatants sat in their corners and a stunned crowd caught their breath, Mills Lane conferred with Marc Ratner, the Nevada State Athletic Commission's executive director. They came to a quick decision. Tyson was disqualified, the fight was over.

Tyson erupted, pandemonium broke loose in the ring, and the two fight camps attacked each other. "Tyson is just taking swipes at anybody in front of him!" Albert shouted. "It's a fiasco!" The Las Vegas Metro Police charged in to the ring to restore order. Holyfield left the ring under his own power, while Tyson left under police escort as fans booed and threw things at him. The piece of Holyfield's right ear was retrieved from the ring and reattached after the match.

Tyson claimed to be retaliating for the head butts. "He butted me in the first round and in the second round again," he said. "What's a man to do? This is my career. I've got children to raise, and I have to retaliate. I complained in the first round and nothing was done." He would later formally apologize to Holyfield for "snapping in the ring."

Evander Holyfield remained the heavyweight champion of the world until he lost a decisive, twelve-round decision to Lennox Lewis on November 13, 1999.

For his part, Mike Tyson still believes he is the world's best heavyweight. He continues to train and fight and holds out hope for one more shot at the title.

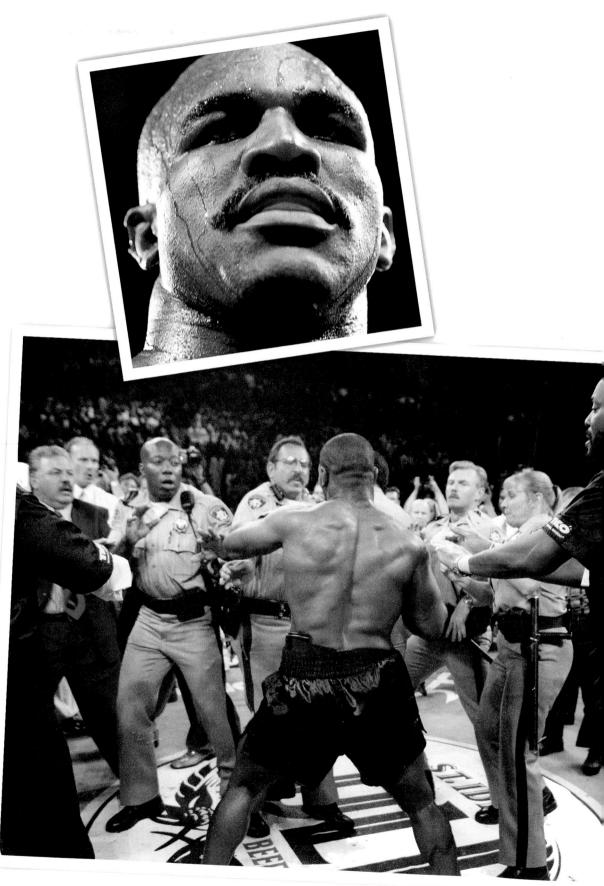

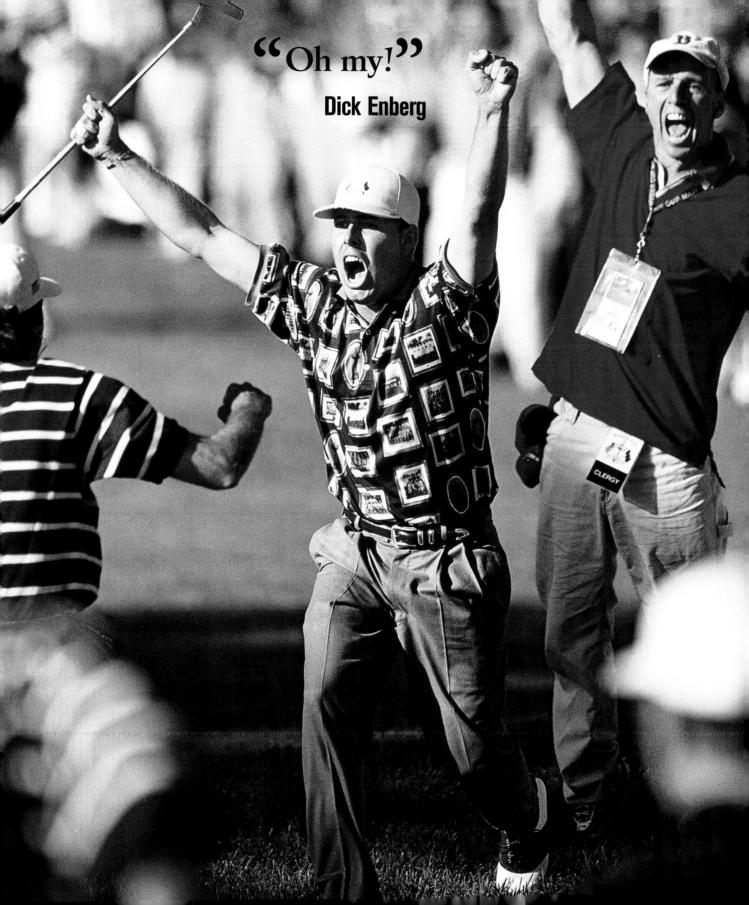

Justin Leonard Putt Seals U.S. Ryder Cup Comeback

For a country that had long taken its supremacy in golf for granted, the United States found itself in an unthinkable position. Not only were they about to lose to the Europeans in the game's premier team event, but it was about to happen for the third time in a row.

It was a sunny, yet somber Sunday in Brookline, Massachusetts, and the European team was quietly exultant. One more day of play in front of the rowdy Boston gallery, and the Ryder Cup would be theirs. The Europeans led ten points to six, and needed just four wins and a tie from the twelve individual matches in that day's singles play to annex the Cup again.

On the face of it, the Ryder Cup is a simple event: America versus Europe. The top ten ranked American players on the United States PGA Tour, along with two others chosen by the team captain, play their counterparts from across the Atlantic, the best players from Great Britain and Europe.

It only becomes complicated when trying to keep score: the first two of the three days are given over to team play, foursomes, and fourballs. A victory is worth one point, and a tie sees the point split.

The Cup is named for its original donor, Sam Ryder, an English seed merchant, who put up a trophy to decide whether the United States or England produced the best golfers. Teams played for the trophy every two years, alternately in the two countries. It was owned for much of its history by the Americans. In 1973, the English had their ranks augmented by players from Ireland. Since 1979, the rest of Europe also has been available for competition. Included in the team defending the Cup in 1999 were three Spaniards, two Swedes, and a Frenchman.

For the first two days of the event, the European team was a study in harmony. Sweden and Spain enjoyed a particularly blessed union, with the eccentric Jesper Parnevik and the new kid on the block, Sergio Garcia, a month removed from a thrilling finish in the PGA Championship with Tiger Woods, winning three matches and tying another.

The Ryder Cup was being played in Massachusetts for the first time since its inception. A surviving member of the 1918 Red Sox world champions was easier to find than a ticket to the Country Club in the Boston suburb of Brookline. Those who found the rare passes celebrated their good fortune with raucous and constant abuse of European team member Colin Montgomerie. The Scot's game and composure emerged from the ordeal unscathed. In

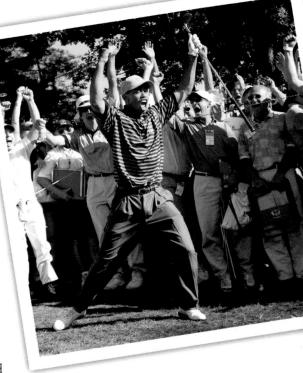

(left to right) Justin Leonard raises his arms in triumph after sinking a forty-five-foot putt on the 17th hole. His putt gave the Americans the half point they needed to win. September 26, 1999 ■ Tiger Woods after chipping in from the rough on the 10th hole of the fourball competition

the landslide that buried many of his teammates on the final day, he was one of the few to resist. His only further consolation was being an eyewitness to history.

The odds facing the American team on Sunday morning were long. They were four points down, and no team had ever recovered from more than two points behind to win the Cup on the last day.

In quick succession, Americans Tom Lehman, Hal Sutton, Phil Mickelson, Davis Love III, Tiger Woods, and David Duval returned the sort of one-sided matchplay results their reputations suggested. They were joined

in victory by Steve Pate, one of the roster choices of U.S. captain Ben Crenshaw. The score was 13 to 10 in favor of the home team, with five matches still undecided. One and one-half points more and the Ryder Cup would return to the U.S.

Garcia's entranced run of victories ended, falling to Jim Furyk. America led 14 to 10.

Paul Lawrie, the unheralded Scottish winner of the 1999 British Open, mounted a European rally by defeating Jeff Maggert.

The score was 14 to 11 with three matches still underway: Montgomerie and Payne Stewart, Padraig Harrington and Mark O'Meara, Jose Maria Olazabal and Justin Leonard.

Level with Harrington after seventeen holes, O'Meara faltered on the 18^{th} , losing the match. The score stood at 14 to 12.

Winless in his three matches on Friday and Saturday, after ten holes, American Justin Leonard trailed Olazabal by four holes. He needed to win at least four of the next eight holes from the defending Masters champion to stay in the match.

But Olazabal bogeyed four holes in a row, and Leonard drained

(clockwise from lower left) Crowds pour down the 18th fairway celebrating the American comeback. ■ Leonard tries to clear U.S. team members and media off the 17th green. ■ Justin Leonard celebrates his putt. ■ Payne Stewart, member of the 1999 U.S. Ryder Cup team

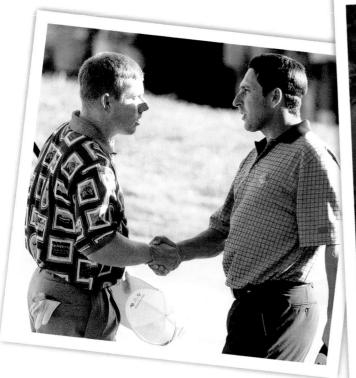

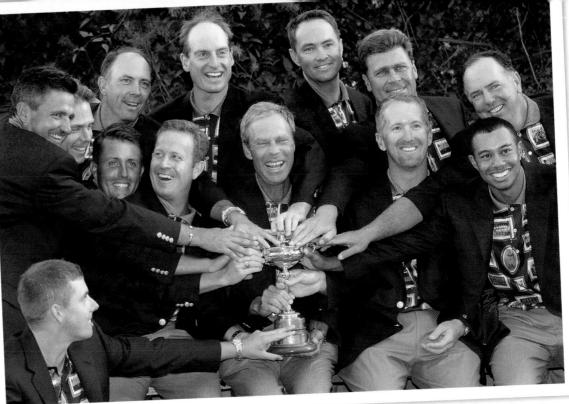

a thirty-five–foot putt on the 15^{th} to level the scores. Both parred the next hole. On the par four 17^{th} , each found the green with their second shots.

Leonard, who was furthest from the hole, was putting first, from forty-five feet. In distance and probability, it was the longest of shots. A birdie, if Olazabal missed his putt, would mean that Leonard could do no worse than tie the match, giving the Americans the elusive half point they needed to win the Cup.

Dick Enberg anchored the team coverage for NBC Television that included reporters Jim Gray, Roger Maltbie, Gary Koch, tower commentator Dan Hicks, and analyst Johnny Miller. In hushed tones, Maltbie appraised the tension-filled, do-or-die putt facing Leonard, "Well, this putt is from around forty-five feet, straight uphill, slow putt. He'll try to move a little bit from left to right. It goes up over this ridge in the green and then only about four paces to the hole once it's on top of that ridge. A tough putt to get the speed right on, John." The gallery grew quiet with anticipation. But as the ball rolled in the direction of the hole, a smattering of applause and solitary commands of "in the hole" punctuated the silence and soon erupted into unbridled jubilation.

The 1997 British Open champion's aim was true. "Oh my!" Enberg shouted. The ball dropped and an implosion of outrageous shirts invaded the 17th green, unfortunately trampling across the line of Olazabal's impending putt. In golf, this is a piece of real estate more sacrosanct than the most exclusive clubhouse. "The Americans really should compose themselves here," said Miller. "It's really very poor sportsmanship on the U.S.'s part there." Leonard suddenly recognized the violation and quickly corralled his teammates off the green, later admitting, by way of apology, "The excitement got the better of me."

Olazabal's putt was from twenty feet. It did not fall, and the celebrations began in earnest.

The final match of the day ended with a merciful gesture. Aware that his team had captured the Cup, Payne Stewart simply picked up opponent Colin Montgomerie's ball on the 18th green, surrendering the match to the European. A gallant deed to top off a golfing comeback for the ages.

(clockwise from left) American Justin Leonard and European Jose Maria Olazabal shake hands after they halved their singles match at the Ryder Cup. ■ The U.S. team surrounds captain Ben Crenshaw as he holds the Ryder Cup. ■ U.S team members celebrate on the clubhouse balcony.

"Touchdown Titans! There are no flags on the field! It's a miracle! Tennessee has pulled a miracle!"" Mike Keith

Disc 2 • Track 21

January 8, 2000

Music City Miracle: Tennessee Titans' Miraculous Kick Return

For execution and labeling, the first sporting highlight of the 21st century to qualify as one of sports' immortal moments occurred during the NFL's AFC wildcard playoff between the Buffalo Bills and the Tennessee Titans. For Bills fans, it's an event they have dubiously dubbed "the immaculate deception," but to Titans fans, it will forever be remembered as the "Music City Miracle."

"Music City" is Nashville, Tennessee, home of the Adelphia Coliseum, the fourth home in four years of the vagrant Tennessee Titans. In an earlier life, the Titans were the Houston Oilers before they fled Texas. They received a tepid welcome in Tennessee, where they turned out a succession of .500 seasons at makeshift homes in Memphis and Nashville. In 1999, they found success.

With a record of 13–3, the Titans were the most over-qualified team ever to play a wildcard game. By contrast, their opponents, the Bills, were unsettled and distracted. Doug Flutie, the Bills' resident miracle worker at quarterback for much of the previous two seasons, had been controversially demoted to the sidelines and replaced by Rob Johnson.

The Titans had not made the playoffs since 1994, when they were the Houston Oilers. Buffalo had, and for fifty-nine minutes and thirty-four seconds, it looked as though that know-how would be decisive. Despite their experience, the Bills went backward as often as forward in the first half. Johnson was stopped for a safety, while the offense as a whole gained only sixty-four yards by halftime. There was a 10–2 disparity in penalties against them, while the Titans' rookie sensation, linebacker Jevon Kearse, was a constant, menacing presence.

Buffalo persisted. Down 15 to 13 with 1:48 to play after a thirty-six–yard field goal by the Titans' Al Del Greco, the Bills mounted a six-play, thirty-eight–yard drive. The drive set up a fortyone–yard field goal attempt by Steve Christie.

The kick was good, and with sixteen seconds left to play, the Bills began to celebrate.

But the Titans had one last piece of unfinished

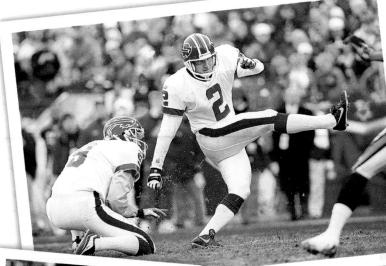

(clockwise from left) Tennessee Titans wide receiver Kevin Dyson celebrates after scoring the game-winning touchdown. January 8, 2000 Bills kicker Steve Christie boots a forty-one-yard field goal to put the Bills ahead 16 to 15 with only seconds remaining. Christie celebrates his successful field goal.

(left to right) After receiving a handoff from Lorenzo Neal, Frank Wycheck starts running right. Kevin Dyson is visible at back left. ■ Wycheck tosses a controversial pass to Dyson.

(opposite page, clockwise from left to right) The Titans sideline looks on as Kevin Dyson (87) runs toward the end zone. ■ Dyson looks for potential tacklers beyond his blockers. ■ Dyson waves to the home crowd after scoring the winning touchdown. business, a play they had rehearsed at the end of special teams practice, code-named the "Home Run Throw Back."

Everyone knew what to do, except the key player, Kevin Dyson. Dyson, the Titans' second-year wide receiver, filled in when the team's first two options as ball carriers, Derrick Mason and Anthony Dorsett, were sidelined due to injuries.

Dyson was quickly briefed by head coach Jeff Fisher, then he lined up in the backfield.

Calling the game on the Tennessee Titans Network were Mike Keith and Pat Ryan. As they waited for the kickoff, Keith wondered prophetically, "Do the Titans have a miracle left in them in what has been a magical season to this point? If they do, they need it now."

The kickoff from the Bills' Christie was short and high, landing in the arms of fullback Lorenzo Neal, who handed off to tight end Frank Wycheck. Wycheck started to his right. With the exception of Christie, the Bills went with him.

Then, in the play's most controversial moment, Wycheck tossed an overhand lateral to Dyson, charging through on his left, at the twenty-five-yard line. Whether the pass was legally thrown behind him, or illegally thrown forward, remains the subject of debate.

"I knew it wasn't forward," Wycheck said of his pass, "it might have been level."

"I took a hard step out and made sure it was a lateral," Dyson recalled. "Everyone was asking, 'Are you sure? Are you sure?' I knew."

"He's got something, he's got something," Ryan said excitedly. Dyson sprinted towards the end zone, a speedboat among an armada of linebackers, whose sole opposition, Christie, was leveled by Terry Killens. The excitement on the field and in the stands was echoed by Keith and Ryan as they called Dyson's run yard for yard, "Forty, thirty, twenty, ten, five, end zone! Touchdown Titans! There are no flags on the field! It's a miracle! Tennessee has pulled a miracle! A miracle for the Titans!" screamed Keith. The rest of the Bills were out of the picture and out of the playoffs. When Dyson crossed the goal line, there were three seconds left.

For several minutes, the crowd of sixty-six thousand at Adelphia Coliseum held its breath as referee Phil Luckett examined the pass on instant replay, re-running it from every angle. Later, Luckett observed, "Taking from where the pass left the passer's hand right on that (twenty-five) yard line...it did not appear to be a forward pass." Finally, Tennessee fans and the Titans sideline exploded with cheers at Luckett's announcement that the score would stand.

Although Titans fans would see their team lose Super Bowl XXXIV to the St. Louis Rams, just eight days into the new century, they had witnessed a play for the ages.

165

"A remarkable week, by a remarkable player, on a remarkable golf course!"

Dan Hicks

Tiger Woods Wins U.S. Open

The top golfers in the world were there, plus amateurs from Australia, aspirants from England, qualifiers from Chanhassen, Minnesota, and Humble, Texas. They were there for perhaps the last time, like Jack Nicklaus, or to see if they still had it, like sports broadcaster Bobby Clampett. Or they were there because a championship like the U.S. Open contested at a remarkable venue like Pebble Beach only comes along every so often.

What they would witness was pure domination, and perhaps the ascension of Tiger Woods from the status of champion to the repute of a legend. While every other starter in the 100th U.S. Open negotiated Pebble Beach like a minefield, Tiger Woods strode it like a catwalk.

The Open began by honoring the memory of defending champion Payne Stewart, killed in a mysterious plane crash in October 1999. A memorial service was held for Stewart the day before the tournament's start. It was followed by golf's equivalent of a twentyone gun salute, with twentyone gun salute, with twentyone players simultaneously launching balls from the 18th fairway into the Pacific Ocean at Stillwater Cove.

Woods was elsewhere, playing a practice round. He had already paid his respects, he said later, and had come to his personal emotional closure with Stewart's death. While his peers were looking back, he was staring forward, unblinking.

The seaside winds, tight fairways, and long rough were supposed to interfere with Woods' massive drives, and the slick greens could have exposed his occasionally fallible putting. But the tough conditions proved to be mere distraction to Woods. He made the most of a calm, early morning start on the first day of the four-day tournament by shooting a record-equaling 65. (clockwise from left) Tiger Woods holds his trophy after capturing the U.S. Open championship. • Woods tees off at the Pebble Beach Golf Links. • By land or by sea, Woods is a fan favorite.

167

On the greens, Woods was solid. He had felt a glitch in his putting stroke early in the week and fixed it. He oneputted twelve greens, holing them from near, eighteen inches, and far, twenty feet, on that first day.

By the end of the first day, it was apparent the elements were on his side too, causing problems for the rest of the field. The wind rose in the afternoon, and then a thick fog rolled over the Monterey Peninsula, stopping play at 4 p.m. The seventy-six players still on the course were forced to resume their first rounds at 6:30 a.m. the next day. Among the confounded and frustrated who did finish their rounds was John Daly, a PGA and British Open champion. Daly shot a 14 on the par five 18th, including a lefthanded bunker shot, to finish the first round with an 83. He withdrew from the tournament.

> The next afternoon, Jack Nicklaus followed him out of the locker room, quite possibly for the last time at a U.S. Open, after missing the cut in his fortyfourth appearance.

"The last century was mine," said Nicklaus, the winner of eighteen major titles. "Tiger can have this one." During the weekend, Woods worked his way through difficult situations as he extended his lead. On Saturday, at the 6th hole, Tiger was in the rough 248 yards from the hole on his second shot, and the fierce Pebble Beach wind and a tree stood between him and the green. NBC's team coverage included Dan Hicks, Johnny Miller, and Roger Maltbie. Caught in the wind, Woods' ball landed in the thick, tall grass surrounding the bunker at the side of the green. "This is one bad break," said Miller.

"There's a big kind of depression with that tall grass behind it. The ball's so far above his feet that he's going to have to swing the club on such a shallow angle at the ball, that I don't see how he can hit down on the ball without going through all that grass behind it. Anything can happen. Eighty-two yards to the hole."

"If he gets it on the green it would be absolutely fabulous. I wouldn't think he would try," mused Maltbie. With no sure stance, Woods improvised as only Woods is able. He positioned himself and swung. As the ball reached the green, the cheering of the gallery swelled. "This is absolutely brilliant play, Johnny, brilliant play there!" Hicks said incredulously.

Coming into the final round on Sunday, the only question that remained was by how many strokes Woods would win. He began the day leading by ten. He ended it winning by an astonishing fifteen. Despite the uncontested romp, NBC pulled in the highest U.S. Open television ratings in over two decades.

As Woods sank his final putt on 18, the gallery erupted. "And Tiger Woods is the 100th U.S. Open

(left to right) Woods hits his approach to the 3rd green.■ Woods pumps his fist on the 18th green after winning the U.S. Open. champion!" proclaimed NBC's Hicks. "A remarkable week, by a remarkable player, on a remarkable golf course!"

Some of the records Woods broke or equaled were merely a generation old. Woods was the first player to lead the Open after every round since Englishman Tony Jacklin in 1970, while his first-round 65 was matched by only one other in relation to par, Gil Morgan in 1992.

Others were almost as old as the game itself: his winning margin of fifteen strokes over South African Ernie Els and Spaniard Miguel Angel Jimenez was the largest ever, surpassing by four the previous Open mark set in 1899.

The record margin in any major thirteen shots—was set by Old Tom

Morris in the British Open of 1862. That disappeared too. So did the Open scoring records for thirty-six, fifty-four, and finally, seventy-two holes, a 12-under-par 272.

Woods handled most questions after his victory with the aplomb of a talk show host. One, though, caught him unaware—how great is he? For the first time on or near the course at Pebble Beach during the 100th U.S. Open, Tiger Woods stumbled, and then recovered. "Aw," he began, "that's not exactly easy for me to answer—I let my clubs do the talking. But I'll tell you this, I'm going to try to get better."

Just five weeks later, Woods won the British Open at St. Andrews, completing golf's Grand Slam. He is the fifth golfer, and at age twenty-four, the youngest, to have won all four majors.

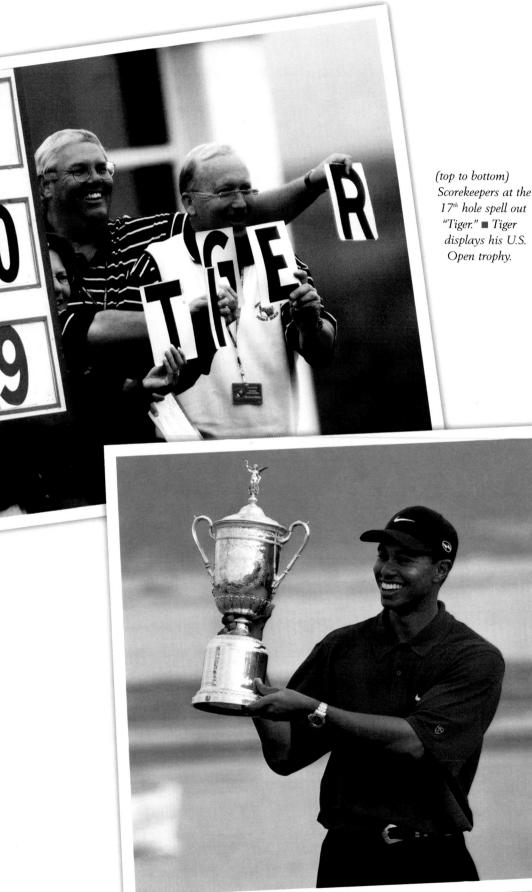

169

And The Fans

Acknowledgments

Roared

owe special thanks to so many people for their generous contributions of talent, guidance, and encouragement.

My deepest gratitude to Dominique Raccah. President of Sourcebooks, for her steadfast support, encouragement, and vision.

Thank you to Todd Stocke. Editorial Director of Sourcebooks, for his skillful editing, creativity, passion, and dedication. He's the best.

Thank you to Beckie Pasko. Norma Underwood. Dawn Weinfurtner, Ron Troyer, Taylor Poole, Micah Taupule, Tressa Minervini, Becky Tracy, Eric O'Malley, and Kirsten Hansen for their artistry in transforming all the elements into the beautiful book you're holding.

I want to thank Amy Baxter for her tireless and meticulous photo researching and cataloging. Thanks also to the rest of the Sourcebooks editorial team, Jennifer Fusco, Katie Funk, Peter Lynch, Angela Barnes, Jay Diehl, and Lyron Bennett.

Thank you to my publicist, Anna Kosse, for her boundless enthusiasm, creativity, and ever-present positive attitude. Here's to another bestseller, Anna.

I owe a tremendous debt of gratitude to Bob

Costas. His knowledge and genuine passion for the subject gives this book a voice that is both authoritative and entertaining.

I am extremely grateful to the Champ, George Foreman, for providing an insightful and entertaining foreword.

Thank you to Pam Davis, Executive Assistant to Bob Costas, for her cheerful disposition, expert diplomacy, and coordination of our scheduling, and to Kay Reller for keeping us all in touch.

My sincerest thanks to Louise Argianas from ABC Sports, Deanna O'Toole from CBS Sports, and Marc LaPlace from NBC Sports. Their enthusiastic support has been invaluable.

Thank you to John Miley for his enthusiasm and his willingness to share his knowledge and passion of sports broadcasting. And to Carole, his wife, for her warm hospitality during my visit to The Miley Collection.

Thank you to Hall of Fame announcer Bob Wolff for his kindness and encouragement.

To the family of Howard Cosell, thank you for allowing me to include Mr. Cosell. He is an icon in sports broadcasting and my book is richer for his inclusion.

To Marc Firestone, thank you, Marc, for your creativity, boundless enthusiasm, insightful counsel, constant encouragement, and most of all, your friendship.

And The Fans Roared

Thank you to Bill Kurtis, the voice that started it all. He brought life to the vision of a multi-media book, and I will forever be grateful.

Thank you to Bill Caplan for his invaluable assistance in introducing my book to George Foreman.

Thank you to Celia Tuckman and everyone at Don King Productions, for their continued support in allowing me to tell their memorable stories.

Thank you to Tony Zirille, for his genuine enthusiasm and support.

Thank you to Joy Dellapina from NBA Entertainment, Dina Panto from Major League Baseball Productions, Roy Langbord from Showtime Event Television for going above and beyond to make sure I had the best audio footage.

Thank you to Ethan Orlinsky from Major League Baseball Properties, Dennis Lewin from the National Football League, Laura Zappi from the United States Olympic Committee, Kathy Jorden from the Professional Golfers' Association, Mark Carlson from the United States Golf Association, and Rich Tallo of the United States Tennis Association, for permitting inclusion of the broadcasts of their memorable events.

Thank you to Heather Marsh-Rumion at Corbis Images, Carolyn McMahon at AP/Wide World Photos, Karen Carpenter at Sports Illustrated, Jim Lee at Allsport Photography, Arlete Santos at Archive Photo, Leo Tarantino at Duomo, and Daniel Walanka at CMG World Wide, for their diligence in providing the best possible images.

A very special thank you to my son, J.B. (James), and daughter, Jillian, for their love and patience; to my parents, Jim and Betty Garner, for instilling in me the drive to pursue my dreams; and to the rest of my family and friends for their love and support throughout.

Finally, thank you to Dan Kavanaugh, Maura Kelley, Janel Syverud, Steve Cross, Bradley Warden, Justin Hixon, Corrie Gorson, Mike Forslund, and everyone at Mirage Productions, for their support and friendship.

Photo Credits

All credits listed by page number, in the order indicated on pages.

Every effort has been made to correctly attribute all the materials reproduced in this book. If any errors have been made, we will be happy to correct them in future editions.

Page vi Ed Horowitz/Tony Stone Images Page xi Deborah Wald Photography Page xii Corbis/Bettmann Jackie Robinson 2 AP/Wide World Photos; 3 Corbis/Bettmann, Archive Photos; 4 Corbis/Bettmann, Archive Photos, AP/Wide World Photos; 5 Corbis/Bettmann, Corbis/Bettmann, Corbis/Bettmann Babe Ruth 6 Corbis; 7 Corbis/Bettmann, Corbis/Bettmann; 8 AP Photo, AP Photo, Corbis/Bettmann; 9 AP Photo/Harry Harris, UPI/Corbis-Bettmann Citation 10 AP/Wide World Photos; 11 UPI/Corbis-Bettmann, Corbis/Bettmann; 12 Corbis/Bettmann, UPI/Corbis-Bettmann, Corbis/Bettmann; 13 AP/Wide World Photos, Corbis/Bettmann Willie Mays 14 AP/Wide World Photos; 15 Corbis/Bettmann, Corbis/Bettmann; 16 Corbis/Bettmann, Corbis/Bettmann; 17 Corbis/Bettmann, Corbis/Bettmann, Corbis/Bettmann Patterson vs. Johansson 18 AP/Wide World Photos; 19 Corbis/Bettmann; 20 Corbis/Bettmann, Corbis/Bettmann, AP/Wide World Photos; 21 AP/Wide World Photos, AP/Wide World Photos Jim Marshall 22 © NFL Photos; 23 Tournament of Roses ® Archives; 24 Corbis/Bettmann, Corbis/Bettmann; 25 Corbis/Bettmann, © NFL Photos/R.H. Stagg Rod Laver 26 UPI/Corbis-Bettmann; 27 Corbis/Bettmann; 28 Corbis/Bettmann, Corbis/Bettmann, Corbis/Bettmann; 29 AP/Wide World Photos, Corbis/Bettmann, All Sport/Ed Lacy Bobby Orr 30 AP Photo/Boston Herald American/Ray Lussier; 31 Archive Photos; 32 UPI/Corbis-Bettmann, Corbis/Bettmann, Corbis/Bettmann, Corbis/Bettmann; 33 Corbis/Bettmann, Corbis/Bettmann Tom Dempsey 34 © NFL Photos/Otto Collier; 35 UPI/Corbis-Bettmann Jim O'Brien 36 Corbis/Bettmann; 37 AP/Wide World Photos, AP/Wide World Photos; 38 AP/Wide World Photos, AP/Wide World Photos, UPI/Corbis-Bettmann; 39 Corbis/Bettmann, Corbis/Bettmann Oklahoma vs. Nebraska 40 Neil Leifer/Sports Illustrated; 41 Neil Leifer/Sports Illustrated; 42 Corbis/Bettmann, Corbis/Bettmann; 43 Neil Leifer/Sports Illustrated, Neil Leifer/Sports Illustrated Paul Henderson 44 AP/Wide World Photos; 45 AP/Wide World Photos; 46 UPI/Corbis/Bettmann, AP/Wide World Photos, AP/Wide World Photos; 47 AP/Wide World Photos, Corbis/Bettmann George Foreman 48 UPI/Corbis-Bettmann; 49 Corbis/Bettmann; 50 Corbis/Bettmann, Corbis/Bettmann, UPI/Corbis-Bettmann; 51 AP/Wide World Photos, UPI/Corbis-Bettmann, AP/Wide World Photos 0.J. Simpson 52 © NFL Photos/Robert Smith; AP/Wide World Photos; 54 AP/Wide World Photos, AP/Wide World Photos; 55 AP/Wide World Photos, AP/Wide World Photos, AP/Wide World Photos Notre Dame 56 Rich Clarkson/Sports Illustrated; 57 AP/Wide World Photos; 58 Rich Clarkson/Sports Illustrated, Rich Clarkson/Sports Illustrated, Rich Clarkson/Sports Illustrated; 59 Rich Clarkson/Sports Illustrated, Rich Clarkson/Sports Illustrated Cettics Beat Suns 60 Dick Raphael/Sports Illustrated; 61 AP/Wide World Photos, UPI/Corbis-Bettmann; 62 Sports Illustrated, Sports Illustrated, Manny Millan/Sports Illustrated; 63 Corbis/Bettmann Reggie Jackson 64 AP/Wide World Photos; 65 Corbis/Bettmann; 66 AP/Wide World Photos, AP/Wide World Photos, AP/Wide World Photos; 67 AP/Wide World Photos, Corbis/Bettmann, AP/Wide World Photos, AP/Wide World Photos Affirmed 68 AP/Wide World Photos; 69 AP/Wide World Photos, AP/Wide World Photos; 70 AP/Wide World Photos, AP/Wide World Photos, AP/Wide World Photos; 71 AP/Wide World Photos, AP/Wide World Photos, AP/Wide World Photos Eric Heiden 72 All Sport/Tony Duffy; 73 Corbis/Bettmann; 74 Corbis/Bettmann, Corbis/Bettmann, Corbis/Bettmann, All Sport/Tony Duffy; 75 All Sport/Aschendorf, Corbis/Bettmann Bill Johnson 76 Duomo; 77 All Sport/Steve Powell; 78 All Sport/Steve Powell, Corbis/Bettmann; 79 Corbis/Bettmann, All Sport/Dave Cannon Kareem Abdul-Jabbar 80 AP/Wide World Photos; 81 AP/Wide World Photos; 82 Corbis/Bettmann, AP/Wide World Photos, AP/Wide World Photos; 83 AP/Wide World Photos, Richard Mackson/Sports Illustrated, Corbis/Bettmann Mary Lou Retton 84 Archive Photos; 85 Corbis/Bettmann; 86 All Sport/Steve Powell, All Sport/Trevor Jones, All Sport/Trevor Jones; 87 All Sport/Steve Powell, Corbis/Bettmann, Corbis/Bettmann Walter Payton 88 Corbis/Bettmann; 89 Corbis/Bettmann; 90 Corbis/Bettmann, AP/Wide World Photos, UPI/Corbis-Bettmann; 91 AP/Wide World Photos, UPI/Corbis-Bettmann, AP/Wide World Photos Pete Rose 92 All Sport/William Hart; 93 Corbis/Bettmann, Corbis/Bettmann; 94 Corbis/Bettmann, Corbis/Bettmann,

AP/Wide World Photos; 95 AP/Wide World Photos, Archive Photos, AP/Wide World Photos Ozzie Smith 96 AP/Wide World Photos; 97 Corbis/Bettmann; 98 AP/Wide World Photos, UPI/Corbis-Bettmann; 99 AP/Wide World Photos, AP/Wide World Photos, UPI/Corbis-Bettmann Bill Buckner 100 Globe Newspaper Company; 101 AP/Wide World Photos; 102 All Sport/T.G. Higgins, All Sport/T.G. Higgins; 103 All Sport/T.G. Higgins, All Sport/T.G. Higgins, All Sport/T.G. Higgins Florence Griffith Joyner 104 All Sport/Mike Powell; 105 Corbis/Neal Preston, Archive Photos; 106 Corbis/Bettmann, Reuters/Corbis-Bettmann, Corbis/Bettmann; 107 Archive Photos, All Sport/Mike Powell Joe Montana 108 All Sport/Mike Powell; 109 AP/Wide World Photos; 110 All Sport/Rick Stewart, All Sport/Mike Powell, © NFL Photos/Rob Rosato; 111 All Sport/Mike Powell, Corbis/Bettmann, AP/Wide World Photos Michael Jordan 112 Sports Illustrated; 113 Sports Illustrated Greg LeMond 114 Reuters/Corbis; 115 All Sport/Vandystadt; 116 Reuters/Corbis, Corbis/Bettmann; 117 Reuters/Corbis-Bettmann, All Sport/Vandystadt, Reuters/Corbis, All Sport/Vandystadt Earthquake 118 UPI/Bettmann; 119 Corbis/Bettmann, Corbis/Bettmann; 120 AP/Wide World Photos, Corbis/Bettmann, AP/Wide World Photos; 121 AP/Wide World Photos, AP/Wide World Photos Magic Johnson 122 AP/Wide World Photos; 123 Reuters/Lee Celano/Archive Photos; 124 UPI/Corbis-Bettmann, Corbis/Bettmann, AP/Wide World Photos; 125 Corbis/Bettmann, Reuters/Kim Kulish/Archive Photos, AP/Wide World Photos Duke vs. Kentucky 126 AP/Wide World Photos; 127 Corbis/Reuters; 128 Damian Strohmeyer/Sports Illustrated, AP/Wide World Photos: 129 Damian Strohmeyer/Sports Illustrated, AP/Wide World Photos, Damian Strohmeyer/Sports Illustrated Al Unser Jr. 130 Indy 500 Photos: 131 Indy 500 Photos: 132 Indy 500 Photos/Ron McQueeney, Indy 500 Photos; 133 AP/Wide World Photos, Indy 500 Photos, Indy 500 Photos, Indy 500 Photos Buffalo Bills 134 © NFL Photos/John Reid; 135 All Sport/Rick Stewart, All Sport/Rick Stewart; 136 All Sport/Rick Stewart, AP/Wide World Photos, © NFL Photos/John Reid; 137 AP/Wide World Photos, All Sport/Rick Stewart Joe Carter 138 Reuters/Corbis-Bettmann; 139 All Sport/Rick Stewart; 140 Reuters/Corbis-Bettmann, Reuters/Moe Doiron/Archive Photos, AP/Wide World Photos, All Sport/Rick Stewart; 141 Reuters/Gary Hershorn/Archive Photos, Reuters/Corbis-Bettmann, Reuters/Mike Blake/Archive Photos Kerrigan vs. Harding 142 All Sport/Clive Brunskill; 143 Reuters/Steve Dipaola/Archive Photos, Corbis/Reuters; 144 All Sport/Pascal Rondeau, Intersport Television, Reuters/Corbis-Bettmann, Corbis/Bettmann; 145 Reuters/Corbis-Bettmann, Agence Vandystadt/Richard Martin, Reuters/Blake Sell/Archive Photos Cal Ripken 146 All Sport/Doug Pensinger; 147 All Sport/Doug Pensinger, Corbis/Bettmann; 148 All Sport/Doug Pensinger, AP/Wide World Photos; 149 Reuters/Stephen Jaffee/Archive Photos, Reuters/Gary Hershorn/Archive Photos, Corbis/Bettmann Michael Johnson 150 Reuters/Mike Blake/Archive Photos; 151 Reuters/Mike Blake/Archive Photos; 152 Corbis/Bettmann, Corbis/Bettmann, All Sport/Gary M. Prior; 153 All Sport/Mike Powell, Reuters/Wolfgang Rattay/Archive Photos, All Sport/Mike Hewitt Tyson vs. Holyfield 154 Reuters/Steve Marcus/Archive Photos; 155 All Sport/Jamie Squire; 156 All Sport/Jamie Squire, All Sport/Jed Jacobsohn, All Sport/Jed Jacobsohn; 157 Reuters/Gary Hershorn/Archive Photos, Corbis/Bettmann U.S. Ryder Cup 158 All Sport/Rusty Jarrett; 159 AP/Wide World Photos; 160 All Sport/Stephen Munday, All Sport/Andrew Redington, Corbis/Bettmann, All Sport/Harry How: 161 Reuters/Gary Hershorn/Archive Photos, Corbis/Bettmann, All Sport/Stephen Munday Music City Miracle 162 All Sport/Andy Lyons; 163 All Sport/Andy Lyons, All Sport/Andy Lyons; 164 All Sport/Andy Lyons, AP/Wide World Photos; 165 AP/Wide World Photos, AP/Wide World Photos, Reuters/Stringer/Archive Photos Tiger Woods 166 AP/Wide World Photos; 167 AP/Wide World Photos, AP/Wide World Photos; 168 AP/Wide World Photos, AP/Wide World Photos; 169 AP/Wide World Photos, AP/Wide World Photos

Credits

A book like this is the result of a team effort. Again, I was fortunate to have assembled the best.

Text/research editorial team:

Steve Springer, sportswriter for the *Los Angeles Times*, and author of three sports books. Gerard Wright Paul Feinberg Todd Donoho

Audio editorial team:

Narration written by Mark Rowland, writer/producer of television documentaries. Archival audio and audio research provided by John Miley, The Miley Collection. Additional audio research services provided by Michael Dolan.

Audio credits:

Bob Costas was recorded by Bill Schulenburg, Production Consultants, St. Louis, Missouri. Audio production engineering by Chris Lindsley.

Some audio segments have been edited for time and content. Archival audio provided by and copyright of:

ABC Sports, Inc. CBS Sports, Inc. NBC Sports, Inc. NBA Entertainment, Inc. Don King Productions, Inc. Major League Baseball Properties, Inc. National Football League NFL Films, Inc.

Special thanks also to:

Baltimore Orioles	Chicago Bears	Los Angeles Lakers	San Francisco 49ers
Boston Celtics	Chicago Bulls	New Orleans Saints	St. Louis Cardinals
Buffalo Bills	Cincinnati Reds	New York Mets	Tennessee Titans

Capitol Networks

KCBS Radio, San Francisco, California

KMOX Radio, St. Louis, Missouri

Showtime Event Television

Ficel Marketing Corp.

Team '72 Representation, Inc.

Toronto Blue Jays

Announcers

The publisher and I would especially like to thank the sportscasters listed below, as well as those we were unable to identify. They brought excitement to these moments, and their words will forever be part of our memories. In order of appearance, they are:

Bob Wolff Mel Allen Clem McCarthy Jack Brickhouse Les Keiter Lon Simmons **Russ Hodges Bud** Collins Dan Kelly Al Wester Jay Randolph Lyell Bremser Foster Hewitt Marty Glickman Van Patrick Howard Cosell Johnny Most Guy Manella **Ross Porter** Dave Johnson

Dick Woolet Chick Anderson Keith Jackson Frank Gifford Chick Hearn Jack Whitaker Joe McConnell Marty Brennaman Joe Nuxhall Jack Buck **Bob** Murphy Charlie Jones Wayne Walker Joe Starkey Jim Durham Johnny Kerr Al Trautwig Sam Posey Al Michaels Tim McCarver

John Rooney Johnny Bench **Bob Harris** Mike Waters Paul Page Van Miller Greg Brown Tom Cheek Mark Champion Jon Miller Tom Hammond Steve Albert Ferdie Pachecho Dick Enberg Roger Maltbie Johnny Miller Mike Keith Pat Ryan Dan Hicks

Joe Garner is the *New York Times* bestselling author of *And The Crowd Goes Wild* and *We Interrupt This Broadcast* and is a twenty-year veteran of the radio business. His expertise on the media's coverage of major sporting and news events has been featured on *Larry King Live, Weekend Today*, CNN, *CBS Up-to-the-Minute* and more than fifteen hundred radio programs nationwide. Garner's books also were bestsellers in the *Wall Street Journal, Publishers Weekly*, and *USA Today*.

Bob Costas has won twelve Emmy awards—eight as outstanding sports broadcaster, two for writing, one for his late-night interview show *Later...with Bob Costas* and one for his play-by-play broadcast of the 1997 World Series. He has been named "National Sportscaster of the Year" seven times by his peers. Costas also provided the narration for Joe Garner's bestselling *And The Crowd Goes Wild*.